German Bodies

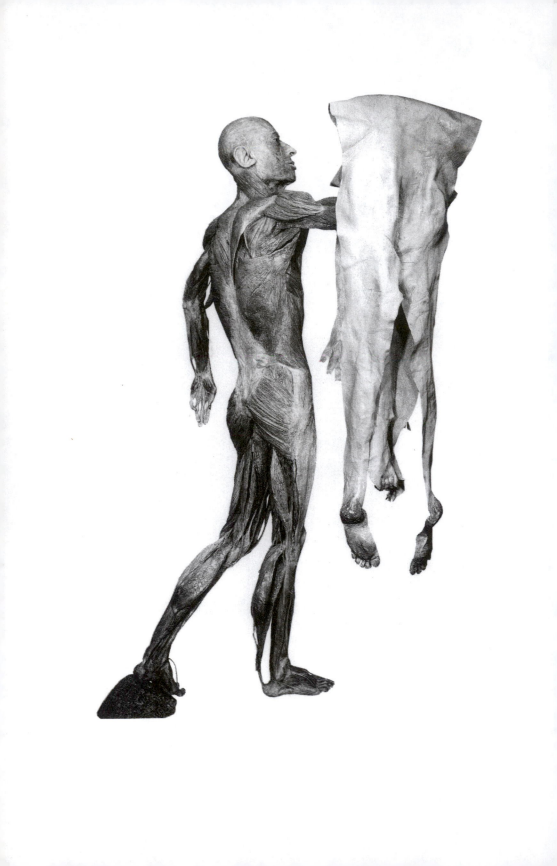

German Bodies

RACE AND REPRESENTATION
AFTER HITLER

•

ULI LINKE

Routledge
New York · London

Frontispiece. *Anatomy on Display: Male Corpse with Skin, Mannheim 1997.* This flayed body of a man holding his own skin is among the displays at "Body Worlds" (*Körperwelten*), an exhibit on human anatomy at Mannheim's Museum of Technology and Work. The life-sized specimens are human corpses, cadavers, that have been preserved through a process called "plastination." The male figure shown here retains all its muscles and organs, but its skin is draped like a coat over one arm. Plastinated preservation remakes the corpse, a German body, into an aesthetic object: With his flesh restored and made immortal, the new man stands transfixed, focused on himself. A set of motifs, which typify the figuration of this corpse—white skin, the muscled body, the heroic pose—reveal a return to an uncanny fascination with fascist masculinity.

The author gratefully acknowledges the cooperation of the following sources in preparing images for this volume:

Figure 1, *Köperwelten* (1997); Figure 2, reproduced by permission of photographer, Marcel Fugère; figures 3 & 19, courtesy of Bündnis 90/Die Grünen; figure 4, Thomas Hesterberg (photographer) from *Der Spiegel* (1998); Econ Verlag for figures 5–8, reproduced from the Jahrbuch der Werbung (1987 & 1993; Düsseldorf); figure 9 reproduced from Smadar Lavie's *The Poetics of Military Occupation* (1990); figure 11, image from 1885 (public domain); Herr Paul Glaser for figure 13, reproduced from *Zehn Jahre Alternative Liste* (ed. Mayer, Schmolt, and Wolf, 1998); Frau Ann-Christine Jansson for figure 14, reproduced from *Zehn Jahre Alternative Liste*; for figure 15, Herr Ernst Volland, editor of the volume *Gefühl und Schärfe: Fotos für die TAZ* (1987); for figure 16, Herr Karl-Heinz Hick and Photo-Agentur JOKER; for figure 17, Herr Michael Gööck, (@Michael Gööck); for figure 18, AP/Wide World Photos, the photo originally appearing in *die taz*, January 27, 1989. Figures 10, 12, 20–32 provided courtesy of author.

Routledge, Inc. respects international copyright laws. We have made every effort to gain permission for the images contained herein. Any omissions or oversights in the acknowledgments section of this volume are purely unintentional.

Published in 1999 by
Routledge
29 West 35th Street
New York, NY 10001

Published in Great Britain by
Routledge
11 New Fetter Lane
London EC4P 4EE

Library of Congress Cataloging-in-Publication Data

Linke, Uli.
 German bodies : race and representation after Hitler / Uli Linke.
 p. cm.
 Includes bibliographical references and index.
 ISBN 0-415-92121-X (hb.)—ISBN 0-415-92122-8 (pbk.)
 1. Body, Human—Social aspects—Germany. 2. Body, Human—Symbolic aspects—Germany. 3. Whites—Germany—Ethnic identity. 4. Germans—Ethnic identity. 5. National socialism—Germany—History.
6. Genocide—Germany—History. 7. Germany—Politics and government.
8. Germany—Race relations. I. Title.
GT497.G3L55 1999
305.8'00943—dc21 98-44572
 CIP

CONTENTS

•

LIST OF ILLUSTRATIONS

•

ACKNOWLEDGMENTS

•

Ideas do not emerge from a vacuum. Many of my colleagues and friends generously offered me assistance, both in locating relevant source materials and in providing useful comments. I am deeply indebted to Allen Feldman, whose unwavering belief in the importance of this project strengthened my determination to bring it to completion. I owe a great deal to conversations with Leslie Adelson, Angelika Bammer, Omer Bartov, Sam Beck, Andrew Bickford, John Borneman, Philippe Bourgois, Karen Colvard, Jean Comaroff, Belinda Davis, Duran Bell, Sam Elworthy, Cynthia Enloe, Heide Fehrenbach, James Fernandez, Jonas Frykman, Susan Gal, Thomas Hauschild, Linda Hogle, Andrea Klimt, Anto Knezevic, Ruth Mandel, Nancy Munn, David T. Murphy, Carolyn Nordstrom, Jeffrey Peck, Linda-Anne Rebhun, Elaine Scarry, Niel Smith, Maria Olujic, Nancy Scheper-Hughes, David Rubin, C. Nadia Seremetakis, Ronald Shearer, George Steinmetz, Paul Stoller, Jacqueline Urla, Lisa Vanderlinden, Ruth Wodak, Brackette Williams, Christoph Wulf, and Joseba Zulaika. For their critical suggestions, and constructive commentary, I thank Erika Dettmar, Volker Harms, Utz Jeggle, Gudrun König, Gottfried Korff, and Bernd Jürgen Warneken, whose support for this project was both generous and heartfelt. I am grateful to Arlene Teraoka for taking the time to read a final version of the manuscript with a critical eye.

This book has been a long time in the making and diverse sources of funding have been essential to its completion. Initial fieldwork in West Berlin was supported by a postdoctoral fellowship from the Social Science Research Council (1988–89). Additional research, analysis, and write-up of the findings have been enabled by several generous grants from the University Research Council at Rutgers (1991–98) and, most recently, a series of competitive fellowships from the Rutgers Center for Historical Analysis (RCHA), the Center for the Critical

Analysis of Contemporary Culture (CCACC), and the Institute of Ethnology at Tübingen (Germany), where I spent six months as a visiting fellow from 1997 to 1998. A number of conference and travel grants, which enabled me to think more critically about the contents of this book, are gratefully acknowledged: the Harry Frank Guggenheim Foundation (1997–99); the Minda de Gunzburg Center for European Studies at Harvard (1997); the Center for Slavic and East European Studies at Berkeley (1995); the Center for European Studies in Minneapolis (1994); the Center for German and European Studies at Georgetown University, Washington DC (1993); and the Wenner-Gren Foundation for Anthropological Research (1991).

Some portions of this book were previously published, although in a much different format. Chapter 3 was the first to be written. An early version, originally published in *New German Critique* 64 (1995): 37–60 with the title "Murderous Fantasies: Violence, Memory, and Selfhood in Germany," is reprinted here with substantial revisions. I have not only altered the title, but added new information throughout the text and notes. A later version, containing some portions of this chapter, was published in *City & Society: Annual Review* (1997): 135–58 as "Fantasizing Violence" [copyright American Anthropological Association 1997]. Together, these two articles provided a blueprint for the current chapter 3. A short version of chapter 2 was first published in *American Anthropologist* 99 (2): 559–73 with the title "Gendered Difference, Violent Imagination: Blood, Race, Nation" [copyright American Anthropological Association 1997]. An expanded version of this piece is to be published in my forthcoming book *Blood and Nation: The European Aesthetics of Race* (Philadelphia: University of Pennsylvania Press, 1999) with the same title. Both of these publications guided me in drafting the text for chapter 2. Most recently completed, chapter 1 has not been published previously. The long excerpt that appears in the introduction to this book was first published in *Konkret: Politik und Kultur* 1 (1994): 42 [copyright Konkret Vertriebsgesellschaft GmbH, Hamburg]. I thank the presses and their editors for permitting me to reprint portions of these previously published texts. Whenever possible I have cited from published English translations of original German texts. In those instances, in which such translations are either not available or unknown to me, I have provided my own translations.

The credits for photographs that appear in this book are detailed in the List of Illustrations on pages vii–ix. In some (although very few) cases, the identity

and/or the current whereabouts of the copyright owner (the photographer) could not be determined. Any legitimate claims regarding copyright fees will, of course, be honored.

INTRODUCTION

•

This book is an attempt to understand social memory. My focus is on the continued existence of social and symbolic violence in German culture after 1945 and its historical connection with Nazism and genocide. My research suggests that the German political imaginary is infused with a racialized violence that has persisted in a more or less unbroken trajectory from the Third Reich until today. In postwar West Germany, Nazism and the murder of Jews are contested and highly charged domains of cultural reproduction. The horror of the past inspires an intense fascination that generates both desire and repulsion: In a diversity of domains (everyday life, mass media, politics, and leftist protest), the past furnishes narrative material for the contemporary construction of identity and difference. Postwar West German perceptions of Nazism and victimhood entail both inversion and continuity, dissociation and invocation. But my work suggests that the National Socialist aesthetics of race, with its tropes of blood, body, and white skin, continue to organize German political thought to the present day. Contemporary Germans invest bodies and physicalities with meanings that derive significance from historical memory: of Nazi atrocities, the Holocaust, and the Judeocide. These events are implanted in social memory through a repertoire of images and symbols, which, by nature of the violence of representation, sustain and even reproduce the culture of the past. Such mimetic evocations, while often tangibly inscribed on bodies, remain below the level of conscious acknowledgment because they exist in disguised or highly aestheticized form (see frontispiece).

1

The essays in this volume are the product of a wide-ranging inquiry into postwar German culture. I examine the cult of the body through several thematic frames of image making and representation: white skin, nudity, blood, and violence. Although the essays focus on memory formations after 1945, my sources range from the Nazi literature on blood, body, and race to the most recent documentation of corporal images used by the West German Left; from the proposals of racial hygiene under the Third Reich to today's media images of blood pollution by immigrants and refugees. Thus, side by side, the reader will find descriptions of Nazi pogroms, skinhead violence, and an analysis of the iconography of murder in leftist political protest. This juxtaposition is intended to reveal the pervasiveness and continuity of specific symbolic forms. While I acknowledge the important differences between symbolic violence, physical violence, and violent rhetoric, my contention is that the shifting terrains of practice and fantasy set into motion a normalizing process that reifies existing levels of brutality by inhibiting critical engagement. My focus on the violence of German memory proceeds by examination of a basic, organizing metaphor: the body. Traumatic history is housed in images of the human body, and these images are in turn connected to agency and corporal practice.

Mapping Modern Bodies

The historical conditions that shaped the modern German aesthetics of race did not emerge until the second half of the eighteenth century, and it was some time before such notions became part of a common framework of cultural perception. According to Michel Foucault (1973), it was only with the sociogenesis of European modernity that blood, body, and race were created as biological entities. With the birth of the clinic, a new body perception became commonplace. The material body was seized by a dissecting gaze that embraced not only the entire organism, not only its surfaces, but also its recesses, orifices, and hidden crevices. It penetrated inquisitively into bodies, relating living organs to gutted and evis-

cerated cadavers, to a visual image of a dead body: the corpse. The penetrating gaze of the physician was like a postmortem dissection; the sick patient was now treated in a way that once had been conceivable only with dead bodies. Foucault (1975) repeatedly points out that the impact of this new clinical discourse turned the body, and with it the patient who possessed it, into a discrete object. The modern medical examiner fabricated a biological body, which could be read and treated only through the grid of an anatomical atlas. The material reality of the patient's body was a product of these clinical descriptions (and not vice versa); for what took hold was the belief that these medical descriptions truly grasped and reproduced a "natural" body. Assigned to the realms of nature and biology, the body was thus expelled from history.

As a result, contemporary histories of the human body examined cultural variations of the body's manifestations and attributes: the history of sleep and food, of sexuality and disease, of age and death. But the vehicle of all this activity, the body itself, was always thought of as a physiologically stable entity. As Barbara Duden (1991) so eloquently put it, "To us the body is essentially an anatomico-physiological collection of organs. Its inner processes, its secretions, fluids, and excretions, its sexual patterning and 'vital events'—birth and death, menstruation and menopause, nursing and ejaculation, procreation and pregnancy—are always thought of as physiological processes. This mental demarcation of a socially 'raw' corporeality has created barriers between historians and the body" (vii–viii). What people of a past age and culture thought about the inside of the body—the stomach, blood, and excrement—was virtually unknown and rarely looked at. But, as I have documented elsewhere (Linke 1999), the very notion of the body as a kind of text, although written for divine purposes, existed already as a construct in late medieval Christianity. After death, holy women's bodies were "opened up" to be searched for anatomical evidence of their sainthood, and some women's bodily interiors were minutely dissected and examined for the visible presence of Christ's stigmata in heart, stomach, or blood (Rothman et al. 1995: 3;

Bynum 1987). Late medieval theorists imagined and described an osmotic or "magical" body and were fascinated by the ways in which the female body could serve as a vehicle for supernatural forces that worked unpredictable, and incredible, effects on female organs and functions.

After all, the body of woman was itself a source of power. Women's bodies housed the forces and substances that could produce good as well as evil: blood, the periodic flow, the afterbirth, the amniotic fluid, and finally the "mother" womb (*Gebärmutter*), which, like an oven, could bring forth or take life (Duden 1991: 8). This power and task of infusing life and destroying it was embodied in woman. But in the wake of the European Counter Reformation, beginning in the seventeenth century, we observe an attempt to shift the source of power from the female body and the utterances of women to the institution of the church and its written word (Delumeau 1978; O'Neill 1984). Priests demanded for the church the power to bestow the life that really mattered to ensure salvation from eternal death (Accati 1979). Thus the magical renderings of female bodies, including the "power over thunderstorms, which old women had long been able to command . . . by baring their buttocks, and the power of a virgin to influence weather by opening her bleeding vulva toward heaven were no longer simply accepted as strange and mysterious powers" (Duden 1991: 8). Regarded as threats to the institutional power of religion, such sanguine abilities were denigrated and negated. According to Robert Muchembled (1983), what took place was a "persistent devaluation of the magic of the body," which was the medium of popular culture (151). From the seventeenth century on, the new bureaucratic power of the church worked to destroy this cosmic anchoring of popular culture: official dogma began to describe the female body and its ambiguous power as a demonic threat, and to explain its very essence as "natural" weakness.

During this same period (between the sixteenth and the eighteenth centuries), when the power of the modern state was being established, the anatomical makeup of bodies gained additional

strategic importance. A new system of legal justice imprinted its gaze upon the bodies of its subjects. The public butchering and disemboweling of the executed or condemned person transformed the "opening" of the body into a strategy of political power (Foucault 1979). The eviscerated body of the witch, heretic, or Jew allowed the acts of justice to become visible to all, "for the people crowd[ed] to the executions as onlookers" (Muchembled 1985: 248). These public executions were often stretched out over several days: A few hours each day, on a stage, the body was "opened" in full view of the public (Camporesi 1984: 16–18). What took place was the dissecting of a living body, in which the act of justice was rendered visible first by dislocating the body on the scaffold, then by burning its skin, and finally by penetrating inside the body and drawing out the intestines. It would seem (from the perspective of the modern state) that the infliction of pain was secondary to the solemn act of taking control by means of the anatomy of the condemned (Duden 1991: 9). The symbolism of punishment was conveyed by "opening" or exposing the innermost flesh. Indeed, anatomy was at this time still a public ritual that linked the penal process to an exhibition of the structure of the human body.

Gradually, in the course of the eighteenth century, the method of dissection changed: the judicial exposure of the inside of a human being gave way to a procedure in which doctors acquired professional knowledge in a closed dissection chamber (Temkin 1977; Ackerknecht 1971; Mann 1984). This shift in dissecting practices did not, however, release the body from the hold of the state. To the contrary, the political meanings behind the anatomizing, the "dissecting," inflicted on bodies persisted and were reflected in a deep-rooted and tenacious aversion felt by ordinary people at losing their bodies to the court anatomists: peasants near Jena as well as London began to protect their corpses in order to escape this further intrusion of the state's power after death (Haeser 1971: 280; Linebaugh 1975). Compounded by religious ideas about resurrection, these feelings of horror at being physically fragmented and dismembered were expressed in a series of revolts against municipal authorities.

A comparison of these acts of undisguised violence (witch perse-
cutions, the scaffold, and anatomy) suggests not only the strategic
significance of the body but also the symbolic value of its integrity.
According to Duden (1991), during the two centuries, when the
modern state rose to power, great importance was attached to two
interrelated developments: In scientific work and in corporal pun-
ishment, the inside of the body was "opened up" and examined.

> In this way, the connections, deeply rooted in popular culture, between
> this (invisible) interior and the macrocosm were eradicated. [Around
> 1700], the act of dissection, which exposed things, and the reduction of
> the body merged into one process. The "state" was able to gain power
> from this opening and isolating of the body because the "biological"
> body and the "social" body were connected, had a correlation in the cul-
> ture's consciousness; whatever was done to the former was never done
> only to a "private body." (10)

A violent process began in the seventeenth century, in which the
body as the embodiment of localized social vitality was symbolically
broken; demonized, atomized, and displayed, the body was
deprived of its meaningful opacity.

The sociogenesis of European modernity was thus clearly impli-
cated in an ever-increasing objectification of blood and skin.
Cultural historians, as I have briefly noted, insisted that what took
place was a political devaluation of the magic of the body. In
Duden's words, "before the body could be constituted as the object
of descriptive observation, it first had to be devalued as a vehicle of
symbolic meaning" (1991: 10). Yet paradoxically, it was precisely
this symbolic valuation of flesh and blood that persisted in
European and German popular culture. Despite the emergence of a
biological model of the body in late-eighteenth-century medicine,
at least some parts of the body retained their magical value: the skin,
fat, tissues, bones, organs, and blood continued to exert an intense
magical attraction in the imagination and ritual practices of com-
mon people. Consequently, our understanding of the modern body
requires some revision. Convential histories of modern medicine
have failed to accomodate the possibility that "some untidy bits of

human experience might conceivably elude the deadly dominion exercised by the power of [the medical gaze] or, for that matter, the discourse of power" (Anderson 1993: 3). Even under modernity, the body retained its magical significance.

Thus in the historical archives of modern jurisprudence we find many recorded cases that describe how ordinary people insisted on the dissection and gutting of human bodies for healing purposes. For example, we learn that in 1822, "(based upon a case authenticated by documents), there lived in Napels an old doctor; he had [begotten], by several women, children, whom he inhumanly slaughtered amid special preparations and solemnities; he cut open their breasts, took out their hearts, and prepared from the heart's blood precious drops that afforded resistance to any disease" (Strack 1909: 92). There appeared in 1890, "before the court at Hagen, in Westphalia, a servant, seventy years of age, on the serious charge of robbery of dead bodies, and desecration of graves. The accused . . . dug up with a spade . . . a child's grave . . . and next day, after opening the coffin with a screwdriver, cut out of the thigh of the corpse a piece of flesh, which he laid on a wound he had had many years on his body . . . He even imagined, at least he said so in [the] hearing of the case, that the remedy had done good" (ibid.. 93). In the late nineteenth century, in the province of Prussia, "[t]hose who had fallen ill through a vampire's bite were healed by having mixed with their drink some of the blood (i.e., the thickish product of decomposition so described by the populace) of [the vampire's] head when cut off . . . Only a few months ago (March 1877), at Heidenmühl, in the Schlochau district, the body of a recently-deceased child . . . was mutilated in its grave, and a small bit of the corpse-flesh was given to a sick child [to eat] as a cure [for vampire's bite]" (ibid.. 95).

According to nineteenth-century German and Prussian popular belief, inextinguishable lamps could be made of human fat; corpse fat was fashioned into candle wax: "If a thief gets the fat of a pregnant woman, [and] makes a candle of it, and lights it, he can steal where he likes without anxiety . . . [Thus] on New Year's Eve, 1864, a fearful murder was perpetrated at Ellerwald on Elizabeth

Zernickl . . . A piece of flesh, nine inches long, and the same in breadth, had been cut out of her belly . . . [And] on the evening of February 16, 1865, . . . a working man, Gottfried Dallian of Neukirch, in the Niederung, was caught, and there was found on him a strange candle, consisting of a tolerably firm mass of fat, poured round a wick, and contained in a leaden container" (Strack 1909: 101–2, 115): The motive for the deed was the delusion that a candle or small lamp prepared from the fat of a murdered person would not be extinguished by any draft, and the flame could only be put out with milk.

Blood, body parts, and excrement were used for medicinal purposes in Germany, Pomerania, and West Prussia until the end of the nineteenth century:

> When there is an urgent conjecture of witchcraft, the person suspected is seized and beaten till her blood flows, in order to give it to the sick man to swallow or to wash him with it, or until she promises to withdraw the spell . . . and only a few [of the many] cases come to the knowledge of the courts and to publicity . . . [Thus in 1868] A peasant in Jaschhütte [Prussia] had broken his leg. He did not seek any professional help . . . Neighbours who visited him persuaded him he was bewitched by a woman in the village. The witch, a young relative . . . [was] made to enter the house of the possessed man, and asked by those present to give him some of her blood to drink . . . [She was] forced by blows of the fist from two of those present to let the salving blood be drawn from her nose. The attempt was a failure. One of the two men went to the courtyard, dirtied his hands with manure, whilst at the same time he made three crosses with it on them. Fresh blows of the fist on the nose with the blessed hands had the desired effect. The witch was now obliged to lay herself on the bed of the possessed man, and to let the blood trickle into his open mouth. [The curse] then indeed, seemed to give way, for soon after the patient was able to utter the words: "Nu wart me beeter" (I am better now!). The still-flowing blood was then collected in a cup for possible relapses. (Strack 1909: 97–100)

These examples illustrating the magical manipulation of blood, fat, and flesh clearly suggest that the making of the modern body was not the result of developments in science and medicine alone. In the course of the nineteenth century, the body gradually emerged as a multilayered entity, with each layer constituted as the text of a different episteme, a different field of knowledge, a different age,

and each woven out of a distinct tropological fabric spun from earlier historical material. The metaphorical stratigraphy of body, blood, and skin, as I suggest in this book, reveals disturbing temporal densities: the "new" (modern) corporeal aesthetic was mediated by a tenacious stream of images and motifs that persisted over centuries. At times, these mythographic patterns seemed to blend and merge, but occasionally, and remarkably, they resurfaced in their original form.

Such a mythographic layering of memory is evident in the dramatic production of "Body Worlds" (*Körperwelten*), an exhibit on human anatomy sponsored by the Museum of Technology and Work in Mannheim (see frontispiece). The bodies on display are real human corpses, cadavers. Harvested from deceased donors, the life-sized specimens are preserved in various stages of dissection. The bodies are sliced open to reveal the interior world of human physiology: skin, muscles, nerves, intestines, blood vessels, lungs, heart, brain, bones, wombs, and penises. Such public displays of corpses, inspiring both morbid curiosity and scientific interest, are part of a larger history of human exhibition, in which the themes of death, dissection, torture, and martyrdom are intermingled: "This history includes the exhibition of dead bodies in cemeteries, catacombs, homes, and theaters, the public dissection of cadavers in anatomy lessons, the vivisection of torture victims using such anatomical techniques as flaying, public executions by guillotine or gibbet, heads of criminals impaled on stakes, public extractions of teeth, and displays of body parts and fetuses in anatomical and other museums, whether in the flesh, in wax, or in plaster cast" (Kirshenblatt-Gimblett 1998: 35). These earlier ethnographic or anatomical displays, built around articulated skeletons, taxidermy, wax models, and live specimens, forged a "conceptual link between anatomy and death in what might be considered museums of mortality" (ibid., 36). The German exhibit, however, presents something quite different. Its galleries of plastinated corpses do not attempt to inspire horror or fear by dramatizing mortality. On the contrary, this collection of bodies, more than two hundred specimens, creates the illusion of life after death. Human anatomy is

staged by creating dramatic visions of the normal, the ordinary body (see figure 1). Many of the life-sized figures are engaged in familiar activities:

> The *Runner* is frozen in the loping gait of a marathoner, stripped of almost everything except bones and muscles. Its outer muscles fly backward off its bones, as if the muscles were being blown by the wind rushing past. The *Muscleman* is a bare skeleton that holds up its entire system of muscles, which looks like an astronaut's bulky spacesuit dangling on a hanger. The Figure with Skin retains all its muscles and organs, but its skin is draped like a coat over one arm. The *Expanded Body* resembles a human telescope, its skeleton pulled apart so people can see what lies beneath the skull and the rib cage. (Andrews 1998: 1)

This exposition of bodies is driven by an aesthetic that seeks to transform the male corpse into an heroic figure. The cadavers are arranged so as to emphasize physical strength, virility, athletic prowess, and muscular vigor. "The beauty [of these corporal forms] displaces revulsion" (Eggebrecht 1998: 1); and "aesthetics becomes a means for pushing away disgust" (Reimer 1998: 2). Out of the raw material of human remains new bodies have been fashioned: beautified, durable, and dramatic masculinities. Presented without reference to personal biography or cause of death, the plastinated specimens perform a symbolic function: The corpses are aesthetized in such a way as to suppress evocations of violence, victimhood, or history. Regarded as "anatomical artworks" (Andrews 1998:1), artistic "statues" (Roth 1998: 51), the displays successfully evade comparisons with Nazi medical experimentation or eugenics and racial hygiene. Indeed, the refurbished corpses are plastinated *German* bodies.

All of the exhibited whole body specimens, except two, are male. Every male figure (regardless of its anatomized disarray) retains an intact penis, emphasizing its sex—its manhood (figure 1). The exhibit's collection of body parts contains numerous healthy organs. Among them are nearly a dozen male genitalia: these erect (plastinated) penises, with scrota, are arranged in their individual showcases. By contrast, women's reproductive organs, that is, vagina and uterus

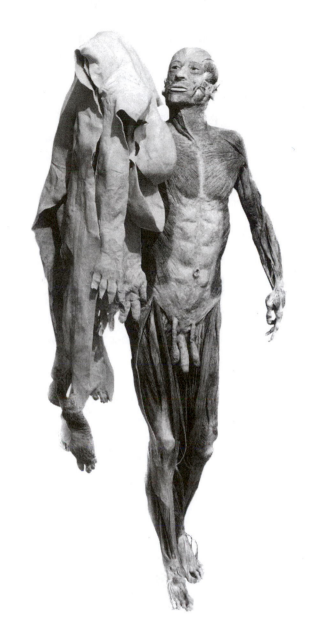

Figure 1. *Anatomy on Display: Male Corpse with Skin, Mannheim 1997*. The male figure shown here, the flayed body of a man holding his own skin, is a display of the importance of the human dermis: a protective armor. "The plastinated corpse shows . . . how defenseless a human being looks without skin, and . . . how the skin, when it is no longer inhabited by the body, can be regarded as a distinct organ. Only after the skin has been carefully removed can the body's anatomical nudity be exposed: [We see] the bones and muscles, which in their turn envelope the innermost organs" (Whalley 1997: 161). The display's visual focus on the figure's muscled body and genital masculinity points to a cultural preoccupation with corporal integrity, that is, the intact body armor of the anatomical male.

with ovaries, are shown with malignancies, tumors and cysts. The museum's exhibit contains only two female figures (out of two hundred specimens): both are pregnant women. In one woman's corpse, the stomach and womb have been slashed open to reveal a five-month-old fetus (see Körperwelten 1997: 136, 138, 140–41). This female body is marked by arrows pointing to her intestinal tract, her uterus, and her fetus, an iconographic rendering that is suggestive of a preoccupation with female emissions and body products: excrement, uterine blood, the fetus. In the exhibit (as in the catalogue), the pregnant women are grouped with an assortment of pathologies—deformed embryos, miscarriages, and terminated pregnancies: "In a glass case at the center of [this] room, visitors encounter a row of plasticized infant corpses, including a pair of conjoined twins" (Andrews 1998: 4). Such an iconographic and symbolic emphasis on female reproduction gone awry—the female body as pathology—belongs to, and is typical of, a racialist conception of womanhood (as I suggest in chapter 2). In this exhibition of human anatomy, German ideals of the national body are inscribed onto the corpses by a medical gaze that is preoccupied with images and representations of gender and race.

Mapping Genealogies: Blood, Nature, History

The modern search for more precise anatomical knowledge, for regularity, order, laws, and causes—in contradistinction to the belief that the natural world was controlled by miracles and by forces of magic—was critical to a new understanding of the body in relation to processes of health and disease. Knowledge and explanation were sought not in the discovery of divine purposes but in the complex fluids, organs, and functions of the body itself. In the modern era, ever more radical explorations and interventions in the pursuit of knowledge began, inexorably leading the medical gaze into the interior of the body itself. Disease was associated with that which was taboo, contaminated, and filthy, particularly when it was supposed that disease posed a danger to public health. Cleanliness was linked

to political stability, and healthy behavior gradually folded into a capitalist definition of moral behavior.

How did an aesthetic of race emerge from this modernist vision of the body? Was the ordering of social identities by physical markers a product of the "progressive enlightenment" of modern science? Or was it based on an altogether different conceptual development? In a series of essays, Michel Foucault (1978) claimed that the modern concept of race, that is, the whole thematic of the species, descent, and collective welfare, was endowed with the ancient (but fully maintained) prestige of blood: "The blood relation long remained an important element in the mechanisms of power, its manifestations, and its rituals. For a society in which the systems of alliance, the political form of the sovereign, the differentiation into orders and castes, and the value of descent lines were predominant; for a society in which famine, epidemics, and violence made death imminent, blood constituted one of the fundamental values" (147). Thus, in the modern era, blood remained an important signifier of power and privilege. The ancient regime of blood continued to support ideas of descent, heredity, and genealogy, providing a basis for fundamental social distinctions (Smith 1995: 726; Herzfeld 1992: 26–44). Blood endured as a descent ideology that became increasingly racialist. The premodern aesthetic of blood, according to Foucault, served as a foundation upon which a more directly biologist (racist) system of modern heredity could be erected.

But how do we explain this historical preoccupation with and commitment to the symbolic value of blood? Why was blood transformed into a societal fetish? Foucault (1978) suggests that this cultural obsession had something to do with the intrinsic qualities of blood. As a liquid, a bodily fluid, blood is always in a state of flux, its containment ever precarious. Blood images could therefore be easily invoked to enhance the drama of violence, suffering, and death: "[Blood] owed its high value at the same time to its instrumental role (the ability to shed blood), to the way it functioned in the order of signs (to have a certain blood, to be of the same blood, to be prepared to risk one's blood), and also its precariousness (easily spilled, subject

to drying up, too readily mixed, capable of being quickly corrupted). A society of blood . . . of 'sanguinity'—where power spoke *through* the blood: the honor of war, the fear of famine, the triumph of death, the sovereign with his sword, executioners, and tortures; blood was *a reality with a symbolic function*" (147).

Foucault thus presumed that the symbolic valuation of blood was organized not around the management of life but around the menace of death: "Clearly, nothing was more on the side of the law, death, [and] transgression . . . than blood" (148). The eviscerated body and the body in pain both furnished an image of valued sanguinity, revealing a distinct regime of power and an old preoccupation with blood and the law. According to Foucault, these imageries of blood tended to revitalize a type of political power that was exercised through the devices of the legal order: "the blood of torture and absolute power, the blood of the caste which was respected in itself and which nonetheless was made to flow in the major rituals of parricide and incest, the blood of the people, which was shed unreservedly since the sort that flowed in its veins was not even deserving of a name" (148–49). As Foucault argues, however, such a symbolics of blood gradually gave way to a new order of power: Under modernity, the workings of blood and death were replaced by a concern with sexuality and racial proliferation. The propagation of the life of the body, not its blood and death, became a novel object of political struggle.

But the emphasis on bloodshed and death, as I suggest at length elsewhere (Linke 1999), was never completely dissociated from a metaphorics of sex, vitality, and gender. Even in antiquity, the flow of blood and women's sexuality were closely related in symbolic terms. In early Europe, blood derived its potency and symbolic power from the linkage of reproduction with the female menstrual cycle. Blood and womanhood were thus interconnected in the European premodern. The later historical preoccupation with either the future of the species or the vitality of the social body was likewise implicated in anxieties over female reproductivity (Jolly 1993; Davin 1978). Issues of blood, race, and motherhood converged in a

political obsession with the life-giving body of women (Koonz 1987; Allen 1991; Moeller 1996). My work suggests that this ancient thematic of blood, life, and fertility was further accentuated in later historical epochs, finding its perhaps greatest intensification in German-speaking lands.

Elsewhere, I document how emergent themes of health, progeny, and race, which marked the threshold of European modernity, were prefigured in much earlier blood fantasies (Linke 1999). A eugenic ordering of society through a mythic iconography of blood called on, and reified, deeply rooted cultural assumptions about nature, health, fertility, and abundance. My investigation into the German, and European, past revealed that metaphoric models of ancestry and blood origin placed the social body into the semantic field of nature. Human fertility and propagation were intertwined with notions of blood loss, bloodshed, and female menstruation as *natural* processes. Genealogical models appropriated images of nature—blood, soil, and tree—as markers of descent, symbolizing the *natural order* of things.

Iconographies of blood, earth, and tree survived in modern European depictions of kinship. Diagrammatic representations of consanguinity and kin relations came to rely on the tree metaphor to depict heredity. According to Mary Bouquet (1996: 47), "mapping out ancestry in the form of a tree" provided an iconographic precedent for the genealogical diagram, the modern anthropological device for representing family relations. Drawing on examples from Britain, the Netherlands, and Germany, Bouquet's work suggests that the graphic representation of kinship owed much to prior European use of tree imagery and indeed relied on literalizing the tree metaphor. Modern genealogical diagrams emerged as simulacra or mimetic artifacts that furnished naturalistic images of blood connections. Such a mapping of kin relations relied on the tree as a visual phenomenon: Roots, tree trunk, branches, and leaves rendered kinship visibly self-evident.

The choice of the tree to metaphorize relational systems arose from a novel concern with heredity, descent, and genealogy. In nine-

teenth-century Europe, particularly in the German-speaking realm, such deeply embedded cultural ideas about blood ancestry assumed form within a modern aesthetic of race. But these concerns with descent and the diagrammatic motif of the genealogical tree were prefigured by much older conceptions of blood and power. Perhaps initially inspired by codes of inheritance and succession associated with property, these diagrammatic representations of kinship "emerged in the context of the calculation of prohibited degrees of marriage" (Goody 1983: 276). Degrees of consanguinity were represented in the form of a crucifix as early as the eighth century. "Later documents display the same information in the shape of a tree (*arbor iuris*) or of a man" (Bouquet 1996: 47–8). By the eighteenth century, such graphic images of the genealogical tree were used to retain "control of procreation through keeping written records that enable[d] the careful channelling of 'blood,' as a key to nobility" (ibid.).

The family tree permitted the genealogical mapping of blood by virtue of its symmetrical and bilateral form. This emphasis on (or preference for) visual symmetry and symmetric modeling promoted the scientific appropriation of the tree as a taxonomic device in nineteenth-century Europe. The tree metaphor was part of a visual language mined by modern science. But the persistence of these diagrammatic images cannot be explained solely by their usefulness for a scientific imaginary. The tree motif was also a conventional cultural image, a representation of blood and reproduction: It symbolized the sexual and social body of man and wife. The genealogical tree, signifying both bloodline and conjugation, was deeply gendered. This is suggested by the frontispiece to a seventeenth-century Dutch example (a genealogy in book form), "which shows Dirk van Dorp and his wife standing beneath their 'tree,' and the score of pages that follow the lateral extensions of that tree" (Bouquet 1996: 63, n. 5). This same emphasis on symmetry, shared blood, and lateral extensions characterizes the iconography of a Dutch "family tree" from the late eighteenth century:

Gerard Schaap's name is shown at the lowest point on the trunk, together with that of his wife Johanna, in a circle—a stylized oak-apple, perhaps—since the leaves are clearly those of an oak. The names of their offspring (two sons and one daughter) are shown, with those of their spouses, on the trunk (Jan and his wife) and two lateral branches . . . [A]esthetics demand a symmetrical layout . . . The bulk of the tree is, indeed, composed of lateral extensions . . . We know nothing of the in-marrying spouses' origins: where does Johanna (Gerard's wife) come from? What does her substance contribute to the solid base of the tree just below her name, where grass and other small plants thrive? . . . The positioning of the name Johanna closest to the earth and the roots of the tree might, however, suggest that she is the ancestral figure. (Bouquet 1996: 47)

In northern Europe, the motif of the genealogical tree reveals a social emphasis on symmetry and lateral extensions. Blood relations, including kin by marriage, appear together in these graphic depictions of ancestry. The tree, in its diagrammatic form, emphasizes the existence of both men and women, husbands and wives, in-laws and offspring. Such an integration and mergence of kin into a common genealogy of blood differs sharply from southern or eastern European examples, in which the tree stands as a metaphor of patrilineality, that is, a symbolic system of tracing descent and blood connections through men alone. The diagrammatic tree seems to contain vestiges of a different social system, in which kin relations were reckoned bilaterally. In German-speaking lands, as I discussed elsewhere (Linke 1999), kinship followed a cognatic system, based on a widely extended recognition of kin traced through males as well as females. In the genealogical tree, traces or vestiges of such a kinship pattern are "embodied in specific graphic conventions, such as the wife's name encircled together with the husband's, in Schaap's family tree, or Maria as an acorn in the tree of Jesse" (Bouquet 1996: 61). Women were joined to, not exorcised from, these genealogical diagrams.

Within the conceptual field of the modern ancestral tree, there was an explicit recognition of women and their birth-giving potential. Despite the patronymic emphasis, women (as sisters, mothers, and wives) were identified and named in these genealogical dia-

grams. Such a recognition of womanhood was also sustained in symbolic terms. The tree appeared to grow from specific female substances: blood and soil. As Bouquet (1996) observed: "If the containers at the base of the tree contain earth . . . this represents a kind of generalized female material" (52). In the northern European tree motif, blood is connected to soil, female matter, mother earth: Earth becomes blood, which becomes sap, which nourishes the life of plants, including the tree. Blood wells up from the ground as an ancestral substance. In an eighteenth-century Dutch genealogy (a biblically inspired vision of human genesis), the "tree thus arises from the soil of Mesopotamia, but its foliage represents populations of the entire earth. Blood would appear to be made from the soil, and soil continues to feed the growth of the tree (the whole family of Man), presumably with the sap that flows through the trunk and the branches into the leaves" (52). Here, earth gives rise to blood, and blood is transformed into both arboreal and genealogical essence.

Blood and nature, that is, human bodies and plant life (flowers/trees), are collapsed in such representations of ancestry. Although the diagrammatic image of the tree glosses over the nature of the genealogical substance, the "persuasive fiction underlying [these trees] . . . is that the earth beneath them has been turned into blood, the blood into sap" (Bouquet 1996: 60). In northern European and German depictions of kinship, the imagery of blood and soil and tree exist as interconnected metaphors of origin.

The genealogical tree thus occupied a certain position in the German etymology of blood: Earth became blood, which became sap, which fed the tree. Blood was a symbol of nature, a product of the earth mother. "Genealogical trees would then reflect a (patriarchal) vision of the present projected onto (and struggling with the vestiges of) a (matriarchal) past" (Bouquet 1996: 61). The symbolic linkages of blood, earth, and tree, which placed emphasis on female substance and maternal essence, dislodged an earlier generic European model, which posited a homologous relation between the male body and the tree. Modern German genealogical diagrams,

including the ancestral tree, belonged to a different metaphorical field. Imagined not as an extension of manhood, a male unilateral channel that arose from a man's seed or corpse, the tree was given life by a different source. In German (and northern European) culture, the genealogical tree took root in female substance: blood, earth, and soil.

Such images persisted into modern times, taking form in a genealogical mode of thought: the German aesthetic of race. Through blood and tree metaphors—as graphic representations of descent—relational systems like kinship, heredity, and lineage were placed into the semantic field of nature. The "naturalized identity between people and place" (Malkki 1996: 437) was thus not solely based on an innocent botanical metaphor. Taken together, the complex of images (arboreal in form and sanguine in content) was suggestive of origins, ancestries, bloodlines. In German history, these images were to become structurally embedded in a racial aesthetic, unifying the symbolics of blood, stock, and heredity with natural iconographies. The genealogical tree (a prominent symbol of modern German statehood) evoked both continuity of essence and territorial rootedness.

What became of these natural symbols in contemporary Germany? And in what contexts might blood and tree be invoked as organizing metaphors? It is disconcerting (although perhaps not surprising) to find such iconographies in recent representations of the Holocaust. For instance, in 1997, a proposed Berlin monument for the Jewish victims of Nazism used blood and tree as prominent symbols. Submitted for consideration toward the design of a "Memorial for the Murdered Jews of Europe," the proposal by Rebecca Horn suggests:

> The premises of Pariser Square should be protectively enclosed by a thick forest area—a grove—of red deciduous trees (blood plum, red maple, Japanese maple, and blood oak). This forest can be seen from afar; such a forest probably exists nowhere else. It is a grove of mental concentration as well as a forest of red-flaming energy. It is, at the same time, a wall that protects the site of meditation and a forest through which one must pass in order to reach the place of commemoration. . . .

[In the middle of the forest] is a rectangular area with slabs of rough hewn slate. In the center of this square is a circular opening . . . As one comes closer, the entrance to a tomb can be seen. Walking down a spiral staircase, one arrives in the depths at a lake of mirrors—the bottom of the tomb. There, inside, the visitors find themselves surrounded by mounds of ashes, which are stacked in layers behind glass walls, extending from the ground to the upper rim of the tomb. The ashes act as a symbol . . . In their amorphous formlessness, the fire having destructively absorbed all energy, the ashes are a sign of extinguished life force. Here, following the encounter with the vitality, the energy, and the beauty of the red forest comes the confrontation with the inescapable symbol of extermination . . . [T]he names of the National Socialist concentration and annihilation camps are engraved in one of the glass walls. The visitor is thereby subjected to the polar signs of life and death. (Horn 1997: 1–2).

The blood-red forest, symbolizing the German nation, arises from the unseen corpses, the ashes of the murdered. No mention is made of Jewish victims nor of the human perpetrators. The highly allegorical text displaces the Holocaust into the natural world: Germans are represented as blood-trees, a red forest, enclosing a tomb of ashes, the dead Jews, whose incineration by fire is termed the "unresolved weight of remembrance" (2). Displaced from German history, the Judeocide is transported into nature. At the memorial site, writes Rebecca Horn, visitors can "experience almost physically this burden of the natural occurrence" (*diese Last mit dem Naturgeschehen*) (2). Victims and perpetrators have been transformed into natural objects: fire and ashes, blood and tree. In this proposed memorial, the Holocaust is erased from German history, its remembrance staged without human actors.

This use of natural symbolism is apparent in another example, from 1990, although here the blood and trees are fused with the iconography of naked bodies. The following are excerpts from a proposal by a Frankfurt initiative to commemorate the victims of National Socialism by building a memorial on the ruins of a former synagogue. The symbolism of the naked maternal body, surrounded by blood and trees, expresses a racial aesthetic that denies victimhood to the Jews.

Until 1938, the largest synagogue in the city of Frankfurt was located at Friedberg Park. The National Socialists destroyed it. And after removing the physical remains [of the building], they built a bunker there. We recognize the entanglement of Jewish and German history at this site. It is therefore a suitable location for remembrance, for coming to terms with this part of German history, for sorrow and commemoration. At this place, the suffering of the Jewish population and the consequences of war for the German civilian population are brought into proximity. The site therefore offers itself as a stage for preservation and historical representation . . .

The intent to construct a memorial inside the bunker requires the remembrance of all those human beings who, at the risk of their own lives, helped those who were persecuted by the Nazi regime. Trees should therefore be planted all around the bunker. These should be dedicated to the memory of these human beings. The task of planting and maintaining the trees, in memory of the human beings who helped the anguished, would be a meaningful undertaking for schools. In this context, the teachers, together with their students, should attempt to uncover biographical details about these benefactors of the past . . . Near the bunker, and in the immediate vicinity of the trees, the flow of a narrow stream should symbolize the vitality which the benefactors, through their brave engagement, passed on to future generations. This representation is also an attempt to counter those forces which desire to suppress the public remembrance of these human beings as well as of the victims.

This watercourse should flow into the bunker and at the threshold turn to blood through the symbolic use of red dye. There are alternative proposals to present the stream either as black or as a torrent. Inside the bunker, the watercourse ends in a pond. On its shore, the multitude of human suffering is personified by four statues of a mother and her child, standing in varying postures and distances from the blood-red water. In the immediate vicinity of the bloody pond, two unclothed women, a Gypsy and a Jew, embrace their naked children with both hands, in a gesture of deep humiliation. A third mother represents the suffering of the Slavic peoples . . . The fourth mother symbolizes the contradictory role of the German woman. She maintains the greatest distance from the bloody pond and is completely clothed. The child, in contrast, embraced by only one maternal arm, is also naked. With the other arm, the mother executes the Hitler salute. The physiognomy of the women and their children is similar, not however their distance from the blood-filled pond . . . The closeness to or distance from the bloody pond symbolizes the differences in the extent of the sacrifice made in blood and the suffering and hardship endured. On the other hand, blood is also a symbol of life, a vehicle of the soul. The symbolic content of the bloody pond is therefore multivalent.

However, within the total field of meaning surrounding the memorial, the symbolism of the blood-filled pond will probably be interpreted almost exclusively in terms of violence and victimization. Thereby, more

specifically, an intense emotional response can be achieved as well, similar to what is labeled "red-shock" in psycho-diagnostics. Its linkage to aggressive drives (war, violence, etc.) would then offer the possibility of exposing the associated repression of guilt and letting it become a starting point for purification . . . Since the neolithic, the representation of mother and child is a commonly used and understood cultural symbol of life, love, and safety. The mother/child unity guarantees the continued existence of life. The template of the child appeals to instincts of protection and nurturance. That it must do because the child is dependent on adults. Hardly anyone can resist this instinct or turn away from the helplessness of a small child.

The morally reprehensible and thereby culpable act (Hitler salute) of the fourth mother and the simultaneous embrace of her child shows the entanglement of this woman, who as it were gives up her identity and thereby inflicts harm on herself and her child, and at the same time suffers victimization. The four mothers, through their separate placements and positionings, refer in an unsurpassed manner to the unscrupulous way in which the former [Nazi] rulers dealt with the primordial values of human life. Their attack was so comprehensive that it put into question the continuity of their own nation. The disdain for human life did not exclude Germans who resisted the regime; it transcended the nation's indigenous threshold of pain. The German woman stands for the willingness of many Germans to participate. Her role as victim may not be overemphasized or downplayed. She raises her hand in enthusiasm and thereby overlooks how much this movement is directed against herself and her child

Independent of the above proposal, one might consider whether additional levels could be added to the existing bunker. This development would proceed provided that the newly constructed premises be transformed into urgently needed living accommodations for immigrant families from various ethnic groups that are resident in Frankfurt. In this newly available residential space on top of the bunker, the attempt would be made to put into practice the principles, whose tentative theoretical foundations are being tested inside the bunker. (*Konkret* 1994: 2)

In this proposed memorial for the victims of Nazism, all traces of Nazi violence against Jews are erased. Although built on the ruins of a synagogue, the site of a pogrom, the memorial would make scant reference to Jewish victimhood. The Holocaust is projected onto a natural landscape devoid of human agency, a scene set with blood, water, and trees. The memory of the Judeocide is concealed, hidden inside the monument's interior. The external environment, an idyllic setting with water, brook, and trees, presents the past as

natural history: The organizing themes are the loss of German life and German self-sacrifice. The terrain outside the bunker is dedicated to the Third Reich's German victims: The trees are planted as symbols of their courage. Inside the bunker, a generalized sort of victimization is represented through human figures, mothers with children, that include the Gypsy, the Slav, the Jew, the German. Their suffering is symbolized by the lake of blood around which the statues are arranged. The emphasis is on female victimhood and loss of blood. The figures' ethnic identities are marked by physical signs: body posture, facial feature, nudity, and motherhood. These are essentializing constructs and images that reify, even rehabilitate, a racial aesthetic intensely preoccupied with blood, body, and gender.

Outline of the Text

My aim in this book is to show the highly ambivalent and stressed relation of the national order to the modern, and its eventual escape from modernity through the essentialisms of gender, nature, body, and race. My ethnographic material is drawn from a diversity of historical sources, not only to illustrate the diachrony of events but also to highlight the fact that German history and cultural memory overlap and appear as repetition—a frozen continuum—in which certain metaphors, templates, and motifs are reencountered, and where the new is mediated by a refurbished sameness via the essentializing images of blood, race, and body: a tropology of corporality. This mode of historicization, of memorializing the anatomy of German nationhood, exposes German historical experience as a pathology, a traumatic syndrome.

In my analysis, our understanding of German history is mediated by the concept of the unconscious, of dream work, and of fantasy formation. Recognizing the material force of the historical unconscious, my emphasis is on the formation, inheritance, and devolution of essentialist symbolic systems, of grids of perception. What are the building blocks of such essentialist constructs? Essentialism is often dismissively critiqued, classed as a reductionist

process that erases cultural content. Essentialism is indeed a construct but the building materials of this construct are rarely examined. My work seeks to contribute to an archaeology of essentialist metaphysics in the public sphere of modern Germany. Throughout, I inquire how essentialism is made. How does it achieves such a deterministic and habitual hold on the experience, perception, and processing of reality?

My work explores these thematic issues through a critical analysis of German public culture. My treatment of a corporal aesthetics, a bodily essentialism, as a formative construct and my notion of a historical unconscious are further elaborated by the material presented in chapter 1. More specifically, I explore the social formation of white public space: How the aestheticization of whiteness, as a technique of the body and as a field of memory, is articulated across a multiplicity of sites; and how the normalization of white skin, as the physical embodiment and sign of social power, is brought about and sustained in different arenas of public discourse. I explore the German aesthetics of whiteness and race by a focus on body practices: public nudity and body exposure. By tracing this cult of the white body across 1945, I suggest that social memory can be transported through corporal iconographies and images. Postwar German representations of national identity are patterned by essentialist tropes, that is, white skin and nakedness, revealing a cultural obsession with return to the natural and authentic in an apparent search for social anchorage. In postwar West Germany, public displays of white naked bodies operate both as cultural protest and national affirmation. Such paradoxes and contradictions, which structure the embodiment of social memory with regard to sex, race, and gender, are crucial in sustaining the aesthetics of white skin across historical space.

In chapter 2, I focus on the German aesthetics of blood and its rehabilitation after 1945. Blood, and the fear of contagion, emerge as organizing tropes in West Germany's public debates about refugees and immigration. My research suggests that the formation of contemporary German nationhood is complicated by a corporal

imaginary: blood, bodies, genealogies. German nationality is imagined as a flow of blood, a unity of substance. Thinking about the German nation takes the form of origins, ancestries, and racial lines, which are essentializing images: a genealogical form of thought. German constructions of difference and otherhood are encoded in the body. Feminine flows, blood, liquidity, and menstrual seepage are metaphoric caption points that appear again and again, and mediate the new and different by a refurbished sameness. I emphasize the interplay of gender and race against the background of medical models, documenting how fears of "natural" disasters (women, Jews, refugees) and medical pathologies like dirt and infection are continuously recycled to reinforce a racialist postmodern.

The material presented in chapter 3 emphasizes the thematic linkages between culture, memory, and violence. With a focus on violence and political protest, especially during the 1980s and 1990s, I suggest that members of the German Left and the militant Right draw on a surprisingly common repertoire of images, symbols, and metaphors in their representations of body and difference. In Leftist attempts to depict otherness, race, and "the enemy," we find a disturbing preponderance of violent iconographies that are invoked from the past (genocide, the Holocaust, extermination) and, most importantly, reproduced as templates for political action and identity.

WHITE SKIN,
ARYAN AESTHETICS

•

Power in contemporary society habitually passes itself off as embodied in the normal as opposed to the superior. This is common to all forms of power, but it works in a peculiarly seductive way with whiteness, because of the way it seems rooted in common-sense thought, in things other than ethnic difference . . . Socialized to believe the fantasy that whiteness represents goodness and all that is benign and nonthreatening, many white people assume this is the way black people conceptualize whiteness. They do not imagine that the way whiteness makes its presence felt in black life, most often as terrorizing imposition, a power that wounds, hurts, tortures, is a reality that disrupts the fantasy of whiteness as representing goodness. (Dyer 1988: 45)

In the Western scholarly imaginary, white skin is designated a discursive construct: Unmarked, unseen, and protected from public scrutiny, whiteness is said to be deeply implicated in the politics of domination. Viewed as a location, a space, a set of positions from which power emanates and operates, white political practice appears to be thoroughly disconnected from the body: Corporality has been removed from the politics of whiteness. Dissociated from physicality, and "the essentially embodied nature of our social existence" (Connerton 1989: 74), whiteness is perceived as a normalizing strategy which produces racial categories. Seen not as a marker of actual skin color, whiteness is no more than a discursive axiom for racial differentiation: It is merely a "politically constructed category parasitic on blackness" (West 1993: 212). Although some scholars concede that "whiteness is embodied insofar as it is lived experience" (Ware 1996),[1] the metaphysical dimensions of whiteness are

generally accepted without challenge. Such assertions are trouble-
some as well as deeply problematic.

What are the cultural and institutional conventions and prac-
tices that continue to normalize white invisibility? How is the dis-
cursive transparency of whiteness sustained? Deconstructing the
category "white" involves making visible its "founding metaphorics
and ideology of invisibility" (Fuss 1994: 22). Like all racial cate-
gories, whiteness is capable of being "created, inhabited, trans-
formed, and destroyed" (Omi and Winant 1994: 55). But, until
quite recently, the multiple ways in which whiteness has been polit-
ically manipulated, culturally mediated, and historically construct-
ed have in large part been ignored (Gallagher 1995). Since "white"
defines itself through a powerful and illusory fantasy of disembodi-
ment, it is important to investigate the place of such phantasms and
desires in the exercise of social power.

In this chapter, I examine the location of whiteness in German
political culture, and I inquire how white skin, as a racial construct
and a site of power, is naturalized and rendered unseen. More specif-
ically, I explore the social formations of white public space: how the
aestheticization of whiteness, as a technique of the body and as a
field of memory, is articulated across a multiplicity of sites (Hall
1985, 1986; Williams 1973); how the naturalization of white skin,
as the physical embodiment and sign of social power, is brought
about and sustained in different arenas of public discourse (Eley
1992; Robbins 1993; Fraser 1993; Benhabib 1992); and how the
configuration of a popular racial aesthetic is structured by specific
historic linkages between the state and its subaltern publics (Landes
1988).

My research is focused on postwar Germany, where whiteness has
been reclaimed as an unmarked signifier of race and citizenship;
where the use of white public nudity has been officially sanctioned to
promote commodity consumption; where the public display of
white naked bodies has emerged as a countercultural strategy of envi-
ronmental and political protest; and where this recovery of the white
natural body has become crucial in legitimating public narratives

about the threat of dark-skinned others. Given the corporal topography of German racial violence, which is obsessively preoccupied with the color of alterity, my project seeks to investigate how the enhancement of whiteness, the very deployment of a white racial aesthetic, surfaced to become an indispensable element in the recolonization of the bodily interior of the postwar German state.

How is whiteness signified in German public culture? Can we use an archaeology of racial representation to expose the metaphorics of white skin in twentieth-century Germany? Or is there another meaning to whiteness in German culture, which originates from an aesthetics of the body that is disconnected from issues of race? After a detailed review of the literature on the dis/embodiment of color, and a critical discussion of this material, I proceed with a dissection of the semiotics of whiteness in modern Germany, from the turn of the century onward. The *Aryan* aesthetic, with its tropes of Germanness, whiteness, and nakedness, is written into the history of German political culture. The mechanisms by which this aesthetic is reproduced is given careful scrutiny and documentation. As we will see, the iconographic representation of the racial body, taking form just before World War I, entailed the propagation of two interrelated signifiers: *white skin* and *nudity*. Since its inception as a popular discourse, the Aryan aesthetic had seized the motif of the natural German body as a validating signifier. Conceived as an authentic, presocial site of truth, the natural body was imagined through a series of mediating symbols or tropes. The terrain of whiteness *and* the phenomenon of nakedness, both metonymic signs of bodily nature, were integrated into separate, but parallel, racial mythographies. My attempts at historical periodization expose the dynamics of this racial aestheticism. Defined by a distinct historiography, symbolic code, and field of meaning, the metaphorics of white skin and naked flesh are mutually implicated and connected.

The naturalization of nudity in the German political arena echoes the dynamics by which whiteness is normalized in other cultures. The discursive transparency of white skin in the United States

can be equated to the perceptual concealment of the cult of nudity in Germany, which renders whiteness commonplace and normative. Put differently, my analysis transports the theorization of whiteness as an unmarked racial category to the German context, outlining how nudity resurrects Aryan symbolism at the same time that it provides a new logic of naturalization, one organized around the paradoxical production of whiteness as normative and unremarkable precisely through its hypervisibility. While there are parallels to the construction of whiteness elsewhere, there are important differences and specificities to the German context. In the German racial state, dreams of whiteness are more directly about the manifestations of lineage, family, and nation. The white (German) body is seen as under threat of contamination by Others who seek to undermine the integrity of an organic nation/state. Whiteness in Germany is also haunted by visions of white bodies that attempt to recall the imagery of classicism, an imagery fixated on an aesthetics of the antimodern, and a corporality that is always trying to erase traces of eroticism or displace it onto others in an effort to consolidate its appeal to a harmonious and cultivated nature. Throughout, I explore how these cultural commitments colonize images of nature that are constructed around white public nudity.

How are whiteness, nudity, and nature mutually implicated? The German integration of white skin with nature (and natural signifiers) moves the body out of history, denying the possibility of history as process. The aestheticization of nudity likewise transforms racialized bodies into natural entities, whereby the dehistoricization of whiteness is rendered uncontested. This denial of history, these attempts to suppress or control fields of memory through a corporal aesthetic seem to be a retreat, a regression, into a mythic past, permitting Germans to exhibit race "innocently" (even after the Holocaust). Such a reinvigoration of the German racial aesthetic is particularly significant in a global world order: Placed within the context of transnational economies, transnational commodity culture, and guest-worker immigration, German nakedness is once again becoming "white." In turn, this form of racialization echoes

Nazi tropes of an earlier era, a circumstance that may well be suggestive of the (re)emergence of the Aryan aesthetics in a postwar German nation.

My discussion exposes the intertwining of *whiteness* and *nakedness* through an archaeology of German political culture, and attempts to document the similarity of their fetishizing dynamics. My ethnographic narrative is a montage of how body space and public space intersect in a political and historical unconscious. I demonstrate the conjuncture of whiteness and nakedness by exploring their mutual naturalization, their mutual capacity to dehistoricize the body politic and to mythify the human body, and to establish a naturalized, presocial self as an uncontested site of truth. Thus, whiteness and nudity (as separate terms in a metaphorics of shared contingency and mutual reification) vibrate sometimes together and sometimes separately. In other words, the naturalization of the naked German body (in contrast to the iconography of the black nude) is a particular extension of the trope of whiteness, the intangible "ground-zero" of all bodily imaging in the West: *invisibility* and *naturalization* being two sides of the same epistemological coin. The shared mythographic, antihistorical, and antimodern subtexts of these mythographic (racialist) iconographies are the paths that lead me to demonstrate the necessary conjuncture of whiteness and nakedness in German public culture. It is this process of mutual reification and refetishization that implicates one in the other. My task is to show how modern Germans became both "white" and "naked" and to document the dramatization of this generational and cross-ideological project of an antimodernist posture.[2]

Defining Whiteness

Whiteness is a location of power, a designation of a political space. Although a crucial signifier of physical difference, grafted onto the skin, whiteness is neither a biological essence nor a racial population as defined within the modern evolutionary framework

(Kaplan 1992; Haraway 1991). While placed in the body, whiteness is at base a social construct. In other words, there are locations, discourses, and material relations to which the term whiteness applies (Lipsitz 1993).[3] Anchored in specific historical circumstances, the meaning of white skin is defined by shifting relations of domination. "Whiteness is not an essential racial category that contains a set of fixed meanings, but a strategic deployment of power. It comprises the construction and occupation of a centralized space from which to view the world, and from which to operate the world. This space of whiteness contains a limited but varied set of normalizing positions from which that which is not white can be made into the abnormal; by such means whiteness constitutes itself as a universal set of norms by which to make sense of the world" (Fiske 1994: 42). Integrated into different fields of power (Bourdieu 1991), whiteness implies engagement with normative cultural practices: Ultimately, in Western cultural history, it signifies the right to dominate (Fanon 1967; Hannaford 1996; Malik 1996).

Within this framework, whiteness is fundamentally a relational category: It is constructed by the way it positions others at its borders (Dyer 1988; Hall 1995; Nederveen Pieterse 1992). Stated differently, whiteness is a space defined by reference to those named cultures it has flung out to its perimeter (Frankenberg 1993: 231). Such a strategic production of otherness persists as a remainder of the colonial legacy: Viewing subject peoples as fundamentally different from Europeans implanted a system of inequality that promoted the administration of natives and the expansion of markets (Spivak 1985). According to Edward Said (1973), "European culture gained in strength and identity by setting itself off against the Orient" (3) through a process of racial othering, a strategic formation of texts and representations to construct the "positional superiority" of Westernness (20). Within these colonial regimes of representation, racial alterity became a phobic projection of a distinctly Western imaginary: a "repository of repressed fantasies," a "mainstay of [white] preoccupations and desires" (Fanon 1952: 170).

Such a "colonialist metaphorics of representation" (Fuss 1994:

20–21) is exceedingly persistent. Commenting on this phenomenon of white racial phantasm, the writer and cultural critic Toni Morrison (1993) has argued that the terrain of "whiteness" in the United States, with its presumptions of power, history, and progress, relies on imagined notions of Africanism, "a fabricated brew of darkness, otherness, alarm, and desire" (25). Whiteness tends to maintain itself as a dominant space by defining racial differences. According to Diana Fuss (1994), "Colonialism works in part by policing the boundaries of cultural intelligibility, legislating and regulating which identities attain full cultural signification and which do not. [For nonwhites], the implications of this exclusion from the cultural field of symbolization are immediate and devastating" (21). For a black man, writes Frantz Fanon, the impact of this process is such that he is sealed into a "crushing objecthood": In an attempt to respond to the violence of racial interpellation, his "very body strains, fragments, and finally bursts apart" (Fuss 1994: 21). "Black" may be a protean imaginary Other for "white," but for itself it is a stationary object: stricken, immobilized, unable to consolidate its own selfhood. Fanon's encounter with the colonial regime of representation is experienced by him as mutilating, a kind of physical dismemberment: "I took myself off from my own presence, far indeed, and made myself an object. What else could it be for me but an amputation, an excision, a hemorrhage that spattered my whole body with black blood?" (1967: 112). Racialization works through a process of objectification: The assignation of identities is fixed and rendered uncontestable by reference to physical or biological markers which incarcerate blackness, and at the same time position the field of whiteness.

But the boundaries that are drawn around the terrain of color (despite the assumed rigidity of these criteria of difference) must on occasion be viewed as decentered and permeable. Because such a space is strategic, and not essential, there is movement into and out of these categories of identity (Lopez 1996). Whereas blackness, as the marked (devalued) signifier, is understood as immutable, invariable, and thus incarcerating, the boundaries of whiteness appear dif-

fuse, permeable, and unfixed. Yet such a perception can be decep-
tive: White space is accessible by invitation only (Dominguez 1986;
Gordon 1996; di Leonardo 1994; Sacks 1994). As Donna Haraway
(1991) explains: "That point makes it easier to remember how the
Irish moved from being perceived as colored in the early nineteenth
century in the United States to quite white in Boston's school bus-
ing struggles in the 1970s, or how U.S. Jews have been ascribed
white status more or less stably after World War II, while Arabs con-
tinue to be written as colored in the daily news" (402).

Relations of racial inequality sustain themselves by averting a
critical gaze from the terrain of whiteness. This avoidance of recog-
nition is tactical. In the United States, during slavery and the years
of apartheid, as bell hooks (1991) explains, domination centered
around white control of the black gaze. "Black slaves, and later man-
umitted servants, could be brutally punished for looking, for
appearing to observe the whites they were serving . . . These looking
relations were reinforced as whites cultivated the practice of denying
the subjectivity of blacks . . . Reduced to the machinery of bodily
physical labor, black people learned to appear before whites as
though they were zombies, cultivating the habit of casting the gaze
downward" (168).

The politics of seeing have remained an effective strategy of terror
and dehumanization. Even though legal racial apartheid no longer
exists in the United States, the structural invisibility of whiteness
continues. As in the past, it is today coupled with spectatorship,
albeit technologically enhanced through the use of video cameras
and television, the "panopticism" of mass media (Feldman 1994:
406–7; Foucault 1978).[3] While attempting to remain unseen, the
white gaze ensures the hypervisibility of dark-skinned others through
exposure and surveillance.[4] The power over public sight emerges as
an important strategy of domination: "to know without being
known, to see without being seen" (Fiske 1994: 46). The discourse of
whiteness retains its position of dominance because of its ability to
both define and monitor the boundary between itself and its others,
and to control the movement of bodies across that boundary.[5]

Seeing through Skin

In her discussion of racial representations in the American media, titled *Postmortems: Facing the Black Male Corpse*, Deborah McDowell (1995) took as her text the pictures of young black male corpses and mourning mothers that have become an increasingly common feature in daily newspapers. Publishing the black male corpse, McDowell suggests, protects the privacy of white death and its mourners. The publicity given to maternal mourning obscures both the factual presence of mourning black fathers and the physical existence of other unphotographed white corpses.

In these visual depictions of alterity, whiteness recedes from public view to assume a disembodied presence: through the lens that records, the gaze that seeks out, the law that observes. By protecting (and privatizing) the public display of white bodies, the visible proximity of dark-skinned others is rendered meaningful through false assumptions of "objective realism" (Feldman 1994: 406). The "seen" is interpreted as *immediately ascertainable fact* (Feldman 1997; Bloch 1990). These same principles of structuring perceptual realism are at work in global terms: "Television transmits endless images of the dying millions . . . : starving Pakistanis, Muslims killed by drowning, mountains of corpses in Biafra or Ethiopia, massacre in Tel Satar, strip bombing in Vietnam, hundreds of thousands presumed killed in Cambodia . . . *and we ourselves are always absent.* These are images of our victories, they confirm our survival [The] ubiquity of visions of mountains of corpses in the Third and Fourth Worlds . . . seem to allow us access to *the psychic ecstasy of power and survival*" (Theweleit 1989: 269; my emphasis). Commanding the public representation of alterity, the predominantly white Western media conjures graphic images of disease, death, and decomposition without distance or respect for the bodies of black subalterns (Ledbetter 1995; Lutz and Collins 1993; Bloom 1994; Hall 1995). White media projects images of a black public sphere that is characterized by presumptions of intrinsic disorder and dependency (Kelly 1995). In these mass-mediated

visions, the representations and dynamics of power are routinely mapped onto black bodies (Nederveen Pieterse 1992), while white presence remains translucent and unacknowledged.

Thus, the white Western self, as a racial being, has for the most part remained unexamined. This evasion must not be viewed exclusively as intentional or consciously engendered: It is partly hegemonic. In her exploration of the experience of race among white American women, Ruth Frankenberg (1993) documents how "whiteness" persists as an unmarked cultural space. The women seem to experience race privilege as normalized, integrated into their commonsense world to the point of invisibility. In their conversations with the author, the women express concern about "the formlessness of being white," the sense of "nothingness," and "having no people." Whiteness is experienced as a cultural void. The women, convinced of the apparent emptiness of "white" as a cultural identity, describe themselves as bland, pale, neutral. Frankenberg's work uncovers an implicit form of racial domination that holds in place the status of whiteness as normative: Masquerading as generic, the cultural experience of whiteness emerges as unadorned, basic, essential. Whiteness is not, however, an empty cultural space. According to Frankenberg, "Whiteness does have content inasmuch as it generates norms, ways of understanding history, ways of thinking about self and other, and even ways of thinking about notions of culture itself" (1993: 231). It is precisely because of the presumed (and perceived) lack of cultural specificity that the terrain of whiteness is hard to define. The social construct "whiteness" can successfully maintain its location of dominance, normativity, and privilege because it remains unmarked and unnoticed.[6]

A key strategy of whiteness is to avoid definition and explicit presence. Deeply embedded in everyday cultural practices, whiteness obscures its location in the discourse of domination (Dyer 1988; Lipsitz 1993). By remaining undefined and amorphous, whiteness "keeps itself out of the field of interrogation" and "allows whites to ignore the history of power that has constructed racial

difference to their advantage" (Fiske 1994: 42, 48). Whiteness cannot be part of the problem or part of the solution because it is not even there. Such a conception of whiteness relies on claims of political innocence: That is, assumptions of the disembodied nature of whiteness offer hegemonic alibis, proving that white men or women cannot be perpetrators because they are not physically present. Such racial phantasms are attempts at relinquishing agency around whiteness,[7] removing white-skinned bodies from the materiality of practice. Whiteness is the signifying absence. Traces of it, however, remain.

Racial Mimesis: Whiteness as Violence

Traces of whiteness persist most clearly in the (post)colonial context, where the aestheticization of white skin is often visibly inscribed or etched into blackness, a violence done to the black body. By looking to such concrete enactments of whiteness, my analysis attempts to substantiate the cross-cultural logic of whiteness: its pretense not to be a racial category; a racialization that masquerades as normative, as not produced by history. These situated instances of the white trace underscore the peculiar ways in which whiteness consolidates its power: by erasing history, by producing conditions of historical amnesia about the manner in which power differentials shape political, economic, and family relations and other social interactions. In the (post)colonial experience, whiteness is rendered visible and read against the grain of bodies that are constructed as nonwhite. What kinds of dissonance does that produce? And what kinds of white visibility does that make possible?

> [I]n attempting to claim alterity entirely as its own, the Imperial Subject imposes upon all others, as a condition of their subjugation, an injunction to *mime* alterity. The colonized are constrained to impersonate the image the colonizer offers of themselves; they are commanded to imitate the colonizer's version of their essential difference. What, then, is the political utility of mimesis for the colonized, when mimesis operates as one of the very terms of their cultural and political dispossession under colonial imperialism? (Fuss 1994: 24)

Whiteness is made visible, taking on a distinctly corporal dimension, in the (post)colonial context, where a racialist discourse of immutable biological difference ceaselessly works to "seal" black bodies in their "blackness" (Fuss 1994: 38), encasing them in the devalued and degraded signifier of racial otherness.[8] Mediated by the metaphorics of a colonial politics, the black-skinned person begins to experience selfhood as an incalculable object, tormented by a deep sense of depersonalization and dislocation. Out of this trauma, on occasion, emerges the black desire for cross-racial identification: to become white, to transmute dark skin into whiteness. Such fantasies of corporal impersonation are always attempts at transformation, masking a will-to-power through a literal changing of skins, by incorporating the valorized signifier of power—whiteness.

When thus locating racial mimesis at the site of both fantasy and power, the strategic appropriation of whiteness can be traced through specific practices and techniques of the body. Psychoanalytic theories of identification all seem to agree that "imitation repeatedly veers over into identification" (Silverman 1989: 19), and "every imitation . . . is also an incorporation" (Lacoue-Labarthe and Nancy 1989: 208). Although such a production of mimic others can be disruptive and reversionary to the colonial discourse and need not leave existing authority relations intact (Fuss 1989; Bhabha 1984, 1985; Taussig 1993: 144–75), racial mimesis generally does *reproduce* existing relations of power and privilege: Corporeal appropriations of whiteness sustain interior colonies, and the violence within. As such, "the particular whiteness achieved from the position of blackness is always montage, inauthentic, a violence done to the black body, Fanon's mask, a graft, incomplete, always signifying its impure origins and usually signifying not through invisibility and nature but through artifice, duplicity, and another form of specificity—the darker bodies around it" (Feldman 1996).

Dark-skinned bodies proclaim their whiteness by an insistence on the visible nature and tangible reality of color: the white racial

icon. The act of whitening is made public on and through the body of the black subaltern. This embodiment serves to authenticate and give material form to the racial transformation. Such a physical inscription or implanting of whiteness, however, tends to legitimate a colonial regime of representation: While rebelling against a metaphorics that incarcerates blackness inside the black body, the practice of whitening black skin promotes a racial aesthetic that privileges white skin.[8] This whiteness, which is achieved from the position of blackness, always remains incomplete, a graft, a failed experiment. By refuting normalization, never to become mundane or commonplace, the whitening of black bodies tends toward dramatic spectacle and hypervisibility:[9] The embodied graft never attains the covert quality of inherent whiteness. Mimic Others thus remain imitations, wanting to possess (but never to diminish) white alterity.

The mimic production of whiteness works through the corporal dimensions of black subjectivity. This is made evident by several contemporary and historical body practices that have emerged out of the context and experience of European domination.[10] In the African postcolonies, for instance, white skin has become not a symbol of status, a *representation* of Western elites, but rather a concrete medium or vehicle for the incorporation of power. Possessing whiteness confers selfhood. The Martinique-born activist Frantz Fanon (1967: 63) confesses through erotic imagery this desire to appropriate white privilege:

> Out of the blackest part of my soul . . .
> surges this desire to be suddenly *white*.
> I wish to be acknowledged not as *black* but as *white*.
> Now—who but a white woman can do this for me?
> By loving me she proves that I am worthy of white love.
> I am loved like a white man.
> I am a white man . . .
> I marry white culture, white beauty, white whiteness.
>
> When my restless hands caress those white breasts,
> they grasp white civilization and dignity and make them mine.

Moving beyond the political metaphor, the acquisition of "whiteness" can be more tangibly embodied. Jonathan Friedman (1991: 156-57) describes how young men in the Congo and other parts of Central Africa, coming of age through the formalized rituals of social clubs, transform their skin with a procedure known as *maquillage a outrance*. A concoction of bleach, shampoos, and salves is placed on the skin and then covered with heavy clothing for several unbearably sweaty days. This application destroys the outer layers of the epidermis and exposes a lighter, yellowish, and dangerously unprotected dermis. The expression *se jaunir* "to become yellow" or "white" refers not only to the bleaching practice but also to the gaining of power and status. According to Friedman (1994), this embodiment of "whiteness" marks the boys' successful transformation into manhood. For Congolese youths, to acquire "white skin" means to become "great men." In this former French colony, the procurement of social power is linked to the material appropriation of everything that is "white": the assumption of a Western lifestyle, travel to Paris, and the purchase of an elegant wardrobe. Ultimately, a man's claim to political engagement with wealthy (European) elites must be accompanied by a certain look: His appearance must be authentic, and the only sure sign of authenticity is his display of "white" skin.

The racial aesthetic, although framed somewhat differently in other postcolonial African states, is always linked to practices of embodiment. In rural northern Sudan, "whiteness" is equated with womanhood, and light skin is thought to enhance a woman's socially defined femininity. Janice Boddy (1982) relates how "whiteness" connotes cleanliness, purity, and fecundity, the prized attributes of womanhood. Brought into association with Europeans, that is, with people having light—or as villagers say "white"—skin, it is uncertain when this aestheticization of color emerged in Sudan's colonial history. According to Boddy, the procurement of whiteness confers prestige. Young girls are whitened in a symbolic sense through an elaborate regimen of physical preparation: the excision of her genitalia and the surgical covering of her reproductive organs in early childhood. Once circumcised, girls are thought of as especially clean

because they are enclosed and protected from dirt and dryness. Whiteness as desirable skin coloring figures prominently in young women's wedding rituals. In her final preparation for marriage, after removing all her body hair, the prospective bride takes a smoke bath, a procedure intended to make her skin soft, fragrant, and desirably lighter in color. A small hole is dug in the kitchen floor, then filled with fragrant woods and lighted. The girl removes her clothing, wraps herself in a special blanket made of goat or camel hair, and sits over the hole, taking care to envelop the rising smoke in the blanket. The bath is considered a success if, when she emerges, the top layer of her skin can be sloughed off, exposing a lighter and smoother surface beneath. Some women, as Boddy observed, in order to further improve the cast of their skin, powder themselves with packaged vanilla custard just before the ceremony. On the day of the wedding, the cosmetically prepared body of the bride is displayed: Her "white" skin signifies fecundity, idealized through notions of cleanliness, purity, and feminine beauty.

In other parts of the world, we encounter the appropriation of whiteness as a reproductive strategy. In seventeenth-century Sao Paulo, Brazil, the desire to produce "white" offspring gave rise to an altered lineage system, in which men with dark skin or little political influence were systematically excluded from genealogical memory. Muriel Nazzari (1996) describes how in this traditionally patriarchal society, the most powerful families began to choose maternal surnames for their children, tracing their descent exclusively through the female line. The matrifocal naming pattern, according to Nazzari, originated as a symbolic marker of "white" skin. Brazil was colonized by the Portuguese in the sixteenth century; early colonial settlers, and practically all European immigrants, were male. Many of these men, lacking other options, married indigenous Indian women. In seventeenth-century Sao Paulo, when plantation labor began to rely exclusively on black slaves, elite families began to privilege white skin as a symbol of political status. The most powerful members of colonial society, all of whom had some Indian ancestry, began "to whiten" their clan lineage: Sons, lacking

access to white brides, were committed to the priesthood, while daughters were married to recent immigrants from Portugal—men whose geographic origin authenticated their white ancestry. Each generation of daughters thus became a means for upward class mobility by improving the whiteness of her offspring. Only daughters could improve the cast of color, and the selection of maternal surnames for children affirmed this fact. Such a symbolic proclamation of maternal whitening precluded public recognition of the Portuguese male immigrants. In Sao Paulo, white European fathers vanished from the indigenous genealogies, thereby suppressing cognizance of competing and conflicting claims of whiteness. The backgrounding of European skin rendered claims to paternal whiteness unthreatening: Only the darker Brazilian mothers, who carried "white" traces, were symbolically acknowledged.

But these acts of proclaiming whiteness were not mere symbolic gestures. In seventeenth-century Brazil, as Nazzari points out, elite status was also dependent on economic power. Established families sought to harness ownership of property and control of land through the manipulation of their children's hereditary rights: Maternal surnames prevented the breakup of estates upon a woman's marriage. Control of property was crucial in colonial Brazil, because whiteness was equated with the possession of material resources: Wealth conferred or bestowed "white skin." As conveyed by a contemporary Brazilian saying: "Money bleaches" (Nederveen Pieterse 1992: 197).

White hypergamy, that is, the upward mobility of racialized bodies through marriage, is evident as well in Puerto Rico, where color is recognized as an attribute and ingredient of class: Dark skin can be altered by access to wealth or by the procurement of symbolic capital, which means finding a white spouse who can propagate lighter-skinned children. Samuel Betances (1992) describes contemporary efforts toward the enhancement of "whiteness" in Puerto Rico:

As such, color is a physical characteristic which can be altered and/or changed in several generations. Marrying someone lighter-skinned than oneself immediately alters the way in which the offspring of such a union would be described. A Negro Puerto Rican who marries a non-Negro Puerto Rican will have children which will be described as non-Negro. If the pattern is continued through several generations, a Negro Puerto Rican can live to see his "white" great-grandchildren. The negative physical element, color, can be eliminated or made to play a less embarrassing role in the lives of those who seek to make things "better for their children". (279)

In Puerto Rico, whiteness is a sign of class privilege, while blackness is equated with poverty and low status. Black skin signifies a lack of social power. The bearer of such a stigma can legitimately be denied the normal gestures of respect, as conveyed by physical distance, formality, and proper terms of endearment. Therefore, as Betances (1992) points out, the more economically successful a man, the more "European-looking" his wife tends to be (279). Even after leaving the island for the United States, Betances observes: "Most of the [Puerto Rican] youths simply stated that they expected to marry someone lighter-skinned but not darker than themselves . . . Most of them [knew] of Puerto Rican neighbors or had parents or relatives who would oppose their [marriage to] anyone . . . who happened to be darker than they were, who could be described as 'real black'" (283–84).

In Puerto Rico, as in Brazil, skin color is taken as an ingredient of class, which suggests that "whitening" is deeply anchored in historical conditions of inequality.[11] Whiteness belongs not merely to the structure of fantasy but also the structure of property. White skin can function as capital—it is an economic asset (Roediger 1991; Lipsitz 1993). Since economic privilege, in Western colonial history, was iconographically marked, whiteness could be interiorized and given physical form through the medium of the birth-giving body. Such reproductive practices attest to the corporal dimensions of power, seeking to "naturalize"—to render uncontestable—a black person's rightful access to property and class status (Martin 1987; Grosz 1994; Fuss 1989). They are instances of a mimetic procedure of embodiment: "incorporation" (Connerton

1989). In seventeenth-century Sao Paulo, the symbolics of white skin could thus be sedimented or amassed in the body in order to be later reproduced "naturally" from its organic interior. Using the choreography of reproductive power, whiteness was made tangible and enduring by its authentication through the body. In negating the social (and historical) construction of racial identification, whiteness was remade by the dark-skinned body: as a physical object, a biological icon, a natural phenomenon.

Public Nudity and Aryan Bodies: (Proto)Fascist Germany

Social categories are articulated and placed onto material objects, like the body, in order to render them natural, irrevocable, and permanent. As such, relations of power are sustained by a reliance on idioms of biological difference (Yanagisako and Delaney 1995). This process of objectification raises the following questions. If the (mimetic) production of whiteness can be naturalized and authenticated by its location and emplacement in the black body, then how can whiteness be made transparent, ephemeral, and insubstantial in the white body? What are the mechanisms through which the whiteness of white bodies is hidden and rendered unnoticed? How is whiteness represented to be read as a natural construct? How can whiteness, white skin, white bodies, be socially constructed as unseen?

Taking issue with the notion that whiteness operates as a discursive construct only, I situate the normalization of a white racial aesthetic in specific body practices. Contesting and building on the notion that whiteness is solely constituted by discursive normalization and public invisibility, my task is not to uncover how much of Western identity is constructed upon the negative identity of others (Fuss 1994; Bloom 1994; Lutz and Collins 1993), but how whiteness is positioned during those instances, those moments, when it is made visible. What are the representational strategies, the specific modalities of power, that are evident in the structuring of white

space? What is the cultural inscription of bodies that renders public displays of white skin normal and unnoticed? More concretely, my aim is to chart the representational landscape within which white bodies draw authority from *biology* and *nature* to assume a privileged position in Western popular consciousness.

The remainder of this chapter explores the construction of whiteness in the German racial state (Burleigh and Wippermann 1991), where issues of citizenship are a point of convergence for public concerns about "belonging," revealing contested notions about identity, culture, and race. What are the various ways in which German identity and citizenship can be imagined in public discourse? And how are these imagined political realities enacted in the corporal metaphysics of public space? Historically, the German concept of citizenship differed from that of other Western European countries. German laws "severed" citizenship from territorial residence and redefined the nation as a "community of descent" (Brubaker 1992). Social historians have documented the legislation's colonial origins, linking German citizenship to a particular type of racial aesthetic, centered on colonialism's preoccupation with whiteness and race (Linke, in press; Wildenthal 1994a, 1994b).[12] Framed by Germany's territorial claims in Southeast Africa, East Africa, and Samoa, the formation of German national identity was closely linked to the emergence of white privilege. For those men and women living in the colonies, the acquisition of German citizenship, property, and land ownership were made conditional on the possession of white skin: Whiteness was used as a visual affirmation of the legitimacy of national membership, both in a judicial as well as political sense. In the German colonial imaginary, whiteness became strategic in a cognitive lexicon of race-marked categories: by rejecting the black icon, which marked both African and Jewish bodies (Gilman 1982), whiteness was transformed into a representational emblem of the German imperial state.[13]

In the German Reich, at the turn of the century, nationalist reform movements promoted the aestheticization of whiteness, giving rise to a racialist vision that was articulated through the body.

Bodiliness, according to George Mosse (1985), became a symbolic site in the nationalist rebellion against modernity: the artificial, the unnatural, the impermanent, the decadent. Modern styles of life, with their materiality and pornographic sexuality, were "condemned as breeding grounds of immorality and moral sickness" (52). The terrain of the city, presumed to induce bodily ills, was set in opposition to the terrain of nature, which was extended to include the natural body: human nudity. Metaphors of authenticity integrated the symbolism of the white body with representations of the German state: the immutable, the purged, the regenerated. "These ideals would be strengthened by the First World War, when nudity, sun, and water would become symbols of cleanliness, beauty, and innocence amid death and destruction . . . The native sky, mountains, valleys, and flowers, rather than the 'artificial' streets or mansions of the city, guaranteed the immutable existence of the nation and its people" (52–53). The German aversion to the modern was expressed by a nostalgia for a vividly imagined traditional, "organic" society, free from the alienation of urban forms of capitalist industrialism (Will 1990). The images of both nudity and nature negated the modern, giving rise to a new sense of the national "body politic."

German nationalism, with its antiurban focus and its rejection of the modern lifeworld, was marked by a rediscovery of the body. Societal reforms were tied to the reformation of the body. In other words, the German disenchantment with the "modern" was to be cured by modifying corporeal practices: Public nudity and the unclothed human body became important signifiers of this new nationalist consciousness.[14] Vanguard protofascist organizations, like the German youth and life-reform movements, began to advocate a lifestyle that integrated the body with nature. "[The movement's] champions refused to hide their bodies as society demanded, and instead sought to expose them to the healing power of the sun and the rhythms of nature" (Mosse 1985: 48). Nude bathing, nude sports, and exposure to the sun were prescribed as a regenerative formula, promoting physical and racial fitness. "The

'culture of sun and light', as nudism was first called in Germany, was founded at mid-century but did not make its mark until the 1890s. By the end of the nineteenth century, regeneration through the sun had become a continuous quest" (49). And while these were typical right-wing, proto-fascist responses to modernity, they were attractive to all segments of German society. Thus, on the left too there was an ardent search for "pure," "natural," or "original" values, a desire to return to the most basic point of orientation, the body. "Nudism was an attempt to regain, in the face of the ravages of industrialization, physical and ideological spaces for the restoration of life in harmony with nature" (Will 1990: 21).

Freed from the constraints of modern life, and purged of the corrupting influences of modernity, the "natural" body could be reconfigured as an external signifier, an external field of expression that revealed through its outward constitution the inner qualities of race and nation. "The body expresses our very being," Baldur von Schirach, the leader of the Hitler Youth, told the League of German Girls. "The striving for beauty is inborn among the Aryan."[15] Greek sculpture, with its stone-carved, white bodies, seemed best to reveal this Aryan aesthetic, and nude or scantily clad youths came to symbolize the strength and vigor of the Third Reich (Toepfer 1997; Mosse 1985; Köhler 1985). The bronzed body, white skin tanned by the sun, was thought especially beautiful; a contrast to the ideal "whiteness" of Greek sculpture that was first admired a century earlier.

Classical bodies continued to provide an idealized physical beauty for both German nationalists and fascists. The "wholehearted acceptance of this Greek heritage, its annexation as the most appropriate expression of Aryan beauty" meant a preoccupation with nudity (Mosse 1985: 171), that is, with white naked bodies. This adoration of Hellenic sculpture, through analogy with the athletes of Greece, symbolically aligned or connected images of white nudity to an ancient European high culture, thereby equating whiteness with *civilization* and world domination. White skin, which was promoted as a nationalist symbol of strength, came to be the presumed

mark of a superior people: "The nude males who came to symbolize Germany's virility and manliness illustrate this process, and so do the naked females who often represented the ideal woman under National Socialism. Such nudes with their almost transparent, smooth bodies were frozen into position, remote and godlike" (91–92). The assumed ideal of ancient Greek beauty was promoted on a racial basis, fashioning an image of the German people as the master race of the world. The classic ideal—a physical ennoblement—betrayed the existence of a racist aestheticism that was intent on the cultivation of bodies whose beauty was supposed to demonstrate superiority over human beings from other races. Stress was on the fashioning of bodies and the display of classic proportions.

The German preoccupation with "lightness" and "white skin" (which belonged to a colonial regime of representation) and "nudity" (which derived its symbolic significance from an antimodernist revolt) converged to inspire a new corporeal aesthetic: Pitted against the artificiality of modern (bourgeois) life, it sparked a search for the genuine, the authentic, unspoilt nature. Representations of whiteness, like the iconographies of nudity, had to be framed by natural images in order to convey the desired sense of cleanliness, health, beauty, and civility. Public displays of white nudity were therefore thoroughly naturalized. "Pictures of the nude body made hard and healthy through exercise and sport were presented as the proper stereotype. [Popular texts] advocated nearly complete nudity in the pursuit of sport or while roaming through the countryside. But the male body had to be prepared carefully if it was to be on public display: the skin must be hairless, smooth, and bronzed" (Mosse 1985: 171). Natural nudism was to be antierotic. Representations of the fascist state required idealized racial images: sculpted icons of Aryan bodies. In other words, white nudity had to be stripped of its pornographic value in order to function as an effective national symbol (Will 1990: 29–38). Fascist political iconography thus insisted on transcending the sexual or erotic in public displays of the white naked body. "The Third Reich sought to strip nudity of its sexuality

by drawing a sharp distinction between the private and the representational. For example, some of the former nudist journals were allowed to continue publication, but as body-building magazines, whose pictures emphasized various bodily exercises during which the seminude body remained abstract, very much like a sculpture" (Mosse 1985: 171). The naked body could thus be tamed into respectability through representational strategies: idealized, remote, remaining strangely detached from reality. Whiteness came to be associated here with white purity, and the connotations of sexual and racial purity were fused.

As early as 1903, nudity was distinguished from the *undressed* body: The latter was the subject of photography; the former a "holy mystery" and the "crown of creation" (Mosse 1985: 51). Nudity, as distinct from a mere lack of clothes, had to be represented as part of the pure, reverential contemplation of nature. "A posed nude, in spite of its framing, was thought dangerously close to lewd pictures, and there was further debate as to how such a nude, even if sun-drenched and placed in a natural setting, might be distinguished from the nude models preferred by pornography. One answer, interestingly enough, advised the use of glossy paper, which would heighten the artistic merit of the female nude without arousing lust" (51). Representations of nudity were acceptable only when the white body was seen in an unspoilt natural setting: framed by meadows and gardens or placed against the background of the sea, that is "the elemental, eternally alive, always liberated" (51). Aestheticization, that is, an emphasis on the beautiful or artistic body, was to elevate nudity into a spiritual principle: "Cleanliness and sunlight strip nakedness of its sexuality, leaving only the beauty to be admired . . . [M]ost nudist magazines and journals of the youth movement took it for granted that the portrayal of sun-drenched bodies in their proper natural setting would transform them into symbols of strength, beauty, and sexual innocence. Artists close to the youth movement at the start of the twentieth century flooded their nudes in sunlight and surrounded them with natural symbols" (120, 52).

The fact that German national symbols and the setting of nudity coincided was no accident: The preoccupation with nature seemed to guarantee the immutable existence of the nation and its people. As Mosse (1985) noted, while some elements of the nudist movement tended to sympathize with the political left and with pacifism, its nationalist wing obtained a disproportionately large influence. "The workers' nudist movements, which had a considerable membership split between various left-wing associations, saw the emancipation of the human body from constraints as part of the liberation of the proletariat" (93). Socialist advocates of nudism implied that people should not only discard their clothes but with them the whole armor-plating of authority-fixated conditioning which held proletarians in deference to their masters: parental authority, the paternalism of school and church, the mass media, and the organs of law and order (Will 1990: 31). Nudism was understood as a strengthening of the individual's potential for opposition. Thus, a nudity cult, stimulated by the yearnings for health and a return to nature did develop on the Left. And here, it was not racist. "But the political right took the opposite approach. Nudity, it was said, furthered the regeneration of the race, reconciled social differences, and ranked the *Volk* according to its character and physique" (Mosse 1985: 93). The nation was represented by "natural" symbols—nudity *and* whiteness, for they pointed to an immutability not granted to the conditions of modernity. "The nation, in turn, strengthened those forces used for setting off the nude body, giving nature a new kind of immutability" (55). The exaltation of nature, and the quest for the premodern, transformed white nudity into a national symbol: an iconographic representation of the strength and vigor of the protofascist movements and, somewhat later, the Third Reich.

The aestheticization of the white racial body, "designed to forge a cohesive national community" (Fehrenbach 1994: 2), thus continued during the Nazi period. "Preoccupation with the human body was typical for fascism as a visually centered ideology . . . Those who did not correspond to its concept of human beauty became out-

siders—degenerates or of inferior race" (Mosse 1985: 178). Targeting the fascist body politic, the enhancement of whiteness was intimately linked with the annihilation of unaesthetic elements in society, "at first through withdrawal of citizenship, then sterilization and euthanasia, and finally through the industrial efficiency of death camps and mass murder" (Fehrenbach 1994: 2). The elimination of "unworthy" life became a medical imperative, which was shaped by racial preconceptions that were fueled in part by the aestheticization of whiteness and white nudity.

Nudity and Death

The end of Nazism, and the collapse of the Third Reich, were accompanied by the immediate and dramatic de-aestheticization of the body and the body politic. Or was it? Heide Fehrenbach (1994), a social historian, asks:

> What happens, then, to the national aesthetic ideal in 1945 with German defeat? Military occupation and victorious Allied armies forced the German public to confront the nature of Hitler's national ethnoracial aesthetic as part of the process of denazification and democratization. German death-camp wardens were assigned to work details to bury the bodies of those they helped kill; Germans who lived in nearby towns and villages were made to walk in procession past the bodies of murdered inmates; and all Germans in the American zone—in order to have their food ration cards validated—were compelled to watch films like *Todesmühlen* (Mills of Death), which showed graphic footage of liberated camps, including mountains of dead. (4)

In such encounters with mass death, the racialized visions of the Jewish body persisted. Although intended to confront Germans with the reality of genocide, these endless images of broken, emaciated, and entangled corpses tended to reify the cultural associations of Jewishness with the unaesthetic and grotesque. Under the gaze of the German public, the Jewish body was thus further debased: rendered lifeless and putrid, dehumanized, and transformed beyond recognition.

These very images and representations of racial alterity continue

to populate Germany's postwar imagination. In the years since uni-
fication, such depictions of the grotesque subaltern body (specifical-
ly the Jewish body) have been relegated to museums (Roth 1989).
In a critical commentary, titled *Das Feld des Vergessens*, Ingrid Strobl
(1993) takes us to the opening of a Holocaust museum in Berlin.
Designed as a permanent showcase, the museum exhibit attempts to
chronicle the "final solution." Primarily a photographic collage, the
exhibit is intended to interface with other educational programs
about genocide in Germany: It is "a site of teaching history." The
exhibition's ultimate goal is to provide educational labor, primarily
for students but also for adults. According to Strobl, "[h]ere in 14
rooms, beginning with the 'Dictatorship in Germany' to 'Life in the
Concentration Camp' to 'Liberation,' mass murder is chronologi-
cally depicted without murderers. There is a hall titled 'The
Wannsee-Conference,' in which one can see parts of the protocol
and photos as well as short life histories of the conference partici-
pants. Otherwise, these and other human agents of racial termina-
tion do not, with one exception (three Nazi doctors), surface again"
(83). Shown are merely the victims, and that through highly dubi-
ous means.

> Seven photographs of women, who are driven naked to the pit or who
> are in the process of undressing, are exhibited in this room. Seven. The
> women, panicked by fear and shame, are pressing their arms against
> their breasts, to cover them, and as a result their pubic hair is left
> exposed . . . This is the final and ultimate act of humiliation before they
> are shot and fall into the pit. These human beings—two million of them
> Soviet Jews—who were slaughtered by the troops, were often required to
> undress in plain view of their murderers, and then they had to place
> their clothes, neatly folded, onto a heap . . . Members of these execution
> units . . . found the time to photograph their victims during these
> moments of debasement and complete vulnerability . . .
>
> In several of the rooms one sees rows of "subhumanity" (*Untermenschen*):
> emaciated, hunched, "ugly" creatures, who stare into the camera, beg-
> ging, panicked, grinning or without any expression whatsoever. These
> photographs were taken by members of the SS, the army, the Nazi "civil
> administration," and professional propaganda-specialists. Without fur-
> ther commentary, without explanation regarding the origin of these pho-
> tos and the intent which produced them, without any attempt to

thematize the distorting gaze of the photographer: thus, what Germans made out of human beings after years of systematic impoverishment and denigration is presented here as a truthful vision of "the Jewish victims." As if they had always looked like this and had always stared into the camera with complete apathy . . .

When we follow Strobl into the last room, which houses an exhibit about the end of the war, we are confronted with photos "which were taken by members of the Allied forces during the liberation of the concentration camps: piles of corpses and living skeletons" (86).

Exhibits like these perpetuate a racial aesthetic that feeds on negative representations of difference: Jewish bodies, depicted as vulnerable and naked, are equated with terror and the grotesque. Seen as repulsive and "ugly," the bodies of racial others are exhibited merely as targets or objects of extermination. "Thus human beings," as Ingrid Strobl remarks, "are stripped once again of their dignity, their individuality, their history, and their unique identity" (85). And when, in the remembrance of the catastrophe, the victims are seen as individuals, it is usually in the period between the completion of their life and the completion of their death, "between the ramp and the oven, as starved, naked, shaved, numbered, emaciated men and women whose physical extremity, and its fearful inscription in their faces, makes us stop before the photographs and consider them one by one. By that time, however, these people were already gone; they were just not yet dead. [In these visual representations] The victims of the Holocaust are known too much by the manner of their death" (Wieseltier 1994: 177). Viewed through a lens of victimization and death, the Jewish body retains its symbolic value: a tenacious signifier of the repulsive. As suggested by the photographic collection in these museum showcases, German (popular) culture is committed to the promotion of racial images that have their political origin in the Aryan aesthetic.

After Hitler, during the immediate postwar years (1945–1950), the German body politic was fueled by such images of Holocaust victims. At this time, representations of the Jewish body assumed

center stage. And while graphic depictions of mass death and of the concentration camps were driven into public consciousness (at first, through the "denazification" efforts by the Allied forces, and much later, German museums), iconographic indicators of the Aryan aesthetic, that is, idealized white bodies and white nudity, receded from public view, together with the public portrayal of Nazi perpetrators. By remaining hidden and unseen, the German body politic eluded reconfiguration and retained its symbolic efficacy, even after 1945.

Postwar Iconographies: The Revival of Natural Nudity

Not surprisingly, the construction of national identity in postwar Germany came to be governed by familiar visions of the racial body. In the late 1960s (no more than two decades after German defeat), we observe the reappearance of whiteness as an aesthetic construct: in West German literature, where white bodies came to function as sites of contested individual identities as well as embattled terrains of sexual contagion (Adelson 1993; Gilman 1992); and in the postwar revival of public nudity in parks and resort areas (Fehrenbach 1994), where the visual accentuation of unclothed German bodies sought to "naturalize" whiteness. The social geography of white skin, with its symbolic implacement of German identity and selfhood, made use of iconographic representations of the antimodern: Nature, Nakedness, Nativity. Legitimated by the creation of officially designated nude sunbathing areas in urban parks, the public display of naked white bodies was symptomatic of a return to a racial aesthetic that celebrated the essential and authentic.

The West German revival of body consciousness, and the privileging of nakedness, received its initial impetus from the student rebellion of the 1960s. During this era of Leftist political protest, the unclothed body became a central icon of sexual liberation. In rallying against a seemingly repressive society, and by defending a new openness of sexual styles and practices, student radicals adopted public nudity as a crucial component of their political activism. The

rejection of sexual repression and the promotion of sexual liberation were closely intertwined with efforts to bring the subjects of Nazism and the Third Reich into public discussion. Disillusioned (and angered) by their parents' inability to acknowledge the murder of millions, student protesters used public nakedness as a symbolic expression of their own victimhood and shame. Although this iconography of public nudity greatly facilitated the students' self-representation as victims of Nazism, full-body exposure also provided a metaphor for the attempt to uncover the past by stripping Germany's murderous epoch of its protective and defensive armor. Public nudity was thus fiercely politicized. Driven by a programmatic call for sexual liberation, the act of becoming naked in public signified a return to the authentic, the natural, the unrepressed, that is, to a way of life untainted by the legacy of Auschwitz. Displays of public nudity were perceived as liberatory, both in a social and historical sense. By rejecting the cultural machinations of a murderous civility (clothing, commodities, memories), Leftist political activities were rendered "free" of shame.

The program for such a body politic, which employed public nudity as a means for transforming German historical consciousness, was first launched by members of the radical New Left—the founders of various socialist communes in Berlin, Cologne, and Munich in the 1960s. Advocating a lifestyle opposite to that of the Nazi generation, these new Leftists or "68ers" attempted to eradicate the private and "hidden" in favor of a public intimacy: "The hard casing of pair-based monadism was to be shattered by the crowbar of egalitarian intermingling: to be able to sleep with anyone; to be able to show oneself naked in front of everyone; to be honest without restraint and willing to speak one's mind without hesitation; to call a spade a spade, never to keep anything to oneself, and never to withhold or repress anything" (Guggenberg 1985: 1, col. 2). Honesty, truthfulness, sexual freedom, and social equality were among the values that governed the new cult of nudity. The democratization of the German body politic was to be acheived by the public shedding of clothes: "bare skin" emerged as a new kind of

uniform, an authentic body armor unmediated by the state or history.

Encoded by these messages of opposition and rebellion, public nudity was soon employed by many young Germans as a personal gesture of cultural protest: seemingly unconvetional and provocative, the practice of disrobing in public was widely adopted as a pastime with countercultural significance. In the early 1970s, public nudity emerged as a popular outdoor activity, and as urban parks were increasingly thronged by those who preferred to sunbathe without clothes, full-body exposure became commonplace. By the late 1970s, nudity in public parks was so pervasive that local prohibitions against body exposure were no longer enforced unless "it caused offense": naked sunbathing was exempt from public indecency codes (Brügge 1985: 149). Confined to natural settings, the naked body seemed devoid of sexual and erotic meaning.

This perception was contested in 1981, when public nudity moved beyond conventional urban spaces. Transgressing the designated boundaries of parks and park-related greens, nudists began to congregate along river shores, on beaches, on playgrounds, swimming pools, and cemeteries, even city centers. In downtown Munich, for instance, nudes were now often sighted in historic fountains, on streetcars, and in shopping centers (Brügge 1981, 1985). Such a migration of nude bodies into the metropolis, the apparent escape of nakedness from "nature," provoked among some segments of the German public deep anxieties about unfettered sexuality.

At issue was the naked male. Exposed masculinity was met with suspicion and unease. Uncovered male genitalia, the public sight of "dangling and swinging penises," (Brügge 1981: 150) was experienced by many Germans as a threat. The open display of the phallus was traditionally prohibited, a thematic much belabored by the cultural critics of the 1960s. Among Leftists, male nudity had been encouraged as a way of promoting sexual liberation, but "in order to experience corporeal freedom, the unclothed [man] often long[s] to walk upright [thereby exposing himself and his sex], something which is still taboo" in Germany (Brügge 1981: 151). When voicing their discomfort, passersby conjured visions of rape and sexual vio-

lence. "I have to look at that," shouted a sixty-three-year-old house-
wife when encountering a naked man in public, "and I know what is
to come after" (ibid.). As suggested here, public body exposure,
specifically that of men, was read through images of sexual deviancy
and unacceptable behavior (Guggenberg 1985: 1, col. 3). In German
popular consciousness, the shedding of clothes signified a release
from civil restraint, an incitement to general rebellion and political
unruliness: The naked male was judged capable of anything.

In order to preempt such anxieties, public displays of nudity had
to be carefully packaged to seem "natural" or artistic. Such a manage-
ment of nakedness had several unintended consequences. Although
awareness of the sexual side of nude bodies could be repressed by
confinement to natural settings, the naturalness had to be rendered
civilized and aesthetically pleasing. "Today nobody cares if thou-
sands take off their clothes in the English Garden. But those thou-
sands, who unintentionally walk by, are forbidden to look. Shame
works the other way around; nakedness must be clothed—by beau-
ty" (Friedrich 1986: 50). This emphasis on nature as an aesthetic
construct worked by exclusion. The naked/natural body was ideal-
ized by juxtaposition to the biological 'ugly': "[German] public nudi-
ty always implies a privileging of the beautiful and youthful body.
The display of nakedness in parks or cafes creates a situation of mer-
ciless scruntinization that intensifies the social marginalization of
those who are physically disadvantaged: the fat and the overly thin,
the misshapen or disfigured, and the handicapped" (Guggenberg
1985: 1, col. 4). In West Germany, public nudity came to be gov-
erned by an ideology of difference that celebrated the unblemished
body as a natural symbol. Naked "nature" was to be rendered free of
the unsightly. Natural nakedness, a quasi-mythical construct, could
not be tainted by physiological markers of age, death, or history.
Public nudity, like nature, was to present a facade of eternal beauty,
unmarred by signs of physical weakness. Such iconographies of
essentialized perfection (youth, beauty, and health) were integral to a
postwar aesthetic that sought to rehabilitate the broken body after
Auschwitz.

Nudity in public places (urban parks, beaches, swimming pools, and saunas) emerged as a semi-legitimate practice during the 1970s. And gradually, over a period of ten years, topless sunbathing and full-body exposure in public would become an acceptable leisure activity throughout West Germany's metropolitan centers (see figure 2). Today, in the 1990s, public nudity is perceived as an unremarkable practice: Naked bodies are an integral and normal part of the urban landscape.

> Berlin. Here in the land of laws . . . there is one activity that offends absolutely nobody: Going nude.
>
> In posh saunas and swimming clubs, nudity is de rigeur—it's bathing suits that are frowned upon. In the city's public parks, topless sunbathing is all the rage, especially now that summer weather and long hours of daylight finally have northerly Berlin in their grasp. And along the nearby beaches and lakes, nobody thinks a thing of shedding clothes and just diving in.
>
> For the uninitiated, it's hard not to do a double-take strolling through the city's massive, leafy park, the Tiergarten. It would seem the park's neo-classical statues of nude women have suddenly abandoned their marble perches and taken to lolling on the lawn and reading the newspaper. But the hordes of topless sunbathers barely draw a second glance from Berliners. (Neuffer 1994: 2)

The German iconography of public nudity, the imagery of naked white bodies reposed on green grass, enveloped by shrubs and tall trees, hearkens back to early pictorial images of Adam and Eve in the garden. Although such scenes evoke wilderness, a sense of the "natural" world, this carefully crafted landscape seeks to shroud the exposed body, repressing it, incarcerating it, and thereby protecting it from the erotic gaze of a nation that does not invite all bodies to be sexual objects.

The naked body is a social body. And public nudity is a performance, a staged display, with intense political significance. In one example, a photographic glimpse of "paradise" (figure 3), a public park in West Berlin, two naked Germans—a man and a woman—are enjoying the tranquil outdoors: domesticated nature. Positioned against a canvas of trees and bushes, the couple is sitting in the

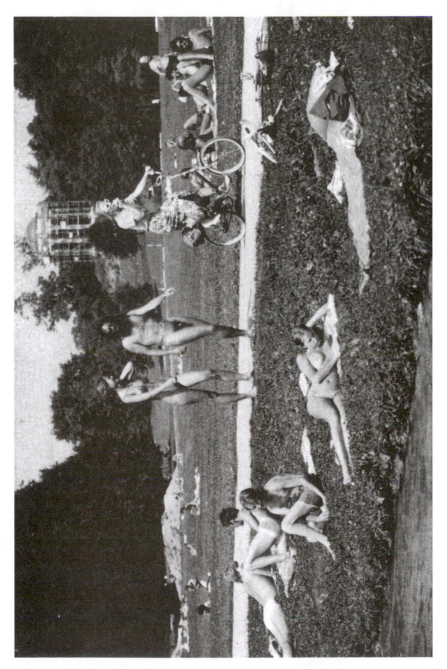

Figure 2. *Naked Sunbathers in an Urban Public Park (Englischer Garten), Munich 1981*. Photograph copyright Marcel Fugère.

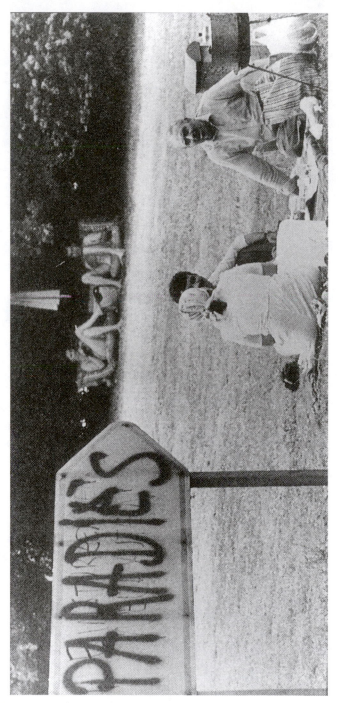

Figure 3. *German Nudists and Clothed Third World Others in the 'Garden of Eden' (Paradise), West Berlin 1989*. Photograph copyright Ralph Rieth.

shady cover of the foliage. Reposed in arm chairs, beneath an unopened parasol, glancing at a newspaper or book, the nudists have personalized a natural space. Their furniture props and unclothed bodies are positioned to convey a domestic (reclusive) state of leisure. Here, the display of nudity draws on existing social fantasies of "paradise," as indicated by the sign's graffiti. Nakedness and body exposure can thus be staged to create a consumerist retreat. Inside the park, with its natural landscape, leisure activity is privatized in other ways. Leisure, experienced as an escape from the collective social world, is displaced to a domesticated natural interior—a primordial garden. Such a mythographic image of nudity is reimagined through the motif of the German parlor, a familial (private) interior space that is externalized as nature or, rather, becomes "nature" privatized as parlor.

The German nudists (much like Adam and Eve) have been positioned as overlords of nature. This is signified by their elevated station: They are seated above nature, in proximity to the ground, although never touching it directly, while the Third World sits on the grass. The dark-skinned Mediterranean (Turkish) Others, who are assembled in the foreground of the photograph, are in tactile contact with the park's natural setting—a tactility that encodes physical labor as the primary relation of these Others to nature. Sitting directly on the ground, their physicality is visually accentuated: by their clothing, their cooking of food on a grill, their tending to the open fire. The photographic gaze connects their bodies to images of work and consumption. The visual immediacy of the immigrants is contrasted with the remoteness of the German nudists, whose naked bodies are partially obscured from view. This obscuration/obfuscation exposes the erotic nuances of leisure.

The Germans' spatial proximity to the ground and to the immigrants implies distance and dissociation. Such images invert Western assumptions of the "civilizing" process: The clothed (concealed) body of the dark-skinned Others signifies a lack of refinement, a commitment to traditional values, a simplistic lifestyle, and a dangerous preoccupation with matters of the body (that is, food,

sex, reproduction). By contrast, the unclothed (exposed) body of the Germans stands as a trope of modernity, a cosmopolitan lifestyle, and knowledge of refined consumption (e.g. Bourdieu 1992). White nudity exposed need not fear its vunerability because of the commodity armor that shields it and the carving out of a privatized sphere (in contrast to the Others' kin-bound aggregation). The immigrants, sitting in the middle of the grass, in the foreground of the picture, are rendered highly visable. This positioning places them on the nation's periphery, on the margins, on the "outside," while the naked Germans, sitting in the background, partially hidden by the vegetation, are positioned within the nation's innermost center, the "inside," which is enclosed as a "natural" domain. White naked bodies, equated with a civilized and privileged state of nature (paradise), can thus be imagined as sites of an authentic national interior. This visual emphasis on natural privilege, which tries to conceal the carnal or erotic dimensions of white nudity, is crucial for the symbolic construction of a national German body politic.

Such a desire to naturalize white nudity, in order to conceal its sexual dimensions, might in part explain the total lack of black-skinned nakedness. In public parks, black nudity is conspicuously absent. But throughout recent German history, black bodies have been equated with the sensual, primitive, erotic. During the colonial era, for instance, the black body was sexualized by a focus on the unclothed and exposed imperial subject (Corbey 1988; Lutz and Collins 1993; Edwards 1992; Steiger and Taureg 1985). Beginning in the 1920s, the erotic framing of black skin was driven by an entertainment industry that commodified the European fascination with black nudity, as suggested by Josephine Baker's spectacular dance routines which embodied white pornographic fantasies of the "black savage" (hooks 1992: 62–3; Nederveen Pieterse 1992:142–4). The sexualization of the black body continued under Hitler, where blackness was equated with decadence, the dangers of miscegenation, and racial inferiority, based on the supposed inability of blacks to control their sexual passions (Proctor 1988; Mosse 1985: 36, 133). Such racially charged iconographies surfaced again

in the years after 1945, when German propaganda perpetuated the cultural portrayal of Allied black soldiers as dangerous sexual predators (Fehrenbach 1996). Given this historical association between blackness and sex, it is perhaps not surprising that the public exposure of black bodies in parks or resort areas is so uncommon. Such a difference in corporal practices suggests that, as a terrain of signification, the naked body (like skin color) is a cultural construct: Not all bodies are equally encouraged to represent the German nation. And although black men and women are not legally prohibited from nude sunbathing in Germany, the spatial or visual proximity of unclothed black bodies in urban parks would constitute a symbolic threat to the German pretense that the public disclosure of white skin is natural and nonerotic.

Positioned within nature, public displays of white nudity want to be viewed as childlike and innocent: The naked German body, enveloped by white skin, is equated with goodness, health, and virtue.[16] Going nude "is a way of thinking that a healthy body ensures a healthy soul," says Wolfgang Weinreich, the Berlin-based vice president of the German Association for Nudists, an avid advocate of a lifestyle that is officially termed "free-body culture" (*Freikörperkultur*, that is, F.K.K.) or, more colloquially, "naturism" (Walsh 1995: E10). The natural body, stripped of its clothing, in the words of one Berlin activist, is devoid of the "unclean" and "unhygienic" (Neuffer 1994: 2). Such a perception of nakedness as natural and healthy also includes assumptions of controlled sexuality. "One has to remember," says Joachim Heilbutt, a passionate promoter of the German nudist movement in the 1930s, "that, in itself, nudity is the only civilized thing . . . Natural nakedness is without shame" (Fallada 1933: 223). According to Dieter Hering, manager of *Thermen*, one of Berlin's better known *saunagartens*, nudity is all about family values, not sexual eroticism. "The nude sauna is perfectly normal," he says. "It's more of a family thing" (Neuffer 1994: 2). Inside the establishment, naked men and women share everything, from showers to whirlpools to saunas to hot tubs and masseurs. Only the changing rooms are segregated by gender assig-

nation: "The atmosphere, however, is anything but sexual. These are sauna-seekers with a mission, who check their watches to make sure they have alternated just the right amount of time in the hot tub with just the right amount of time in the cool pool. A fenced-off outdoor section allows the hardy to stroll outside for a brisk blast of the winter wind after a sauna, should they wish" (2).

In Germany, nudism is a body practice aimed at steeling and conditioning the body by its exposure to the "natural" elements: sun, wind, and water. The conceptual image of the body "hardened" and enduring (*abgehärtet*), which was coupled with the fascist racial aesthetic in the 1920s and 1930s, has been recovered as a vehicle of national health in contemporary Germany.

> Nude sunbathing, swimming and saunas are part of European culture . . . But nudity in Germany has its own special roots, in the Freikörperkultur or "free body culture", that first gained popularity in the 1920s.
>
> Workers and middle-class intellectuals, drawn by the philosophy that a nude body is better for a free spirit and healthy living, would have family picnics, swimming parties, and even exercises in the nude. Members of the Wandervogel, the youth movement, whose clubs spawned the Hitler Youth, also would have outings and picnics in the buff.
>
> Nudity [as an expression of personal identity] disappeared under Hitler [when it was used to promote the racial state]. But it had its renaissance in the 1960s. (Neuffer 1994: 2)

The presumed "naturalness" and "innocence" of naked bodies (relying on the habitual repression of white sexuality) gave rise to a racial aesthetic which equated "whiteness" with "nativity" and citizenship. In West Germany, political membership and national identity continued to be visually encoded, physically grafted onto the skin (Gilman 1982). However, in the postwar German state, the racial aesthetic was submerged in other body practices, notably consumerism. Notions of citizenship were mediated by a consumer aesthetic, which encouraged conspicuous displays of self (Fehrenbach 1994). In this context, public nudity began "to articulate an alternative model of democratic freedom," focused on personal choice and desire: "By the 1950s, democratic freedom came to be identified

with material prosperity and consumer choice. Consumption in the form of dress, leisure activity, even physical bearing and movement—was employed by some (especially young) Germans as a means to challenge old models of gender and national identity" (Fehrenbach 1994: 4).

The public exposure of white skin, a "marginalized pastime of antiurbanists at the turn of the century" (Fehrenbach 1994: 4), became an accepted expression of cultural protest in postwar Germany. Offering a "language of commodity resistance" (Appadurai 1986: 30), and inverting the logic of capitalist consumption, public nudity articulated a countercultural reality. The naked white body, stripped of its materialist trappings, signified freedom from the constraints of modern German society. As in the 1920s, white nakedness came to symbolize freedom from the deceptive armor of clothing: the nude body was purged of the artificial, the illicit, the erotic.[17]

Ironically, the postwar rejection of modernity took form through an ensemble of images that had their origins in the nationalist reform movements of the Weimar period. In Germany, during the 1920s, the antimodernist revolt gave rise to a racialist vision that was articulated through the body. Corporeality became a symbolic site in the nationalist rebellion against modernity: the unnatural, the impermanent, the decadent. Modern styles of life, with their materiality and pornographic sexuality, were "condemned as breeding grounds of immorality and moral sickness" (Mosse 1985: 52). The terrain of the city, presumed to induce bodily ills, was set in opposition to the terrain of nature, which was extended to include the natural body: human nudity. German nationalism, with its anti-urban focus and its rejection of the modern lifeworld, was marked by a rediscovery of the body. Societal reforms were tied to the reformation of the body. In other words, the German disenchantment with the modern was to be cured by purging the body of its materialist wrappings: Public nudity and the unclothed human body became important signifiers of this new nationalist consciousness.

After 1945, in postwar Germany, the rejection of modernity was expressed and took form through nearly identical mythographies. The naked (white) body was imagined as a priviledged, natural or presocial site of truth. Nude swimming and sunbathing were deployed as strategies for the promotion of personal health and well-being. Moreover, exhibits of public nakedness were used as a new terrain of resistance against consumer capitalism. But unlike the aestheticization of white nudity at the turn of the century, the West German critique of modernity was not at first driven by an overtly nationalist agenda. This dimension was to be added later. Rather, the unclothed body (as authentic truth-claim) was pitted against the facade of the state. The open display of the naked body was contrasted with images of political order, bourgeois authority patterns, conformity, and consumption, that is, tropes of the Nazi state and the economic structures which produced fascism.[18]

Public nudity became an iconographic tool with which Leftist political activists could proclaim their opposition to fascism. The rejection of consumer capitalism, the commitment to democratic values, and an opening of bourgeois morality by furthering the sexual revolution were central components of the political rebellion of the sixties and seventies, a rebellion that was closely intertwined with the New Left's efforts to bring the subjects of fascism and the Third Reich into public discussion. Student radicals were among the most open, provocative defenders of the new publicity of sexual styles and corporal practices, making the case that sexual repressiveness was a bulwark of a politically and economically repressive society. For them, sexual liberation, and nudity, was an indispensable component of political revolution.

The West German New Left student movement was never very large—actual activists probably numbered only in the thousands—but it was extraordinarily influential. Not only did the movement shape the values of its own and subsequent generations in the broadest and most profound ways, but in the decades since the sixties the movement's existence has also been taken—even by conservative observers—as a sign that Germans truly were capable of

democracy. This made the student movement in West Germany peculiarly important by comparison with the movements in other nations (Bude 1995: 17–22, 41–2). The West German Left was appalled by many forms of social and political injustice, and it supported a broad array of resistance struggles, both in the Third World and at home. The damaging consequences of capitalism, racism, imperialism, and militarism worldwide were major preoccupations, and the war in Vietnam or the struggles of the Palestinians figured as prominently in Leftist activism as did the legacy of Auschwitz. Yet the fact of German Nazism and Judeocide left an inescapable imprint on postwar West German culture and affected people's lives and self-understandings in the most intimate ways. It was ultimately no coincidence that members of the West German generation of 1968 repeatedly made reference to the Third Reich, and the Holocaust, in their battles with each other and with members of their parents' generation (Herzog 1998). Such battles often raged over the sexual mores and the sexual politics of bourgeois culture, and the links between Nazi libidinal pathologies and genocide.

Experiments in communal living, new parenting styles, and a renegotiating of gender relations, among other things, were elaborated against the backdrop of the perceived legacies of the Nazi past. In developing new sexual attitudes and practices, the "68ers" declared that they were breaking with what, in their view, had caused German fascism in the first place: not only "capitalist imperialism," but also a particular set of (what they called) "bourgeois" family arrangements and a specific form of conservative Christian morality (Herzog 1998: 395–6). Yet much of what the "68ers" were actually rebelling against were their own experiences in the post-fascist 1950s and the interpretations of Nazisms sexual legacies proffered by parents and religious leaders in that decade. While church and political leaders presented sexual sobriety as the most effective cure for the nation's larger guilt and moral crisis, the New Left focused on Nazism's sexual politics as inseparable from the other crimes (Haug 1965: 30–1). Throughout their programmatic writings on sex, members of this postwar generation returned frequently

to the problems of genocide and brutality within the concentration camps, suggesting that it was male sexual repression that engendered the Nazi capacity for cruelty and mass murder (see Theweleit 1987; Heider 1986; Preuss-Lausitz 1989; Siepmann 1984). The fierce anti-fascism of the German New Left was centrally preoccupied with assaults on male sexuality, specifically because of the perceived connection between men's release of libido and evil.

A noteworthy feature of so many of the debates within the Left scene about sex, and about sex and fascism, was thus their focus on the male body, and male desires and anxieties in particular: "In postwar West German struggles over various sexual lessons of Nazism, male bodies were called to a kind of public visibility and accountability that most scholars of the history of sexuality generally assume to be reserved for women" (Herzog 1998: 398). Striking is the obsessiveness with which this postwar generation tried to make public some of the most intimate ways in which men related to their own bodies and the bodies of others. The public exposure of the male body, including men's sexual desire, became a political agenda in Leftists' attempts to reform gender relations and revolutionize the bourgeois/fascist individual. By 1968, various socialist collectives, including the infamous *Kommune 2* in West Berlin, had integrated radical male nudity both into their domestic lifestyle and their public political program (Dürr 1994: 418–20; Bookhagen 1969: 92).

The West German Left had initiated such nudist body practices in part to strengthen their case for sexual liberation with the most shocking metaphors available. One group that did so—with spectacular flair—were the members of the *Kommune 1*, a small but endlessly publicized and debated experiment in communal living and anarcho-radicalism launched in Berlin in 1966. A classic example of the *Kommune 1*'s provocative style was provided by the photo of its members—including the two children living with them—distributed by the members themselves on a self-promotional brochure (see figure 4). This photo has been reprinted many times—usually in a spirit of humor and/or nostalgia—and now counts as one of the icons of this era (Herzog 1998: 405). What was the political signif-

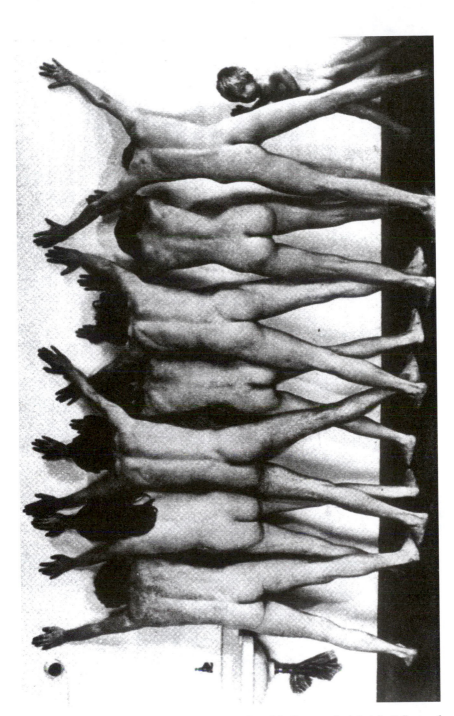

Figure 4. *"Naked Maoists before a Naked Wall": Members of the Kommune 1—A Socialist Collective of Young Maoists, West Berlin 1967.* Photograph copyright Thomas Hesterberg.

icance of this portrait of collective nudity? In 1988, former leader of the Socialist Student Union (*Sozialistischer Deutscher Studentenbund—SDS*) Reimut Reiche (long hostile to the *Kommune 1*) would make the following observation about this photo: "Consciously this photo-scene was meant to re-create and expose a police house-search of the *Kommune 1*. And yet these women and men stand there as if in an aesthetically staged, unconscious identification with the victims of their parents and at the same time mocking these victims by making the predetermined message of the picture one of sexual liberation. Thereby they simultaneously remain unconsciously identified with the consciously rejected perpetrator-parents. 'Sexuality makes you free' fits with this picture as well as 'Work makes you free' fits with Auschwitz" (Reiche 1988: 65). Commenting on this persistent tactic by the New Left to represent instances of their own political victimization in terms of Judeocide and Auschwitz, cultural historian Dagmar Herzog (1998) observes:

> The apparent inability to leave the past behind—indeed, the apparently unquenchable urge to bring it up over and over again precisely in the context of sexual relations—not only reveals how intense was the felt need to invert the sexual lessons of Nazism drawn by their parents' generation but also, and perhaps even more significantly, suggests something about the difficulty of theorizing a sexual revolution—of connecting pleasure and goodness, sex and societal justice [i.e. nudity and freedom]—in a country in which only a generation earlier pleasure had been so intimately tied in with evil. (400)

However, by the 1970s, the public display of naked bodies, in particular the public viewing of nude men, was rendered acceptable by severing these links with historical memory. West German nudes were "naturalized" (by placement in a pre-social space) and disguised as unerotic or non-sexual through an appropriation of classic iconography. As public nudity was adopted as a popular pastime, and emerged as a commodity fetish in West German advertising, its political and oppositional meanings were gradually suspended.

Interiorizing Whiteness: East Germany

The construction of nudity, the unclothed body set in opposition to the state, was further accentuated in East Germany, where the expansive apparatus of the socialist regime had forged a different cultural aesthetic. Following state doctrine, socialism was defined in direct opposition to Nazism, indeed, as its negation. East German discourse cultivated an official narrative of resistance and postwar leaders depicted themselves first and foremost as antifascist. Directed toward the abrogation of what Germans had been in the Third Reich, the East German state began to pattern a way of life different from that of the West. Condemning Western capitalism for its historical ties to Nazism, and in an attempt to consolidate its own political authority, the East German regime became obsessed with centralizing its power. During the 1950s, the state apparatus effected the radical restructuring of East German society: through the surveillance of citizens by state security agents (*Staatssicherheitsdienst* or *Stasi*); through the forced reorganization of households, domestic groups, and political alliances; through the nationalization of industry and other means of production; and through the political insistence on a sacred collective mission (Borneman 1992). The expansionist control mechanisms of the socialist state promoted a policy of demarcation (*Abgrenzungspolitik*) and containment, which culminated in the creation of a "protected space for its utopian experiment" (4): the building of the Berlin Wall in 1961. Official discourse constructed a narrative in which personal expressions of experience and choice were repressed in favor of community and family. Collective interests were privileged by a political apparatus that sought to control, even annihilate, private dreams of self-realization and personhood (Schaefer 1996). During its attempts at nation building, the East German state codified, and transformed into law, a blueprint for specific kinds of social relations and specific kinds of selves.

Thus, in the 1950s, the East German state had established a political system that gave form to the everyday experiences of its cit-

izenry: a regime maintained by surveillance, force, and fear. For East Germans, "[v]ictimization permeated the memory of the last years of the war and the beginning of occupation: Feelings of loss, waste, and powerlessness became a trope for the entire postwar experience" (Borneman 1992: 125). The expansive apparatus of the East German state became an integral part of a dual political organization, which was constructed in contradistinction, as mirror-image, to the capitalist lifecourse in the West.

The socialist project, that is, East Germany's attempt at nation building by trying to define, regulate, and normalize even the domestic practices of "self" was not implemented without opposition. Despite the ubiquity of a massive control machinery, there were uprisings, revolts, and efforts to withdraw compliance. Although overt acts of resistance were typically unsuccessful, often resulting in brutal punishment, some forms of defiance persisted. Beginning in the 1950s, public nudity appeared as a localized counterdiscourse to the state. East Germans who traveled to the Baltic Sea on vacation adopted nude sunbathing and naked swimming as a nonviolent means of resistance. "East Germans . . . had discovered in the early years of their repressive state that going bare on the beach was one of the few freedoms they were ever likely to enjoy. They fought valiantly to keep freebody culture just that: Free" (Walsh 1995: 10).

Public nudity, as an assertion of selfhood, was treated as a potential threat by the socialist state: a regime that made use of clothing, attire, and dress to impress upon its citizens the codes of social conformity. The wearing of uniforms signified participation in an organized society, where mandatory service in youth groups, in the army, and in the socialist party as well as in the various state-sponsored committees and associations marked the passage of everyday life: Organizational control was strategic in the making of the socialist citizen. Within this politicized world, the naked white body stood as an antithetical sign: a trope of an authentic "self," that is, an iconographic image of personhood unmediated by the state. In East Germany, public nakedness was experienced, and read, as a

way of being, of projecting an authentic identity, without state intervention.

Not surprisingly, the East German government prohibited public nudity entirely in 1952: "Files kept by the despised East German secret police, painstakingly preserved and archived since the Berlin Wall came down, show various Communist functionaries calling nudism 'a dangerous cult', and an example of 'decay' and 'imperialist decadence'" (10). Once the prohibition against public nudity had passed into law, the East German government even dispatched police officers to the beach to enforce the ban. These efforts, however, proved to be in vain: Militant nudists threw the outnumbered clothed officers into the water. "As soon as something is prohibited, of course, it becomes more attractive," says Peter Jusciak, a thirty-five-year-old eastern German bricklayer who has brought his wife and two young sons to the beach at present-day Goehren. "Going nude in East Germany was a way you could provoke the state" (10). In East Germany, nudity became a direct challenge to the official version of history in a continuing contestation of nationness. East Germans saw the significance of nakedness as a trope that subverted what they perceived as a political obsession with work and production.

Free-body culture promoted the normalization of local attempts at resistance by making them part of the natural order. The (de)reification of political identity, unclothed bodies, and the shore were merged into a grand system: nature. The naked white body, lying on a sandy beach, engendered a mythographic vision of genesis that symbolized birth, rebirth, and perhaps, metamorphosis. Propelled out of history, attached to a narrative of human origin, nudity signified the primordial beginnings of life. Linked to notions of "coming-into-being" (Yanagisako and Delaney 1995), clearly a transformative fantasy, public nudity conveyed a sense of nostalgia for idealized nature as well as a sense of hope for redemption or deliverance. The motif of the natural body and the motif of the sea were thus crucial for the East German construction of a pre-social, unmediated location of truth. The naked white body was

reconfigured as a site for the representation of an authentic (natural/immutable) interior of self and nation.

The East German iconography of public nudity persisted more or less unchanged until (re)unification, in October 1990. Soon after the fall of the Wall, with the introduction of consumer capitalism, the naked body was turned into an erotic object, a commodity form (Herold 1993; Spiegel 1990a, 1990b; Kuntz-Brunner 1990). It was only with the collapse of the socialist regime that the public exposure of the naked body lost its oppositional meanings, its potential for rebellion and personal protest, in East Germany. In West Germany, the iconography of public nudity was to undergo a similar change: from commodity resistance and political protest to sexual eroticism. But here, such a transposition of meanings took place much earlier: The symbolics of nudity were seized by the interests of West Germany's consumer capitalism, a process of the 1960s. The oppositional dimensions of white nakedness were subverted and transposed by an expanding postwar economy and, more specifically, by West Germany's recovering culture industries. In order to increase the market demand for consumption, West German media and advertising was thoroughly sexualized by the 1970s. Subject to commercialization, public nudity was reduced to a commodity fetish. In these contexts, erotic displays of naked bodies were immediately (re)racialized.

Nudity and Sex: The West German Media

> [I]f the [West German] TV networks air a soap ad showing a topless woman in the shower, nobody gets on the horn to complain. Bra ads here feature bare-breasted women pulling on their undies before the cameras. Sober, respected weeklies go to press with covers rivaling Playboy centerfolds. Sun worshipers take it all off in the parks. Dance-club patrons show up in nothing but garter belts and a few spaghetti-thin leather straps . . . [I]n Germany, it's just part of the landscape. (Walsh 1995: 10)

In West Germany, beginning in the early 1970s, the formation of white public space was further enhanced by "a specific capitalist form of pornography-based sexuality" (Borneman 1992: 265), and

by the officially sanctioned use of erotic nudity in West German advertising (Jeske et al. 1987: 39–55). In these sexually charged media representations, we observe a different "framing" of the unclothed body. No longer concealed by placement in a natural setting, the nude body was made visually accessible to arouse commodity desire. Such a liberalization of sexual body practices, which had begun in the late sixties, when it was driven by the German student movement and its demand for "sexual revolution," became an integral part of mass culture in the early seventies. Prior to this period, throughout the 1950s, and the early 1960s, sexual bodies had been tightly controlled; the free use of sex was taboo (Herzog 1998). Until the seventies, media depictions of nudity in connection with prostitution or other assertions of female sexual independence were linked to moral degeneracy and public shame: For instance, cinematic representations of unregulated female sexuality, construed as an expression of excessive materialism and dangerous individualism, caused deep disturbance among conservative political and religious leaders (Fehrenbach 1995: 92–117). During the fifties and sixties, the mass-mediated production of erotic female agency was not only perceived as a challenge to patriarchal authority but also as a threat to the normative social order. Opposition to these repressive cultural conventions, which were perceived as a continuation of fascist order and morality, was first launched by members of the radical student movement. Their militant, and sometimes violent, advocacy of alternative lifestyles and sex practices did result in a dramatic shift in public attitudes and norms. But by the early 1970s, such a general sexual liberation of West German public culture took a surprising form:

> [E]ven as social authorities tried to restrict the sexual practices of [the postwar generation], to hold what people heralded as the "sexual revolution" in check, a sex wave hit the press, especially the right-wing, conservative tabloids. Popular illustrated magazines such Bild and Stern began at this time to show nude women on their covers. A specific capitalist form of pornography . . . based on the public sale of women's services, quickly established itself in the middle and upper-middle classes of large cities, epitomized in the ubiquitous "Sex Shop" to be found in every busi-

ness or nonresidential area of West Berlin [and elsewhere].[19] (Borneman
1992: 265–66)

The sexualization of public nudity was sometimes mediated by
racist iconographies. In Germany, the erotic exposure of naked bod-
ies was governed by a specific racial aesthetic: the hierarchization of
color (which privileged white skin); and the construction of differ-
ence between bodies of color (which devalued the black icon). In
the pornographic fantasies of German image-makers, "whiteness"
was evaluatively contrasted with "blackness." Through the medium
of commercial images, nude white bodies were exalted and magni-
fied, even adored, as cultural artifacts that could be transformed and
perfected by acts of consumption (see figure 5).[20] Nude black bod-
ies, in contrast, were packaged as commodities, imagined in white
erotic fantasy as embodiments of regressive authenticity.

German commercial culture displayed white bodies through
images that idealized, visually sculpted, the nude flesh. Often
stripped of sensuousness and sexuality, the visual desirability of
white skin relied on image-constructions that made such bodies
appear inaccessible, distant, unattainable.

This is suggested by a series of West German advertisements for
men's cologne, in which complete male nudity took center stage
(figure 5). Image-makers introduced their new product line, which
commodified men's bodies in various stages of undress, with the fol-
lowing text: "The new interest by men in their own bodily aesthetic
goes far beyond the basic need to pamper oneself. Body conscious-
ness, sensuality, delight in one's own appearance and its effect on
others have increasingly become also a male concern" (Jeske et al.
1987: 418). Adopting the pose of classic statues, the male models
are typically clad only with the scent of the commercial product.
The text of the advertisement reiterates this point: "He wears Care"
and "Care allures/attires" (zieht an). The classic beauty of the male
nude, with his fortified and hardened body, seems impervious to
seduction by the spectators' gaze. Standing immobile, upright, and
somewhat remote, the nude model resembles a white marble statue:

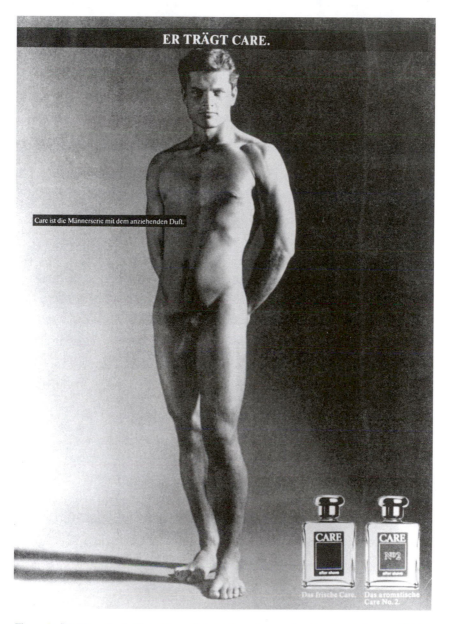

Figure 5. *"He Wears Care": White Naked Male Bodies as Commodity Fetish, West Germany 1985–87.* Photograph copyright Jahrbuch der Werbung, ECON Verlag GmbH, Düsseldorf.

a perfected masculinity—reminiscent of the classic/Aryan ideal.

Beginning in the late 1970s, these images of male nudity were introduced by German advertisers as a cultural provocation: The naked man had market value and effectively supplanted the standard fetish of the female nude (Köhler 1985b). Working against the popular perception that mass media was productive only in its creation of fantastic falsehoods, of imaginary worlds and illusory needs,

> [West German image-makers] began to produce a new materiality, a new essentialism; terminating all artificiality, at the apex of what is often experienced as fabrication, stood suddenly the naked, unadulterated human body . . . An industry, which was actually preoccupied with the concoction of packaging, wrapping, and pretense, suddenly remembered an authentic state of nature. But this dialectic of clothing and unveiling corresponds to social changes, which are so complex and pervasive that the naked man, as we show him, can merely be a signifier of these fundamental transformations.

> In the case of our ad campaign for [men's cologne] *Care*, we are dealing with a product . . . that has little material substance; it is a tender liquid, whose materiality cannot be easily represented or dramatized. Its value, moreover, lies in its pleasant odor—ephemeral, hardly demonstrable, nearly metaphysical. In other words, the product tends toward immateriality . . . postmodernity . . . the future . . . In this sense, the naked male body stands as an icon of the postindustrial society, a symbol of the consumption of insubstantial goods . . . In our ad campaign, we use naked men, who bear the immaterial substance on their skin, and who charismatically project its aura (determined by the application of the product) with self confidence, because they are enhanced by it. But here something was still amiss: nakedness is perceived only through the representational specificity of the human body. Taken as a whole, human beings have a face, mimicry, and body language, which are used as classic means of self-expression . . . In our *Care* campaign, we could finally unveil the monument for the postmodern man in its entirety . . . an entire naked human being/man, but rendered particular through the unveiling of the most distinctive of male body parts—the penis. (Schirner 1987: 39–41)

But in West German advertising, such a novel exposure of naked masculinity, the denuding of the phallus, was immediately aestheticized through familiar iconographies and images:

> Whatever was unthinkable a few years ago, has today become a matter of course. Fashion magazines vie for a male readership, and cosmetic com-

panies carry body products "For Him." Anointed and parfumed, styled and groomed, HE presents himself and the beauty of his body . . . The borders of shame have shifted. A segment of the male population has been exposed. The decorum of hard masculinity has been removed, as has the surplus of freedom and adventure. These men show themselves as they are . . . naked, and bare . . . These men are sensitive types of slender, almost tender stature, who appear to pose for themselves. All obtrusiveness has been removed; their bodies have been dipped in soft light, providing their contours with a gentle, blurred hue. These men appear world removed and introverted . . . Sun-tanned and smooth . . . Beautiful, perfect, and immaculate . . . Nobody can take amiss his nakedness: shadows graciously cover his sex . . . [his nudity is] discreet and, from an aesthetic perspective, staged to perfection . . . The male body has been cleverly postioned like an antique statue . . . the pose is unmistakable. It is suggestive of a Greek hero and makes us anticipate his victory . . . The image toys with our memories. It is emeshed with a code that is commonplace in our culture: the classic age . . . Is it a coincidence that the new man often makes his appearance in the nudity-costume of aniquity? Is it not true that many of these images operate with men's lust: his desire for his own body and his own sex? . . .

Such symbolic disguises obviously have meaning. They legitimate male nudity [and sublimate its homoerotic appeal] . . . These images seem inoffensive, harmless, safe. They are like art. Men's fascination with these bodies is focused on a work of art, and the spectator distances himself from any suspicion of perversion. Subliminally, apparently innocently veiled, and without anybody being able to take notice, the desire for one's own sex can be released. (Soltau 1987: 42–3, 44, 45, 46–7)

The aestheticization of male nudity, by a reliance on mimetic tools of classic iconography, and the corresponding emphasis on marble, rock, and art liberated the naked body from its sexual and political history: it became a "timeless" image, a "natural" artifact, which could be put on display without evoking traumatic memories of male libido and violence.

Black nudity gained attention through very different visual practices: German advertisers transformed black bodies into carefully positioned icons of eroticism (figure 6). Black nudity, appropriated as a perceptual terrain of sexual pleasure and excitement, became synonymous with the savage, the animalistic. Unlike their white German counterparts, black bodies were deployed to enhance product authenticity: by emphasis on the symbolic linkages of blackness

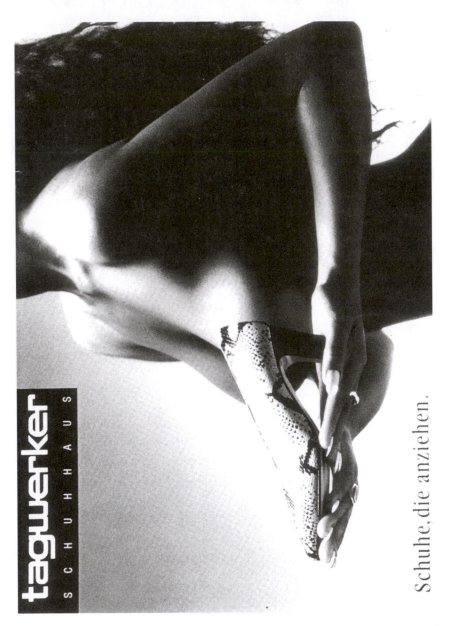

tagwerker SCHUHHAUS

Schuhe, die anziehen.

Figure 6. *"Shoes that Attract—Shoes that Attire": The Erotics of Black-Skinned Nudity in Commercial Culture, Salzburg 1992*. Photograph copyright Jahrbuch der Werbung, ECON Verlag GmbH, Düsseldorf. This German advertisement for women's footwear, featuring a black-skinned nude with alligator shoe, promotes a sense of reptilian/exotic elegance: sleek skin and predatory sensuality. The black female body and the leather of the shoe are visually and symbolically connected. The alligator shoe explodes from the black woman's breast. The breast imagery may here indicate a cultural artifact—the shoe—emerging from woman/nature as primitivity: the maternal black breast. The black body is positioned in a visual field that conflates the agent of labor (female nude) and the commodity form (shoe) as agency.

with the exotic, primitive, bestial, and predatory. Supporting "racist notions that black people were more akin to animals than other humans" (Bell 1992: 67), German media used representations of black nudity to capture a sense of "premodern" physicality, exploiting the texture, color, and shape of dark skin (see figures 7 and 8). Black presence allowed white Germans to sexualize their world by projecting onto black bodies a narrative of sexualization dissociated from whiteness (Gilman 1986; Mosbach 1991).

Reconfiguring Whiteness: German Tourism

During the mid-1970s, the West German aestheticization of white nudity took on a further political dimension. Around this time, at the height of the energy crisis and a growing economic recession, the naked German body first appeared as an important motif in contexts of tourism: "nude hippie beaches" sprouted along the Sinai peninsula (Lavie 1990); "sex tourism" made its way into Turkey and Greece (Zinovieff 1991; Ganser 1984); nudist colonies were established in southern Italy, France, and Spain (Ganser 1979a, 1979b); and naked white bodies began to populate Mediterranean tourist resorts and north African beaches (Kreyssig 1978; Ganser 1977, 1980; Meyers 1984). Such a commoditization of the unclothed body (not unlike the use of erotic nudity in West German marketing and advertising) ameliorated the decline of consumer capitalism and reduced the threat of economic recession. By eroticizing travel and geographic mobility, the German fetishization of white nudity nurtured a modern Western quest for authenticity and pleasure (see figure 9).

The sudden emergence of a multibillion-dollar tourist industry, which explicitly promoted white nakeness was, however, also a political issue: Sex tourism and nudity were engaged in the (sometimes unwitting) construction of racial and national stereotypes. The exposure of white bodies/breasts on foreign beaches constituted a reaffirmation of Germanness as imagined at this point in time: Signifying prosperity and leisure, nude sunbathing abroad enabled

Das Komponieren ist uns
in Fleisch und Blut übergegangen.

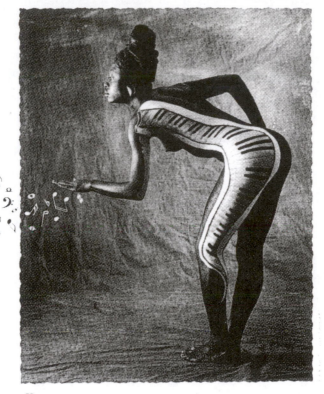

Dabei stehen wir mit beiden Beinen auf der Erde. Schließlich gilt es, eine Brücke zu schlagen zwischen Kunst und Kommerz. Und da ist uns im Laufe der Jahre das Kunststück gelungen, ein unerhört feines Gespür für das zu entwickeln, was nicht nur blendend aussieht im Tapeten regal, sondern auch noch reißend von der Rolle geht. Seitdem soll es Handelspartner geben, die unseren Dessins mit Haut und Haaren verfallen sind.

EIN GUTES GEFÜHL

Figure 7. *"The Composition of Music Has Entered into Our Flesh and Blood": Black Female Nude as Erotic Fixture in Department Store Advertising, Freiburg 1993.* Photograph copyright Jahrbuch der Werbung, ECON Verlag GmbH, Düsseldorf. With a piano keyboard painted onto her torso, and musical notes springing from her hands, this black female nude is portrayed as a fixture, a "play thing," for German entertainment. In this advertisement for a furniture store, the black body is depicted as a commodity form that must provide sexual and erotic labor.

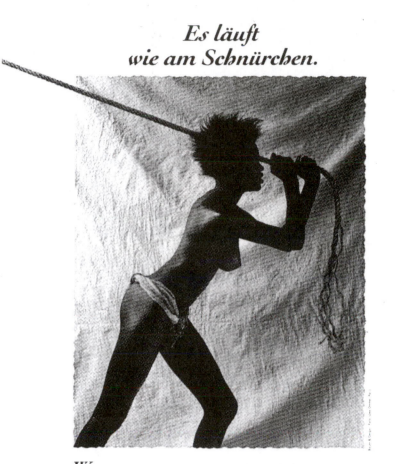

**Es läuft
wie am Schnürchen.**

*Was zum Teufel steckt hinter der magischen Zugkraft unserer Tapeten?
Ganz einfach: Alle ziehen an einem Strang, wenn wir die Dessins der neuen
Collection küren. Allen voran die freien Designer und das ausgefuchste Verkaufs-
team. Sie ziehen alle Register, um den neuesten Geschmack Ihrer Kunden heraus-
zukriegen. Dadurch haben sie ein unerhört feines Gespür für das entwickelt, was
nicht nur gut aussieht, sondern auch noch blendend läuft. Klingt einfach. Oder?.*

Erismann

EIN GUTES GEFÜHL

Figure 8. *"Everything Runs Smoothly": Black Female Nude as Toiling Native in a Department Store
Advertisement, Freiburg 1993*. Photograph copyright Jahrbuch der Werbung, ECON Verlag GmbH,
Düsseldorf. In this German advertisement about interior decoration, the black female body is shown
in the performance of her primary function: laboring in German homes, toiling over the installation
of tapestry and wallpaper. Naked, and covered only by a narrow loin cloth, black womanhood is
staged as a premodern exemplar. Black nudity, in contrast to white nakedness, is imagined as carnal
and erotic. Whereas black bodies are typically shown in motion (a trope for labor), whiteness is often
stationary (a trope for leisure).

Figure 9. *Nudist Beaches on the Sinai Peninsula: The Coastal Israeli Military Patrol at its Daily Perusal of Naked Northern European Women, Nuweb at Mzeina 1977.* Photograph copyright Shalom Bar-Tal. Body exposure is a West German status symbol. Tanned skin has become a "commodity fetish" (Adorno 1969: 61), a signifier of affluence and wealth. "Pale skin is devalued because it is associated with factory or office work" (Spiegel 1985: 144). A deep tan, by contrast, is taken as a sign of privilege, physical fitness, and sexual attractiveness: White skin turned "bronze brown" . . . is associated with travel into the world, with exotic sun-drenched countries or Alpine landscapes. Those who can afford to engage in leisure activities—skiing, surfing, sailing, or playing tennis—pronounce their athletic abilities through the 'tanned-skin signifier'" (142, 144).

West Germans "to erase their pasts, both in memory and physically, and to allay their fears of disorder and dirt" (Borneman 1992: 235). Driven by the demands of commodity capitalism, such exhibits of white nakedness in foreign countries became a terrain for the mediation of national identity: by "showing someone who knows the world well through traveling, and has the money to see it" (235). In part a display of self, the nude white body was configured as a site of representation: an assertion of Germanness and citizenship.

Across the border, on Mediterranean beaches (where northern European tourists encountered a predominantly dark-skinned public), the naked German body signified purity, whiteness, and untouchability. As a sign of wealth and national identity, symbolizing the political privileges of a powerful West German state, white public nudity tended to reify a sense of self. This experience of self, however, could no longer be authenticated through mere exposure of the naked body. Although national selfhood was firmly inscribed in the "white" signifier, the unclothed body was generally read as evidence of sexual availability. Nude sunbathing abroad, that is, the "showing of flesh" on foreign beaches, despite efforts to the contrary, often acquired an overt erotic dimension. Nakedness and body exposure became a distinctly, and often disturbing, sexualized icon (Lavie 1990: 229–37; Schmalz 1987; Spiegel 1982a). Given these readings, should we interpret white nudity as an attempt to eroticize the German nation through the (presumably innocent or unintentioned) incitement of sexual desire among members of a dark-skinned public? Was the public display of white skin in foreign countries a disclosure of Germany's Aryan aesthetic?

For West German tourists, the contradiction between their pretense of desexualized nudity, that is, the nonerotic show of nakedness, and the apparent object-focus of the foreign gaze was an important problematic. One summer, in the late 1970s (as recounted by my sister), a young German woman was arrested for nude bathing in Corsica, an incident that brought to an end her summer holiday which she had shared with her husband and three young children. The case ended with expulsion: After paying a fine, the

family was deported from the Corsican island. In 1989 (according to German media reports), a mother and daughter, both residents of West Berlin, took a camping trip to the Turkish interior. Their nudist practices ended in a drama of rape and murder: The women were arrested in Istanbul on charges of unlawful exposure and manslaughter, having killed their attacker. In these transborder encounters, the white body is clearly a sign of political importance. Regarded as "natural" and "normal" by West German tourists, such attempts to display and exhibit nakedness are countered by local efforts to either cease and take hold of the white body or to control and mute white sexuality (see Ganser 1979c; Spiegel 1982b, 1984b; Schauer 1982).

Outside Germany, the tanned (Caucasian) body thus undergoes a process of denaturalization. White nudity, viewed as sexual/erotic, becomes subject to punishment and repression: imprisonment, expulsion, ridicule, rape. All such encounters serve to reaffirm German racial attitudes toward the black and dark-skinned Other: a premodern predator, a primitive, who lacks control over his sexuality. Given these scenarios of race and sex, we might ask what happens to whiteness or nudity when Germans are in the exclusive proximity of other white bodies? What mechanisms surface to signify national identity and which practices naturalize the body when the Aryan aesthetic cannot be exploited by opposition to or against the canvas of dark-skinned/black bodies?

The Armored Body

In northern European tourist resorts, Germans congregate on beaches along the North Sea and the Baltic shore. Here we encounter attempts to naturalize the unclothed body through a reconfiguration of the barren landscape: the building of sand castles (*Burgen bauen*). Sometimes for mere pleasure but more often to protect the unclothed body from contact and intimacy with others, tourists attempt to reshape the beach where natural dunes are lacking. Vacationers from Germany come to the shore with big shovels,

immediately beginning their work on the construction of towering sand sculptures (see figure 10).[21] The castles, typically requiring several days of labor, are shaped around a large sand pit in the center. The sides of the structure are steeply elevated by the construction of a thick wall or dam. Sometimes, depending on the builder's preference, a shallow moat is added to the castle's outer perimeter, thereby minimizing erosion from the incoming tide. The making of these sandcastles is customary only along the northern and eastern seashore, and is practiced exclusively by German tourists (Kimpel and Werckmeister 1995). If asked to justify their labors, beachgoers would emphasize the castle's functional value: it screens the inhabitants against the harsh northern wind; it physically demarcates a beach site as private space; and it accommodates the storage of personal belongings. The castle walls thus offer protection of several sorts. As an armored enclosure and an extension of self, this semi-natural construct shelters the exposed body: against the impact of the weather as well as the physical proximity and probing gaze of other German tourists. In short, sandcastles are defensive constructs that shield the vulnerable (unclothed) body from infringements on privacy.

An early commentary on castle building appears in the childhood memoirs of the German novelist Hans Fallada (a pseudonym). In *Damals bei Uns Daheim*, the author recalls a family expedition to the Baltic seashore when he was about ten years old, one summer during the first decade of the twentieth century:

> So bathing [in the open sea] always seemed more a compulsion than an act of pleasure, and we [children] were always glad when we could slip back into our clothes and make for the home-castle, always with bated breath to see whether in the meantime an unauthorized invader had not taken possession of it. Despite the relatively small number of tourists in Graal in those days, fierce rivalries for the nicest sand-castle were already in full bloom; and we did not want to exert ourselves for days, building a dike and a mote large enough to resist even the strongest tide, if it was all to be in vain!
>
> [I remember] The joy, when we arrived at our own castle and everything was still in ship shape; and the outrage, when someone had stolen the wooden board across the mote or even the beam that we used for mother's

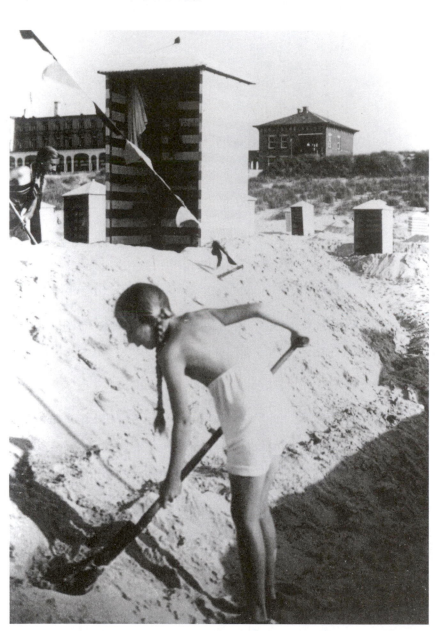

Figure 10. *"Building a Sandcastle": German Tourists at a North Sea Resort, Juist (Germany) 1936.* In this photo, the author's mother and aunt are shown laboring over the construction of a sandcastle's five-foot wall. Often built with enormous towers, a thick wall, and a protective mote, these sand sculptures offer defense and fortification. As material constructs, they promote distance. By providing protection, sandcastles safeguard the intimacy of bodies. The construction of these castles transforms public space into a symbolic bulwark from which personal property, notions of appropriate behavior, and value systems can be publicized and defended (Kimpel and Werckmeister 1995: 19). In the 1970s, Baltic tourist resorts restricted the size of such constructs in an effort to curb the expansionist land-claims by beachgoers (Hartmann 1972: 42; Enzensberger 1976: 4).

seat! Reconnaissance expeditions were organized, and spies were sent out, and if the whereabouts of the loot could be ascertained, then, to regain possession (depending on the character and strength of the new owners), we decided to resort to simple pleas or open violence or cunning. (Fallada 1955:163)

This description abounds with images of transgression, invasion, occupation, and annexation. As indicated here, castle building is deeply embedded in the historical semantics of war: Reminiscent of violent conquest and military strategy, the making of sandcastles resembles the digging of trenches in warfare (figure 11). These associations still hold true in postwar Germany. Nations with access to the North Sea, like the Dutch in Holland, interpret the German construction of sandcastles not as a harmless pastime, but as symbolic reminders of the Nazi invasion (Kimpel and Werckmeister 1995: 48–49). I remember, when I was a child, spending my summer vacations in the Netherlands, how all German castles were systematically destroyed every night, trampled into the ground on North Sea beaches, where the black ruins of old bunkers loomed large, towering above the sea, as permanent memorials to World War II, and Hitler's Germany.

Why are German vacationers burrowing below the surface of the beach? Can we detect in this practice an effort to protect the exposed body from an external threat? The sandcastles' imposing exterior lends fixity to a system of representation: By sheltering the nude (or topless) practitioner in a stationary/fortified space, the castle anchors the transient (volatile) body to a particular site in the natural landscape. Housed in a protective enclosure, the soft body is given an exterior shell: White nudity acquires solidity. As an armored extension of the German self, the building of sandcastles seeks to restructure a public terrain. In a symbolic sense, the castle is a material demarcation of identity (see figure 12): a way of space-claiming, of gaining "living space" (*Lebensraum*).

Sandcastles, as geophysical constructs, are made to protect the unclothed German body. On the beach, unable to blend into a landscape that lacks natural props (i.e., trees, shrubs, grass, dunes),

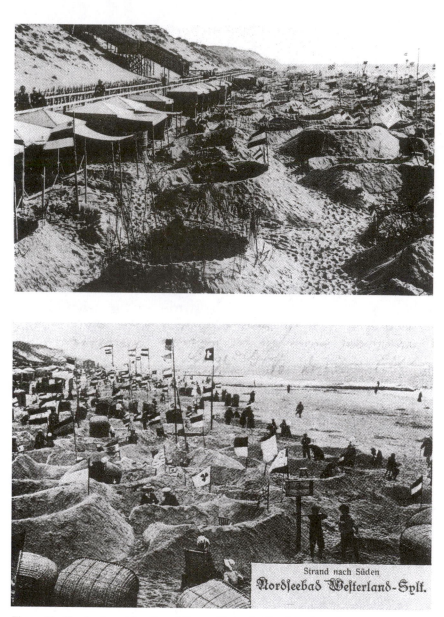

Strand nach Süden

Nordseebad Westerland-Sylt.

Figure 11. *"Sandcastles as Metaphors of German Nation-Building," North Sea Resort Westerland (Sylt, Germany) ca. 1885.* Sylter Archiv, Westerland. These nineteenth-century photos of a northern German beach site reveal how a natural terrain was transformed into a political landscape. The beach resembles a war zone, in which sandcastles take the form of fortified trenches—replete with national flags, military pennants, and stockades. The earliest accounts of such beach sculptures date from the beginnings of the German Reich in 1871, when "the sandcastle emerged as a metaphor for the aggressive disposition of an integrated nation state; the flourishing sandcastle culture reflected the mentality of the new imperial Germany" (Kimpel and Werckmeister 1995: 62).

Figure 12. *"Privatizing Public Space": Mapping Identities and Landscaping Territories, Juist (Germany) 1936.* The author's aunt and mother are shown after the completion of their sandcastle, having decorated its walls with shells. The name of their hometown, and its official emblem, are the center-pieces of the display. Even after 1945, sandcastles continued to be a medium for self-representation: shells, rocks, and drift wood were used to create simple ornamental patterns or more abstract iconographic signs (Kimpel and Werckmeister 1995: 19–26). By proclaiming identities through emblematic signs, sandcastles facilitate a symbolic mapping of space. Many vacation resorts have accommodated this strive for status recognition: beachgoers can enter their sand sculptures into local competitions and win a small prize (ibid., 27–36). Through such practices, public spaces are appropriated and transposed into domains with political meaning.

German tourists try to conceal their volatile bodies within the castle's interior. Through the tactics of space claiming and privatizing terrain, castle builders seek to reproduce the ways of naturalizing white nudity that prevail in the German metropolis: On the shore, as in the urban public parks, the unclothed white body can evade eroticization by being integrated into a sculpted or crafted environment. Along the northern coast, this aim is accomplished by the construction of sandcastles. Since the normalization of nudity relies on invisibility (as does the white signifier), the unclothed body must be protected from the possibility of being seen by other German tourists. Hidden within the confines of the castle, the naked German body remains nonerotic: a natural object.

White on White: Internal Colonization

Different mechanisms of concealment continue to operate along the Baltic shore, on beaches located within the former East German territories. Here, after reunification, the politics of white nudity were governed by West German attempts to "(re)establish borders" (*Grenzen ziehen*), and to physically separate naked (Eastern) bodies from clothed (Western) bodies in order to authenticate competing political identities (Neuffer 1994: 2): East and West German tourists have marked their respective nationalities by different nudist body practices.

Cut to the northeastern corner of Germany, the Baltic coast, where the small town of Goehren lies on a two-mile stretch of unspoiled white-sand beach. Whispering pines line the shore; small, child-friendly breakers toss shells onto the sand. For 44 years, these pleasures were all but forbidden to those from the Federal Republic—the West. Once Germany unified, curious *Wessies* flooded to these shores to partake of the natural beauty that had been beyond reach for all those Cold War years. But one look at the beach and its dune to dune nakedness and they soon huffed off to the office of the mayor, Carola Koos. "They came to find me, saying they would never come back unless things were changed," Koos says. "They wrote letters, and articles, which they submitted to the newspaper." What was bothering her new compatriots from the West, Koos discovered, was the absence of some sort of fence between the happy nudes and the clothed beach-goers. The arriving Westerners "wanted a strong

borderline", she says. "Even in the water. What they would really love is a curtain." (Walsh 1995: E10)

Goehren, like many other prime beaches on the Baltic coast, has concluded an uneasy truce between East and West by drawing literal lines in the sand. Mayor Koos, herself an avowed Eastern nudist—"a normal woman," as she put it—decreed the closest stretch of beach "swimsuit territory," and the farthest part a "nudist beach," with the remaining 1,000 yards in the middle designated a "mixed" enclave. Yet this system works imperfectly: "The boundary signs saying "F.K.K."—the German initials for free-body culture—keep getting stolen, so those who want to take a walk on the wild side can't be sure where the official wild side is. Those who accidentally stray into swimsuit territory run the risk of being filmed as they bound into the surf by clothed Western men wielding video cameras" (Walsh 1995: 10). As suggested here, the politics of seeing are clearly implicated in the eroticization of nudity. Viewing the naked body through male spectatorship radically transposes the public "structure of feeling" (Harvey 1992), revealing a pornographic erotic: Western Germans "are very nosy," complains Rose-Marie Hinze, sixty-five and celebrating her wedding anniversary on the beach in only a floppy sun hat and a little coral-colored toenail polish. "They walk up and down the boardwalk so that they can peak at the nudists" (Walsh 1995: 10).

The visual consumption of nakedness turns the unclothed body into a sexual object, a perceptual (sensual) commodity. Thus the insistence on the spatial segregation—the territorial separation—of bodies (clothed/unclothed) by West German tourists leads to unexpected consequences. Rather than to hide or conceal nakedness from public view, as is implied by the West Germans' request for a "borderline," a "fence," or a "curtain" for the nudists, the partitioning of the beach in reality promotes the hypervisibility of nakedness. Indeed, the West German injunction against integrated nudist beaches seems to create new possibilities for political domination: By contesting East German sovereignty, even jurisdiction, West

German tourists enhance their ability to define and monitor the boundaries between themselves and others, and to control the movement of bodies across those boundaries. Thus the spatialization and territorialization of German nudity on Baltic beaches perpetuates a colonial metaphoric: It permits/encourages the (Western) eroticization of the subjugated (Eastern) nude.

White Skin as Body Armor

Control over public sight thus emerges as an important dimension of political power. This same principle applies when Germans travel abroad to southern Europe or North Africa, where tourists encounter a predominately dark-skinned public, and where white nudity eludes sexualization by attempts to repress or inhibit the black gaze. Although an important site for the contestation of German national identity, the naked body—when displayed in foreign settings—is reconfigured as a terrain of racial representation. On foreign beaches, along the Mediterranean shore, the material boundaries that shield white nudity from public view are displaced onto the body's surface: white skin. Lacking the enclosing armor of sandcastles and the protective camouflage of city parks, the naked German body is wrapped in whiteness: a racial signifier. White skin is thus invoked as a border, a boundary, which is symbolically charged. In this racial metaphorics of the white body, an iconographic representation of the German nation/state, we observe the gradual (re)assertion of the Aryan aesthetic.

The configuration of the German racial aesthetic is in turn linked to the control of foreign spectatorship. In other words, the normalization of white nudity abroad is driven by German tourist attempts to manage the black gaze. Although these politics of racial display can lead to the establishment of segregated nudist beaches, as in Greece or southern France, where such a spatialization of bodies has intensified the hypervisibility of white nakedness, an unforeseen condition that motivates German tourists to resolve their problematic differently. Aiming to naturalize the racial construct

"whiteness," which negates the possibility of white erotic nudity, German beach-goers deny the sexual dimensions of their pornographic exhibits by invoking a "pretense of invisibility." The commentary by bell hooks (about the workings of American racism) applies well to the German situation: "[white people] can 'safely' imagine that they are invisible to black people since the power they have historically asserted, and even now collectively assert over black people, accorded them the right to control the black gaze. As fantastic as it may seem, racist white people find it easy to imagine that black people cannot see them if within their desire they do not want to be seen by the dark Other" (hooks 1992: 168).

Such a pretense of invisibility requires the negation of black subjectivity: German tourists naturalize their nakedness by denying the equality of dark-skinned people. On the Mediterranean shore, and on North African beaches, West German vacationers practice nudity as though black spectators are absent. Thus, without apparent need to guard or hide their naked bodies (physically or symbolically), they behave as though their nudity is imperceptible to dark-skinned onlookers. Thus nude sunbathing, a terrain for the formation of white public space, banishes black spectators to objecthood. Along foreign beaches (as in German advertising), the black icon is used as a vehicle, a commodity, for the positioning of German identity. Racial apartheid thus continues in contexts of white nudism, where West German tourists negate black subjectivity.

Essentializing White Skin:
Nudity in West German Environmental Politics

In West Germany, these formations of white public space were further complicated by the sudden emergence of nudity in radical political discourse. By the middle of the 1980s, the public display of naked bodies emerged as an instrument of contestation in the West German environmental movement. The public exposition of white nakedness became a strategic form of countercultural and anticapitalist protest (see figures 13–16). The naked body, during such

Figure 13. *"Writing Political Opposition": Nude Male Activist's Dramaturgical Battle against Police Brutality, State Violence, and (Neo)Nazi Incursions, West Berlin 1988.* Photograph copyright Paul Glaser. An unclothed German activist uses a house wall as a political bulletin board. Nudism, as a body practice, is staged as an alternative form of political expression. The practitioner hides his face to protect his identity from police surveillance. In his critique of the German state, nudity is transformed into a signifier of authentic nationhood—a white national interior—that stands in opposition to the monopoly of violence.

Figure 14. *"Self-Empowerment through Nudity": Leftist Activists Protest Western Imperialism by Exposing White Masculinity, West Berlin 1988.* Photograph copyright by Ann-Christine Jansson. Leftist criticism of the capitalist world order triggered a series of violent protests in West Berlin. For several weeks, students and political activists took to the streets to voice their opposition to Western (specifically American) imperialism. In this context, male nudity was displayed as a form of ridicule, a message of debasement and negation: The unclothed body stood as an oppositional sign, posted against market-driven forms of inequality and violence.

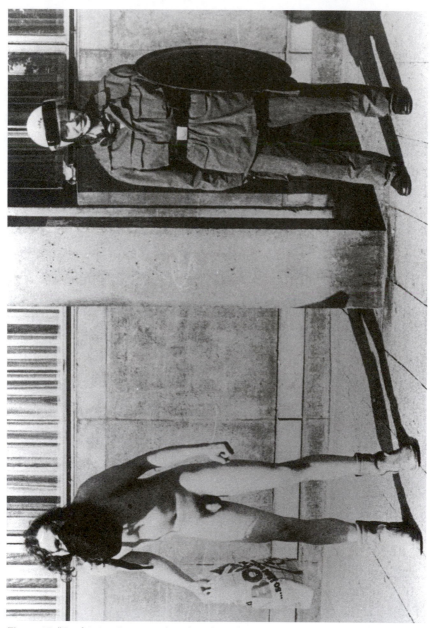

Figure 15. "*Proclaiming Opposition through Male Nudity*": *Using Their Bodies as Performative Icons, Leftist Activists Rally against City Government (TUWAT Demo–Rathaus Kreuzberg), West Berlin 1981.* Photograph copyright Voller-Ernst Agentur, Berlin. White nudity authenticates a national German subjectivity that stands opposed to the protective armor of state police. Criticizing a variety of urban policies, ranging from housing shortages to the cost of public transportation, Leftist students protest unacceptable conditions through innovative measures: public nudity. Police in riot gear stand opposed to the naked male, who uses his unprotected body as a political symbol: an authentic (unmediated) self, at best an innocent victim.

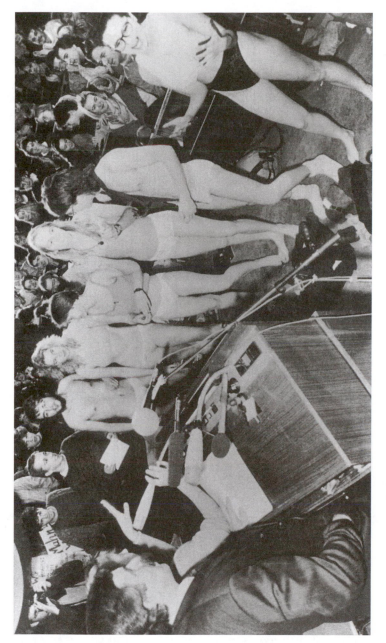

Figure 16. *"Stripped to Our Undergarments": University Students Protest Shortfall in State Funding for Education, Bonn 1988.* Photograph copyright JOKER: Foto-Journalismus-Archiv, Bonn. Inadequate funding of West German universities incited this student protest: standing, stripped to their undergarments, the nearly naked young men and women attempt to convey their plight for education visually. Arguing with a political representative, the demonstrators use nudity strategically to gain publicity and media coverage.

moments of popular rebellion, was configured as a shared cultural symbol, an authenticating sign, a truth claim, which was pitted against the facade of the state. Green protesters adopted public nudity as a presocial truth form: a site for the representation of an authentic national interior. Like their East German counterparts, West German activists relied on the imagery of the naked body as an oppositional symbol: Displayed not as a concrete expression of the state (as during Nazism), nakedness was exhibited in opposition to the political establishment. Antiestablishment activists deployed their nakedness to contest existing realities, using their unclothed bodies to dereify unacceptable relations of power.

Leftist environmental activists,[22] like other German practitioners of nudism, attempted to conceal the sexual dimensions of the unclothed body. Participation in political events that sported bare skin (like nude sunbathing or swimming) was characteristically limited to white nakedness. During such political performances, black nudity was conspicuously absent. Although immigrants, refugees, and blacks did participate in other forms of protest, marching alongside their German acquaintances, they avoided encounters of this sort, not wanting to have to publicly expose their bodies to the white gaze. Dark-skinned nakedness, limited to commercial advertising or sexualized entertainment, was completely lacking from these political rallies of the 1980s. Given the historical linkage of blackness and sex (which I discussed earlier), it is perhaps not surprising that West German environmentalists, during their attempts at political agitation, relied exclusively on the metaphorics of white nakedness. As a trope of the natural (nonerotic) body, whiteness existed as a shared (but commonplace) cultural symbol: an authentic artifact of nationhood. During such political performances, white skin was not necessarily a salient racial category, operational in the political intentionality of leftist activists. Rather, the white signifier was subsumed as an unconscious subtext, a truth claim of universal significance.

Green political activists used public nudity to demonstrate their commitment to democracy, freedom, and equality. The bare/exposed

white body, a tangible icon of the physical world ("nature" and the "natural environment"), was equated with vulnerability and victimization: environmental issues like pollution, ozone depletion, and deforestation as well as concerns about economic deprivation and male domination were publicized through open displays of the unclothed human body (see figures 17 and 18). How is a public imagining of German nationhood affected when Green antiestablishment activists promote the political display of white skin? In West Germany, leftist political practice engenders a racial aesthetic that essentializes whiteness. Such a strategy (with its appeal to universal human values) unwittingly subverts recognition of racial inequality and difference. I contend that Green/environmental activists invest white bodies and white physicality with meanings that have significance for the larger German body politic.

The Symbolic Economy of Dark Skin

These political formations of white public space further rely on constructs of the unaesthetic. In contemporary Germany, refugee and immigrant bodies are depicted as wet, devouring, filthy, with insatiable appetites for unpermitted pleasures (see Linke 1995, 1997, in press). Media images of "invading" masses are transformed into a public discourse about dark-skinned others, a racial threat. In media images, bodies of color are always shown in transience: placed in an empty room, an airport hall, a train station; immigrants are shown sleeping, sitting, waiting—idling between spaces. Rarely are ethnic others portrayed as performing socially useful tasks. In these racially charged photographs, white German bodies simply disappear, thereby removing the possibility of a conflictual relationship to emerge visually. Refugee bodies are seemingly driven and held in place only by their longings. The fluid depictions of their desires and needs are countered with assertions of German manhood and state authority: strength, hardness, order. Subaltern bodies are placed against solid (inanimate) structures: Brown human flesh is pressed against modern installations. It appears as if

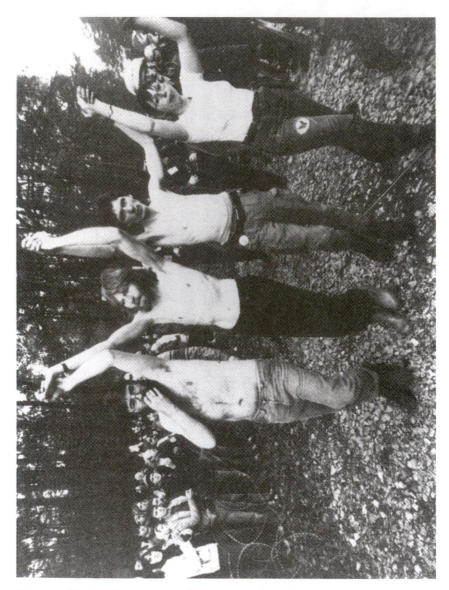

Figure 17. *"For Every Tree a Human Body": Environmental Activists Oppose the Destruction of Urban Woodlands by Planned Airport Expansion (Project "Startbahn West"), Frankfurt 1981.* Photograph copyright Michael Gööck. German activists use their exposed bodies as shields against police in an effort to prevent the uprooting of trees. The iconography of nature is juxtaposed to the destructive effects of modern urban life: the expansion of the Frankfurt airport. By protecting the endangered trees with their bare bodies, the demonstrators not only want to delay construction efforts, but also heighten the public's awareness of the forest as a living organism. Although body exposure is the salient signifier, whiteness appears as a hidden subtext insofar as the protesters invoke national cultural symbols: German bodies and German trees are seen as threatened by global capital expansion.

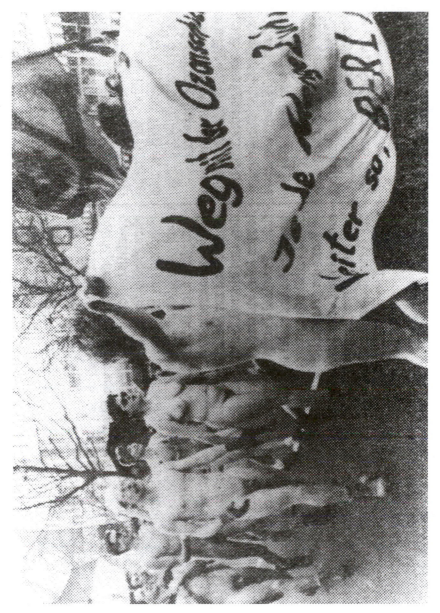

Figure 18. *"Marching against Air Pollution": Green Environmentalists Protest Global Ozone Depletion by Displaying Nude Bodies, West Berlin 1989.* Photograph copyright AP/Wide World Photos, New York. White nakedness is shown as an organizing icon in the Left's political struggle against the state's indifference to pollution. The message of collective nudity is one of vulnerability and victimization. Several hundred men and women assembled to participate in this rally, a show of unclothed solidarity. The naked (white) body is displayed as a universal signifier: Through genital and full body exposure, the threat of global pollution is linked to public concerns about national reproductive health. The banner's sarcastic commentary predicts the doom of German posterity: "Eliminate the ozone layer! The future promises abundance! Keep it up, Berlin."

these foreign bodies must be fenced in and contained: they are described as a flood, a deluge, a surge, which threatens to submerge the country's interior (Linke 1997). Framed by familiar points of reference (buildings, walls, transport technologies, men in military uniforms), these visual contrasts allow the German audience to confirm the sources of their privilege. In these images, race is always a subtext.

Although the peculiar characteristics of these racialized bodies were forged and culturally encoded by the gendered world of fascist politics (Mosse 1985; Theweleit 1987/89), images of the unaesthetic racial other have reappeared in postwar Germany, albeit displaced onto a different field of relevance. After the Second World War, during the era of economic reconstruction, German cultural politics continued to perpetuate racial prejudice, invariably keeping the "other" at a distance, "under control"—a recipe for psychological terror. Relations between Germans and racial "others" came to be socially organized and regulated, the object of laws (Schwerdtfeger 1980). Economically, foreign workers and immigrants were needed, even as politically the German state sought to eliminate them (Linke 1982, 1997). Feeding on images of otherness and difference, ultimately taking control of them, German capitalist culture nourished the symbolic constructions for its own ends. The postwar German state depended on racial otherness as an ideological and structural phenomenon, which it simultaneously sought to exploit and to destroy.

Beginning in the late 1960s, when white public nudity first appeared as a strategy of commodity resistance, German industry started to alleviate its temporary labor shortages by the recruitment of foreign workers. These "migrant laborers" (brought from southern Europe and its immediate periphery) were hired on short-term contracts. They were employed in the service sector or in production, there taking on the unskilled, manual, and often most dangerous jobs (Klee 1975; Linke 1982). Thus inserted into the capitalist economy, migrant workers were reduced to the function of commodities. After the onset of the energy crisis in 1973, and a deepen-

ing economic recession, when the sexualization of mass-media images was officially sanctioned, West Germany closed its borders to foreign workers, initiated elaborate (and costly) programs of repatriation, and tightened its laws concerning refugee and immigration rights (Borneman 1992:206–7). In the 1980s, when Green/environmental activists first embraced white nudity as a strategy of political protest (see figure 19), German officials began to criminalize refugees, interpreting the increased influx of asylum seekers as a direct result of attempts by foreigners to circumvent Germany's restrictive immigration policies. In commemoration of the terror and dislocations caused by the last world war, by fascism, and the concentration camps, the West German state had incorporated the "right of asylum" as an integral part of its judicial foundation. This foundation, the very basis of postwar state authority, was deemed threatened in the early 1980s, when German officials noted the sudden increase in refugees from Africa and Asia, who sought asylum in Germany as victims of political persecution.

In discussing this influx of foreign peoples, German politicians began to conjure images of an invasive "flood" of bodies, a "rising tide" that threatened to inundate the country. Germany's political men envisioned the threat of alien bodies as a liquid mass —inundating, flooding, surging (Linke 1997). Their terror and revulsion of this liquid "other" continued to find tangible expression in the compulsive use of metaphors that described political events as natural processes. Once again, the nation's defense began to be "located in a white body whose periphery had been de-eroticized, its interior incarcerated and objectified as flowing with filth and dangerous water" (cf. Theweleit 1989: 278).

Since the 1980s, when the aestheticization of whiteness and the de-aestheticization of blackness was most closely coordinated in public space, racial violence defined a new corporal topography (Linke 1995). Linked to the murderous elimination of subaltern bodies, the naturalization of whiteness emerged as an indispensable element in the "purging" and "cleansing" of the physical interior of the German state.

Figure 19. *"Embracing White Nudity": Photo of Green Party Activists as Featured in Election Campaign Pamphlet, West Berlin 1985.* Courtesy Bündnis 90/Die Grünen. In 1985, the Green/Alternative party introduced a new political platform. West Berlin was to be celebrated as a cultural center, with its artist colonies, museums, and diversity of lifestyles. Members of the party's cultural forum (Kulturbereich) assembled for a photo session, which was featured in the campaign pamphlet. Embracing a neo-classical statue, the forum (according to the figure caption) "justifies its existence (visually)." Although the pamphlet emphasizes the group's anti-fascist activities, giving recognition to the "authentic expressions of minority groups," like the folkloric practices of Turkish immigrants, three additional photos of nude Greek athletes appear in this slim publication for illustration purposes.

Dreaming of Whiteness

Given the correspondences in the corporeal articulation of whiteness across different public spaces, my research points to the interconnections, the apparent synchronization, between different political spheres. In contemporary Germany, a plurality of organizational forms, including Green/environmental activists, promote whiteness as a common arena for the formation and enactment of contradictory social identities. But linked to a terrain of politics that is dedicated to countercultural and antiracist positions, the phenomenon of "naturalizing" white skin among antiestablishment activists requires explanation.

Where does the German desire for exhibiting white nudity originate? How do we explain the discursive silence surrounding the public exposure of white-skinned bodies? The answer, I think, can be uncovered by exploring the symbolic linkages between German public memory, identity, and political practice (Forsythe 1989). If in Germany, as Stuart Hall (1992) proposes, "racism expresses itself through displacement, through denial, through . . . the surface imagery of an unspeakable content, the repressed content of a culture" (15), then we must begin to interrogate these distortions, these representations, and "absences," even if we must probe the social imagination of countercultural activists.

Writing during the early twentieth century, when the aestheticization of whiteness and the "cult of the white body" took form in protofascist displays of nakedness, Sigmund Freud attempted to uncover the symbolic meaning of this motif in fantasy: that is, in folk narratives and dreams.[23] Although neglecting to comment on nudity as a political practice, Freud carefully explored the phenomenon of exhibiting bare skin in the German cultural imagination: through the logic of the unconscious, the dreaming of whiteness.

Dreams of being naked or insufficiently dressed in the presence of strangers . . . dreams of being naked in which one *does* feel shame and embarrassment and tries to escape or hide [belong to a repertoire of typical dreams] . . . Its essence (in its typical form) lies in a distressing feeling

in the nature of shame and in the fact that one wishes to hide one's nakedness, as a rule by locomotion, but finds one is unable to do so. . . . The people in whose presence one feels ashamed are almost always strangers, with their features left indeterminate. In the typical dream it never happens that the [absence of] clothing which causes one so much embarrassment is objected to or so much as noticed by the onlookers. On the contrary, they adopt indifferent or (as I observed in one particularly clear dream) solemn and stiff expressions of face. (Freud 1972:275–76)

In an attempt to interpret and make sense of these "embarrassing dreams of being naked," Sigmund Freud remarked that such unconscious projections were a function of memory as well as repression: Dreaming of nudity expressed a longing for childhood's innocence and, at the same time, articulated an awareness of being unable to repossess or restore this state of innocence. The dream-work, shrouded in the symbolism of nudity, was therefore a fantastic scheme of self-deception: "The moralizing purpose of the dream reveals an obscure knowledge of the fact that the latent dream-content is concerned with forbidden wishes that have fallen victim to repression . . . they are based upon memories from earliest childhood" (277). Furthermore, the dream is typically populated by "a lot of strangers," who seem to take no notice of the spectacle that is offered. The spectators' lack of response to the display of nakedness, their very indifference to public nudity, signifies the yearning for a regressive retreat into childhood. In other words, the dreamer's desire to exhibit the naked body without retribution, without attracting the slightest notice or attention, derives from his or her earliest memories of childhood, when a sense of shame was lacking: "It is only in our childhood that we are seen in inadequate clothing both by members of our family and by strangers—nurses, maid-servants, visitors—and it is only then that we feel no shame at our nakedness . . .Children frequently manifest a desire to exhibit" (277).

In dreams of nudity, Freud argued, such childlike displays of innocence are recast in fantasies of the unclothed body as "unremarkable," "transparent," "commonplace": The public disclosure of bare skin is thereby effectively normalized. With this normalization of nakedness follows an unquestionable acceptance of the white sig-

nifier. Once removed or displaced from the foreground of the imaginary spectacle, whiteness recedes from the field of awareness: It is supplanted by a dramatic exposure of the naked body. Since white skin, in these dreams by Freud's patients, is made visible whenever the body is displayed without clothes, whiteness (the Aryan aesthetic) is rendered as unremarkable and as innocent as the dreamer's nakedness.

Freud implicitly imagined a white nudity when he discussed these dreams of nakedness. The dreamer's naked body was coded white in Freud's thinking: It was, after all, the "civilized" adult who dreamt the presocial and therefore nude child. In his early work, Freud repeatedly aligned whiteness and white skin with civilization, evolving his script of history in accord with his culture's racialist assumptions (Torgovnick 1990: 196).[24] In Freud's writings, the symbolism of "the civilized," that is, the rational, white male, adult citizen, stands in opposition to "the primitive," a term that designates an imaginary union of mythological creatures, animals, and dark-skinned natives. Freud's notions fit the traditional Western paradigm by defining the relation of primitive to civilized as antithetical. Although all nations emerged from primal origins, "the primitive" was something to be left behind, residual (like the "id" within the mature "ego"), which had to be controlled.

Such thoughts found expression, for example, in an essay written during World War I called "Thoughts for the Times on Life and Death" (1915). In this essay, Freud perceived that "the great ruling powers among the white nations upon whom the leadership of the human species had fallen" persecute nonwhite societies in order to civilize them (pp. 206–7). He also perceived that "white nations" required of their citizens "renunciation of instinctual satisfactions" (p. 215). He wrote in 1915, however, with confidence that "the great ruling powers among the white nations" should wield power over others and with the hope that Germany (despised as "barbaric" by its enemies in World War I) would be rehabilitated by virtue of its previous "magnificent co-operation in the work of civilization" (p. 211). (Torgovnick 1990:197)

Up until the 1930s, before Nazism, Freud felt certain that "Europeans like the Germans and Austrians were civilized and that

primitive life belonged to the past" (Torgovnick 1990: 200). The renunciation of instinctual satisfaction was crucial in this establishment of relations of mastery: sexual or aggressive urges, and free sexuality, were configured as primitive freedoms that had to be excised and suppressed by a civilized person. Whiteness, in Freud's work, signified a specific type of racial aesthetic, devoid of the erotic. Dream images of white naked bodies were not a fantasized return to savagery, but representational memories of childhood's innocence. Black nudity, in contrast, was equated by Freud with objects of fear: untamed nature, the female psyche (i.e., "a dark continent"), the hyper-sexual and primitive.

Thus the motif of the *white naked body* is a trope of sexual innocence, cleansed of allusions to lust and desire. In the corresponding dream-images, public displays of nudity are rendered nonerotic, purged of their sexual meaning. According to Freud's analysis, the "infantile desire to exhibit" is reconfigured through idealized images of nature: "paradise." "When we look back at this unashamed period of childhood it seems to us a Paradise; and Paradise itself is no more than a group phantasy of the childhood of the individual. That is why mankind were naked in Paradise and were without shame in one another's presence till a moment arrived when shame and anxiety awoke, expulsion followed and sexual life and the tasks of cultural activity began. We regain this Paradise every night in our dreams" (Freud 1977: 278). Through a process of metaphorization, childhood is equated with a mythic realm, the Garden of Eden, in which nudity signifies purity, innocence, and freedom from original sin.

In the typical dream, the naturalized displays of nudity are however coupled with feelings of embarrassment; the dreamer experiences an intense sense of discomfort, of being found out or discovered: Although sanitized and purged from all sexual references, representations of public nudity retain connotations of the illicit. Thus "repression plays a part in dreams of exhibiting; for the distress felt in such dreams is a reaction on part of the [censure] system against the content of the scene of exhibiting having found

expression in spite of the ban upon it" (279). This tensive experience propels the fantasy of innocence to take shape in dream images of childlike displays of nakedness.

Sigmund Freud did not comment on the political significance of nudity in a colonial regime of representation nor did he remark on the symbolic relevance of white nakedness for a nationalist metaphorics. However, it cannot be utter coincidence that Freud began to notice and write about *dreams of white nudity* at a time when public displays of nakedness marked the rise of the Aryan aesthetic in Weimar Germany. Freud arrived at the general conclusion that "[d]reams of being naked are dreams of exhibiting" (278) and that an "unconscious purpose requires the exhibiting to proceed" (279). What are the reflexive insights of this interpretation for a semiotics of nudity in German culture? And how do we explain the emergence of a racial aesthetic that idealizes white nakedness in distinctly different historical contexts?

Nudity, Nationhood, and History

In the Western cultural imagination, the naked body appears as a metaphor of childhood: the presocial, authentic, and unmediated material of life. In German political fantasy, nudity is a trope that signifies the infancy of nationhood: the emergent German nation. This process of national emergence, the narrative of becoming or coming-into-being, is in German discourse configured through corporeal images and practices. White nudity (at the turn of the twentieth century as well as after World War II) signified the political integration of nature with nation. In German popular culture, the national landscape was imagined through visions of the natural body: White nudity, as a metaphor of infancy and childhood, became a developmental icon for the nation in the making. "The connection to the child is the pretense to universalistic norms located in the human body: it is natural, the necessary "origin" of the body—and by extension, humankind. It turns a certain kind of social time into the natural progress of individuals and nations" (Tanaka 1995: 3).

This connection between childhood and nationhood was brought to the surface at the turn of the century, in the 1920s, when the aestheticization of whiteness was celebrated by public displays of the nude body. For German nationalists, the revolt against modernity implied a retreat into historical childhood, that is, a regressive idealization of the past as a point of mythical origin: Through the adoration of Greek sculpture and iconography, a "civilized" state of nature could be recovered. Nudism became part of the search for a new Germany, freed of artificiality, and inner-directed, symbolized by nature and the physical beauty of whiteness.

The naked exposed body has often been taken as an emblem of a people entirely confident in themselves and at home in their political world (Sennett 1994: 27–67): Public nudity was interpreted not as a sign of vulnerability but an expression of inner strength. In probing what white nudity meant to Germans, my work sought to understand instead how this corporeal aesthetic became a source of disturbance in the relation of Germans with refugees and immigrants, in the shaping of political space, and in the practice of democracy and nation building. In the German case, the emergence of public nudity (during different historical epochs) always signified a troubled political process: the quest for a unified (integrated) nation.

In postwar Germany, beginning in the 1960s, the promotion of a white racial aesthetic validated the persistence of colonial enclaves in a metropolitan capitalist regime and, at the same time, negated the possibility of historical continuity by its emphasis on dissociation from fascism. The integration of white skin with nature moved the body out of history, denying the possibility of history as process. In West Germany, the aestheticization of nudity likewise transformed racialized bodies into natural entities, whereby the dehistoricization of whiteness was rendered uncontested. This denial of history, these attempts to suppress or control fields of memory through corporeal aesthetics seem to be a retreat, a regression, into the past (temporal childhood) to regain a lost sense of safety, innocence, and lack of shame. In the German postwar period, white

nudity thus gained an added dimension: It permitted Germans to exhibit race "innocently," without fear or guilt, and without having to publicly (or consciously) acknowledge their participation in a racial mythography, the Aryan aesthetic, which continues to colonize the German national imaginary even after Hitler.

BLOOD, RACE, NATION

•

> While mainstream Germans, like other Europeans, talk about immigration in terms of rivers and floods . . . far-right Germans speak of filth. One neo-Nazi leader in Chemnitz, talking about immigration in 1992, said: "In the Hitler era, Germany was something good, something clean, something big and powerful. Now we're covered with dirt." Another Chemnitz extremist said, "We're going to clean up this country. No foreigners, no filth, no drugs, no pornography, and work for everyone." These metaphors of pollution expose not only contempt for immigrants but also a fixation on a pure nation, which has few close parallels in Britain or in the United States. (Christenfeld 1996:4)

What became of the "symbolics of blood" after 1945, following Hitler's defeat and the collapse of the Third Reich? How were the themes of health, progeny, and race inscribed into German memory after the war? According to Michel Foucault (1978), the thematics of blood, specifically a sanguine aesthetics of race, had their origin in a premodern age, in which the genealogical principle (with its emphasis on birthright, descent, and kin) had maintained the ancient forms of rank and privilege. In the twentieth century, as Foucault observed, the blood myth was disinterred to serve the political interests of a modern state apparatus: "Nazism was doubtless the most cunning [in its deployment] of the [old] fantasies of blood [and] power. A eugenic ordering of society, . . . in the guise of an unrestricted state control, was accompanied by the oneiric exaltation of a superior blood; the latter implied both the systematic genocide of others and the risk of exposing oneself to a total sacrifice. It is an irony of history that [under Hitler] the blood myth was transformed into the greatest blood bath in recent memory"

(ibid, 149–50). But did the death of the Nazi state, and the end of its regime of terror, successfully eradicate these long-lived preoccupations with blood, body, and race? Was the traumatic shift in political systems able to dislodge the sanguine aesthetic from its firm hold on the German historical unconscious? While no longer endorsed as an official ideology after 1945, the blood mystique was often visibly inscribed on the historiographic surface of postwar Germany. Residing at the margins of awareness, fantasies of blood were rendered visible in fragments, each appearing by itself in a "scene," thereby providing the performative labor of social memory. For instance,

> In 1983, during an air show at an American military base in the Rhine Palatinate, West German peace protesters staged the occurrence of a nuclear Holocaust by simulating mass-death: dressed in black costumes to symbolize the victims' charred bodies and skeletal remains, the protesters arrayed themselves on the ground. When the military police finally intervened, the event turned into a form of dramatic poetry in which members of the German audience played out familiar roles, becoming participants in the physical brutalization of their political opponents. One spectator, a man with a small son, proclaimed that he wanted to "rip the heart" from one of the protester's bodies. Another shouted that the activists "should be run over with a tractor." A man to his left, who until then had been contentedly chewing on a hot dog, suddenly poured his cup of beer over a young woman lying on the ground, and began to shout "Blood! Blood! Blood!" while rhythmically stomping his foot up and down. A female spectator, while kicking and spitting at the protestors, screamed: "Beat them to death, beat them all to death!" As the peace protesters were loaded onto the waiting military trucks, another man proclaimed: "And now into the gas with them!"[1]

What are we to make of these violent encounters? And how do we explain the persistence of a political imaginary that is saturated with memory templates of bloodshed and genocide, which infiltrate everyday understandings of national belonging, body, and race? Seeing nationalism as a generalized condition of the modern political world, Liisa Malkki (1996) suggests "that the widely held commonsense assumptions linking people to place, and nation to territory, are not simply territorializing but deeply metaphysical" (437). This chapter is a schematic exploration of further aspects of

this metaphysics. I examine the ways in which specific national identities are dissociated from the fixities of place and geographic implacement that are normally associated with the modern nation state. The formation of German nationality is complicated by a corporeal imaginary: blood, bodies, genealogies. My intent is to show that the naturalizing of the links between people (i.e., the national community) and the state is routinely conceived in specifically organic metaphors. German images of "the national order of things" (Malkki 1995b) rest on metaphors of the human organism and the body. Among the potent metaphors for the national community is blood (Brubaker 1992; Borneman 1992b: 48–52). Nationality is imagined as "the flow of blood": a unity of substance (Williams 1995). Such metaphors are thought to "denote something to which one is naturally tied" (Anderson 1983:131). Thinking about the German nation thus takes the form of origins, ancestries, and racial lines, which are "naturalizing" images: a genealogical form of thought.

Much recent work in anthropology and related fields has focused on the process through which such collective representations are constructed and maintained by states and national elites.[2] Here I focus on powerful metaphoric practices in everyday life and examine how media discourse and political language are deployed to understand and act upon the aberrant boundary conditions of blood and nationhood in postwar Germany. I examine the location of violence in German political culture, and I inquire how subaltern bodies, as racial constructs and potential sites of domination, are imagined in public discourse. My aim is to shed light on postwar Germany, where the feminized body of the outsider (foreigner, refugee, other) has been reclaimed as a signifier of race and contagion; where violence defines a new corporal topography, linked to the murderous elimination of refugees and immigrants; where exterminatory discourses have once again begun to colonize the national imaginary; where ordinary citizens with divergent political beliefs participate in the reproduction of cultural violence;[3] and where notions of racial alterity and gendered difference are publicly

constructed through iconographic images of blood and liquidation.

I trace the (trans)formation of these conceptual models from the turn of the century through the postunification era, thus illuminating the persistence of German ideas about racial purity and contamination. I propose that modern forms of violence are engendered through regimes of representation (de Lauretis 1989) that are to some extent mimetic, a source of self-formation, both within the historical unconscious and the fabric of the social world (Feldman 1991). I begin by drawing attention to the racist biomedical visions of blood that emerged under fascism. The representational violence of such blood imagery, which entered the popular imagination through political propaganda, emerged as a prelude to racial liquidation. Genealogies of blood were medicalized, conceived as sources of contamination that needed to be expunged through violent bloodletting. Documenting cultural continuities after 1945, I explore the implications of a racialist politics of blood for the German nation-building process in the postwar period. I analyze more closely the linkages of blood to gendered forms of violence, focusing on the central role of masculinity and militarism for a German nationalist imaginary. Images of women, blood, and contagion became fused in the fascist visions of the corporality of German nationhood. I explore the metaphoric extensions of a "symbolics of blood" in postwar German culture, and I show how easily a misogynist militarism is reconfigured to (re)produce a violent body politic that legitimates the brutalization of immigrants and refugees. Throughout, I emphasize the interplay of race and gender against the background of medical models, documenting how fears of natural disasters (women, Jews, refugees) and medical pathologies like dirt and infection (i.e., bodily infestations) are continuously recycled to reinforce a racialist postmodern.

The Symbolics of Blood

The production of death and the erasure of Jewish bodies were central to the fascist politics of race. The aim of genocide was to

maintain the "health" of the German body politic by enforcing a strict regimen of "racial hygiene."[4] German political fantasy employed a model of race in which the images of difference were not visibly written on the skin, but had rather to be carefully constructed in order to identify the other (Gilman 1992: 178). The axiom for this construction of ideas of difference derived from a typology of blood. Race, disease, and infection were imagined through blood metaphors. Blood became a marker of pathological alterity, a signifier which linked race and difference (Linke 1995a; Herzfeld 1992: 17–70; Theweleit 1987). The attempt to expunge the racial subaltern (specifically Jewishness) was thus imagined as a multilayered discourse of "liquidation": the consumption by fire and the reduction to blood. Images of blood were invoked both through the genealogical ordering of society, in which blood functioned as a verbal signifier of descent and citizenship (Brubaker 1992), and through the violence inflicted upon subaltern bodies, thereby effecting the transfiguration of the linguistic construct "race" into its physical signs: blood, pain, and contagion. Imagining racial differences through the blood motif became a prologue to extermination, effectively feeding the political rationalizations of death. As early as 1916, these images of blood and liquidation were popularized through lyrics that were later adopted by Nazi political song:

> "Blood, blood, blood must flow/ Thick as a rain of blows/ To hell with the freedom of the Jewish republic" "In blood we must stand/ In blood we must walk/ Up to, up to our ankles" "We are ready for the racial struggle/ With our blood we consecrate the banner . . . / Keep from the Reich the foreign Jews/ Let Aryan blood not suffer destruction."[5]

In these songs, German fascists expressed both the mandate of National Socialism and the manner in which it was to be carried out. I suspect that these visions of blood (much the same as the visions of fire and burning bodies) existed as a core fantasy of fascist violence: a way of publicly imagining (and visually anticipating) the dissolution of bodily reality, the termination of identity and difference in a river of blood.

The German politics of blood and the discourse of liquidation were thus closely connected. Both sought to reduce the salient other into an undifferentiated mass. Such attempts at liquidation tended to follow a fixed sequence: death was indexed first by fire, next a flood, then blood. For instance, in German war prophecies from 1914, events of mass death were predicted through the symbolic chronology: a fire year, a flood year, a blood year (Bächtold-Stäubli 1917: 3). This same sequence of fire, flood, and blood reappeared in fascist writings in the 1930s (Theweleit 1987: 236–7). In each case, the flow of blood was tantamount to a logical consequence: Blood was equated with race; blood was expected to flow; the murdered were expected to bleed.

The construction of this idea of genocide, the very discourse of liquidation by blood, has analogues in the postwar German understanding of alterity, an understanding shaped by a deep-seated revulsion to racial difference and facilitated by a vocabulary of race that originated during the Nazi period. For instance, in fall 1991, the prime minister of the State of Schleswig-Holstein, Björn Engholm, a liberal Social Democrat, referred to persons seeking political asylum in Germany as a threatening "counterrace" (*Gegenrasse*) whose continued existence "had become a question of survival for Germany" (Ebermann and Trampert 1991: 10). Around the same time, the mayor of Vilshofen, a member of the conservative Christian Democratic party, announced his opposition to Germany's constitutional guarantee to protect political refugees: "Today we give the asylum-seekers bicycles, tomorrow our daughters" (ibid, 12). German politicians are surprisingly candid in their articulation of these ideas about the "dangerous other." A councilman from the city of Dormagen thus explained his position on German refugee politics in 1991: "Some people talk . . . about integration, others about amalgamation. I speak about the adulteration and filthy mishmashing of blood" (*Blutverpanschung und-vermanschung*) (ibid). In November 1988, Bavaria's minister of the interior, the conservative Christian Democrat Edmund Stoiber, claimed that Germans were becoming "hybridized and racially infested" (*durch-*

mischt und durchrasst) by the influx of foreigners and those "not of the blood" (*blutsfremd*) (Otto 1988:14; Jhering 1988: 79). In painting a picture of a "mongrelized society," Stoiber, who is now Bavaria's head of state (*Ministerpräsident*), thus not only naturalized but also sanctioned xenophobic tendencies as necessary for German ethnic well-being (Mattson 1995: 72–3). Popular notions of "genetic identity" are here subsumed by fears of racial im/purity. For Stoiber, the racial/blood purity of the German people is threatened by the mere presence of ethnically diverse groups. His assertions are deeply embedded in biological images of difference: blood and blood contamination. In German popular culture, according to Stuttgart's mayor Manfred Rommel (1989:4), such notions of blood origins, that is, concerns about "where the blood comes from" (*woher das Blut kommt*) are at work in the determination of racial otherness.

This vocabulary of blood as an index of difference and genealogical placement is used not only by political conservatives. Derived from a West German understanding of the past, the language of race appears in the public discourse of liberal politicians and, sometimes, even the more radical left.[6] In January 1989 in Berlin, at a working dinner with representatives from the major political parties,[7] Gabi Vonnekold, the evening's Green/Alternative spokeswoman, declared that Germany's politics of repatriation (which actively encouraged the return-migration of ethnic Germans from Eastern Europe and elsewhere) were legitimately based on ideas of "bloodright" (*Blutrecht*): Ethnic Germans, she asserted, were granted citizenship because of their "blood ties" (*Blutbande*) to the German nation.[8] Supporting similar statements made by the other politicians, Vonnekold argued that such verbal images had no racial connotations because they originated in the commonsense reality of kinship. She noted that it was this meaning of "blood relatedness" or "kinship by blood" (*Blutsverwandtschaft*) that had been adopted as law by the postwar West German state. Several weeks later, after a successful election campaign for the Berlin Senate, a militant faction of the Green/Alternative Party (i.e., *Gruppe Grüne Panther*)

distanced itself from Germany's policy of repatriation. The practice was denounced in a public forum, however, without making the concept of bloodright and *citizenship-through-blood* a critical issue.[9]

In the German political imagination, cultural differences tend to be constructed as differences of blood. For instance, a commentary by Herbert Gruhl, one of the conservative founders of the Green Party, is suggestive of the habitual infusion of ethnicity and nationality with biologistic overtones. In Gruhl's opinion, most refugees are biologically or organically incompatible with Germans. In an interview from 1990, in which he outlined his differences with the Greens, Gruhl thus stated:

> If one thinks ecologically, one must acknowledge that there are organic peoples, languages, and cultural communities. The Greens, on the one hand, consider all human beings in the world to be interchangeable, like numbers. That is unacceptable. It simply is not true that everyone is the same. If someone comes from India, South America or the GDR [East Germany], it is a big difference. . . . It is after all most natural that one accepts those with whom one already shares a common historical fate and with whom one even has direct blood ties. (Gruhl 1990:148)

Apparently exempt from critical inquiry in political debates, the judicial field of German nationality seems to have rendered "normal" a modern conception of race: The citizenship law of the Federal Republic determines national membership through the idiom of descent, as expressed by the Latin term *jus sanguinis*, "power/law of blood" (Senders 1996). Enacted in 1913—and still in effect today—the German citizenship law permits, and even encourages, the nations's social/racial closure: Individuals born within the territory of the German state cannot automatically acquire citizenship. German nationality is determined by an understanding of a community of descent, shaped by an "ethnocultural" or "ethnonational" perception of statehood (Brubaker 1992). Deeply embedded in Germany's imperial history, the blood-principle of citizenship is defined by racial premises, which were established at the turn of the century to deny colonial subjects inheritance and voting rights (Wildenthal 1994a/b). Once inserted

into the German legal system, the concept of the modern nation as a "reservoir of blood" was rendered unremarkable. But this iconography of nationhood, defined by a symbolics of blood, has retained its association with violence and racial contagion.

In the German imaginary, the invocation of blood, whether in the context of genealogy or racial liquidation, presupposes an act of violent transformation. This violence is aimed at producing a particular condition of the racial body: its dissolution, liquification, and reduction to blood. Such a transformation of the body (flesh to blood/solid to liquid) is probably intended as a form of cleansing. When in June 1992 the Dresden city councilman Günter Rühlemann announced that "he wanted to cause a bloodbath among foreigners," this plan seemed somehow to be connected to the expectation of a rebirth, the beginning of a new era without the threat of "blood contamination" (*Blutverschmutzung*).[10] Coordinating attitudes of violence with fears of pollution and dirt, the German discourse of death requires the transfiguration of racial others into blood, an act of ritual purging.

In Germany's racialist mythography, the external production of blood takes place within a particular field of meaning. On the one hand, blood loss through violence is perceived as cleansing: a release, a sacrificial libation, which purges the body of ritual impurities. But blood effusion takes on sexual connotations whenever this image of the bleeding body is symbolically connected to the periodic emission of women's menstrual flow (Linke 1992). This analogic affinity of menstruation and blood spillage confirms the metaphoric linkage between "sexuality and those diverse forms of violence that invariably lead to bloodshed" (Girard 1979: 35). Masculinist ideology can thus reconfigure the flow of blood as a social threat, an attack on manhood and the national body politic. On the other hand, blood spilled by violence is read as a stigma, a red stain of contagion; it contaminates, inundates, and subsumes everything with which it comes in contact. This discourse of blood is formative within a particular regime of representation:

> When violence is [unleashed], . . . blood appears everywhere—on the
> ground, underfoot, forming great pools. Its very fluidity gives form to the
> contagious nature of violence. Its presence proclaims murder and
> announces new upheavals to come. Blood stains everything it touches the
> color of violence and death. (Girard 1979:34)

The flow of blood visibly exposes or unmasks everything that is
undesirably different: women and women-associated others (i.e.,
Jews, revolutionaries, homosexuals, etc.). Blood metaphors thus
establish a "sanguine connection to sexuality, gender identity, and
the biologization of the Jew" (Geller 1992: 254). Moreover, violent
bloodshed creates an observable physical condition: liquidity, sexual
contagion, and carnal femininity. The bleeding body (in much the
same sense as menstruation) becomes a mark—a stigmata—of
femaleness: a (dangerous) liquid corporeality. The German dis-
course of *liquidation* (both in its genealogical and violent forms) is
thus integrated into a pattern of domination that transforms the
"racial other" into "woman."

Imagining Jewish Bodies

The feminization of the racial subaltern, particularly the Jewish
body, emerged as a construct of the European cultural and religious
imagination. Assumptions of Jewish male menstruation, for
instance, can be traced to medieval notions of difference that con-
tinued at least into the late eighteenth century (Gilman 1986,
1987). Likewise, the existence of the presumed link between blood,
ritual periodicity (or cyclicity), and Jewish sexuality has been chron-
icled through centuries of European history, from medieval
Christianity to twentieth-century Germany (Dundes 1991; Hsia
1988; Geller 1992). Fears of sexual degeneracy and bleeding male
bodies merged in the modern German mythographies of race.

> Here it is necessary to point out that the stereotyped depiction of sexual
> "degenerates" was transferred almost intact to the "inferior races," who
> inspired the same fears. These races, too, were said to display a lack of
> morality and a general absence of self-discipline. Blacks, and then Jews,

were endowed with excessive sexuality, with a so-called female sensuousness that transformed love into lust. They lacked all manliness. Jews as a group were said to exhibit female traits, just as homosexuals were generally considered effeminate. (Mosse 1985:36)

Furthermore, the development of modern scientific disciplines, with their allegedly objective epistemic discourses, provided these constructions of difference with a new form of legitimation. The emergent sciences offered a grammar of truth that treated the reproductive system, and the female body, as a language through which difference could be expressed as "a fact of nature" (Gallagher and Laqueur 1987; Poovey 1988; Foucault 1973). This emphasis on reproduction led to representations of the "abnormal" that were increasingly biologized. Femaleness, and difference, were now defined by a medical model (Foucault 1978; Turner 1984). Through the ascription of disease and pathology, the feminine body became a repository of sexual identity and race.

The medical model, which defined Germany's nationalist agenda in the early twentieth century, was anchored in the complementary discourse of descent and reproduction: Blood was the common icon. Encoded with qualities characteristic of the ideological construct "woman," blood became the iconic marker of pathological difference: a signifier of sexual disease and racial contagion (Gilman 1992). These fantastic images found political expression in the 1930s, when the promotion of glorified hypermasculine values, and an emphasis on proficiency in physically aggressive activities like sports and warfare, were intertwined with a fear of pollution from "bad" blood. In the late 1930s, German fascism became obsessively concerned with controlling both women and reproduction (Mosse 1985; Herzfeld 1992). Politically effective images of difference were drawn from fantastic fabrications about female carnality and visions of the destructive power of the vulva and its fluids. Society's energies were subsequently directed inward toward "containing" the penetration of the masculine (political) body by racial impurities. The eradication of racial difference, through the evisceration of the feminized Jews, thus emerged as a central template of violence in Nazi Germany.

Racializing Female Bodies

The violent obsession with the female body, and its reduction to blood, is documented in Klaus Theweleit's *Male Fantasies* (1987/89). Mapping the collective unconscious of the protofascist warrior, Theweleit examines the men's motivations for terror against women and the linkages between race hatred and male power. Theweleit focuses on the fantasies of a particular group of men: members and officers of the *Freikorps*, the private, mercenary armies that fought the revolutionary German working class in the years immediately after World War I. These "white" troops (consisting of former imperial soldiers, anticommunist youth, and adventurers) regarded the socialist labor movement as the greatest threat to their image of the nation and German manhood. After suppressing the communist insurrection of 1919, under the leadership of the socialist chancellor Friedrich Ebert,[11] the *Freikorps* soldiers came to play a crucial role in the rise of Nazism. In several cases, they emerged as key functionaries in the Third Reich: "The Stahlhelm, the SA, and the SS all recruited many of their most prominent leaders from the alumni of the *Freikorps*" (Rabinbach and Benjamin 1989: xv). Rudolf Höss, a former *Freikorps* officer and influential Nazi, was appointed commandant of Auschwitz.

The excavation of *Freikorps* literary remains, of novels, letters, and autobiographies, uncovered the terrifying visions of these protofascists, visions of hatred and fear in which women were reduced to a series of blood images: the red tide, the red flow, a sea of blood. Women, perceived as sources of contagion, were equated with dirt, pits of muck, effluvia. The nature of femaleness and womanhood, envisioned in terms of bodily emissions or secretions (blood, mucus, excrement) was experienced as menacing. The *Freikorps* soldiers hated women, specifically women's bodies and sexuality. Their hatred surfaced in an endless series of liquid images, in which women were associated with everything that threatened to flood or deluge the boundaries of manhood. It was a dread, ultimately, of dissolution, of being swallowed, annihilated.

Fascist soldiers always depicted women and female bodies through a lens of violence. A military operation against the primarily female participants of a labor protest is recounted with an emphasis on blood and dismemberment:

> "They're probably spitting there again," thought Donat [a *Freikorps* soldier], knitting his brow. Suddenly, he saw a mouth before him. It wasn't really so much a mouth as a bottomless throat, ripped wide open, spurting blood like a fountain . . . They certainly were spitting. But the men of the brigade didn't take it lying down. Quick as lightning, they turned their carbines around and ground them into those spitting faces. (Dwinger 1939: 296)[12]

The same discourse of violence, with the aim to obliterate the female "other," characterized another military expedition against women demonstrators:

> A rain of spittle hits the soldiers . . . The spitting woman . . . stands before the barrel of his gun—his sight is pointing straight into her mouth, into the center of that slobbering hole, so wide open with hysteria that he can even see the gums. "Get away!" he screams again, as if he afraid of himself. It's really her. Now he recognizes her. "Fire!" . . . Everything turns suddenly to frenzied flight. Yet [the soldier] sees nothing of this. He sees only the woman who was standing there before him a moment ago. It threw her onto her back, as if she had been blown over by some gigantic wind. Is that thing at his feet really her? That person without a face? The head isn't really a head anymore, just a monstrous bloody throat. (Dwinger 1939:276ff)[13]

In these violent encounters, specific parts of the female body are attacked: "[A] woman is punched in the mouth; she is clubbed in the teeth with a rifle butt; a shot is fired into her open mouth. The mouth appears as a source of nauseating evil, a 'venomous hole' that spouts out a 'rain of spittle'" (Theweleit 1987: 191). According to one soldier: "Women are the worst. Men fight with fists, but women also spit and swear—you can't just plant your fist into their ugly pusses" (Salomon 1930: 180, 184).[14] The men's attacks destroy those parts of a woman's body that are perceived as a threat to manhood: her head, her mouth, her genitalia.

Mouths can symbolically represent the vagina, and the effluvia

pouring out of them, its secretions.[15] It is possible that all the objects with which the soldiers' attacks were carried out represent the phallus: whips, boots, rifle butts, bullets. Following this frame-work, we might conclude that we are dealing with violent erotic advances: The murders or attacks were committed against women with whom the perpetrator was engaged in violent sexual inter-course, an act of rape.[16]

But it is the mutilated female body, rather than the soldiers' actions, which assumes primary symbolic significance. The men's violence aims to expose woman's horrifying sexual potential. Female bodies are penetrated, opened up, and exposed to the male gaze. All that remains is a bloody throat, a bottomless throat, ripped wide open. "[T]he killings are conceived as corrective measures, which alter the false appearances of the women so that their 'true natures' can become visible" (Theweleit 1987: 196). The women's wounds magnify the men's source of terror, revealing what the soldiers knew all along: Women are whores, vehicles of urges, emasculators. They are treated accordingly.

The men's desire to perceive women in the condition of bloody masses seems to be the driving force behind the killings. The assault itself is a means to this end. Consider the following example, in which Marja, a communist woman, falls into the hands of the German *Freikorps* soldiers and is beaten to death:

> Moving along the stream, [the soldiers] are astonished to see it blocked by the bodies of Bolsheviks. The soldiers must have been given an order . . . to toss all of the wounded into the water . . . The last body they ride past seems to be that of a woman. But it's very hard to tell, since all that's left is a bloody mass, a lump of flesh that appears to have been completely lac-erated with whips and is now lying within a circle of trampled, reddish slush. (Dwinger 1935:141, 144)[17]

The woman is reduced to a pulp: a shapeless, bloody mass, tram-pled flesh. This same imagery appears in other narrative descrip-tions of women's bodily remains: a blood-drenched mass; naked and cut to pieces; a pulp of blood and excrement. The soldiers' reduc-tion of the murdered woman into a "reddish slush" meant that the

victim had lost her outlines: her solid body, her identity. Her wounds were no longer discrete entities nor was the body to which these wounds belonged.

Fascist violence was preoccupied with this dissolution of the body and of the woman as bodily entity. The soldiers' attacks fit into a series of repeated attempts at exposing the *woman* in the body: through the infliction of wounds (bleeding vagina) and by the production of blood (the menstrual flow). In the violent imagination of the fascist soldiers, women's bodies had to be transfigured into a deluge of blood, causing total obliteration. The point seemed to be to make everything red, a color which (like blood) functioned as a dominant metaphor for the men's erotic *desire* and *fear*.

The *Freikorps* soldiers' fear and revulsion of women manifests itself in the incessant invocation of metaphors of an engulfing fluid or flood, the terrifying deluge. Fearing that which they both see and expose (the erotic female "other"), the men want to be freed from all that could be identified with women's bodies: liquidity, emotional warmth, sensuality. Theweleit (1989) believes that this desire gave rise to a fascist body politic that tried to elude and repel feminization. The hardened male body with its stiff military pose became the armor men used to protect their inner selves. Repulsed by their own corporeality, the *Freikorps* soldiers attempted to subdue and repress the woman within: It was she, or what she stood for, that constituted the most radical threat to the men's own integrity. "[T]he most urgent task of the man of steel [was] to pursue, to dam in and to subdue any force that threaten[ed] to transform him back into the horribly disorganized jumble of flesh, hair, skin, bones, intestines, and feelings that call[ed] itself human" (160). The soldiers' repudiation of their own bodies, and of femininity, became a psychic compulsion which equated masculinity with hardness, self-denial, and violent destruction.

The armored organization of the male self depended on the use of violence to maintain its integrity. In the act of killing, the corporal boundaries of the victims were transgressed while the inner cohesion of the male self remained intact: By penetrating and

dismembering women's bodies, the men's own bodies became armored and whole; by liquifying female bodies, theirs became hard. The men's destructive impulse derived from their inability to feel or sustain any sense of bodily boundaries without inflicting violence. The symbolic construction of the dangerous female other, and her eventual obliteration, served as a mechanism of self-cohesion. Threatened by imaginary "floods," "torrents," and "raging waters," the men stood firm against these onslaughts of surging womanhood. Hardened by military procedures, the male body was transformed into a machine, the man of steel.

> Fear of the inner body with its inchoate "mass" of viscera and entrails, its "soft" genitalia, its "lower half," is translated into the threat of the "masses" in the social sense of classes or—especially in those chaotically mixed groups with women and children in the forefront—mass demonstrations. The mass is diametrically opposed to the need for a rigidly, hierarchically structured whole. (Rabinbach and Benjamin 1989: xix)

To the *Freikorps* soldiers, communists—like individual women—were an undifferentiated force that sought to engulf: "a sea of blood, a flood, a swamp, a tide, a threat that came in waves" (Theweleit 1987: 229). Consider the following examples: "The wave of Bolshevism surged onward, threatening . . . to swallow up the republics . . ."; "The Reds inundated the land"; ". . . the Red wave surged onward"; ". . . the raging Polish torrent"; "The stream of insurgents pours like the Great Deluge over . . . against . . . the Germans"; ". . . the all-destroying flood . . . advancing toward the west" (229). The fascist soldier wanted to keep the red flood of revolution away from his body. He wanted to hold himself together as an entity, a distinct body with fixed boundaries. He wanted "to stand with both feet and every root firmly anchored in the soil" (230). His fear that contact with women would make him cease to exist as a discrete entity was here reproduced as a fear of being inundated, flushed away, dissolved. The dread of women, which existed at the core of the fascist movement, was thereby linked to anticommunism as well as race hatred. "All that [was] rich and various [had to] be smoothed over (to become like the blank facades of architec-

ture); all that [was] wet and luscious [had to] be dammed up and contained; that [was] 'exotic' (dark, Jewish) [had to] be eliminated" (xv). In the end, it was the men's battle against feminization which led to the use of violence, and ultimately murder.

As Barbara Ehrenreich emphasized in her foreword to *Male Fantasies* (1987), the boundaries that delineate the protofascist warrior cannot be precisely defined. The line between fascist militarism, the soldiering male, Nazism, and male fantasy is intentionally blurred by the author. This blurring of historical distinctions raises some important questions. If these desires or fantasies are not limited to the men of the *Freikorps*, if they are the common property of bourgeois males, then what distinguishes these *Freikorps* men from other men? Is it that they are military men?

> Military culture divides itself from non-military culture in its equation of civilian life with femininity, the existence of "masses" or "classes" with unpermitted pleasures of the body. The fascist warrior turns nation, race, and volk into instruments of the militarization of the self—the pain principle. (Rabinbach and Benjamin 1989: xviii)

Theweleit himself posits a continuum between ordinary male fantasy and its violent counterpart. His work suggests that the militarization of German society was accomplished by incorporating, and often intensifying, existing notions of misogynist masculinity. Fascist soldiers, who used terror against women as a strategy of war, were dependent on peacetime constructions of society and gender (Bartov 1996). German fascism created a culture of terror by accentuating the everyday forms of violence against women, privileging those cultural images of masculinity and manhood that were driven by a desire for bloodshed: The brutalization of woman, her reduction to a bloody mass, was fundamental to the making of the German fascist. Using the soldiers' repulsion of women as a starting point, Theweleit's work uncovered the "military's heavy reliance not just on men as soldiers, but on misogynist forms of masculinist soldiering" (Enloe 1995: 224). In fascist Germany, as in other modern nation-states, military violence, militarization, and everyday cultur-

al practices shared resonances that mutually reinforce these masculinist visions of power (Nordstrom 1996; Feldman 1997). Sexual violence and female mutilation were fundamental to fascist militarism because such physicality, the imagery of broken bodies, was also a cultural phenomenon. Blood (bleeding corpses, menstrual flows, a threatening fe/maelstrom) existed as a dominant metaphor of the German body politic.

The German militarization of violence, directed against a perceived feminine threat, was deeply connected to the social fabric of race. The soldiers' efforts were directed against women and other forms of contagion that could be imagined through the threat of (female) blood pollution. In recognition of such a linkage, some scholars have begun to trace the connections between military patterns of rape, on the one hand, and racial stratification on the other (see Enloe 1993; Nordstrom 1991; Olujic 1995; Stiglmayer 1994; Sutton 1995). Such studies seek to expose how societal systems of racism need particular forms of sexualized violence in order to survive. Given this pattern, we should not be surprised to find evidence of a certain kind of fantasy material, a misogynist/racialist politics of representation, in contemporary Germany.

In German media culture, visions of female liquidity and foreign flows have merged into a common frame of reference: liquification/liquidation. But what are the specific implications of finding the threatening image of a "raging flood" applied to immigrants or refugees? How do we interpret the rhetorical invocation of public images of dissolution and subsumption by "streams of refugees" in a united Germany? My comparative tracing of fascist imaginings and postwar representations of racialized bodies shows how such powerful tropes are maintained in cultural systems to emerge in wartime militarization or peacetime immigration reaction, and how such schemata can motivate violent civil aggression against foreigners, and women, in present-day Germany.

The Threat of Foreign Bodies: Blood, Flood, Contagion

Soon after 1945, after the end of fascism in Germany, the spatial proximity and mingling of racialized bodies emerged again as an unresolvable dilemma. In the postwar period, during the era of economic reconstruction, German cultural politics continued to perpetuate racial prejudice, invariably keeping the "other" at a distance, "under control"—a recipe for psychological terror. Relations between Germans and racial "others" came to be socially organized and regulated, the object of laws (Schwerdtfeger 1980; Senders 1996). Economically, foreign workers and immigrants were needed, even as politically the west German state sought to eliminate them (Linke 1982). Feeding on images of otherness and difference, ultimately taking control of them, German capitalist culture nourished the symbolic constructions for its own ends. The postwar German state depended on racial otherness as an ideological and structural phenomenon, which it simultaneously sought to exploit and to destroy.

Beginning in the late 1960s, west German industry attempted to alleviate its temporary labor shortages by the recruitment of foreign workers. These "migrant laborers" (brought from southern Europe and its immediate periphery) were hired on short-term contracts. They were employed in the service sector or in production, there taking on the unskilled, manual, and often most dangerous jobs (Klee 1975; Linke 1982). "Initially called *Fremdarbeiter*, foreign workers, in a carry-over from the forced laborers imported during the Third Reich, they were quickly rechristened *Gastarbeiter*, 'guestworkers'. All Germans believed that these guests, who were considered *Ausländer*, foreigners, would eventually return to [their home] countries" (Borneman 1992a: 206–7). Inserted into the capitalist economy, migrant workers were soon reduced to the function of surplus labor. After the onset of the energy crisis in 1973, and a deepening economic recession, West Germany closed its borders to foreign workers, initiated elaborate (and costly) programs of repatriation, and tightened its laws concerning refugee and immigration

rights (Borneman 1992; Linke 1982; Senders 1996). This period of
state repression, and racial tension, persisted until the early 1980s.

Germany's closure of national boundaries was complicated by a
legal system that defined political asylum as a basic human right. In
commemoration of the terror and dislocations caused by the war, by
fascism, and the concentration camps, the West German state had
incorporated the protection of refugees as an integral part of its
judicial foundation. This foundation, the very basis of postwar
German state authority, was deemed threatened, attacked "at its
core,"[18] in the early 1980s, when German officials observed a sud-
den increase in refugees from Africa and Asia who, as victims of
political persecution, were seeking asylum in Germany.
Administration officials interpreted this influx of refugees as a direct
result of attempts by foreigners to circumvent the state's increasing-
ly restrictive immigration policies.

In discussing the influx of foreign peoples, German politicians
began to conjure images of an invasive "flood" of bodies, a "rising
tide" that threatened to inundate the country.

> A hundred-thousand, perhaps more, foreigners are expected to enter the
> Federal Republic this year and appeal to the constitution which promises
> asylum for victims of political persecution . . . [T]his stream of foreigners
> pouring into Germany is regarded as a wrong. Politicians acknowledge
> this by talking about dams that should be raised against the "flood of asy-
> lum seekers."[19]

German politicians envisioned the threat of alien bodies as a liq-
uid mass—inundating, flooding, surging. Their terror and revul-
sion of this liquid "other" continued to find tangible expression in
the compulsive use of metaphors that described political events as
natural processes.

By the early 1980s, refugees were thus reconfigured as a menace,
a "deluge" of unimaginable proportions: "The stream of asylum-
seekers [is] pouring in," a "human flood"[20]; a "rapidly rising stream
of foreigners,"[21] which "pours into the Federal Republic"[22]; the
"river rose to nearly fifty thousand immigrants"[23]; "West Germany
[is] inundated by a wave of foreigners"[24]; a "torrent," a "river"[25]; a

"deluge," "streaming into the country."[26] There is "wide-spread uneasiness about the foreign flood" in Germany[27]; "the flow of refugees"[28]; the "rising tide," the "wave," the "in-pouring of foreigners"[29]; "the stream of asylum seekers into the Federal Republic."[30] It is an "untamed stream"[31]; a "dangerous surge of foreigners"[32]; a "fearsome flood."[33]

These same images of Germany's inundation by asylum seekers reappeared in 1990 after unification: Germans began to "fantasize about an invasion by millions, the flood of refugees, that threatened to subsume them" (Kreft 1991: 28). These signifiers functioned to prefigure public images of refugees as a negative presence. In public speech, discussions about asylum seekers were "often coupled with nouns denoting some natural and/or uncontained disaster: flood [*Flut*], river [*Strom*], mass [*Masse*]" (Mattson 1995: 66). The natural energy of this torrential flow was encoded as "foreign"/"other": untamed, dangerous, destructive. Its manifestations inspired terror as well as repugnance: Mighty streams were pouring out over Germany, transforming it upon contact, leaving it substantially altered.[34]

> Does the Federal Republic have the strength to cope with the so-called "economic refugees" who are inundating the country? At the moment, these problems are still manageable. But how will it be in three, four years, if the river pouring into Germany remains constant or becomes even greater?[35]

The terror of the external invasion was combined with a fear of dissolution. Contact with the "flood" killed: It posed a threat to the nation's bodily integrity.

Within this roaring cauldron, the men's own bodies appeared—struggling to contain the terrifying deluge—but also a larger, external body: the metropolis. The city was conceived as a human body (perhaps even a female body): inundated, depleted, weakened.

> The rising stream of foreigners into the Federal Republic is taking on precarious forms. Many cities are literally flooded by the refugees . . . The German council of mayors urged the Federal Minister of the Interior,

Gerhard Baum, to correct the processing of refugees. If it proved impossible to dam the flood, then the bearers of public responsibility at all levels might no longer retain control of the events [*Herr des Geschehens bleiben*].[36]

Metropolitan centers like Stuttgart, Frankfurt or Berlin no longer have the strength to handle the surging flood of asylum seekers . . . The Eritreans have reduced the city of Leinfelden-Echterdingen to such a state of desperation that the Chief Mayor threatened to issue a temporary decree of emergency unless the government agreed to move the Eritreans out into other communities, beyond the inundated city: "If the state does not take charge of a larger proportion of the refugees, then emergency intake camps must be constructed in order to retain control of the human flood [*der Menschenflut Herr zu werden*].[37]

The flood metaphor is abstract enough to allow processes of extreme diversity to be subsumed under its image. Their common linkage is the politicians' fear of transgression, which threatens to destroy the cohesion of the nation, of cities, and the German body. The symbolism of the foreign "flow" provokes (or agitates) particular racial and historical memories: It unleashes something that has been forbidden.

Germany's political men demand that "something be done" about the "mighty stream": they want to stop the flood, "dam up" and "contain" the flow, "stem the tide," "halt" or better yet "reverse the flow" of immigrants.[38] Gerhard Baum, federal minister of the interior, "wants to dam up the tide of refugees with his emergency program."[39] Chancellor Helmut Schmidt wants "to dam and contain the rising stream of foreigners by changing the constitutional right of political asylum."[40] "The stream of asylum seekers has risen to such enormous proportions that the administrative agencies and the courts no longer have the strength to cope with the flow."[41] Herbert Ehrenberg, minister of labor, intends "to stop the Turkish invasion," the "surge of foreigners," and the German government promotes such efforts as a form of "self-defense" (*Notwehr*).[42]

The spatial proximity of refugees inspires growing fears of "over-foreignization" (*überfremdung*).[43] The term, conjuring an undesirable transgression of race, refers to the estrangement of a people from

their cultural or genetic heritage through the superimposition, a "grafting," of alien bodies.

> The refugees were soon so numerous that onto every village dweller came one asylum seeker (*daß auf einen Dorfbewohner ein Asylsuchender kam*).[44]

> Germany is "over populated" and "racially inundated" by foreigners (*von Ausländern übervölkert*).[45]

Such visions articulate a fear of "racial inundation" (Schütt 1981:65) that appears to be resilient, persisting after 1990. Frankfurt's city councilman Daniel Cohn-Bendit, a prominent member of the leftist Green Party, received hate-mail letters which accused him of being an "enemy of the German people" because he did nothing to prevent "the foreign inundation" (*Überfremdung*).[46] By contrast, the conservative Steffen Heitmann, who had declared his candidacy for the German presidency in 1993, promised to "protect the nation from the racial superimposition by foreigners (*Überfremdung*)."[47] In southern Germany, "the Christian Socialist Union party (CSU) renewed its commitment to transform the German fear of 'over-foreignization' (*Überfemdung*) into a political platform."[48] The head of this same party, Theo Waigel, affirmed that the "threat of foreign inundation" [*Überfremdung*] would become a central campaign issue in the forthcoming elections.[49]

These anguished visions of the foreign "flood" are governed by recurrent images of weakness, disorder, and loss of control. Germany's politicians articulate their fears of extinction through images of emasculation and impotence. Control of the foreign "invasion" is construed as an assertion and display of manhood: to "remain a man/master/ruler over the events" (*Herr des Geschehens bleiben*); "to become the man/lord of the human flood" (*der Menschenflut Herr werden*). The common German title *Herr* means both "man" and "master," in the sense of "lord," "ruler," "head." The plural form of this term is linked to expressions of racial superiority: German *Herren-rasse* means "master race." It refers (quite literally) to a "select breed of men." In the German imaginary, the

subduction of the foreign flow, its containment and annihilation, is perceived not only as a rightful assertion of masculinity but also as an act of racial domination.

Defined as a threat against the German state, the containment of refugees requires "drastic measures": the construction of "camps for foreigners" (*Ausländerlager*),[50] "residency camps" (*Wohnlager*),[51] "emergency in-take camps" (*Notauffanglager*),[52] "the setup of mass camps" (*Massenlager*),[53] "concentration camps" (*Sammellager*)[54] and "federal internment camps" (*Bundessammellager*),[55] that is, the "placement [of refugees] in fenced barracks with armed guards."[56]

The language we encounter in these political visions curiously resembles that of the *Freikorps* soldiers: Perceived reality is annihilated and reconstituted in order to preserve an ideational representation and to "see" reality in terms of an existing paradigm. The hated foreign "other" is feminized by reduction to a series of liquid images: a "flood," a "tide," a "deluge," a "dangerous flow" of bodies. The images that vivify these fantasies of extinction are few and almost always the same ones. The racial subaltern is equated with the destructive potential of "woman" and is reduced to her bodily functions: a beast of consumption capable of producing much waste and devastation.

German state-makers communicate the "feminine" threat through the affective intensity with which they talk about the imminent catastrophe: the coming of the racial "other" who seeks to inundate, engulf, swallow. Germany's political men, like their fascist counterparts, feel threatened by the "natural" manifestations of devouring "femininity": her flooding, surging, streaming. The refugees, according to media depictions, exhibit signs of unrepressed (and uncontrolled) consumption: the nation has been "ravaged" by a wave of foreigners that was "hungry" for it.

The source of this dangerous (all-consuming) torrent can thus be localized more specifically. It seems to flow from inside those foreign bodies: their yearnings, their wants, and their insatiable "hunger" for a better life. "There is the growing realization among politicians that the rising stream of refugees . . . is driven by the

desire to improve their standard of living . . . to find in the Federal Republic of Germany the promised land: work, high salaries, security, generous financial support, and carefree leisure."[57] This image of the "flood" represents a maelstrom of terrifying desires: the emotional, the irrational, the uncontrollable, and the female (e.g., Lutz 1988; Stewart 1993). Its significance lies in its ability to convincingly displace the exaggerated desire for consumption onto a fantastic (and nightmarish) manifestation.

Refugees, as depicted by the German media, possess a voracious appetite for wealth, money, and status, and an unquenchable craving for power and Western affluence. German image-makers presume that the foreign "flood" is soley driven by economic interests: "to find work or to receive social welfare payments"[58]; to "open the flood-gate to the land of economic miracles," to enter "the promised land"[59]; to find an "economic paradise."[60] This process of inverse projection transforms the German nation into "the object of longing by millions of people."[61] Reconfigured by alien desire, the German nation is equated with the sensual, and the feminine. Picturing the nation as "female" makes it seem so much more vulnerable to conquest.

> [M]any of those, who set out from far-away lands, are economic refugees, enticed in their home-countries by the reputation of the Federal Republic as an island of the blessed, where one can easily gain a foothold.[62]

Shaped by these visions of foreign desire, the German nation is consistently described as "a utopia," a "paradise," a "garden of delights," an "island," a "treasure mountain," a "resort." The naturalism and eroticism of these cultural themes (e.g., Lutz and Collins 1993: 153) provides the German imaginary with the elements of powerful stories about the origins and rationality of gender and race distinctions: refugees, equated with the category "woman," are perceived as devourers, pleasure-seekers, freeloaders. Such a configuration of the racial other as "consumer" is no less fantastic or violent than its literalization in the vagina dentata myth, for it is a concep-

tion which functions to erase the true labor, the true productivity of "woman" or her symbolic stand-in: in this case, the refugee, the foreign worker, the immigrant (cf. Stewart 1993). Yet this erasure forms the very possibility of exchange.

It is ironic that these conceptions of the racial "other" were unwittingly encoded in the German constitution or "basic law," which was drafted shortly after 1945. In these legal documents, victims of political persecution were described by a language saturated with consumer images. According to the juridical rhetoric, the right of asylum was granted unconditionally. Political refugees were entitled to protection: They "enjoyed" (*genießen*) the right of asylum. The German term *genießen* means "relish," "taste," "enjoy," "luxuriate," "consume."[63] It refers to the pleasure and sensual gratification that a person derives from acts of consumption. More specifically, it conveys a sense of the experience of "partaking" in cultural commodities, an experience which is centered in the body: the sensuous immersion of the inner "self" in things of pleasure (that is, leisure, food, travel, sex). The choice of this term (which rarely appears elsewhere in the German constitution[64]) suggests that in the judicial and political imagination of the German founding fathers, the right of asylum was conjured as a commodity, a gift of leisure (and value).

Such a conception of political refugees (as unproductive, antisocial labor) facilitated the revival of the Aryan (fascist) racial aesthetices: Conventional notions of race and difference were patterned by a booming German postwar economy and linked to a nationalist aesthetic of consumer culture. Images of the materialist behavior and devouring promiscuity of foreign refugees came to be identified as perhaps the most radical threat to Germany's attempts at national reconstruction.

Out of the experience of war and defeat, Germans had generated a story of their own postwar victimization. The state reemploted these experiences into a romantic, future-oriented narrative. The appeal to tradition, virtue, and assimilation into a prosperous community of Germans became an antidote for this sense of victimization (Borneman 1992). The state's master narrative was restoration.

By the 1950s, the propagation of consumer images and the stimulation of consumer desire was encouraged as an integral part of the reformation of German national identity (Fehrenbach 1995): Western democratic freedom came to be identified with material prosperity and consumer choice.

The integration of German citizens into consumer culture was thus desired by postwar West German governments (Boehling 1996). The state's official narrative encouraged participation in the economic miracle of the 1950s by buying consumer goods as a reaffirmation of Germanness. "Prosperity forms the integument of West German identity, enabling to erase their past, both in memory and physically, and to allay their fears of disorder and dirt" (Borneman 1992: 236). Work and prosperity were the central organizing tropes of their life constructions: They saw virtue in work; pensions and free time were understood as rights earned in exchange for labor.

In Germany's postwar economy, conspicuous consumption became emblematic of a national "birth right": a symbol of nationhood and citizenship. Free-market consumption was depicted as a type of democratic citizenship, and commitment to economic growth served as a surrogate object for tarnished feelings of national pride. As Erica Carter put it: "In the absence of a unified nation, postwar West Germany witnessed a transposition of some of the characteristic qualities of nationhood onto the social market economy as a discursive formation" (1997: 23). Thus, after 1950, economic recovery, material prosperity, and conspicuous consumption were equated with Western democratic freedom: Consumer choice became inextricably fused with West German efforts to reconstitute the nation. Attempts by foreigners to partake in these privileges of a "closed" community were experienced as transgressive: a threat to German personhood and statehood. The writings of political analyst Rudolf Wassermann are a compelling example of such discourse. In a critique of Germany's asylum politics, he equates refugees with economic opportunists:

The motivation is understandable. Legally, however, they are—and one must, for the sake of terminological clarity excuse the hard word—asylum con-men [*Asylbetrüger*]. They conjure up facts purportedly pertaining to their political persecution that do not correspond to the truth. And they do this in order to force the German state to grant them the status of political refugee, which is bound up with the right to settle in Germany and is tied to financial advantages. (Wassermann 1992:12)[65]

By conjuring images of refugees as "economic parasites" (e.g., *Wirtschaftsschädlinge*), Germany's political men foster an atmosphere which legitimates the use of race-based violence. German public discourse imputes criminal intent to applicants for refugee status: fraudulence, illegality, corruption, and a fierce materialism are among the inherent traits ascribed to Third World or Eastern European peoples (Mattson 1995: 69). Foreigners are transformed into villains as politicians attempt to tear the masks from their faces and the disguise from their bodies, thus revealing their duplicity and deception. In doing so, they seek to justify the persecution of the "pretend-refugees" (*Scheinasylanten*), the "non-authentic asylum seekers" (*unechte Asylanten*) possessed by economic self-interest, the "economic refugees" (*Wirtschaftsflüchtlinge*) marked by their illicit appetites, unrelenting materialism, and grotesque bodies.[66]

Upon closer inspection, German politicians began to "see" the foreign flood as an indistinguishable tangle of bodies, a mass of brown flesh. Foreign corporeality was deemed a racial threat, which was connected to a repugnance with disorder and dirt. Housed in public facilities, refugee bodies invaded the nation's interior spaces: Schools, gyms, lecture halls, and hotels were now occupied, seized, and appropriated for alien purposes. The inundated (besieged) city eventually burst, rupturing its bounds of order. When its interior reached the men's bodies, the latter were destroyed. Their corporal boundaries were exploded, liquified. Thus the more directly the men were exposed to the events, the more overwhelmed they were by fear: the fear of dirt, contamination, death.[67]

In the German imagination, the proximity of racialized bodies was linked to processes of deterioration, and filth:

[G]overnment officials discovered houses in the inner city, in which Pakistanis and Indians had been packed together, houses in a state of disrepair and decay.[68] Where there had been 60 available openings . . . there now lived 160 foreigners.[69]

Crammed into impossibly small spaces, those foreign bodies evoked images of dirt, improper hygiene, the grotesque: "antibodies," endangering the clean and proper German bodies. Refugees, defined as "matter out of place" (e.g., Douglas 1980), were conceived, and experienced, as sources of contagion. "Officials wade through unbearable hygienic conditions, spray-can in one hand and notepad in the other. But, on occasion, people lie there packed together so tightly that the door does not even open and the official inspectors cannot advance at all into the rooms."[70] The men were standing "in filth," disgusted. Direct physical contact with "dirt" (the contamination of the bodies' peripheral areas) rendered them "lifeless": They are felled, cut down, knocked unconscious (*Das haut uns schlicht um*).[71]

The consequences of Germany's "racial inundation" are closely connected to processes that occur within the human body. Dirt dwells in the depths, in the bowels of the body: There, nothing is solid; everything is sloppy mush. According to media depictions, the nation's interior had become a morass. And the morass became simply human filth, a pit of liquid manure—teeming with bodies. This type of contamination "seeped" through the walls of judicial containment, seeking to subvert the German legal system: "Most of the applicants for refugee status spill into the black labor market" (Fromme 1980a: 1). According to German political commentators, the implementation of more restrictive immigration laws or even constitutional changes was unlikely to prevent desperate individuals from entering Germany, thereby exacerbating the nation's problem with illegality and the perception of refugees as criminals (Mattson 1995: 80–1). During political debates about German refugee laws, Konrad Weiss, an elected member of the leftist Union Greens (*BündnisGrüne*), formulated this possibility in his parliamentary address in 1993:

Human beings, who as asylum-petitioners are still tolerated today—at least for a while, will soon vegetate in the underground [the black labor market]—in a gray zone of illegal work and criminality that we will no longer be able to control. This pre-programs the rise of serious social conflicts compared to which today's situation will appear harmless. (Das Parlament 1993 [June 11]: 4)[72]

Equated with illegality and unlawful practices, foreigners were presumed intent on disappearing, "diving below the surface of detection" (e.g., *versinken, untertauchen, wegtauchen, abtauchen*), seeking shelter underground in cellars and sewers, roaming in darkness, and in dirt: slowly "seeping" (*versickern*) into the German body like a toxin that permeates the soil (Fromme 1980a: 1).

The government's task was to get rid of any "dirt" that settled on the "body of the nation." The political order thus appeared to take on the same function as the fascist soldiers' body armor: a protective enclosure that "bottled up" the nation's seething interior. German politicians, like their fascist counterparts, took comfort in imagining themselves and their nation as "armored enclosure," preserving a "pure interior." In the everyday experience of those men, the "wave" of refugees had managed to break and transgress their defensive barriers: the nation's interior fell pray to erosion, becoming "hollowed out" by the torrential foreign flood (Heutgen 1980). Weakened by the foreign onslaught, the integrity of the law and the strength of the state were perceived as threatened (Spiegel 1980a: 17). Defense was now located in a social body whose protective armor had been ruptured, its interior contaminated, flowing with filth and dangerous water. "Excrement poses a threat to the Center—to life, to the proper, the clean—not from within, but from its outermost margin. While there is no escape from excrementality, from mortality, from the corpse, . . . the (social and psychological) goal is to get rid of it quickly, to clean up after the mess" (Grosz 1994: 207). Violence, even murder, could be imagined as a viable form of defense against this threat.

Blood, Gender, Violence: Thinking the Nation

The nation-state is a political configuration of modernity (Linke 1997), which as an "imagined community," a "conception of peoplehood,"[73] relies on traditional iconographic repertoires for the construction of its symbolic universe. Burdened with myths and metaphoric rigidities (Offe 1987: 2), there probably exists no "privileged narrative," no "normal" way for a modern nation to be or to define itself (Bhabha 1990; Sedgwick 1992). Nevertheless, the German state clearly exemplifies the powerfully homogenizing version of the Western nation that seeks to constrain, oppress, and eviscerate difference.

Modern states tend to constitute their subjects in a gendered way: The sphere of the political project itself is defined as essentially male in its capacities and needs; the sphere of the nation, in its symbolic figuration, is constructed as female (Anthias and Yuval-Davis 1994). The modern state thus works in part through a process of politicizing gender roles: "[I]t politicizes or constructs the kinds of citizens women and men are supposed to be under the state's jurisdiction" (Moore 1988: 149–50). Predicated upon gender difference, the modern state inscribes this difference into the political process.

> According to some writers, women are relegated to the margins of the polity even though their centrality to the nation is constantly being reaffirmed. It is reaffirmed consciously in nationalist rhetoric where the nation itself is represented as a woman to be protected or, less consciously, in an intense preoccupation with women's appropriate sexual conduct. The latter often constitutes the crucial distinction between the nation and its "others." (Kandiyoti 1994:377)

Control of women and their sexuality becomes central to the national project (Yuval-Davis and Anthias 1989; Martin 1990). Implicated in gender relations, each state embodies a definable "gender regime" (Connell 1990).

The trope of nation-as-woman draws on a particular image of female selfhood: She must be chaste, dutiful, daughterly, maternal

(Parker et al. 1992: 6). The representational efficacy of such depictions of the nation as a female body, whose violation by foreigners requires its citizens to rush to her defense, "has served to bolster colonial conquest and racist violence throughout Western history" (de Lauretis 1988: 16). In the German case, however, the violent imaginary is centered on the equation of the woman's body with the "grotesque," envisioning the "fluidity" of female corporeality as filth, death, and contagion.

> [I]n the West, in our time, the female body has been constructed not only as a lack or absence but with more complexity, as a leaking, uncontrollable, seeping liquid; as formless flow; as viscosity, entrapping, secreting; as lacking . . . self-containment—a formlessness that engulfs all form, a disorder that threatens all order . . . women's corporeality is inscribed as a mode of seepage . . . liquidity. (Grosz 1994:203)

This iconography emerges most clearly under German fascism. The corporal metaphysics of the fascist soldier were encoded in two basic types of body. The first type was the soft and liquid female body: a quintessential negative "other," lurking inside the male body, a subversive source of contagion that had to be expunged or sealed off. The second type was the hard, phallic body, devoid of all internal viscera, which found its apotheosis in the machine. This body-as-machine was the acknowledged ideal of the fascist warrior.

While the peculiar characteristics of these imagined bodies were forged and culturally encoded by the gendered world of fascist politics (Mosse 1985; Theweleit 1987/89), images of the unaesthetic racial other reappeared in postwar Germany, albeit displaced onto a different field of relevance. Like the fascist soldier's fear of his inner body, with its inchoate mass of entrails, and his terror of women, Germany's political men transformed their revulsion with physicality into a repugnance toward "otherness," specifically the "feminized" racial other. During the 1980s, some thirty years after the last world war and the end of fascism, we encounter the vision of the "armored (male) body" and the "inundating (female) flood" in the purely civilian context of German racial politics.

In contemporary Germany, we see the conflation of foreignness

with femininity: Refugee bodies are depicted as wet, devouring, filthy. Media images of "invading masses" are transformed into a public discourse about dark-skinned others, a racial threat. The language of German politics contrasts the "femininity" of the foreign "mass" with the need for a rigid, hierarchically structured whole: Assertions of manhood and state authority are translated into images of control, mastery, containment, law, strength. In these images, race is always a subtext.

Such allegories of gender and race are implicated in the murderous elimination of subaltern bodies in contemporary Germany. In the 1980s, racial violence defined a new corporal topography: the purging of foreign bodies from German territory. Such a "cleansing" of the national landscape, the erasure of refugees and immigrants, emerged as an indispensable element of the recolonization of the physical interior of the modern state, and of German manhood.

The Contaminated Body: A Ruined Modernity

In this chapter I have attempted to show (through a critical analysis of German public culture) the highly ambivalent and stressed relation of the national order to the modern, and its eventual escape from modernity through the essentialisms of blood, race, and gender. My ethnographic material was drawn from a diversity of historical sources, not only to illustrate the diachrony of events, but also to highlight the fact that German history and cultural memory overlap and appear as repetition—a frozen continuum—in which certain templates and motifs are reencountered or return again and again, and where the new is mediated by a refurbished sameness via the essentializing metaphors of blood and body: a tropology of liquid corporeality. This mode of historicization, of memorializing the anatomy of German nationhood, exposes historical experience as a pathology, a traumatic syndrome.

In my analysis, our understanding of German historicity is mediated by the concept of the unconscious, of dream-work, and of fantasy formation. Recognizing the material force of the historical

unconscious, my emphasis was on the formation, inheritance, and devolution of essentialist symbolic systems, of grids of perception. What are the building blocks of these essentialist constructs? My work sought to contribute to an archaeology of essentialist metaphysics in the public sphere of modern Germany. Throughout, I inquired how essentialism is made. How does it achieve such a deterministic and habitual hold on the experience, perception, and processing of reality?

My treatment of essentialism as a formative construct (a content-filled, yet murky, density) and my orientation toward the notion of a historical unconscious means that the point of emergence of ethnographic data in this type of study does not conform to the highly localized/bounded profiling or extraction of data typical of conventional anthropological analysis. A major historical condition for the replication of essentialism (as I demonstrated in this chapter) is a continued oscillation between free-floating fantasy formations (haunting various cracks and crevices of popular culture) and the frightening instantiations of fantasy formations in precise locales and in specific performances. From what discreet sites of social experience, class affiliation, or gender identity does essentialist fantasy originate? We are no longer within the circumscribed space of childhood socialization, the nuclear family, the residential community. Popular culture and mass media have deterritorialized fantasy, although instantiations of fantasy can be given a discrete coordinate or topography. In many cases, the fantasy formations, particularly those embedded in linguistic and visual icons (as I demonstrate) criss-cross divergent class and political positions: thus, the powerful thrust of excavating a common symbolic grammar of blood between the neofascist right and the leftish Greens; or the disturbing evidence for a common logic of liquidation between the Social Democratic Left and the Christian Democratic Right. Such essentialist ideological/fantasy formations gather force and momentum precisely due to their murky and indistinct parameters in cultural repertoires (Taussig 1992). This fuzziness evades simplistic cause/effect style analysis. Rather, as my research suggests, it

requires ethnographic exploration on a heterogeneity or montage of discursive and image-making sites: political demonstrations, the mass media, popular memory, linguistic substrata, and symbolic geographies, which all share a translocal, national scope.

The German instrumental imagination of current ideologies of violence works with mystified bits and pieces of materiality, rehabilitating old positivities in the search for social anchorage as well as personal and class efficacy. We are in the material culture of blood and the linked somatic and medicalized nationalism that has specific German (but also trans-European) coordinates. A root metaphor of the German state defines citizenship by blood (as opposed to soil—i.e., place of birth—in the case of France). Blood and soil, body and space, constitute the materialist theory of national interiority and foreign exteriority. There exists a fundamental contradiction between the liberal state's promotion of tolerance and of diversity and the founding charter of familial blood membership, which underwrites stigmatizing imageries of otherhood. For the pathos of the nation-state, that is, the political community as an object of patriotic feeling, derives from the liberal revolution, with its infantilization and gendering of the subjects of the "fatherland."

In the twentieth century, however, the familial model of the organic nation was medicalized. By the early 1930s, fascist sociologists began to envision nations as "units of blood." A good deal of German social theory during the first part of this century was in effect a medical anthropology, a diagnostic science of the racial body. Accordingly, the nation was imagined as a "unity filled with blood," an "organic river basin," which functioned as a genealogical reservoir for a *healthy* German body politic:

> Just as the Nazi goes back to the peasants, as the most organic caste, so for him the personal physicians, racial doctors and hygienists are his social science so to speak. They are also important to him in terms of state theory; hence not only the pathos of heredity and selective breeding, but above all the national pathos of blood.

> The nation thus becomes, in medical terms as well, a unity filled with blood, a purely organic river basin, from whose past humanity stems and

into whose (most traditionally limited) "future" its children go. Thus "nationhood" drives time, indeed history out of history: it is space and organic fate, nothing else. (Bloch 1990:90)

Nationality came to be accepted as a medical fact by the fascist state and its supporting racial ideologies. Such a medicalized vision of nationhood resulted in the transposition of earlier forms of state culture into the political vernacular of everyday life (as is evident in contemporary Germany). My ethnographic data shows that a retrograde archaism of national state culture is continuously repositioned in the present. Crucial to this reappearance is the fact that the current manifestations of the civil state, as I have noted, remain both neutral and even opposed to these ideologies of organic unity and spatial purification, but nevertheless abet them. This is dialectical necessity, since it is precisely such residual archaeological strata, older sediments, earlier ideological manifestations and cultural memories of the state that are thrown up and expropriated to organize the political perceptions of the present. Thus blood imagery and organicism, as a devolved language of the nation-state, also inflects the discourse of the German left. There exists, as I have tried to show, a cultural complicity of the left in the organistic iconography of the right. The left unwittingly accepts the fascist polarity between defilement and sealed armament, the national body. The historical project of this masculinist enclosure (as characterized by Theweleit) is focused on the containment, indeed, the eradication, of feminized flows and streams of foreign bodies. When thus attempting to decipher this logic of German national fantasy, as Allen Feldman (1996) noted:

> [W]e cannot escape the image of the archaeological ruins of Nazi state culture emerging from a forest of public memory as a substructure of everyday life—like one of Max Ernst's brooding cityscapes. It is as if a flea market of former bureaucracies and ideologies opens up for ideological traffic, with its used dusted-off-contents of gas chambers, military campaigns, racial hygiene, racist economic rationalities, war imagery, and formulaic linguistic codes. These antiques are excavated by the anxieties of everyday life, and are superimposed on and redecorate contemporary

German social space, endowing it with the aura of authenticated ruins—
a ruined modernity. Struggles for political legitimacy mobilize an attic
full of authenticating artifacts by both left and right. (June 16, personal
communication)

The ideological ruins of the Third Reich, of race and soil and the
Other, are thus required by Left and Right for a massive re-
metaphorization of the political landscape—a performance that
indicts the poverty of available "nonviolent" political depiction and
of the failure of existing institutional optics that can no longer visu-
alize contemporary experience with any public satisfaction.

CULTURE, MEMORY, VIOLENCE

•

What are the effects of Nazism on contemporary German culture? Can we uncover traces of past concerns with blood, race, and hygiene outside the symbolic universe of postwar national identity? How is the past, specifically the murder of Jews, configured in the imagination, language, and metaphors of a postwar generation that is firmly committed to the restoration of a democratic society? Or is the social world after 1945 in fact "the same world that produced (and keeps producing) genocide" (Bartov 1998: 75), a claim perhaps supported by the overt manifestations of paranoia, anxiety, and hysteria, and the intense brutality that accompanied public representations of immigrants as racial threats before and after German unification. The reality of the Holocaust, the underlying discourse on enemies and victims, and its effects on German perceptions of history and nationhood can be viewed as among the most critical issues of this century. It is a vast topic, and I do not presume to cover it in its entirety. Rather, in the context of this chapter, I am concerned with several closely related matters: postwar German perceptions of self, and German attitudes toward Nazis and Jews. My discussion is focused on everyday forms of representation, which, as we will see, reveal an obsessive preoccupation with the fracture and violation of the body.

The Troublesome Past: Memory, History, and Shame

Cultural historians have often argued that Germans practice denial with regard to their past and particularly with regard to the

murder of the Jews.[1] Denial and concealment are clearly efforts to deal with a painful, embarrassing, and guilt-producing subject. The excesses of inhumanity and brutal murder that occurred during the Third Reich were difficult to confront by a nation defeated in war. For many years after 1945, countless Germans pleaded ignorance of the death camps or claimed that the atrocities never happened at all (Vidal-Naquet 1992; Lipstadt 1993). For more than thirty years, the horror of the Judeocide was either repressed or silenced. And while the victimization of Jews was denied, Nazi criminality was repeatedly associated with the *suffering of the Germans*. As Omer Bartov (1998) observed:

> Germans experienced the last phases of World War II and its immediate aftermath as a period of mass victimization. Indeed, Germany's remarkable reconstruction was predicated both on repressing the memory of the Nazi regime's victims and on the assumed existence of an array of new enemies, foreign and domestic, visible and elusive. Assertions of victimhood had the added benefit of suggesting parallels between the Germans and their own victims. Thus, if the Nazis strove to ensure the health and prosperity of the nation by eliminating the Jews, postwar Germany strove to neutralize the memory of the Jews' destruction so as to ensure its own physical and psychological restoration. (788)

Moreover, any attempt to tackle this denial of history on part of the postwar generation (that is, the sons and daughters of those who had known or played a part in Nazism) was met with a wall of silence.[2] Collective shame became a central issue for these younger Germans, who refused responsibility for the atrocities committed by their elders. The Holocaust was defined as an event carried out by others: the Nazis, members of another generation, one's parents or grandparents.[3] While refuting accountability for the horrors of the past, in particular for the murder of the Jews, these younger Germans experienced their own suffering and shame very keenly. As individuals, and as a group, they began to identify with the fate of the Jews insofar as both were victimized, although in different ways, by Nazism. "In this manner, the perpetrators of genocide were associated with the destroyers of Germany, while the Jewish victims were associated with German victims, without, however, creating

the same kind of empathy" (Bartov 1998: 790). Opposition to and rebellion against a murderous past were used by these young Germans as organizing tropes in their ongoing battles with identity and memory.

In postwar West Germany, intergenerational frictions over issues of morality, body, and sex were appropriated as sites where such battles could be waged, both in public and in private, and "at which younger Germans worked through their anxieties about their [specific] relationship to the mass murder in the nation's recent past" (Herzog 1998: 442). Interestingly, in the experience of many young Germans, the entry into adulthood was somehow linked to their access to forbidden knowledge, their induction into the repressed memories of genocide. In the following example, the leftist 1968er activist Barbara Köster summarizes her own, and her generation's, coming-of-age in this way:

> I was raised in the Adenauer years, a time dominated by a horrible moral conformism, against which we naturally rebelled. We wanted to flee from the white Sunday gloves, to run from the way one had to hide the fingernails behind the back if they weren't above reproach. Finally then we threw away our bras as well . . . For a long time I had severe altercations with my parents and fought against the fascist heritage they forced on me. At first I rejected their authoritarian and puritanical conception of childrearing, but soon we came into conflict over a more serious topic: the persecution of the Jews. I identified with the Jews, because I felt myself to be persecuted by my family. (1987: 244)[4]

Köster's claim to adulthood, which provoked her rebellion against her parents, relies on a disturbing, even offensive, appropriation of the suffering of others. But Köster (who eventually visited Israel, which caused the final break with her parents) was not alone. As she put it: "[The murder of the Jews] was a permanent and painful topic, and it was only when I got to know other students that I understood that this was not just my problem, that the shame about the persecution of the Jews had brought many to rebel against parental authority" (ibid.).

During the 1960s, student rebels, in their private and public battles, perpetually invoked the mass murder of Jews as a represen-

tational sign: Judeocide became a signifier of German shame, of their own suffering, a tactic that ultimately blocked and subverted direct engagement with the racial politics of the Third Reich. Such a deployment of history suggests not only a continuation of "postwar Germans' evasions of the memory and legacy of the Judeocide" but also points to an "irresolvable obsession with it" (Herzog 1998: 444). Postwar West German perceptions of victimhood thus entailed both inversion and continuity.

Leftists and conservatives alike deployed Holocaust images in their political battles as a sledgehammer technique, "bludgeoning each other with the country's past" (Herzog 1998: 440). The invocation of Auschwitz and the Third Reich "became a sort of *lingua franca* of postwar West German political culture, saturating ideological conflict over all manner of issues" (ibid.). Thus, for instance, antinuclear activists from the 1950s to the 1980s could warn that atomic war would mean "a burning oven far more imposing than the most terrible burning ovens of the SS-camps,"[5] or would be a catastrophe compared to which "Auschwitz and Treblinka were child's play."[6] Or, in another example from the 1970s, global economic injustice could be described as "a murderous conspiracy measured against which the consequences of Hitler's 'final solution' seem positively charming."[7] What do we make of such pronouncements that relate a nuclear disaster or an economic injustice to Judeocide? While this sort of rhetoric was clearly meant to break open the taboo of the past, to shock and startle a complacent German public with the provocative invocation of Nazi crimes, these verbal tactics also reveal that the murder of Jews became an auxiliary concern in a discourse dominated by identity politics and the crisis of political self-definition:

> In a peculiar but crucial way the Holocaust is at once absent *and* present in all that talk . . . [T]he centrality of the Judeocide to the Third Reich is the very [subject] that is constantly being evaded when facile comparisons are put forward in the context of other political agendas, [but] it is also—however paradoxically—precisely the Holocaust's existence that allows self-definitions in opposition to fascism to serve as a sort of short

hand to anchor and assert the legitimacy and morality of one's own claims. (Herzog 1998: 443)

But at the same time, this rhetorical preoccupation with Judeocide, often invoked in an analogic or metaphorical way, was suggestive of a deeper pain—the immense historical burden—that many younger Germans experienced and longed to alleviate by substitution or displacement. Holocaust images, as oppositional signs, facilitated a profound dissociation from shame.

Postwar West Germany's preoccupation with identity and memory was highly problematic, effecting not only a redefinition of Nazis and Jews but also a remaking of victims. How do we analyze such a process? In a series of remarkable essays, Janine Chasseguet-Smirgel (1986, 1988) draws our attention to the psychological mechanisms that are at work in these emotional struggles with terror and shame. Her work suggests that experiences of trauma are often managed, albeit never resolved, by a process of inverse projection. The very acute shame of a society, faced with the gigantic task, indeed the measureless effort of reparation, is perceived by individuals as an assault on the "self" by a demanding and pitiless agency. These maleficent attacks, emanating from an unrelenting social censure system, can be blocked or diverted if the affective impact becomes unbearable. The psychological assault, the sense of threat, is projected outward and affixed to concrete objects (e.g., refugees, the environment, the body). In this process, the individual's sense of terror or fear is displaced and transferred to the outside world. Inverse projection thereby produces imaginary scenes: Perceived reality becomes a world of highly charged objects and sites that are attacked in their turn by uncontrollable forces or are themselves experienced as threats. Such projective fantasies, Chasseguet-Smirgel (1986) observes, never resolve but merely intensify a person's feelings of guilt and anxiety: "This vicious circle is well-known and the kind of guilt brought into play cannot be worked through as such, because there are no feelings of sorrow or pity, just terror and persecution" (109). The imagined reality of an external threat

inevitably increases the individual's experience of victimization, of helplessness and distress, and thereby renders the process of resolving the underlying trauma more difficult, if not impossible.

Guilt, according to Chasseguet-Smirgel, must find an outlet or doorway through which it can be expressed: Fragments of a denied past tend to reappear, often in form of an external threat or a persecutory fear of the world. Traces of what parents, or even grandparents, have silenced, manifest themselves in the cultural imagination of their children or grandchildren, and however distorted, disconnected, and faint such traces may be, they are never entirely unrecognizable: "If we assemble the different pieces, fill in the blanks, mend the shreds, turn over a few bales of cloth—then there is no mistaking the undying specters of the past" (138). Where are the traces of Germany's denied past to be found? And how and in what form is the repression of guilt made manifest in contemporary Germany?

After examining a variety of cases and texts in which the underlying themes of guilt and atonement are recurrent, Chasseguet-Smirgel (1986) suggests that echoes of these same themes can be uncovered, albeit in distorted and persecutory form, in the cultural visions of the Green Movement. For instance, in February 1984, West Germany's environmental pacifists, known as "Greens," organized a second Nuremberg Tribunal to bring to public attention the threat of mass destruction by nuclear weapons. The opening contribution by Joachim Wernicke[8] claimed that a nuclear war, which would result, of necessity, in Germany's destruction, was in fact but another example, taken to its very extreme, of a process that began with the terrible bombings that Germany suffered during World War II, especially from 1943 onward. Moreover, his text places the Anglo-Saxon democracies (whose destruction of German civilian targets is not presented as a consequence of Nazism) in a category with the Nazis, and even regards them as more essentially evil. In this context, the author recounts the air-raid attacks on German and Japanese towns, focusing in particular on the atomic bombing of Hiroshima and other sites. The text, as Chasseguet-Smirgel

notes, makes no mention of the fact that these bombings must be considered as an effect of National Socialism, let alone that they were a punishment. The blame for the destruction of cities is projected onto the allied Anglo-Saxon nations, which are equated with unpunished war criminals. In the author's words: "After the war, a Military Tribunal was held at Nuremberg by the victors to deal with war crimes committed by those whom they had conquered, whereas it was impossible to deal with war crimes committed by their own subjects. Subsequently, however, the Principles of Nuremberg were drawn up and today they form an integral part of international law." In this text, the concentration camps, the Holocaust, and the murder of the Jews are passed over in silence.

It is extremely difficult to be—or even to have been—the object of prolonged hatred or contempt and to know that one's nation once incarnated (and not just represented) absolute evil. How is it possible to face such guilt? According to Chasseguet-Smirgel, few are able to bear up against it other than in the form of *persecutory* guilt. In the context of their Nuremberg Tribunal II, the Green Movement bypassed the guilt associated with the Nazi *Luftwaffe* air raids by laying blame with the Allied Anglo-Saxon nations, freeing itself in the process of the most terrible guilt, the guilt of genocide, the final solution, which made Nazism unique among the dozens of fascist regimes that have existed and still exist throughout the world. In West Germany, as Chasseguet-Smirgel (1986: 120) points out, the Left speaks of a *nuclear holocaust*, and there such references are more frequent than elsewhere. The German obsession with being destroyed by an atomic bomb can, in fact, be understood as a fantasized return of the final solution, a mass destruction of which they would become the victims this time: the final solution to the German problem.

> If then German pacifism is, at least in part, the expression of anxiety, the measure of which can be gauged from the photos of pacifist demonstrations, with their figures clad in garments portraying skeletons, or gigantic clocks pointing at five to twelve, suggesting the countdown that brings the end of the world . . . and if this anxiety constitutes a form of persecutory guilt, what about the other themes of the Green Movement, and in

what way are these related to the anxiety generated by a fear of the final solution . . . [and to] the intensity, the heatedness, the excessiveness, the violence in Germany? (120-21).

In postwar West Germany, social memories of violence and mass death have become highly contested and enormously politicized arenas of cultural reproduction. Nevertheless, German discourses about nation, immigration, and identity continue to rely on expressions and images that are drawn from the past: the Holocaust, the concentration camps, and genocide. In the following pages, I further explore the symbolic manifestations of guilt management in the Green environmental movement, with particular emphasis on how such memory formations are implicated in the terror of contamination, pollution, and bodily injury, and in the pervasive iconographies of German victimhood. Although at any given historical moment a number of contrasting reality constructions may coexist, particular discourses emerge as dominant to provide a "deeply saturating" sense of reality for most people (Williams 1973: 37). Such a prevailing sense of the world is unlikely to be the production of a single group or to serve one set of hegemonic interests.

The Green Environment: Poison, Death Camps, and Victims

Since the mid-1970s, the political landscape of West Germany has been marked by the rapid formation of several neopopulist movements centered on protest, resistance, and retreat. The potential currents of discontent arose from a multitude of problems characteristic of advanced industrial societies: the dangers connected with nuclear power, atomic waste, environmental hazards, ecological imbalances, the scarcity of resources. In West Germany, spontaneous protests were sparked in particular by the tangible destruction of the natural environment: the destruction of forests by pollution and urban expansion; the demolition of the countryside by bad residential planning or industrialization; and health impairments due

to the proliferation of toxic substances. These were developments that seemed to "visibly attack the organic foundations" of the external world (Habermas 1981: 35). Such visions of the gradual extermination of life appeared to evoke intense feelings of fear among large segments of the German population and to enhance the individual's sense of disempowerment, of being overwhelmed by the uncontrollable magnitude of the destructive process.

The terror of annihilation emerged as a prototypic theme of Germany's antimodernist rebellion. Such a fear of extinction was saturated with traces of historical memory: Images of genocide and mass death were inserted into debates about the destruction of the environment. But on the surface, in ideological terms, such protest movements were seen as critical responses to a wide range of ecological and environmental problems. The social composition of active protest participants was typically heterogeneous, consisting of a mixture of conventional farmers, elite professionals, and politically more radical students and young workers.[9] Resulting from this diversity of associations and groups, in addition to the frequent changes in alliances, scenes, and topics of discontent, the environmental movement lacked a common or unifying ideological frame.[10]

Despite such a particularistic fragmentation, West German environmental activists found collective representation in local and state governments. A common political forum for these leftist critics was provided by the party of the Greens (*Die Grünen*), which was constituted in the late 1970s.[11] Initially formed as a loose confederation of local groups with a countercultural slant, the Greens entered the German Parliament in Bonn for the first time in 1983. During the 1987 general elections, the Green Party received more than 10 percent of the popular vote.[12] By then it had accrued more than six million dues-paying members.[13] While the Greens successfully entered the formal arena of government, the great diversity of the movement's political roots persisted in the different ideological concerns and aims of its local branches.[14]

Although heterogeneous in ideology and practice, the Greens cultivated a sense of political identity through the use of certain

symbolic forms. Perhaps most striking was choice of the party's name: *Green* was appropriated as a symbol of life and nature. The implicit meanings of the term "green" were opposed to the political connotations of "red," the symbol of blood, both in the sense of revolution and sacrifice.[15] While red represented violence and bloodshed (associated historically not only with radical Marxism but also with the atrocities of National Socialism), green stood for nature, peace, and nonviolence. Indeed, green was appropriated as a natural symbol, a timeless signifier with universal validity. In contrast to red, a trope for violent social history, green represented nature, a symbolic configuration that stood outside of history, severed from processes of social memory: Green/nature existed without connection to the horrors of the past. These semantic implications greatly facilitated the Green Party's ability to unify the diverse and seemingly unrelated agendas of its membership.[16] The green icon embraced and gave meaning to a disparate set of ideological commitments, such as pacifist (*gewaltfrei*), grass-roots democratic (*basis-demokratisch*), social, communal, humane (*sozial*), and ecological (*ökologisch*).[17] These political principles that invert were the totalitarian ideals propagated by the Third Reich.

The activists' insistence that green symbols meant nature, not history, was probably influenced in part by an existing repertoire of German songs, proverbs, and idioms that unequivocally defined green as the color of plant life: the forest, and the tree. In German folk speech, excursions into the countryside are coded green: Green nature, that is, life in rural areas, stands in opposition to the grey bleakness of the urban environment, the city (Linke 1988).[18] A conventional metaphorical image, appropriated by the Green Environmental Movement, equates health, fertility, and happiness with rural life—nature (symbolized by the forest, tree, garden)— and links corruption, decadence, and death to urban growth. These symbolic visions are deeply embedded in German traditional culture. Historical parallels can be found in the German romantic movement of the nineteenth century and, more surprisingly, in the National Socialist universe of the 1930s and 1940s (Eder 1993;

Linke 1999). Both the Greens and the Nazis stressed the need for "purity" in the face of "pollution": one by a focus on internal cleanliness (genetics, purity of bloodline), the other by an emphasis on the external world (untouched nature, nontoxic environments). Such rhetorical similarities are all the more striking given the diametrically opposed philosophies of the two movements. The Green environmental movement displays a perpetual reliance on a repertoire of metaphors and images that was (and is) historically problematic. It seems as if Nazi preoccupations with racial hygiene and tainted blood have been reproduced, in a distorted and transposed form, in the Greens's intense obsession with pollutants, toxins, and contaminated nature.

In the Green imaginary, the world, especially Germany, is defined as a dangerous locale. Filled with poisonous and noxious substances, it is a site perpetually threatened by lethal waste products. These terrifying visions of poisons, toxins, and suffocating gases, which not only attack the natural world but also smother and infest the body, are fundamental to the worldview of the Green Movement. Such perceptions are clearly linked to social memory and history, as is suggested by the following text, which reveals by analogy how Green perceptions of an endangered environment might be patterned by a preoccupation with genocide and Nazism. The text, a play titled *Schwarzer Schwan* (Black Swan), written by Martin Walser in 1961, provides an interesting illustration of such a process of repression and displacement. The play documents in a dramatic way how a denied past can reappear in supplanted memories, surfacing in fictional scenes as an endless series of images reminiscent of death camps (smoke stacks, incinerated corpses, stinking fumes, and suffocating gases), which expose the characters' intense fascination with a historical reality that they had desperately wanted to repress. The script revolves around a young man, Rudi, who has recently graduated from high school but has refused his diploma. On the grounds that he is suffering from a nervous disorder, he is taken to a neurologist, Professor Liberé. We understand that the physician is guilty of past crimes but has avoided punishment by

changing his name, wiping out the past to the point of making others believe that he and his family spent their lives in India.

> "Excuse me, Herr Professor," says Rudi to the physician, "if somebody lights a cigarette and, at the first puff, thick blue-yellow smoke pours from his mouth, what are you thinking about? Nicotine, tar products, coronary arteries, or the incineration of Indian widows? Yes? I immediately see chimneys, especially coarse-broad-rectangular chimneys. And the stench of them is the same."[19]

The denied past surges up again when the physician's wife, in speaking about their pretend-lives in India, "recalls" her memories of Benares, of the funeral pyres on the banks of the Ganges, and of the cremation of corpses.

> "One should pick up a machete, and shred the heavy fumes, rip them apart until from somewhere air floods in. There still must be air somewhere that one can breathe," says Frau Liberé.[20]

> "The scent of Benares, a repulsive stench of smoke; on the banks, men, blackened by soot, prodding their iron stakes into the pyres. All around are bones, and heaps of ashes, several feet high. And what's the purpose of all this? To mollify the spirits of the dead. As if every living person needs to have a bad conscience," says Frau Liberé elsewhere.[21]

These more or less explicit evocations of the cremation ovens and gas chambers, where one suffocates and in desperation, to the point of exhaustion, tries to find some "breathable air," belong to a repertoire of images that appears, endlessly repeated, in various texts published by the Greens under the heading "air" (*Luft*). In one example, a brochure from 1984, which outlines a clean-air program for Hamburg, we find the following:

> The air of Hamburg is saturated with dust particles . . . that are . . . highly contaminated . . . smog [and] air pollution have reached levels that, in the long run, can only result in devastating damage . . . waste gas . . . emissions . . . an "equitable distribution" of the poisons by heightening the chimneys . . . In some places, the concentrations of noxious substances must be measured precisely.

> The [Green Alternative List] calls for immediate action to cleanse the air

of pollution. This involves the following: Hamburg must be declared a
site threatened by air pollution . . . [We demand] filtering equipment to
purify gas fumes . . . [and] that legal action be brought against industries,
which poison the air (chemical factories, refineries, blast-furnaces) . . .
[We demand] an immediate evaluation of the conditions of air pollution
in Hamburg (the toxicity of dust, the impact of interacting noxious sub-
stances) . . . [We demand] surveys of emissions . . . [and] an immediate
halt to the burning of waste gas from refineries."[22]

Another text, a proposal for a federal antipollution program,
contains a striking photograph of factory chimneys vomiting a
thick, black smoke, an image that is clearly reminiscent of the cre-
mation ovens (Die Grünen 1984a: 6). In this same brochure, we
read the following under the heading "air":

In the Federal Republic, gigantic amounts of waste gas and dust are pro-
jected into the air . . . called suffocating oxide . . . as well as dust and soot.
Thousands of people have already fallen victim to catastrophes brought
about by fog. The combined action of the different noxious substances . . .
and the accumulation of poisons through the food chains lead to an
increase in the health hazards that endanger human life . . . [We demand]
the immediate enforcement of an effective set of measures curbing the
discharge of poisonous substances by industrial complexes . . . by cars
and airplanes, waste incinerators, public and private heating systems,
[and] the violent exhaust given off by cars . . . [We demand] a total ban
on the . . . evacuation and dissemination of all carcinogenic toxic sub-
stances . . . In order to reduce the quantities of exhaust gas discharged
into the air by cars and factories, the installation of filtering equipment
should be made obligatory.[23]

Can it be a mere coincidence that the Green Movement's per-
secutory vision focuses on toxic smog, suffocating gas, emis-
sions, and exhaust fumes as the primary environmental threat?
Which is metaphor and which is reality? Consider the following
dialogue that describes how the Jews were murdered by Nazis. In
the film *Shoah* (1985), director Claude Lanzmann gets Franz
Schalling, a former concentration camp guard, to speak. He asks
him:

Can you describe what you saw? How long did the Jews stay there?

Long enough to undress. Then, stark naked, they had to run down more

steps to an underground corridor that led back up to the ramp, where the gas van awaited them.

Describe the gas vans.
They stretched, say, from here to the window. Just big trucks, like furniture removal vans, with two rear doors.

What system was used? How did they kill them?
With exhaust fumes. It went like this. A Pole yelled "Gas!" Then the driver got under the van to hook up the pipe that fed the gas into the van.

Yes, but how?
From the motor.

Yes, but through what?
A pipe—a tube. He fiddled around under the truck. I'm not sure how.

It was just exhaust gas?
That's all.[24]

There certainly is some truth in the accusations that the pollution of the atmosphere damages the forest, living creatures, and the architecture of cities, "and this [very truth claim] is what lends credibility to the unconscious staging of a scene where the ghosts of the past make their reappearance. As a matter of fact, the world of the Green Movement, the "alternative" universe, is called *die Szene*, that is, "the stage" (Chasseguet-Smirgel 1988: 123). On this stage, built to provide an alternative reality that stands in opposition to the past, Green fantasies of persecution are dramatized and played out. If we add to this fear of pollution the Greens's concern for the elderly, the disabled, the mentally ill, and the fight against vivisection, we find a certain number of attitudes and aims that run counter to the horrors of Nazism, where euthanasia was the fate of the disabled and of psychotics, and where Nazi physicians experimented on deported prisoners. Add to this also the Green Movement's struggle to put an end to discrimination against Gypsies and homosexuals, and the campaign conducted in favor of the Third World. The aim is to fight for the rights of those populations that had previously been labelled "inferior" races. Nazi values have been inverted. The brochures of the Green Movement are full of photographs of men,

gaunt with hunger, and children with immense eyes and emaciated bodies, a set of images recalling only too vividly the prisoners who were discovered during the liberation of the concentration camps. But while these agendas and commitments are staged in opposition to the Nazi past, and are played out in an inverse relation to history, they are publicized through a repertoire of symbols, images, and metaphors, which, when used uncritically as templates of protest, curiously replicate the surface messages of a murderous discourse, a discourse from which Green ideology desperately wants to withdraw and retreat. Moreover, as Chasseguet-Smirgel (1988) suggests,

> In a situation of persecutory guilt, it seems that a subject, who feels he is the bearer of evil, must project this evil onto the person he takes to represent good . . . in order to eliminate the distance that separates the two protagonists. The distance represents the difference between good and evil and constitutes, of necessity, a permanent accusation. The object, then, is to vitiate the person who resembles you the least. It can be supposed that the same process takes place where nations are concerned. Inasmuch as one still harbors unconscious feelings of guilt for the horrors of Nazism, this evil is not projected onto those powers that indeed have features in common with Nazism (e.g., totalitarianism or the universe of the concentration camps) but onto those which resemble Nazism the least [the United States or Israel]. (124)

The destruction of Hiroshima, as the records of the Green's Nuremberg Tribunal II tell us, is directly linked to the bombings of German cities. Thus persecutory guilt constructs its scenery: West Germany is envisioned as a concentration camp—attacked by poisonous "suffocating" gas coming from car exhausts or pouring from huge factory chimneys in thick clouds of smoke—under threat of imminent environmental and nuclear "holocaust." In these staged fantasies, "Germans have taken the place of the Jews in this world. That is in fact the unconscious meaning of the play, which is performed on the stage of the Green theater" (ibid.). We are faced with the effects of guilt, which lead a certain number of Germans toward an unconscious identification with the victims of their parents. The distorted, mutilated, and censored past is actualized in the present: It is here and now, in postwar Germany, that

the total catastrophe is about to take place, in flames and smoke and blood.

Purgation: Stoking the Fire

What perceptions of the past do we find among Germans who do not participate in the Green Movement? According to a 1982 survey, less than 25 percent of all West Germans have abandoned the traditional pattern of anti-Semitic prejudice, a frightening statistic if true.[25] Ten years later, by 1993, the intensification of race-hatred is exposed by overt acts of murder: "A wave of anti-Semitic and xenophobic violence has claimed 24 lives over the last year and a half [in Germany], with the bulk of the attacks inspired, if not directly ordered, by militant nationalists and neo-Nazi groups" (Whitney 1993: 1). A surge of firebombings, directed particularly against Turkish immigrants and eastern European refugees, has been reported since 1989: 2,584 violent crimes against foreign residents in Germany were recorded in 1992, of which 550 were arsons.[26] During the months of September and October 1991, up to fifty such acts of attempted murder were reported every day.[27] This pattern of race-based violence persists. Since 1992, arsons aimed at immigrants averaged nearly a dozen attacks each month.[28] Consider the following examples:

> In November 1992, in the western town of Wuppertal, rightist militants attacked and killed the fifty-three year-old Karl-Hans Rohn because they thought he was a Jew. While trying to argue with his attackers in a local pub, Rohn was beaten and kicked, then doused with alcohol and set on fire. The innkeeper encouraged the perpetrators, shouting "Jews must burn!" The men loaded the dying victim into the innkeeper's car, drove across the border to the Netherlands, and dumped his body into a ditch. The burned corpse was found there the next morning.[29]

> A month later, in December 1992, in Wiesbaden, a group of rightists attacked a thirty-five-year-old Turkish man. After taking his wallet and beating him, they doused his clothes with gasoline. Shouting racist slogans, they left without igniting the man's body.[30]

> During the same month, in December 1992, subway tickets issued from

machines at underground stations in downtown Berlin carried slogans advocating racial violence. One ticket read: "The igniting of foreigners is not permitted while the train is in motion." Public transit officials claimed to be uncertain as to how the tickets had found their way into the machines.[31]

In March 1994, a Berlin court convicted a man for inciting the killings of non-Germans. In a letter to an acquaintance in prison, the man had commented on a previous arson attack in the town of Mölln, which had killed three Turkish nationals, an elderly woman and two young girls: "The burning Turk-house," he wrote, "was really tops. It pleased me immensely that three brown bitches were torched. I wished more of them would burn."[32]

Nationalist violence displays a remarkable continuity in form, relying on symbols significant to German culture: fire, burning, cleansing. Rightist militants, in their attempt to annihilate the ethnic other, make use of fire, which is in Christian (and Nazi) symbology a sign of overcoming, a possible transformation into a new period. Such efforts at ethnic cleansing by setting fire to the homes and bodies of racial Others are coordinated with the erasure of identity and economic subsistence by burning houses of worship, businesses, and workplaces (e.g., Kurthen, Bergmann, and Erb 1997).[33] Over the last few years, Germany's racially motivated arson attacks have shifted their targets from public refugee housing to ethnic shops to immigrant homes to individual bodies.

It is remarkable that this same repertoire of symbols and images is invoked as a medium of violent protest by the political left. Postwar German militants use arson in their struggle against capitalism and the state. By setting fire to large shopping centers, which were despised during the 1970s as products of capitalist culture and consumption (and historically as the property of wealthy Jews), members of the Red Army Faction returned to the violent tactics of the generation that preceded theirs—"though, of course, they conceived of themselves as fighting for the exact opposite cause, and their appeals were no longer linked with anti-Semitism" (Borneman 1992: 256).

In fact, leftist militants used arson as a central strategy in their

campaign against racism. By firebombing government offices, which during the 1980s came to symbolize the bureaucratic instruments of race hatred, members of groups like the so-called "Revolutionary Cells" (*Revolutionäre Zellen*) expressed their opposition to West German refugee politics in violent terms. The acts of setting fire to the Central Registry for Foreigners in Cologne or to the Central Bureau for Social Aid to Asylum Seekers in Berlin were not intended as mere symbolic gestures. Rather they were aimed at the destruction of records and documents, thereby severing the administrative link between racial others and the state. For instance,

> In November 1989, the "Agency for the Intake and Advisement of Ethnic Minorities," a subordinate branch of the constabulary in Cologne [*Ordnungsamt*], was set on fire by members of the Revolutionary Cells. In their letter claiming responsibility, the Revolutionary Cells noted that already in 1919 armed supporters of the Munich Soviet Republic had destroyed thousands of documents of the political police together with the total inventory of the "Gypsy" personnel files . . . : "In recognition of the longevity of statistical information . . . we took possession of all the documents in the Cologne agency. At the same time, by setting fire to the premises and the remaining material, we lent emphasis to the demand made by the Roma [gypsies] and their supporters that projects modelled after the Cologne registry be closed." (Tolmein 1992:37)

As journalists, scholars, and politicians scrambled to make sense of the dramatic insurgence of violence in a united Germany, it became increasingly clear that this violence was much more than a fleeting outburst of personal hatred against foreigners or a violent critique of Germany's immigration policies. It was also an integral part of a national struggle with issues of identity, citizenship, and race.

Expulsion: Eliminating the Racial Subaltern

In the German cultural imaginary, the violent, ritual use of fire evokes memories of fascism, race-hatred, genocide. Fire and burning bodies appear in visions of extermination, implanting in public consciousness a mimetic connection to the Nazi period, in particu-

lar the Holocaust, when German anti-Semitism reached its apogee with the burning of Jewish bodies and the reduction of masses of corpses into ashes.

Conceptually, and in practice, fire was elevated to a sacred symbol of the Nazi movement.[34] Already in the early 1930s, images of purgation or cleansing transfiguration were popularized by the lyrics of Nazi political song (see Lidtke 1982: 190–1, 192):

> A holy fire sweeps our Land
> The nation arises from its slumber
> Action is what we need
> Enough has been said
> Germans awake!
> And death to the Jew!

The production of death, and the burning of undesirable bodies, were to become central to the Third Reich's policies of race.

The radicalization of Nazi racial attitudes was exposed in the *Kristallnacht* pogrom: On the night of November 9, 1938, Germans demolished and set fire to Jewish homes, businesses, and houses of worship. During this night of violence, Jews were beaten, murdered, and transported to the camps. According to eyewitness reports, school teachers led their classes to the sites of destruction: "The students were stationed in front of the homes of Jewish citizens and had to shout 'Jews out!'" (*Juden raus*).[35] Anti-Semitic graffiti, before and after the pogrom, demanded the expulsion of Jews. One such example, painted on the window of a shoestore in Cologne, depicted a Jewish man, walking swiftly with his long coat and top hat, shouldering a bag of belongings. This image of a man in flight was enforced by the text: "Better get out quickly" (*Aber hurtig raus*).[36] In December 1938, local politicians began to post eviction notices on the doors of Jewish residences: "Jews finally and everywhere out!" (*Juden entdgültig und überall raus*).[37]

The aim of genocide was to maintain the "health" of the German body by enforcing a strict regimen of racial hygiene (Proctor 1995; Müller-Hill 1988; Aly et al. 1994). German political fantasy employed a model of race that relied on images of disease,

dirt, and infection. Blood became a marker of pathological differ-
ence, a signifier of filth and contagion: Jews and outsiders were
equated with excrement that had to be eliminated or expunged
(Dundes 1984). After 1945, these same images reappeared in con-
texts of right-wing protest: Foreigners, seen as pollutants, a danger-
ous racial threat, were targeted for expulsion. Thus, in 1988, some
forty years after the Holocaust, rightist militants announced their
party's candidacy in communal elections under the banner of their
primary initiative: "Foreigners get out—National Assembly"
(*Ausländer raus—Nationale Sammlung N.S.*).[38] In the city of
Langen, in southern Germany, such a campaign initiative was pro-
moted by flyers which declared that after the elections in autumn
1988, "A storm of renewal will sweep through our town," and
"Langen will become the first city hostile to foreigners" (*fremden-
feindlich*).[39]

Such attitudes, transformed into violence, surfaced with particu-
lar force during the period of German unification:

> On Thursday, October 3 [1991], Germans marked the one-year anniver-
> sary of reunification. Some celebrated with a rampage of neo-Nazi vio-
> lence against foreign workers and asylum-seekers . . . Arson attacks,
> stabbings, and beatings . . . threats and racial slurs . . .
>
> In the city of Hoyarswerda, neo-Nazi youths hurled rocks and Molotov
> cocktails at buildings housing foreign workers and asylum-seekers. A
> large crowd stood by and cheered—particularly when a bus convoy trans-
> porting foreigners out of the city was attacked. (Thaler 1991: 14)[40]

The burning and bludgeoning of refugee bodies continued for
several days without police interference. Onlookers watched, chant-
ing: "Germany for Germans! Foreigners get out!" (*Deutschland den
Deutschen! Ausländer raus*).[41] In their graffiti, the political right
called for the expulsion of all ethnic others. One such example,
which had appeared on the radio tower in Frankfurt, expressed the
desire to purge the German nation of foreign (and polluting) mat-
ter: "Foreigners out of Germany, excrement out of the body"
(*Ausländer raus aus Deutschland, Scheisse aus dem Körper*).[42]

In their protests against such forms of terror, supporters of the Anti-Fascist League in Berlin and elsewhere made use of the following formulaic slogans.[43]

"Turks in! Nazis out!"
(*Türken rein! Nazis raus!*)

"Nazis get out!"
(*Nazis raus*)

This text, which appeared on a house wall in Berlin's city center (see figure 20), demands the expulsion of fascists. Spray-painted in red capital letters, the implied urgency of the postulate is supported by visual means. The typographic message fades into the image of a grotesque, mask-like face, a template of the despised "Nazi." Drawn with exaggerated oriental features, the image signifies the alien or foreign. This Leftist graffiti is an attempt at demonization, accomplished by a disturbing reliance on race-based iconographic markers. Such a depiction of evil, which envisions "the Nazi" as an "Asiatic threat" that must be stopped, expunged or driven out, entails an unsettling confusion between the perpetrators of genocide and their victims. As Omer Bartov (1998) observed:

> West German representations of the past have often included the figure of "the Nazi." This elusive type, rarely presented with any degree of sympathy, retains a complex relationship with its predecessor, "the Jew." Serving as a metaphor for "the Nazi in us," it inverts the discredited notion of "the Jew in us" [a racist axiom propagated by National Socialists] . . . Simultaneously, it presents "the Nazi" as the paradigmatic other, just as "the Jew" had been in the past . . . The new enemy of postwar Germany, "the Nazi," is thus both everywhere and nowhere. On the one hand, "he" lurks in everyone and, in this sense, can never be ferreted out. On the other hand, "he" is essentially so different from "us" that he can be said never to have existed in the first place in any sense that would be historically meaningful or significant for . . . contemporary Germany [or] the vast majority of individual Germans . . . Hence "we" cannot be held responsible for "his" misdeeds. Just like the Devil, "the Nazi" penetrates the world from another sphere and must be exorcized. (792-94)

For the New Left, "the Nazi" is a metaphor of the satanic ele-

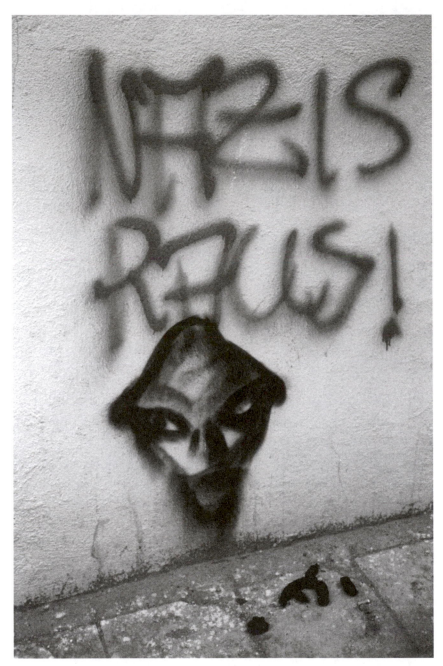

Figure 20. *"Nazis Out": Anti-Fascist Graffiti, Berlin 1994.* Photograph copyright Uli Linke.

ment in German postwar society: a legacy of the Holocaust. The spray-painted portrait of "the Nazi" reveals deep-seated anxieties about the ubiquity of evil—an elusive threat that is rendered tangible through images of racial difference. Such a representation of "the Nazi" as Asian (Jewish) Other serves two purposes. It distances Leftist Germans from the past and acquits them of their sense of guilt by placing Nazis into a separate, race-marked category. Moreover, their conflation of the Nazi threat with "the Asian/Jewish menace" (a postulate of the Third Reich that is rehabilitated by unthinking anti-Semitism) also greatly facilitates the New Left's sense of martyrdom and victimhood.

> Nazis get out!
> Drive the Nazis away. Foreigners stay.
>
> (Nazis raus.
> Nazis vertreiben, Ausländerinnen bleiben)

The text, painted on the facade of a university building in West Berlin (see figure 21), demands the expulsion of fascists while opposing the extradition of non-Germans. Written as a political protest, these anti-fascist slogans advocate tolerance of ethnic diversity. But the chosen language of expulsion (*raus* "get out," *vertreiben* "drive away") and emplacement (*bleiben* "stay") operates from assumptions of a 'pure' nation, and taps into postwar memory formations of blood, history, and homeland. The German term "expulsion" *(vertreiben)* refers to the forced removal or extradition of people from a national domain: it conjures images of territorial dislocation or displacement. Under Hitler, before 1945, this meaning of expulsion was employed by National Socialists to describe their policy of Judeocide: to kill and to "drive out the Jews" *(Juden vertreiben)*. After 1945, with the collapse of the Third Reich, the language of expulsion became a signifier for victimization, referring to those Germans displaced by Hitler's war in Eastern regions *(die Vertriebenen)*. In such contexts, and as used by these slogans, expulsion means "termination," an uprooting, which kills, renders home-

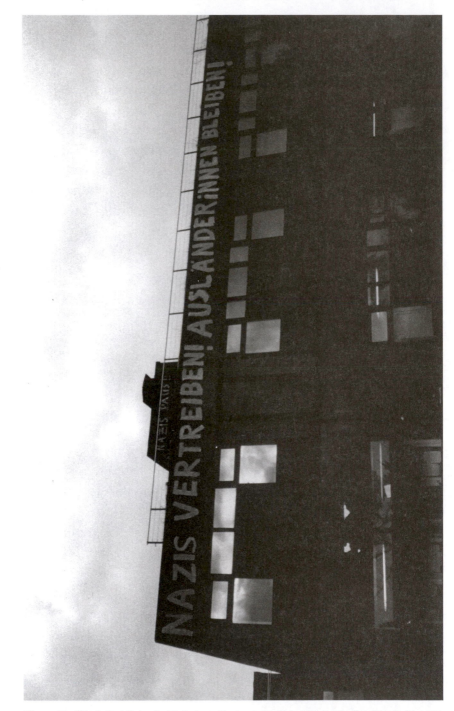

Figure 21. *"Nazis Out! Drive the Nazis Away, Foreigners Stay": Anti-Fascist Graffiti, West Berlin 1989.* Photograph copyright Uli Linke.

less and exiles. The German discourse of expulsion works from assumptions of a political community, a "homeland," that is defined by contrast to all that is foreign or distant: a quasi-mythical realm— fixed, unitary, and bounded—it privileges "racial purity" and "homo-geneity" (Peck 1996: 482–83). In the German historical imagination, this concept of homeland *(Heimat)* is invoked as "a syn-onym for race (blood) and territory (soil)—a deadly combination that led to exile or annihilation of anyone who did not 'belong' . . . Under the National Socialists [it] meant the murderous exclusion of anything 'un-German'" (Morley and Robins 1996: 466). As an act of rhetorical violence, the slogan's demand to banish or to expel "Nazis" (that is, right-wing extremists) taps into this nationalist dis-course of "murder" and "homeland" *(Heimat)*.

Other Leftist slogans make explicit this desire to eradicate the "enemy" by relying on a language of elimination:

"Garbage out! Human beings in!"
(*Müll raus! Menschen rein!*)

"Foreigners stay! Drive the Nazis away!"
(*Ausländer bleiben! Nazis vertreiben*)

"Nazi dirt must be purged"
(*Nazi Dreck muss weg*)

"Annihilate the brown filth!"
(*Hau weg den braunen Dreck*)

"Keep your environment clean! Get rid of the brown filth!"
(*Halte Deine Umwelt sauber! Schmeiss weg den braunen Dreck!*)

"Nazis out! Cut away (exterminate) the excrement!"
(*Nazis raus! Hau weg den Scheiss!*)

We see here that the German rhetoric of expulsion, as exempli-fied by the oppositional terms *rein* and *raus*, transcends historical and ideological boundaries. Unlike the corresponding "into" and "out of" in English, the terms *rein* and *raus* are not merely spatial referents. Their use is grounded in a paradigm in which the nation,

the imagined political community, is a human body. The denial of
membership, and the expulsion of people, is linguistically concep-
tualized as a process of bodily discharge: a form of excretion or elim-
ination. German *raus* belongs to a semantic field which defines
expulsion as a physiological process, a process of termination and
death (*aussen, ausmachen, heraus, Garaus, austilgen, ausmerzen*, etc.).
German *raus* is also a historic cognate of terms like Latin *uterus*, Old
Prussian *weders*, and Old High German *wanst* denoting belly, stom-
ach, uterus, intestines.[44] German *raus* thereby retains a metaphoric
connection to body parts that expel or excrete waste matter.

The converse of this discorporative symbolism, designated by
the German term *rein*, is likewise based on a physiological model.
The affirmation of membership, and the inclusion of people, is lin-
guistically conceptualized as a process of incorporation and simulta-
neously as a process of homogenization and cleansing. Indeed,
German *rein* belongs to a semantic field that comprises both mean-
ings (*herein, reinlich, einig*).[45] This duality is reflected in contempo-
rary German usage. *Rein* signifies inclusion as in *Türken rein*,
literally "Turks in," a slogan coined in the 1980s by the political left,
advocating an agenda of ethnic integration. The term also denotes
purification or cleanliness as in *Judenrein*, meaning "cleansed of
Jews," an expression coined in the 1930s, articulating a program-
matic concern with racial purity. One of the announced Nazi goals
was to make Germany *Judenrein*, that is, "free of Jews," an impera-
tive for purging (Bauman 1989: 104; Dundes 1984: 126). The
metaphoric equation of purity with membership is further attested
by evidence from semantic reconstructions: German *rein* is a his-
toric cognate of terms like Old High German *hreini*, Gothic *hrains*,
and Old Saxon *hritian* denoting cut, separate, rip, slice, tear, sever.[46]
As suggested by the linguistic evidence, the claim to German mem-
bership always requires some form of purging: the excretion of pre-
sumed filth or the excision and amputation of contaminants.

Images of ethnic integration or German solidarity are often
expressed in terms of this corporal language of expulsion, a language
through which killing is redefined as therapeutic. Interestingly,

physicians who participated in genocide under Nazism often used the same rationalization to legitimate their participation in mass killing. Frequently, they drew analogies to surgery: Just as a physician, in order to heal, will cut off a gangrenous leg, so the "social" physician must amputate the sick part of society (Lifton 1986). Racial differences were presented, and treated, as matters of medical pathology.

Effacement: Supplanting Unwanted Identities

During the late 1930s, the body emerged as an important symbolic site in the struggle for the representation of identity. Jews—defined as racial others—were marked by public emblems to make them visible and easily identifiable as members of a subaltern category. These emblems, which simultaneously represented and "essentialized the enemy" (Burke 1989: 213), were derived from an assortment of traits by which a class of typified others was defined: The yellow six-pointed star (signifying a demonized religion) was selected for Jews; the pink triangle (signifying the feminized male) for homosexuals.[47] Such emblematic representations, interpreted as metonymic signs, rendered the constructed characteristics of otherness natural and authentic: Classificatory demarcations became "key symbols" (Ortner 1973) of identity, synthesizing and collapsing, in an undifferentiated way, the racial suppositions of the German fascists. In prewar Germany, the political right employed symbolic strategies that facilitated the exaggeration and manufacture of alterity. Stereotyping by looks—branding on sight—was basic to German racism, "a visually centered ideology" (Mosse 1985: 133-52). Members of subaltern social categories were made clearly recognizable in order to be punished, controlled, excluded from society.

In post-cold war Germany, such identity-constructing mechanisms were replaced by a different kind of terror: the erasure of place and self through the symbolic imposition of the swastika. Worn, as adornment, on a chain or as a tattoo on the body, this terrifying sign

has reappeared in German youth culture as an emblem of the politics of race. In the swastika we recognize a sign which, above all other signs, ought to be fixed, solidified, in its cultural meaning and connotation forever: "And yet there it dangles, partly — but not entirely — cut loose from its profound cultural reference in twentieth-century history. What does it mean? What is it signifying?" (Hall 1981: 237–8). For members of the political right, the swastika is an integral part of the German language of expulsion: It symbolizes the early stages of their "movement," provides an emblem for German racial purity, and is equated with the "banner of blood."[48] Projected out of and extracted from German history, the swastika is used as a form of symbolic self-proliferation: Inscribed in the body as "a stereotyped symbol of physical strength and aggressiveness" (Favazza and Favazza 1987: 127), the swastika displays a sense of shared identity. Yet its reproduction, and the terror which it represents, aims to extinguish otherness. Its use in rightwing graffiti becomes itself a signature of violence, a manifestation of the desire to eradicate all traces of that which is different. This occurred, for instance, when in July 1993, in the town of Gansee, in Brandenburg, rightist youths spray-painted the building facades along the length of several city blocks in a working-class neighborhood with black swastikas;[49] when during the same month, in the city of Augsburg, rightist militants set fire to a business owned by a Turkish immigrant and then painted a black swastika on the door of his warehouse;[50] when one night in October 1992, in southern Germany, rightist vandals painted a memorial for victims of Nazi death camps with swastikas;[51] or when in August 1993, in the city of Worms, neo-Nazis painted swastikas and SS signs on more than a hundred tombstones at a Jewish cemetery.[52] The reclaiming of place and space, laying claim to *Lebensraum,* through the symbolic power of the swastika, is coordinated with the erasure of otherness through the violation and profound transformation of the subaltern body.

In August 1993, in the town of Lotte, near Osnabrück in northern Germany, rightist militants attacked and savagely beat a twenty-four-

year-old Turkish man. After he lost consciousness, they spray-painted a black swastika on his forehead.[53]

In November 1992, in Bautzen, northern Germany, two neo-Nazis attacked the fourteen year-old Dominique K.: They called her a leftist slut and then, with a knife, sliced a palm-size swastika into the side of her face.[54]

In December 1992, in Düsseldorf, three rightist militants attacked a young Greek girl. "You don't belong here," they told the sixteen-year-old, and then, with a knife, carved a swastika into her forehead.[55]

In January 1994, in the eastern city of Halle, three skinheads attacked the seventeen-year-old Elke J., a girl confined to a wheelchair. When she refused to chant their slogans, "Gas the cripples!" and "Foreigners get out!," one of the attackers pulled out a knife and cut a crude swastika into the left side of her face.[56]

Such acts of terror, with their symbolic evocation of transgression and rape, seek to transform salient others into emblematic signs, capturing (and annihilating) difference with the same icon—the swastika. The use of this symbol is clearly intended as a colonizing strategy: an extension of the "white male terror" into the urban landscape, and into the body of the racialized outsider—the foreigner, the immigrant, the erotic woman, the cripple.

Political Complacency: Sustaining Racial Violence

In November 1991, Chancellor Helmut Kohl called the attacks on immigrants "a disgrace, a blemish for Germany" because "we would not have reached our standard of living, our affluence, without foreign labor."[57] At the same time, Kohl announced his intent to "pursue the perpetrators without lenience" because they had "degraded Germany's standing in the world community."[58] Two years later, in October 1993,

[A]fter a long period of playing down the violence . . . Chancellor Helmut Kohl and other leaders have taken a sharper tone of condemnation: "The damage that neo-Nazis have done to our reputation in the world cannot be described drastically enough," Mr. Kohl said last month. (Whitney 1993: A1)

A series of arson attacks against eastern European refugees were reported from the vicinity of Bamberg, Upper Franconia, in February 1989. During the first incident, two firebombs were hurled against a housing complex occupied by fifteen refugees from Hungary and Poland. As reported by the news media,

> Memmelsdorf residents react with indifference to last night's occurrence; the Catholic priest points out that after all one asylum-seeker costs the government 2,300 marks each months. The refugees live in fear . . . 24 hours after this attack another Molotov cocktail is thrown against the door of a residential project at the outskirts of Bamberg. This former shelter for the homeless also houses refugees, primarily from eastern Europe . . . The police, after the last arson attack, . . . refuse to talk about a right-wing movement in and around the city of Bamberg . . . [Instead] police even consider a family quarrel as a possible motive. A policeman, delegated to protect the homes, does not want to exclude the probability that the refugees started the fire themselves in order to gain public attention. (Siegler and Ennsle 1989: 5)

In December 1988, the nineteen-year-old Josef S. was arrested in connection with the firebombing of a residence in Schwanndorf, northern Bavaria: The inhabitants, three Turks and one German, were killed by the fire. Josef S. confessed and admitted to the act of arson "out of rage against foreigners." The man was known to local law enforcement officials because of his previous involvements with the right-wing organization *National Front.* Several thousand mourners marched in silent protest. But according to news reports,

> Schwanndorf's mayor does not see it necessary to attend the demonstration. For him, there is "no reason for such a declaration." He does not participate for fear of giving the impression that "here in our town is a stronghold of neo-Nazism and that one has to fight against such tendencies." . . . There is, according to the judicial press secretary Guerrein, no evidence that links Josef S. "to the members of a rightwing radical group or youth organization." . . . Police and the prosecution cultivate their version of the perpetrator as "a loner without political affiliation" (Siegler 1989:5).

Street violence against immigrants is sustained (if not promoted) by the attitudes of German law enforcement officials. For instance, when in late August 1993, in Lotte near Osnabrück, northern

Germany, a twenty-four-year-old Turkish man was attacked and savagely beaten by rightist militants so that he had to be hospitalized, police and prosecutors could not confirm that the man was a victim of rightist violence. On the contrary, they charged him with conspiracy and participation in "the fabrication of an unlawful act."[59] The case was closed—the investigation remained inconclusive.

Collusion: Uncovering Residual Memories

The resurgence of violent nationalism can be documented in other contexts. Reporters for the German weekly *Die Zeit* describe a celebration of election results by right-wing Republicans at their party headquarters in Cham, Bavaria:

> There they hovered with their obese bodies in their folk costumes, red-faced with rage and fixated eyes and shouted . . . When the reporter blocks the view of the guru [party leader], someone in the back calls out "Beat it or else you'll end up in Dachau." Similar outbursts were directed against the small crowd of brave protesters outside the beer hall. "Parasites!" "Gold-bricks!" "Kanakas!" they are called . . . "To the gas with them. The cancerous growth must be gassed," a man hisses in passing. (Grill et al. 1989: 17)

In late October 1992, an arson attack destroyed an unoccupied building in the town of Dolgenbrodt, near Berlin; the building was scheduled to become a shelter for political refugees. Prosecutors subsequently pursued reports that the residents of this German town raised money to pay rightist youths for burning the shelter. Their investigation revealed that just before the incident,

> [S]everal dozen Dolgenbrodt residents met in a local tavern to discuss the pending arrival of asylum-seekers. According to press reports, some of them expressed fear that the refugees would be Gypsies who, having nothing to do in the placid village, would turn to house-breaking and other crimes.

> Several nights later a group of youths on motorcycles . . . drove by the hostel. One youth threw a firebomb, and the hostel burst into flames . . . [Almost 6 months after the event, police finally detained a suspect]. He later confessed and told them that he had been paid for his participa-

tion . . . The money [for the firebombing] is said to have been secretly collected from the 250 townspeople. (Kinzer 1993: 1, 6)

By August 1993, almost a year after the incident, the nineteen-year-old suspect began to deny his participation in the firebombing, but admitted that others—having received "logistic support" from the village population—had taken the money. While rejecting the accusation of popular conspiracy, the mayor of Dolgenbrodt, Ute Preissler, confessed: "We were not particularly sad when our problem was temporarily resolved [by the fire]."[60]

Enactments: The Routinization of Violence

German antifascist activists, voicing their opposition to the nationalist resurgence, publicized their protest against violence through the following formulaic slogans:[61]

"We rip open/tear up the Republican's asses!"
(Wir reißen den Republikanern den Arsch auf)

"Hit the skin (heads), until they split/burst!"
(Haut die Glatzen, bis sie platzen)

Such acts of narrative violence tend to follow a predictable pattern: Intended as a political response to the brutalization of refugees, these critical utterances by leftist protesters often consist of violent verbal formulaics. For instance, in January 1988, in Schriesheim near Heidelberg, six young men (four of them skinheads) entered a shelter for political refugees and savagely beat two Indian men with wooden sticks, insulted and threatened the other residents, and then left unrecognized. The police were able to apprehend the perpetrators several days thereafter.

Days before the beginning of the trial [almost a year later], a flyer by an "anti-fascist action group" circulated at the universities in Mannheim and Heidelberg. It encouraged "attendance at the Nazi trial": "Don't give an inch to the fascists!" "Hit them/beat them wherever you meet them."

"Foreigners stay, drive the Nazis away!"[62]

In West Berlin, in January 1989, immediately after the Senate elections, antifascist activists and members of the Green/Alternative Party assembled in protest. Their anger was directed against the militant right-wing party of Republicans, which had unexpectedly gained eleven seats in the Berlin Senate. The protesters organized nightly demonstrations, where they displayed banners expressing their political sentiments. One banner showed a clenched human fist smashing a swastika, fragmenting it. Another banner, a white cardboard poster fastened to a stick, showed a tightly closed fist squashing (with a top-down movement) a black swastika, crushing it beneath (see figure 22). A large banner, carried by several protesters, read: "University rage against the Nazi *brood" (Uni Wut gegen Nazi Brut)*. The sign's red-lettered text appeared on a white cloth, which, as its centerpiece, displayed a black swastika smashed (broken) by a clenched fist (see figure 23).

In this example, student opposition to right-wing extremism, accentuated by the smashing of a swastika, is made verbally explicit. The slogan names the protesters' target of wrath: "the Nazi brood!" *(Nazi-Brut)*. In this instance, violent opposition is directed not against fascism, but its postwar legacy: Hitler's progeny. The reference to Nazi "brood" *(Brut)* conjures frightful images of evil: beastly offspring, a litter of non-human fiends, which—hatched and cared for—populate the world. By drawing on genealogical metaphors of "progeny" and "breeding," the protesters speak of their right-wing opponents as a colonizing threat. But this language of propagation also entails an act of racialization: the political enemy is typified by reference to dehumanizing and biologizing symbols. Such a choice of signs compels the use of violence: Brutality and uncontrolled anger is turned into a weapon of defense. Painted in red (a Leftist symbol for sacrifice and revolution), the word "rage" alludes to a berserker state *(German Wut* "fury"), an irresistible drive that relies on bloodshed as a violent or cathartic release (Jones 1951: 262). The slogan's accompanying visual image recommends annihilation: a fist smashes a swastika. The fist extends from the figure of a bear,

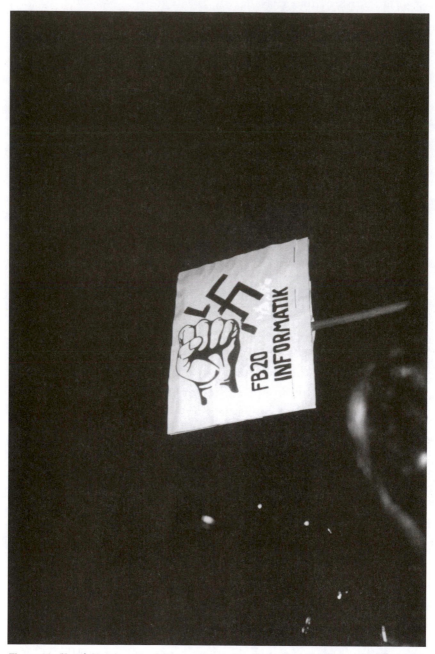

Figure 22. *"Smash Nazi Incursions" (Human Fist Bashing a Swastika): Anti-Fascist Poster, West Berlin 1989*. Photograph copyright Uli Linke. In this motif, perhaps an iconographic representation of the verbal slogans "smash the Nazi gangs" and "hit them/beat them wherever you meet them," we see a human fist punching a swastika, breaking it upon impact. The swastika stands as an emblem for fascism and its postwar progeny.

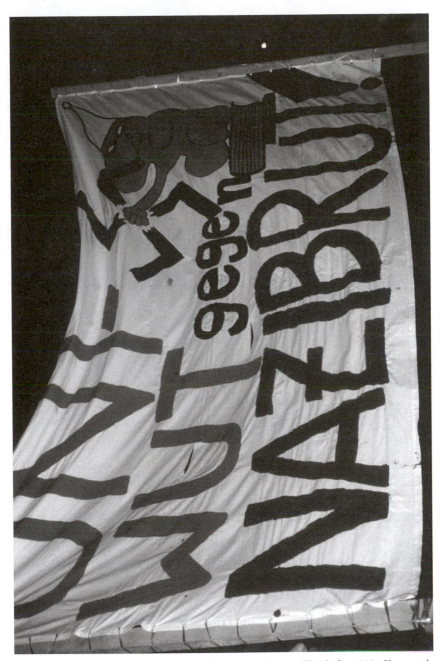

Figure 23. *"Eradicate the Nazi Brood": Anti-Fascist Protest Banner, West Berlin 1989.* Photograph copyright Uli Linke.

the traditional emblem of the city of Berlin. This identification of political activists with a geo-political site expresses the overt desire to eradicate or banish "Nazis" from a concrete social domain.

Another banner, made to resemble a national flag, fashioned from red-and-green cloth (the emblems of the urban environmentalists and the old Left), showed a large human fist smashing a black swastika (hitting it dead center, fragmenting it) (figure 24). Yet another banner displayed a human skeleton made of cloth and paint. It was accompanied by a cardboard sign which read: "Hit/smash away/annihilate (hack) the brown filth [*Hau weg den Dreck*] (figure 25). Variants of this slogan appeared in protest chants, on stickers, and as graffiti.

> "Death to fascism!"
> (*Tod dem Faschismus*)

Below this text, painted in red, were two gallows from which dangled an SS sign and a swastika (figure 26).

> "Smash the Reps to bits!"
> (*Reps zerschlagen*)

Spray-painted, in jet black ink, on the facade of a house in downtown Berlin, was a gallows from which was suspended a black swastika.

> "Nazis out!"
> (*Nazis raus*)

The slogan was accompanied by a black SS sign with a horizontal red bar superimposed, the mark of an antisymbol (figure 27).

> The letter "A" (for anti, anarchy, autonomy, alternative) and "caution, right-free zone" (*Achtung! rechts-freie Zone*) was written on a housewall.

This slogan played with the double meaning of the German term *Rechtsfrei*, which denotes "right" both in a political and legal

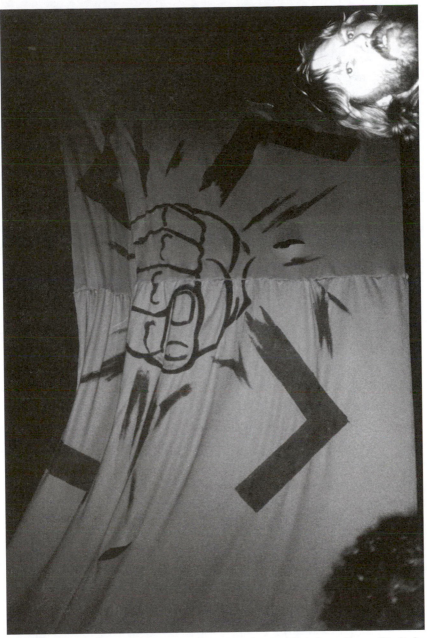

Figure 24. *"Smash Nazis" (Human Fist Fragments a Swastika): Anti-Fascist Protest Banner, West Berlin 1989.* Photograph copyright Uli Linke. Central to this message of Leftist political opposition is an iconographic image: a clenched human fist fragments a swastika. The fist, as a physical or corporal sign, makes tangible the anti-fascist agenda of potential political allies: the Green Alternative Party (the "new" Left) and the Social Democratic Party (the "old" Left), which are represented through their emblematic colors—red and green. [The "fist" and "swastika" are painted in black on red and green cloth.]

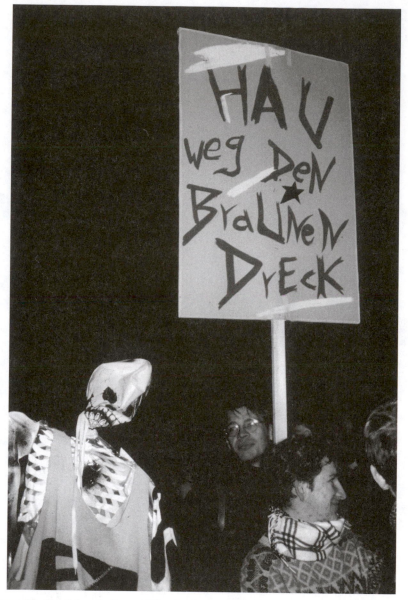

Figure 25. *"Annihilate the Brown Filth": Anti-Fascist Iconography (Image and Banner), West Berlin 1989*. Photograph copyright Uli Linke. The text advocates the extermination of political opponents, Neo-Nazis, who are reduced to muck or dirt: "Hack/smash away the brown filth!" *(Hau weg den Dreck)*. The enemy's reduction to dirt, specifically excrement, taps into race-based fantasies of "elimination"—a legacy of the Holocaust. Until 1945, under Hitler, German anti-Semitism was promulgated by an obsessive concern with scatology: Jews were equated with feces and dirt, a symbolic preoccupation that encoded Germany's drive for "racial purity" (Dundes 1984). The protesters' banner, which demands the violent erasure of "brown filth"—a circumlocution for "Nazis" as fecal waste—is accompanied by a large skeletal figure. The iconography of skull and bones warns against Nazi perpetrators: life-takers, death-givers.

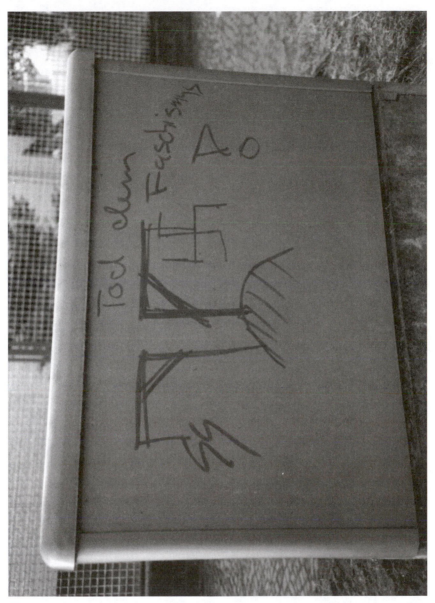

Figure 26. *"Death to Fascism": Anti-Fascist Graffiti, West Berlin 1989.* Photograph copyright Uli Linke. Text and image demand annihilation: "Death to fascism!" *(Tod dem Faschismus)*. The stylized gallows proclaim the fantasized killing of Nazis through their signifiers—the swastika and the SS sign. The verbal message affirms the visual recommendation: "Hang Nazis." [The graffiti is painted in red.]

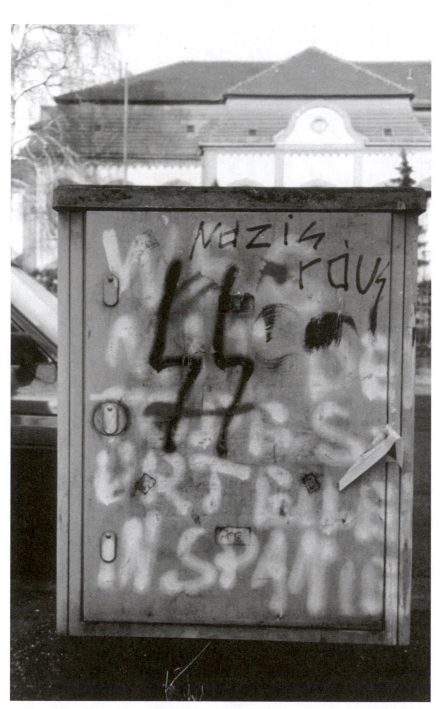

Figure 27. *"Nazis get out": Anti-Fascist Graffiti, West Berlin 1989.* Photograph copyright Uli Linke. The text demands the expulsion of fascists: "Nazis get out." The visual image affirms this mandate: the black SS sign is symbolically deleted or crossed out by a horizontal red line.

sense: It refers to lawlessness and being free or purged of rightists. Below this text appeared a single zigzag arrow (an inverted S from SS) pointing up.

"Rulers will pay!"
(*Herrscher werden zahlen*!)

Below this graffiti was a triangle (the Nazi concentration camp insignia) intersected by a single zigzag arrow (an inverted S from SS) pointing up.

"Croak storm troopers! Holocaust!
Death to all neo-Nazis!"
(*Sturm Staffel verrecke! Holocaust!*
Tod allen Neo-Nazis)

"Croak/rot to death, Republicans! Out of the Senate.
Signed Red/Green."
(*Reps verrecke! Aus dem Senat.*
gez. Rot/Grün)

In these antifascist protests, German activists often equated their opponents with "Nazis." In one example, an election campaign poster showed the candidate for the conservative Christian Democratic Party shaking hands with a taxi driver. The graffiti text was written across the poster: "dumb idiot, pig, liar." A black swastika added further emphasis to the protester's message: From it, an arrow pointed directly to the mayoral candidate, linking him to fascists. In another instance, the political message of a Christian Democratic election poster was countered by a "do not litter" sign: A red-on-black sticker displayed a stylized man throwing a swastika into a trash bin. In this case, a conservative party was equated with Nazism and with dirt that must be disposed of. I noted a similar message on another election poster: Its campaign text had been partially erased or torn off and rewritten. The original text "Berlin needs him" (*Berlin braucht ihn*) had been changed to "hit/smack/slap him" (*haut ihn*).

Similar forms of narrative violence appeared in formulaic statements such as "smash the Reps to pieces!" (*Reps zerschlagen*) or

"bash the Nazi gangs" (*zerschlagt die Nazi Banden*), a graffiti text (typically written with green paint) that was accompanied by the image of a fragmented swastika or some other shattered icono-graphic representation of the militant right (i.e., the acronym NF [National Front] or NS [National Assembly] used by neo-Nazi groups). Variants of this motif appeared in the following slogans (see figure 28):

> "With shovels hit the Nazis on their heads until they crack"
> (*Nazis mit den Spaten auf die Köpfe hacken bis sie knacken*)

> "Hit the Nazis in the neck until their throats crack"
> (*Haut den Nazis in den Nacken bis die Hälse knacken*)

> "Hit the fascists on the nose and reach orgasmic ecstasy"
> (*Haut den Faschos auf die Nase und geratet in Extase*)

> "Don't give an inch to the fascists!
> Hit them/beat them wherever you meet them!"
> (*Keinen Fussbreit den Faschisten! Schlagt sie wo ihr sie trefft*)

The final set of examples derives from observations of a political demonstration that was organized in solidarity with the remaining Red Army Faction members held in German prisons.[63] The organiz-ers protested the conditions of their internment: solitary confine-ment, a sentence imposed during the late 1970s. The demonstration was organized by members of the Berlin Anti-Fascist League, under the auspices of the Green/Alternative Party. As in other typical marches, the assembled participants were rallied behind the carriers of a large banner that conveyed the primary message of protest: "Against solitary confinement" (see figure 29). This lead cluster of demonstrators, consisting of the mothers of the inmates, was fol-lowed by protest supporters (masked with Palestinian scarves) and the Green/Alternative membership (attired in a colorful blend of punk, red hair, bluejeans, and leather) (figure 30). Several marchers were holding a bright-red poster of Rosa Luxemburg (a revolution-ary woman), thereby raising a feminist issue, chanting: "We demand: castration for every bull-pig (i.e. policeman) to be funded

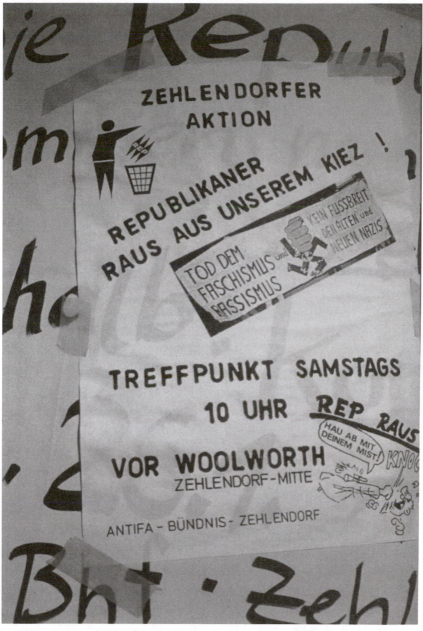

Figure 28. *"Dispose of Old and New Nazis": Anti-Fascist Flyer (Advertisement for Protest Rally against Right-Wing Political Groups), West Berlin 1989.* Photograph copyright Uli Linke. The text consists of a pastiche of anti-fascist slogans: "Republicans out of our neighborhood"; "Death to fascism and racism"; "Don't give an inch to the new and old Nazis"; "Republicans get out"; "Get lost with your crap." The images confirm the demand for expulsion: a stylized man disposes of the acronym REP (Republican Party) by throwing it into a trash can; a clenched fist crushes a swastika; an angry punk smashes his fist into the face of a Rightist.

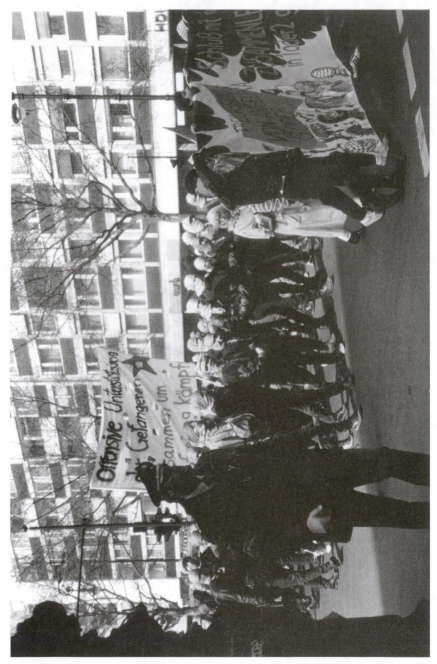

Figure 29. *Green Support for Militant Left: Anti-Fascist Protest Rally, West Berlin 1989*. Photograph copyright Uli Linke. Green/Alternatives and Leftist sympathizers march in support of imprisoned Red Army Faction members. Their mandate requires support for political prisoners.

Figure 30. *"Marching against a Repressive State": Anti-Fascist Protest Rally, West Berlin 1989.* Photograph copyright Uli Linke.

by the national healthcare system" (*Wir fordern: Für jedes Bullenschwein, Kastration auf Krankenschein*) (see figure 31). Others, while marching with interlocked elbows, were repeatedly chanting in chorus: "Build bombs, steal weapons, hit the bull-pigs (police) on their snouts" *(Bomben bauen, Waffen klauen. Haut die Bullenschweine auf das Maul).* Assembled behind these diverse groups were the members of the so-called "black block" *(der schwarze Block):* dressed in black leather jackets, black pants, black army boots, with black face masks (to hide their identities from police surveillance cameras), and large wooden sticks (see figure 32). According to public (official) dogma, the members of the this "black block" were autonomous, politically unaffiliated, alternative lifestyle supporters. Unofficially, however, they were present at every Green/Alternative demonstration that I attended, functioning as a political "alter-ego" for the rally organizers by inciting the use of violence through police provocation. During such encounters, from which Green Party officials could later dissociate themselves, they acted as left "bashers." The name "black block," their black leather clothing and military boots, and their use of public (covertly sanctioned) violence evokes images of Hitler's "black corps" during the fascist period.

Violence in the Political Imagination

When analyzing the rhetorical schemata or discourses of violence which incite the imagination of the political left, the following assessments can be made. German antifascist activists tend to promote the use of violence as a medium for political contestation. A range of highly charged image schema, focused on death, silencing, and physical brutality (typified by the swastika, SS sign, gallows, Nazi rhetoric, and death camps) are appropriated as antisymbols and are transformed into a language of resistance against the German state.

Such images of violence, marked by a language of death and annihilation, with its evocation of simple brutality, ranging from an

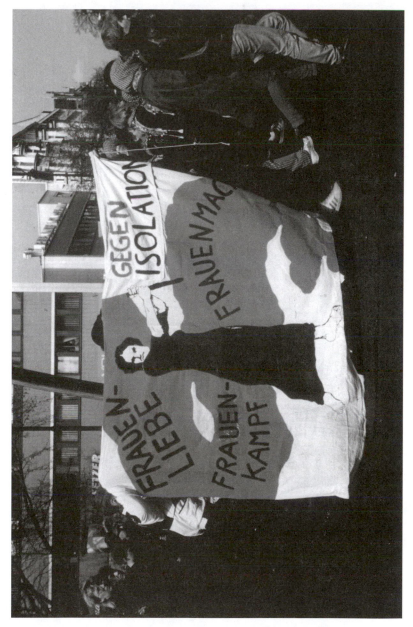

Figure 31. *"Support Female Empowerment": Anti-Fascist Protest Rally, West Berlin 1989*. Photograph copyright Uli Linke. Members of the feminist forum, a political initiative of the Green/Alternative Party, carry a poster of Rosa Luxemburg. The text emphasizes the rally's primary message: "Against solitary confinement" *(Isolation)*. In the image, the revolutionary female figure holds a red banner that advocates female empowerment: "women's love," "women's battle," "women's power." Such statements are directed against the German patriarchal state, and its law enforcement officers. [Text and image are painted in red and black on white cloth.]

Figure 32. *Members of the "Black Block" (i.e. the Autonomous and Alternative Scenes—Kreuzberg): Anti-Fascist Demonstration, West Berlin 1989*. Photograph copyright Uli Linke. Remarkable is the uniformity of these activists' attire: The apparent dress code, which favors the color black, serves as an emblematic expression of political membership. "Black clothing is a visible sign of the renounce-ment of worldliness and carnal pleasure. It was therefore not only the primary color of specific phas-es of the life cycle . . . but also of various religious orders . . . The meaning of black as a sign of world renunciation and, at the same time, of protest against the world are mutually complementary." (Soeffner 1992: 86-88) Among Leftists, black is "a marker for being separate and/or distinct" and "belonging to a renunciatory elite." (89) Articulating a fierce desire for release (a revolutionary promise), the black-clothed body communicates an exculpatory death wish.

advocacy of expulsion to murder by strangulation and bludgeon-
ing, permeated all levels of Green/Alternative politics in Berlin. In
the course of my research (from 1988 to 1994), I uncovered such
fantasies in the domain of political agitation; in the rhetorical
speech-styles of propaganda and campaigning; in the contexts of
organized protest; in the articulation of conflict at the party's grass-
roots level and in committee meetings. Never, however, did I
observe the use of such fantasy material at the level of public ideolo-
gy or parliamentary representation, where instead the global goals of
democracy, peace, women's rights, and environmental protection
were promulgated.[64] How can we explain the prevalence of such vio-
lent fantasy material at the local level? And how does it contribute
to the formation of political identity among antifascist activists?

The most prominent image schemata appeared in the form of
the swastika, SS sign, gallows, and the color black. The political
mobilization of these symbols permits the evocation of the past: The
swastika, for instance, is appropriated as an icon of German history.
It stands as a sign for the Nazi regime: the totalitarian state, the
party, the police and military as well as other administrative agencies
of the fascist state. The icons of German history stand for institu-
tional violence and institutionally enforced violence: the dehuman-
ized, faceless, sanitized perpetration of brutality.

In the oppositional rhetoric of the Green/Alternatives, the
swastika, as the other icons, is mobilized as a metonym, signifying
the congruence of the Nazi regime with the contemporary German
state and its enormous police force and right-wing political spec-
trum. Fantasies of violence, directed against the political Other, are
thereby not merely historicized, but reproduced as templates for
action and identity. Transformed into an antisymbol, the swastika
is integrated into a "key scenario" (Ortner 1973)[65] in which the use
of violence is legitimated and tangibly "embodied": the clenched
fist, signifying the "muscle" of the Green/Alternative membership,
resists and crushes the iconographic emblems of Nazi institutions.
In the oppositional discourse of the political left, the swastika (the
sign of difference) is turned into an effigy: The work of violence is

performed on a disembodied signifier. Projected onto a lifeless sign, fantasies of murder and dismemberment can be released because the overt connection to victimized bodies and Auschwitz has been repressed.

Through a reversal of these depictions of "disembodiment," the violent content of the key scenario, with its message of death and brutalization, is intensified. The use of a generalized social category, such as "Nazis," unlike the iconographic evocation of the past, promotes recognition of membership and agency. The term "Nazi," unlike the swastika, stands for the human (rather than the institutional) perpetrator of genocidal cruelty. It thereby permits or even invites the equation with other contemporary agents: the "bulls" or "bull pigs" (police officers), the "Reps" (Republican Party members), "fascists," "neo-Nazis," and so on. In the political slogan, the social and historical reality of the "Nazi" is made tangible by his physicality of presence—he is embodied. The textual references envision "Nazis" with heads, necks, throats or mouths, and sometimes genitalia, to which acts of violence can be applied. In these key scenarios, the fantasizer assumes a disembodied presence: Violence is inflicted through technical contraptions or instruments—the gallows, the shovel, the clenched fist. The fantasy is focused on the act and consequences of violent behavior: crush, crack, smash, hit, hack, kill. The implied brutality of Green (antifascist) political fantasy is shocking because of the casual invocation of murder and the rhetorical absence of emotional affect.

What role do these scenarios assign to violent agency? Is there a connection between the articulation of brutality and the concealment of the figure of the leftist perpetrator? In these texts and images, the antifascist—who acts out such violence in fantasy—appears only as a faceless, disembodied signifier. In the political slogan, which expresses the intent to kill, the perpetrator stands outside the violent fantasy. By a reliance on killing tools or implements, human agency remains elusive, even tenuous. By dissociating himself from the proposed act of murder, the leftist protester is able to blot out or evade the question of guilt.

Such murderous fantasies, which seek to expunge the political opponent, avoid engagement with the past: Social memories of the Holocaust are invoked to create a stage on which other kinds of battles can be fought. In these confrontations, "the Nazi" is used as an uncontestable sign of evil, however, without making reference to the ideology of racism that gave rise to the Judeocide. In Germany, political activists speak of "fascism," not Nazism. In East Germany, this made the phenomenon consistent with the Marxist schema. Fascism could, if necessary, be taken as a variant of capitalism. But genocide is something quite different. "For Germans from the West, the use of the word 'fascism' instead of 'Nazism' places Hitler's regime on a level with those other dictatorships of Mussolini, Franco, and Pinochet. It evades the very essence of Nazism, that is, an ideology based on racism and carried to its logical conclusion, the 'final solution' and the ruling of the world for one thousand years by the Aryans. There is no way of saying anti-Nazi in German. [Leftists] use the word 'anti-fascist'" (Chasseguet-Smirgel 1988: 126). Such semantic manipulations permit a certain confusion between categories. In their protests, the West German Left defines Nazis as fascists. The Nazi becomes an ascriptive label that is generalized to include all agents political power: the police, the state, men in uniforms. As "antifascists," leftists place themselves in opposition to these figures of authority. Once equated with embodiments of evil, attacks against them seem legitimate.

Inversions: The Ambiguities of Memory

In Troschenreuth, a village in Upper Franconia, the nationalist Republican party received more than half of the electoral votes. Here, the far right has a simple majority. Yet in February 1989,

> After the Berlin elections, the [spray-painted] slogans: "Nazis out!" and "Thwart the early beginnings!" were clearly displayed on a wall in the center of the village. They have remained there until today and provoked Dettenhoefer's son [the son of the nationalist village leader] to draw oblique historical comparisons. "That's just how it got started back then, when people began to defile the synagogues." (Grill 1989: 15)

In February 1989, in West Berlin, after an antifascist protest rally, the following graffiti text appeared on the wall of a subway station:

"With shovels hit the Nazis on the neck,
until their bones crack"
Signed Janina
"Nazis were Jews"
(*Mit Spaten haut den Nazis auf den Nacken*
bis die Knochen knacken.
Gez. Janina.
Nazis waren Juden)

In these examples, history and genocide have been redefined: Nazis and Jews, perpetrators and victims, are equated, legitimating the use of violence, past and present, against both. In such scenarios, contemporary Germans (conservatives and leftists) seem to see themselves, by implication, as the real objects of threat and suffering. Their use of violence against the presumed threat can be rationalized as a matter of self-defense.

Interpretations of Narrative Violence

Anthropological interpretations of the coercive mechanisms of power have tended to regard the occurrence of violence as atypical, abnormal events, as a form of action or behavior that inevitably disrupts the continuity of intentions, the regularity of behavior, on which causal, historical, or structural accounts are based. However, in some cultural contexts, as Robert Thornton (1988) suggests, "violence is constitutive of social order and social identities through the elaboration of narratives and political symbols that provision the ongoing political process" (3–4). In other words, when we explore the cultural characteristics of violence as a social process and social form, we seek explanation in terms of the actors' symbolic representations of community, self, and the state, rather than in terms of instrumental action within a formal political system. Violence has cultural and symbolic dimensions, which are imposed upon acts of violence through attempts at interpretation and understanding.

According to Thornton, it is precisely because people routinely represent violence to themselves in terms of causal frames that politics can appear to "use" violence instrumentally. What it uses, however, are the rhetorical narratives, memories, images, and signs, which people construct in order to understand violence and give it meaning (Feldman 1991; Thornton 1990a, 1990b).

But it is not only the interpretation of violence that is intrinsically cognitive and discursive. Although violence relies on the use of implements, as Hannah Arendt (1990) observed, and acts of violence are perpetrated on others by the use of such implements, these tools of violence are not necessarily physical. Violence, as suggested recently by Pierre Bourdieu (1991), can also be symbolic and narrative. Acting below the level of consciousness, narrative violence may be concealed or unseen, but it makes its presence felt in quasi-physical form.

Discursive or narrative forms of violence are expressions of what Maurice Godelier has termed "conceptual" violence:

> Though committed in thought and by thought, this violence joins with other, less conceptual [ideél], that is, physical, forms of violence, humiliation, insults, and other kinds of psychological violence, and social violence as well . . . However, these various kinds of violence break out on relatively rare occasions . . . Conceptual violence, on the other hand, lies permanently at the heart of the . . . entire social organization, in every aspect of . . . practice; what makes it so efficient is that, as the ideas arise, they are self-legitimizing and justify all the forms of physical, psychological, and other violence. Such violence steps beyond the bounds of thought yet forever refers back to it for recognition that it is part of the very "order of things." (148)

As a symbolic medium, violence plays an important part in the formation of contemporary German identity. If we take Anderson's notion of the nation as an "imagined political community" (1992), then images of violence are among the principal themes which structure the German imagination. Common to all discourses about being German is the centrality of narrative violence. Violent fantasies memorialize German history as an agent of political identity. Among rightist nationalists, violent images and practices reaf-

firm German self-identity by invoking partial memories of a once negated past to restore its promise of power and racial supremacy. Among leftist activists, narrative violence is an equally important vehicle in the construction of political identity. Through their fantasies of violence, members of antiestablishment/alternative movements have constructed patterns of linkages—genealogies—of events and roles that link their interpretation of a contested present to cultural memories of a contested past.

Memory and National Identity

Although such discourses of violence appear to be at odds with the pacifist ideology of the Greens, the narrative vehicle by which they are expressed, a combination of invocation and dissociation, is a pervasive one in contemporary German culture. Since World War II the construction of a German national identity has been mediated by the reconstitution of collective memory. The legitimacy of the West German state (Federal Republic) was built upon a dual consensus: the rejection of fascism and the rejection of a socialist solution (Maier 1989). The regime was defined by what it was not. Reunification in 1990 further exacerbated this pattern of historical amnesia and remembrance by the displacement of one past by another. The thematic focus of German political identity was (and is) therefore one of dissociation from the past. German collective identity relied on motifs of negation and opposition. Yet while historical contiguities were officially denied, images and events from the past continued to be invoked culturally.

The resilience of fascistoid material was mentioned by the linguist Victor Klemperer in 1946, who was disturbed to see the unselfconscious and uncritical reproduction of Nazi thinking by means of verbal templates: "The language of the Third Reich seems destined to survive in several characteristic idioms; these have buried themselves so deeply that they seem to become a permanent property of the German language" (2). Klemperer appears to have been correct, and anti-Semitism and the fanta-

sized brutalization of others are inextricably rooted in German ways of speaking.

References to the death camps permeate everyday language: a boring situation or event elicits the formulaic response "it ought to be gassed"—made extinct (*Es ist zum Vergasen*). Another variant of this gruesome idiom, in common use in contemporary Germany, describes the consequences or endurance of an exhausting, repetitive task, performed "up to the moment of gasification" (*bis zur Vergasung*). The utterance refers to someone carrying out an action to the point of extinction or utter futility (Dundes and Hauschild 1987: 27).[66] In such rhetorical instances, the memory of the Holocaust is diffused and trivialized by the routinized verbal encounter. Inserted into the cultural vocabulary, the language of violence has become part of the normal German repertoire of speaking.

The motif of genocide also surfaces as a metaphor in the language of the political left: a smoke-filled, crowded pub is termed "a densely packed gas chamber" *(Gaskammervoll)* by a reporter for the radical Berlin daily *die tageszeitung*.[67] The news editor, accused of carelessness by the rest of the staff, responds:

> I really don't feel like defending this man's infantile garbage. I don't know whether I would have deleted the word from the text, because I don't know whether it is good or evil, and I don't have any associations there. I don't concern myself with German history. (Riedle 1988: 8)

The ensuing editorial debate about the abuse of metaphoric language is sarcastically dismissed by another staff member (Droste 1988: 9), who calls such inquiries the "final solution of the *Duden* question" (*Endlösung der Dudenfrage*): Duden is the German word for "dictionary" and it rhymes with Juden which is the German term for "Jews." In this instance, historic memory is used in an attempt to oppose the editorial board's decision to impose greater restrictions on the writers' "verbal spontaneity and humor" (Jhering 1988: 79). In these contexts, media images of genocide are thereby not only invoked as figures of speech but also used instrumentally as historical commodities.

Left-wing environmental slogans similarly reproduce such

imagery uncritically. A graffiti text, from February 1994, West Berlin, written on the facade of a residential building, recommended the following course of action to promote a clean, pollution-free city: "Commit murder! Gas the car drivers" (*Ermordet! Vergast die Autofahrer*). Here, killing is perceived as a legitimate act of self-defense: Air pollution, caused by dangerous automobile emissions, poses a threat to physical health, transforming Germans into victims. Car drivers, as perpetrators, must be punished for this crime. Although the use of gas as a killing tool invokes the memory of genocide, the slogan evades the question of guilt: Car drivers, and by implication Jews, are not victims, but must die to atone for a greater sin—the threat of pollution.

The identification of Germans with Jewish victims is explicit in another slogan, which appeared in 1982, when it was in use during the violent protests against *Startbahn West*, a political project aimed at the expansion of Frankfurt's international airport. Airplanes, Green protesters argued, produce pollution, and are therefore an environmental threat; through emissions, exhaust fumes, acid rain, and the destruction of forests, they pose a danger to human life. This sense of threat was expressed by the political slogan: "The Jews were gassed in the gas chambers, we are gassed in the streets" (*Die Juden wurden in Gaskammern vergast, wir auf der Straße*).[68] So worded, the slogan bears out the hypothesis of persecutory guilt: Environmental pollution is seen as a form of violence that kills Germans in the same manner as gas chambers killed Jews.

> It is, however, very disconcerting to find that this sudden awareness of one of the main fantasies on which the Green Theater is built does not bring the whole "scene" toppling down with it. Here, we find some clues regarding the nature and violence of the mechanisms that come into play, and the function that ideology (in this case the Green ideology) carries out. In cases where a belief is shared by a group, individual reality testing is removed in favor of the group's beliefs. This makes it possible to believe one really is the victim of car exhaust gas in exactly the same way as the Jews were, without bursting into laughter at the scandalous nature of such a statement, or rather into tears, because one should never underes-
>
> timate the immense grief, which the Green illusion must turn into persecution at all cost." (Chasseguet-Smirgel 1988: 161)

Similar fantasies of extermination are projected onto narrative encounters, which dramatize acts of genocide through the symbolic medium of play-acting. One such event took place during an air show at a U.S. military base in the Rhine Palatinate in Germany.[69] Antiestablishment protesters staged the occurrence of a nuclear holocaust by simulating mass death: Dressed in black costumes to symbolize the victims' charred bodies and skeletal remains, the protesters arrayed themselves on the ground. When the U.S. military police finally intervened, the event turned into a form of dramatic poetry in which members of the German audience played out familiar roles, becoming participants in the physical brutalization of their political opponents. One spectator, a man with a small son, proclaimed that he wanted to "rip the heart" from one of the protester's bodies. Another shouted that the activists "should be run over with a tractor." A man to his left, who until then had been contentedly chewing on a hot dog, suddenly poured his cup of beer over a young woman lying on the ground, and began to shout "Blood! Blood! Blood! while rhythmically stomping his foot up and down. A female spectator, while kicking and spitting at the protestors, screamed: "Beat them to death, beat them all to death!" As the peace protesters were loaded onto the waiting military trucks, another man proclaimed: "And now into the gas with them!" In this collectively sustained performance, fantasies of violence are used for cognitive ends: The symbolism of the event renders explicit cultural memories of genocide and, at the same time, deflects the history of violence which it attempts to legitimate.

The same patterns of invocation and displacement are revealed by so-called Auschwitz jokes and video games. In these narrative contexts, the sordid and vicious details of the extermination of Jews in such concentration camps as Dachau, Buchenwald, and Auschwitz are remembered and made the subject of humor and entertainment. In several of the jokes and games, the death camp reality is appropriated as a key scenario with contemporary human targets: Turkish immigrants (who symbolize the salient Other in postwar Germany) are incorporated into the German repertoire of

violent fantasy. Thereby, the annihilation of Jews is historicized, whereas the threat of victimization is directed against Turks (Albrecht 1982; Linke and Dundes 1988b; Nierenberg 1984). The same fantasy is promoted by concentration camp video games: "The player must manage the camp, selling gold fillings, lamp-shades and labor to earn enough money to buy gas and add gas chambers to kill Turks" (*New York Times* 1991). According to one version of this game, called *The Aryan Test*, the players' racial purity is established by killing Jews in concentration camps and by elimi-nating others of mixed ancestry in combat at the eastern front. The successful conclusion of the game produces the text: "Sieg Heil. The state needs men like you" (Freudenreich 1989: 13). In each of these cases, the violent content of the fantasy is objectified (and deperson-alized) through its displacement into the past, and German self-identity is constructed through the fantasized annihilation of others.

Such racialist templates constitute the broader context of cultur-al attitudes within which German political identity is formulated. As John Borneman (1992) recently suggested, the concentration camps, particularly Auschwitz, have become a key symbol around which guilt, Germanness, and identity cohere in the national imagi-nation of the postwar German state. I argue, moreover, that such templates exist not merely as representational or summarizing sym-bols; they function more dangerously as metaphor or key scenario: Through the invocation of historical brutalities from a contested past and the use of narrative violence as an element of cultural memory, political activists assert their cultural identity, while at the same time reenacting (according to unarticulated formulae) the cul-tural sequences of fantasized violence aimed at annihilating the cul-tural or political Other. In contemporary Germany, where such fantasies are once again acted out literally, and where immigrants and refugees have increasingly become targets of racist violence, we witness the transformative power of such scenarios: Symbolic (nar-rative) violence has become ritualized practice and continues to reproduce templates of violence, which are incorporated into the

German popular imagination and there replenish the already existing repertoire of violent fantasy.

Decentering Violence

The public culture of violence in Germany, which follows a pattern of invocation and dissociation, has found anchorage in a variety of social settings. It is reproduced, albeit in sanitized form, by academic responses to my research on violence. Often delivered in scathing polemics and personalized attacks, scholarly criticism tends to dismiss the validity of such research. For instance, at a conference in 1994, a well-known German historian angrily responded:

> I live there and I don't recognize the Germany you describe. That's not the Germany I know. I suggest you go back and check your sources. Nobody would say such things. I've never heard anybody say anything like that. It's taboo. You cannot say these things in public without an inevitable scandal. Political parties would never endorse such statements. Who are these people you cite? They are irrelevant, insignificant people. They are not representative. I am sure that this person you quote does exist, but she would have never said anything like that. So my suggestion to you is: go back and check your sources!

Such objections to my work, which I consistently encountered, were based on the rejection of my ethnographic sources. German academics contested the existence of discursive violence by denying the validity of my evidence: Local-level politics, graffiti, slogans, everyday sociolinguistics, street violence, normal ways of speaking, and the language and vocabulary of popular media were rejected as legitimate data. After presenting my work at an international symposium in 1994 (Berlin), a meeting focused on violence and racism, I was told that my research had missed the mark entirely by examining political language. As one historian instructed me:

> In politics, the rhetorical aim is to annihilate the opponent. But the selection of metaphors, with which one can accomplish this, is limited. There are only few methods, few possibilities: stabbing, hanging, shooting. And
>
> these methods should not be taken literally. To put it bluntly: language is

different from action; rhetoric is a matter of theater—political drama—
and cannot be taken too seriously.

According to my German critics, language and violence were
antithetical discourses. Verbalization was privileged as a cognitive
tool, while violence was interpreted as an unmediated practice, an
expression of primordial hatred. Based on these conceptions, my
descriptive exposure of narrative violence was dismissed as insignifi-
cant and even meaningless.

Puzzled by my treatment of language as cultural practice, some
German scholars were even more incensed by my investigation of
violence across political boundaries. How could I suggest that right-
ist militants and antifascists produced a common cultural discourse?
Did I not realize that leftists were engaged in an ideological struggle
against fascism? According to my German critics, violent fantasy
was engendered by a specifically right-wing agenda. While the left
spoke violence, which was dismissed as a rhetorical tactic, the right
enacted violence. This attempt to attribute the practice of violence
exclusively to right-wing agency was perceived as unproblematic.
According to several German commentators, violence was a charac-
teristic expression of a conservative or rightist mentality. In contra-
diction to the empirical evidence offered by several sociological
studies (Heitmeyer 1992; Held et al. 1992; Hoffmeister and Sill
1993), rightist perpetrators were imagined as uneducated members
of the lower classes, who were unemployed and dispossessed of sta-
ble social relationships; they were typified as social marginals, who
used violence to compensate for their inability to verbalize (*die
Unfähigkeit zu Versprachlichen*). Here the use of language was
defined as a transformative medium, which converted primordial
desires into rational social precepts. Since verbal articulation was
perceived to be a leftist prerogative, rightists were constructed as
"primitive others," whose rational faculties were impaired without
this mediating capacity of language. In any case, such presupposi-
tions (in fact, conjured stereotypes) might account for the fact that
my descriptions of right-wing violence were never once contested.

Of course, some German academics conceded that my disclo-

sure of leftist discourses of violence was basically correct. But even during these moments of covert agreement, the perpetration of violence was quickly dissociated from the moderate left and projected onto a more militant, antisocial periphery. At a symposium on identity, in March 1993, a young German scholar thus angrily explained:

> I was really disturbed by your presentation about the Green/Alternatives. As you should know, most supporters of this party are committed pacifists. The Greens, even in Berlin, never use violence in their public protests. So when you are describing the violent discourse of the German left, you are really referring to political alliances other than the Greens. Violence is used systematically by members of the autonomous and anarchist factions. They still believe in armed struggle. In Berlin, they live in Kreuzberg. That's a completely different scene. They don't work within the system. You can't just lump them all together like that.

The displacement of annihilatory discourses to the fringes of German society was a common ploy of critique and denial. Contesting the pervasiveness of discursive violence, some German scholars tended to dismiss my ethnographic evidence by these strategies of displacement. Such attempts at invalidation were sometimes coupled with other forms of dismissal: Included were demands for greater relativization; accusations of a totalization and exaggerated cultural criticism; charges of implementing a program of language purism; and an advocacy for American-style political correctness. How dare I tell Germans how to speak?

These angry objections to my findings sometimes took the form of outright denial. A young woman, at an international conference in 1994, responded as follows to my presentation:

> I worked with the Greens for several years, and among them were some of the kindest and gentlest people I have ever met. How can you say these things about them? I think you are wrong to say that the Greens have a problem with violence or pollution. If that was true they would advocate the use of pesticides against insects or promote the dumping of toxic wastes into the oceans. These are things which they oppose.

Such attitudes of denial and dissociation by German academics were on occasion coupled with their plea for my silence. For exam-

ple, at a meeting for area specialists, in April 1994, I was angrily reproached by a German legal scholar: "You just can't say these things about the Left. The Left has made headway, changed many things with their initiatives, and if you say such things it leads to setbacks."

My ethnographic documentation of exterminatory violence and its perpetual contestation by members of my German audiences engenders a paradox: Genocide, both as a practice and a discourse, is clearly linked to modernity, yet some German scholars prefer to deny this. Their attitude toward violence is embedded in a theoretical approach that promotes a basic assumption of progress. Modernity is equated with the development of a civil society, in which outbursts of violence are suppressed by the state's pacification of daily life. From such a perspective Nazism, genocide, and annihilatory racism are interpreted as anomalies, as regressive aberrations, resulting from temporary social breakdown.

Violence and Modernity

What are we to make of these collective imaginings? Zygmunt Bauman, in *Modernity and the Holocaust* (1989), argued that genocide in Germany must be understood as a central event of modern history and not as an exceptional episode. The production of mass death was facilitated by modern processes of rationalization. Exterminatory racism was tied to conceptions of social engineering, to the idea of creating an artificial order by changing the present one and by eliminating those elements that could not be altered as desired. Genocide was based on the technological and organizational achievements of an advanced industrial society. A political program of complete extermination became possible under modernity because of the collaboration of science, technology, and bureaucracy.

Such an interpretation of mass violence requires a critical reconsideration of modernity as a civilizing process—a progressive rationalization of social life.[70] It requires rethinking genocide, not as an exceptional episode, a state of "anomie" and a breakdown of the social, a suspension of the normal order of things, a historical

regression, or a return to primitive instincts and mythic origins,[71] but as an integral principle of modernity. Comprehensive programs of extermination are neither primitive nor instinctual.[72] They are the result of sustained conscious effort,[73] and the substitution of moral responsibility with organizational discipline.[74]

This concept of modernity emphasizes the normalcy of the perpetrators. In the 1930s and 1940s, ordinary German citizens participated in the killings.

> As is well known by now, the SS officers responsible for the smooth unfolding of operations were not particularly bestial or, for that matter, sadistic. (This is true of the overwhelming number of them, according to survivors.) They were normal human beings who, the rest of the time, played with their children, gardened, listened to music. They were, in short, civilized. (Todorov 1990: 31)

The genesis of the Holocaust offers an example of the ways in which ordinary Germans—"otherwise normal individuals"—could become perpetrators by their passive acceptance of the "political and bureaucratic mechanisms that permitted the idea of mass extermination to be realized" (Mommsen 1991: 252–3). The technocratic nature of Nazi genocide attests to the "banality of evil," that is, the sight of a highly mechanized and bureaucratized world where the extermination of entire groups of people, who were regarded as "contagion," could become a normal occurrence (Arendt 1964).[75] From this perspective, race-based violence and public machinations of mass death cannot be understood as regressive historical processes:[76] They are manifestations of new forms of cultural violence and the centralizing tendencies of modern state power.

But such a modernist conception of genocide, while it seeks to comprehend the industrial efficiency with which Jews were killed, is also deeply disturbing. As Omer Bartov (1998) suggested: "Recent works on the links between genocide and modernity have both the potential of distancing us from the horror (by sanitizing it) and of making us all complicit in it (since we belong to an age that perpetrates horror)" (799). The perpetration of mass murder, even in a modern age, must be understood in its relation to the existence of a

powerful political imaginary through which everyday understand-
ings of national belonging, race, and body are defined. How do we
analyze a cultural history of genocide? Modernity, as Yehuda Bauer
(1998: 13) points out, whatever the definition of the concept, did
not affect only Germany, and in any case, it does not explain why
the Jews were the victims. As I have tried to show, the study of the
social consensus formed by ideologies, attitudes, and symbolic prac-
tices transmitted over historic time produces the possibility of
answering why it occurred.

NOTES

•

White Skin, Aryan Aesthetics

1. Vron Ware conceded this point during a discussion of her forthcoming book, *Seeing through Skin*, from which she presented excerpts to the Rutgers Humanities Gender Group on March 18, 1996. Her work expands on the discursive construction of whiteness that she had previously analyzed in *Beyond the Pale* (1992), and examines cross-cultural examples of transracial posing.

2. This essay does not attempt to provide a history of race formation. Rather, it examines the symbolics of whiteness and the aestheticization of white skin in the historical context of German body politics. The material shifts and material forces that give rise to race privilege are not considered here. This line of inquiry has been addressed elsehwere (e.g., Lewis 1929; Alba 1990; Goldberg 1993). My aim is to show how whiteness and nakedness claim to define and utilize physical space as moral space and represented (national) privilege.

3. Here, I am referring to media events surrounding the O. J. Simpson trial, the Anita Hill and Clarence Thomas supreme court confirmation hearings; the Rodney King beating; the Stacey Koon shooting: these were events during which the dark-skinned "other" was brought on stage by video taping, television, and other audio technologies for consumption by the white gaze (Fiske 1994; Feldman 1994).

4. Consider the use of secret video surveillance in the case of Washington's (former) mayor, Marion Barry.

5. For an examination of the material bases of the rise, formation, and degrees of stability for (what is now generally taken as) the generic whiteness of privilege and its manifestation in (what is called) cultural racism, consult

217

Horsman (1981), Roediger (1991), Allen (1994), and Saxton (1990), among others.

6. My analysis of whiteness as an umarked social category excludes discussion of essentialist racism and assertions of white supremacy among the militant right (e.g., Ridgeway 1990). The relation of white ethnic identity to essentialist racism has been observed by Omi and Winant (1986), who suggested that such a conception of color, in which whites see themselves as inherently superior to blacks, was an early form of U.S. racism that now has been superseded by others. But on the right wing of society, traces of essentialism are retained in conservative deployments of whiteness, and the persistence of grass-root ideologies of "white supremacy" (Fiske 1994: 44; Frankenberg 1993).

But in an analysis on identity politics in the academy of the 1990s, Charles A. Gallagher (1995) discusses the recent "racialization" of whiteness, and the erosion of white invisibility among American university students. He describes the contemporary process of white reconstruction taking place among a sizable part of the white population, particularly among young people. "Whiteness is no longer invisible or transparent as a racial category because it is in crisis" (168). Whiteness as the "normalizing" center is no longer defensible or sustainable in the face of multiple attacks on white privilege by racially defined minorities. White identity is being reconstructed as an explicit, salient category of self-definition emerging in response to the political and cultural challenges of other racialized groups.

7. Such a "de-realization" of white agency takes on a distinctively gendered quality in Klaus Theweleit's work, *Male Fantasies* (1987): In the literary productions of German fascist soldiers, "whiteness" appears as an important signifier of the good woman; she is nonerotic and therefore not threatening to the men, for whom the whiteness of female skin stands as a symbol of the "lifeless" and "dead" (i.e., the absence of sexual agency).

8. This incarceration of blackness is made apparent in colonial attempts to "whiten" black skin. The depiction of dark skin as unclean and the washing of blacks to turn them "white" has been a popular motif in the advertising of soap, both in Europe and the United States: Here, attempts to transform the subaltern and to eliminate the signs of difference could be interpreted as a means for assimilating the other. At the same time expressions like "washing the Moor" came to mean "to undertake something impossible"; a transformation which is proverbially impossible has become the condition for blacks to be acceptable: In such advertisements, the dark other is seen as irrevocably different and inferior (see Nederveen Pieterse 1992: 195–8).

9. Racial mimesis, as taken up here, operates through the dramatic exposure of whiteness and white skin. While there is much to be said about the issue of physical alterations of body and social forms in an effort to pass, assimilate, or otherwise reduce black visibility, the practices discussed here are not aimed at achieving white normativity: Whitened/lightened subaltern bodies assert themselves through diplay, spectacle, and hypervisibility. In the postcolonial context (Latin America, Africa, Asia), the production of desire for white skin typically relies on public disclosure and dramatic exposition (see Schein 1994), not camouflage and habitus.

10. The subsequent accounts of whitening dark skin might seem overly simplistic. My intent, however, is not to theorize these moments of white hypervisibility, but to suggest (through ethnographic documentation) that whiteness can and does assume material form and, as such, is rendered visible. Whiteness, as a location of power and prestige, is anchored in bodies: The meanings of white skin are therefore negotiated along specific material and physical dimensions. Through the procedures of embodiment, whiteness can be appropriated, uncovered, and exposed. But the white body is not universally positioned as normative and unremarkable. The cases described in this section thus function as heuristic devices, permitting us to interrogate different possibilities for "seeing" white skin, and allowing us to illuminate the cultural logic of whiteness by looking to its enactments in various other cultural or historical contexts.

11. For further readings regarding the complexity of the whitening process as it varies across racial classifications in Latin America, and the differences in place and symbolic function of whites in black genealogies, consult Levine (1977), Martinez-Alier (1997), and Wade (1993), among others.

12. The citizenship law of the Federal Republic of Germany defines "national belonging" and citizenry through the idiom of descent, as expressed by the Latin term *jus sanguinis,* "power/law of blood" (see Article 116, Basic Law). Enacted in 1913—and still in effect today—the German citizenship law permits, and even encourages, the nation's social (and racial) closure: Individuals born within the territory of the German state (unlike in France or the United States) do not normally receive citizenship. Membership status in the German nation is determined by an understanding of a "community of descent," shaped by an "ethnocultural" or "ethnonational" perception of statehood (Brubaker 1992). Deeply embedded in Germany's imperial history, the blood-principle of citizenship is defined by racial premises, which at the turn of the century denied colonial subjects inheritance and voting rights (Wildenthal 1994a, 1994b).

13. White identity, in the German national imaginary, is not constructed from a racially bifurcated dialectic (e.g., white agency and black/other) as in the American case. It is a construction of whiteness in which all that is non-white—the dark-skinned (black) other—emerges as a highly amorphous and imagined ensemble of a multiracial and multiethnic configuration, which includes Jews, Gypsies, Turks, Slavs, southern Europeans, Asians, and blacks, as well as migrant laborers and refugees. The German nation/state was envisioned as a homogenous ethno-national community, a vision materialized in 1945, through the effects of genocide, and the perpetual closure of political boundaries to immigrants, especially after World War II. The white space of German politics is thus not build on cross-racial symbiosis, but a self-referential imaginary of whiteness.

14. The rediscovery of the body, and nudism, according to Mosse (1985: 62), was not associated with attempts to renew the nation in other European countries. In England, for instance, the "beautiful male was not symbolic of the nation or the national landscape, but simply part of an individual's literary sensibilities" *(ibid)*.

15. Baldur von Schirach, cited in Mosse (1985: 170–71).

16. Michael Taussig provides several intriguing examples of the romanticized quest for the "white naked Indian" by American anthropologists in the late nineteenth and early twentieth centuries: These "white children of nature" (Taussig 1993: 144-75) were perceived as "civilized" or "noble savages" because they were "white."

17. These symbolic assertions seem analogous to the "bra burning" movement in the United States in the 1960s, which however was specifically focused on the liberation of women's bodies from social constraints, and did not emphasize complete nudity.

18. Commodity resistance or the opposition to consumption was to take a central place in the antifascist violence of German leftists. During the 1960s, the opposition of urban guerillas (e.g., Red Army Faction) was largely focused on the destruction of the capitalist lifestyle and those structures or institutions that facilitated the corresponding political culture. Banks, shopping centers, casinos, and night clubs were regarded as symbols of consumption *(Konsum)* by which they were repulsed (Borneman 1992: 254–56). Like public nudity, these violent tactics were seeking agency against the control instruments of social and state structures.

19. For further elaboration on the sexualization of the German public

sphere, in particular the creation of sex shops and pornographic advertising, see Kinzer (1996), Spiegel (1979), Pai (1985), Time (1981), Eglau (1972), and Uhse (1989).

20. See T. J. Jackson Lears (1983), who argued that a therapeutic ethic, where commodities appeared as curative agents, emerged in the United States at the turn of the twentieth century. The work, however, makes no reference to race or ethnic difference in the promotion of this therapeutic ethic among consumers.

21. The scholarly literature on sandcastles is scarce. For a selection of the sources I consulted, see Kimpel and Werckmeister (1995), Buse (1992: 12–16), Hartmann (1972), Pfaffenberger (1965), Diers (1986: 139–44), and Kürtz (1994).

22. Throughout I am using the terms "political left" and "political right." I suggest that a preoccupation with the maintenance of hierarchy, order, continuity of tradition, and status quo defines the agenda of the political Right. A concern with secular and egalitarian issues, discontinuity and revolutionary or futuristic transformations designates the agenda of the political Left. I am here following Michael Minkenberg's conceptualization (1994); Minkenberg examined the dualism or political polarization of "Left" and "Right" from a historical perspective, tracing the shifting articulations of this polarization from the French Revolution to the German post-cold war era. He argued that despite ideological changes focused on religion, class, income, and postmaterialist issues (e.g., the "new" left), the dichotomization of political parties into "left" and "right" is meaningfully maintained.

23. The first German edition of Freud's *The Interpretation of Dreams* was published in 1899, although its title page was postdated to 1900.

24. Historical discussions that place Freud and his development of dream interpretations in the context of both German culture of the period and the relation of Jewishness to civility (that is Gentileness and, hence, the foundations of whiteness) are taken up at length elsewhere (e.g., Cuddihy 1987; Mosse 1993; Harrowitz and Hyams 1995).

Blood, Race, Nation

1. My description of these events is based on the observations and reports by Schrep (1983: 72–3) and Lange-Feldhahn et al. (1983: 207, 209).

2. See Handler (1988), Herzfeld (1987), Hobsbawm and Ranger (1983), and Linke (1997).

3. See Heitmeyer (1992), Held et al. (1992), Hoffmeister and Sill (1993), Marx (1994), and Linke (1995).

4. See Proctor (1988), Lifton (1986), Aly et al. (1994), Friedlander (1995), Mosse (1985: 133-52), and Müller-Hill (1988).

5. See Lidtke (1982: 174, 182–3, 185) and Theweleit (1987: 234, nn. 26, 27).

6. According to Minkenberg (1994), a preoccupation with hierarchy, order, continuity of tradition, and status quo defines the agenda of the political Right. A concern with secular and egalitarian issues, discontinuity, and revolutionary or futuristic transformations designates the agenda of the political Left. Minkenberg examines the dualism or political polarization of "Left" and "Right" from a historical perspective, tracing the shifting articulations of this polarization from the French Revolution to the German post-cold war era. He argues that despite ideological changes based on religion, class, income, and postmaterialist concerns (e.g., the "new" Left), the dichotomization of German political parties into "Left" and "Right" has been meaningfully maintained. The best recent English-language histories of the West German "new" left are in McCormick (1991), Markovits and Gorski (1993), and Dirke (1997). For further discussion, see also Habermas (1985: 147–51), Dalton (1988: 118–21), Graf (1976), Burns and van der Will (1988), and Laponce (1981: 141–77).

7. The working dinner (which took place on January 11, 1989) had been organized by the Ministerial Counselor, Götz Freiherr von Groll (e.g., the representative of the Federal Foreign Ministry in West Berlin). The aim of the evening was to bring together German politicians with American academics, in this case Bosch and SSRC fellows resident in Berlin, to discuss issues of relevance to the still divided city and its role in Western European politics. Since the event was scheduled a few weeks before the upcoming Berlin Senate elections, the political representatives took the opportunity to present their official party platforms. In addition to the Green/Alternative representative, the Christian Democrats, the Free Democrats, and the Social Democrats were in attendance with one delegate.

8. Vonnekold's remark here refers to the citizenship law of the Federal Republic of Germany, which defines "national belonging" and citizenry through the idiom of descent, as expressed by the Latin term *jus sanguinis*, "power/law of blood" (Article 116, Basic Law; see Senders 1996; De Soto and Plett 1995).

9. The event, sponsored by *Die Gruppe Grüne Panther*, a splinter group of the Green/Alternative Party in West Berlin, was scheduled for February 3, 1989. The second in a series of discussions, the meeting focused on the adoption of federal laws by West Berlin and the possible opposition to such a "national-ization" or legal incorporation of the city by a potential Green/Alternative and Social Democratic coalition (see "Veranstaltung 2: Übernahme von Bundesgesetzen—eine Hürde für Rot-Grün?" Discussants: Hartmut Gassner, Dr. Erhart Körting, Renate Künast).

10. See *Archiv für Sozialpolitik* (1993a: 31; 1993b: 16).

11. Friedrich Ebert (1870–1925) was the first president of the German Republic. The son of a tailor, he became a harness maker, joined the Social Democratic party, was elected to the Reichstag in 1912, and assumed leadership after Bebel's death, representing henceforth the extreme rightist wing of the Social Democratic party (e.g., Lowie 1945: 117).

12. In Theweleit (1987: 177)

13. In Theweleit (1987: 179-80).

14. In Theweleit (1987: 65).

15. Theweleit (1987:191-92) makes this point by relying heavily on Siegmund Freud, who argued in his *Interpretation of Dreams* (1976) that the equation betwen mouth and vagina/womb was not a mere product of uncon-scious thinking, but could be attested in linguistic usage by drawing a parallel between the labia and the lips that frame the aperture of the mouth. Therefore, the secretions of the human body emerging from the two body parts can, in some contexts, function as symbolic replacements. Emily Martin (1990) offers a feminist interpretation of the connection between the female mouth and vagina/womb. She argues that the metaphoric link is one of control: the attempts in modern Western history by medical/political interests to take control of women's bodies and sexuality.

16. Interestingly, Theweleit himself rarely uses the term "rape," which appears twice in the entire volume. Instead, he applies the image of "sexual intercourse" to these violent encounters, although he does acknowledge that "the penis is also put to use in nonsymbolic ways as a weapon" (1987: 192, n. ***). The notion of rape seems to me more appropriate to these instances.

17. In Theweleit (1987: 187–9).

18. See Birkenmaier (1980: 3).

19. See Fromme (1980a: 1).

20. See Birkenmaier (1980: 3).

21. See *Alfelder Zeitung* (1980a: 1).

22. See *Frankfurter Allgemeine Zeitung* (1980h: 1).

23. See *Der Spiegel* (1980a: 17).

24. See *Der Spiegel* (1980b: 32).

25. See *Rhein-Zeitung* (1980c).

26. See *Der Spiegel* (1980b: 34).

27. See Fromme (1980a: 1).

28. See *Frankfurter Allgemeine Zeitung* (1980j: 2).

29. See Fromme (1980b: 10).

30. See *Alfelder Zeitung* (1980b).

31. See Philipp (1980).

32. See *Frankfurter Allgemeine Zeitung* (1980d: 1).

33. See Klein (1980).

34. Fluid metaphors also appear in the American media, but without the corresponding expressions of repugnance and terror of nationwide catastrophe. For example, descriptions of the influx of Haitian refugees into the United States in 1994 abound with references to "the tide," "the flood," "the flow," which "comes," "surges," "rises," and "swamps" (Greenhouse 1994a: 1, 6; 1994b: 3). But an earlier analysis of American media images and political metaphors of Cuban refugees in 1980 suggests that such liquid metaphors and underlying fears of immigrant "waves" were linked to perceived threats of sexual attack (Borneman 1986). Although regarded as a "male threat" at this time, such a gendered perception of Cuban refugees was grounded in fears of feminization: an implosion of "the Cuban gay male threat," the "red

(Communist/Cuban) invasion," and "the erosion of American masculinity." These were images framed by political fears of disorder, loss of control, perversion, illegality, and criminality. Other regimes of representation, and corporeality, are pertinent in trans/national media images of refugees and transborder populations elsewhere (cf. Seremetakis 1996; Malkki 1996).

35. See *Frankfurter Allgemeine Zeitung* (1980c).

36. See *Rhein-Zeitung* (1980b).

37. See Birkenmaier (1980: 3).

38. See Edinger (1986: 56–7).

39. See *Frankfurter Allgemeine Zeitung* (1980e: 1–2).

40. See *Der Spiegel* (1980a: 17).

41. See *Frankfurter Allgemeine Zeitung* (1980f).

42. See *Der Spiegel* (1980a: 18).

43. See, for instance, Philipp (1980). The reference to "over-foreignization" appeared continually in most media reports from January through July of 1980. The term was popularized once again in the early 1990s. The initial use of this word can be traced to the 1930s and 1940s, when it carried anti-Semitic connotations.

44. See *Frankfurter Allgemeine Zeitung* (1980i: 1).

45. See *Frankfurter Allgemeine Zeitung* (1980k).

46. See *Archiv für Sozialpolitik* (1994b: 38).

47. See *Archiv für Sozialpolitik* (1993d: 23).

48. See *Archiv für Sozialpolitik* (1994a: 35).

49. See *Archiv für Sozialpolitik* (1994a: 32).

50. See *Der Spiegel* (1980a: 18).

51. See *Frankfurter Allgemeine Zeitung* (1980d: 2).

52. See Birkenmaier (1980: 3).

53. See *Der Spiegel* (1980b: 32).

54. For additional examples, see *Frankfurter Allgemeine Zeitung* (1980a: 4, 1980e: 2, 1980g: 1), and *Alfelder Zeitung* (1980a). In a technical sense, the word *Sammellager* should be translated as "assembly camp": In German *sammeln* means "gather together," "assort," "collect," "assemble." But *Sammellager* can be read, I believe, as a postwar locution for *Konzentrationslager* (concentration camp), a Nazi term whose usage is categorically taboo except as a historical signifier. Yet this insertion of *Sammellager* into political language conveys something more than a convenient terminological displacement. It also points to a profound denial of history, a muting of collective memory. In German (as of course in English, too), *Konzentration* means "to focus," "to fix one's attention upon something," and "to gather one's thoughts or efforts to accomplish a matter." These are meanings that disclose the Nazis' programmatic use of camps for physical annihilation, a murderous campaign semantically disguised as a concentrated mental effort: that is, the political conception of a "final solution" for the "Jewish problem." But unlike the corresponding English terms, *Konzentration* or *konzentrieren* lacks connotations of internment: in German, "concentration camps" are semantically, and linguistically, configured as death camps. The current German use of *Sammellager* represses this nexus to murder entirely. By a shift of meaning to "rounding up" or "amassing people," it prevents the disturbing evocation of the past. Nevertheless, the intent behind such camps is not entirely benign. As suggested by the semantic field of *Sammellager*, the internment of refugees is perceived as a means to "regain composure," to achieve "a state of tranquility or repose," and to become "self-possessed" (e.g., *sich sammeln*), meanings that hint at a cultural desire to purge the troublesome and foreign. The move to house refugees in these so-called "concentration camps" (*Sammellager*), an idea first suggested in Bavaria in the late 1970s, had a decided impact both on the public perception and on the public identity of the refugees (Mattson 1995: 74–5). Initially intended as one of the measures designed to scare away refugees (Münch 1992: 73), and later justified as necessary to simplify public assistance for the asylum applicants, these steps ironically were also defended as crucial to ensuring the safety of the refugees from attacks by right-wing extremists (Wassermann 1992: 16). Of course, it also became much easier for right-wing terrorists to find and attack the refugees that the government had brought together in large groups (cf. Mattson 1995: 75). Thereby the "concentration" camps in fact facilitated the political goal to get rid of unwanted foreign populations.

55. See *Frankfurter Allgemeine Zeitung* (1980b).

56. See *Der Spiegel* (1980a: 18).

57. See Fromme (1980b: 10).

58. See *Frankfurter Allgemeine Zeitung* (1980d: 1).

59. See *Der Spiegel* (1980a: 17, 18).

60. See Klein (1980).

61. See *Frankfurter Allgemeine Zeitung* (1980d: 4).

62. See Fromme (1980a: 1).

63. See Klappenbach and Steinitz (1967: 1534) and Drosdowski (1972:995) for an elaboration of term's entire semantic field.

64. For a closer reading of the legal semantics, see *Grundgesetz und Landesverfassung* (1971), a publication of the Institut für Staatsbürgerliche Bildung in Rheinland-Pfalz, which I consulted. In West German legal rhetoric, after 1945, basic rights are typically granted through the invocation of phrases like *Anspruch auf, Recht auf, hat das Recht*—has a right to or can insist on (28, 32, 120–1). The term *genießen* or "to enjoy" appears infrequently, and only in connection with certain types of "privileges": geographic mobility, freedom of residence and trade, political asylum, and protection from extradition (see Basic Law [GG]). I document the usage of the term in the following exerpts: "*politisch Verfolgte genießen Asylrecht*" (Basic Law, article 16.2 [after 1993, article 16a]); "*Alle Deutschen genießen Freizügigkeit im ganzen Bundesgebiet*" (ibid, article 11.1); "*Fremde genießen Schutz vor Auslieferung und Ausweisung*" (Landesverfassung Rheinland-Pfalz, article 16); "*Alle Deutschen genießen Freizügigkeit*", "*Nichtdeutsche genießen . . . die gleichen Rechte*" (ibid, article 15). This metaphoric vision of the consumption of rights probably emerged in response to the symbolic requirements of West Germany's postwar capitalist economy.

Although the German term *genießen* predates this current usage (see Grimm and Grimm 1897: 3451–55), its connotations prove surprisingly resilient: "take in," "consume," "enjoy," "have desire, lust, or appetite for," "take pleasure in," "feast on," "make use of," "take possession of," etc. Even in specific legal contexts, where the term *genießen* referred to the "enjoyment of a privilege" or the "laying claim to an advantage" (ibid., 3455, 3458), it denoted a usufructary, a profiteering.

65. In 1993, after German unification, the process of granting political refugee status underwent drastic "reform": shorter court hearings, the denial of social benefits, and the partial closure of borders were used to discourage refugees from seeking asylum (Griesbeck 1997). By the end of 1996, Germany's population—numbering 82 million—was composed of 7 million immigrants and 1.6 million refugees (Severin 1997: 15).

66. See, for instance, Klein (1980), Philipp (1980), and Fromme (1980b). For a more extensive discussion of the negative connotations of terms like "refugee" and "asylum seeker" in Germany, see Gerhard and Link (1991), Jäger (1993), and Link (1983).

67. For a brilliant reading of the anti-Semitic implications of this fear of dirt and contagion, consult Dundes (1984) who traces the cultural/symbolic connections between the terror of pollution and Judeocide before 1945. For a more recent discussion, see Korff (1996), who provides rich documentation of how West Germans deploy dirt images in their ethnicization/racialization of East Germans after 1990.

68. See *Rhein-Zeitung* (1980a).

69. See *Der Spiegel* (1980b: 35).

70. Ibid.

71. Ibid.

72. Quoted in (and translated by) Mattson (1995: 80).

73. See Anderson (1983), Linke (1990), and Malkki (1995a/b).

Culture, Memory, Violence

1. The literature on the politics of post-Holocaust memory is enormous. For some outstanding recent examples, see Berenbaum and Peck (1998), Geyer (1996), Bartov (1996), Hartman (1994), Friedländer (1992), Grossmann (1995), and Baldwin (1990).

2. For recent works on this issue, specifically the problem of collective memory and its evasions in German postwar politics, see Moeller (1996, 1997), Naumann (1996), Herzog (1998), and Markovits and Reich (1997).

3. As Omer Bartov (1998: 793) has pointed out, the enthusiastic reception by third-generation Germans of Goldhagen's book, which argued that in the Third Reich Nazis and Germans were synonymous, was related to this desired sense of the past being "another country," or rather the grandparents' Fatherland. See, for example, Roll (1996), Ullrich (1996), and Joffe (1996).

4. See Herzog (1998: 442, and n. 113).

5. Sauer (1955: 426), in Herzog (1998: 440, n. 107).

6. This was a prevalent 1980s peace movement slogan; quoted in Claussen (1986: 61), and in Herzog (1998: 440, n. 108).

7. Piwitt (1978: 39), in Herzog (1998: 440, n. 109).

8. In his book *La force du vertige* (1984), André Glücksmann discusses the Green Movement's Nuremberg Tribunal. Also, see Chasseguet-Smirgel (1988), and Die Grünen (1984a).

9. See, for instance, Bolafi (1979: 165), Feher and Heller (1984: 35–36), and Habermas (1981: 34).

10. This fragmentary diversity was still apparent in the 1980s, when the Green Movement was riveted by political in-fighting and factionism. In Berlin (and elsewhere), interest groups like the Fundamentalists and Eco-Socialists emerged on the Left spectrum. Centrists created the initiative *Gruppe Aufbruch* (literally "let's go, rise up"), while moderates formed the Green Panthers. So-called Realists advocated nonviolence and promoted political work within the existing democratic system. In short, leftist environmentalists and Greens did not share an integrated ideological agenda. Instead, members exhibited a pattern of particularistic decision making and opposition to specific issues. This pattern was reproduced at the local level. In the 1989 Senate elections in West Berlin, several dozen issues competed for media attention as primary electoral concerns: the urban housing crisis; rent control; police brutality; feminist issues; the Nazi involvement of Christian Democratic candidates; the privacy violations committed by the German "constitutional protection" agency (*Verfassungsschutz*); the economy and unemployment; urban decay; and the inadequacy of public transportation.

11. The Party of the Greens was constituted in the late 1970s in West Berlin. As a political initiative, the party was initially sponsored by participants of the squatter's movement and the German student riots of the late 1960s as well as by members of those radical Communist or Marxist organizations that had

been outlawed after the terrorist purgings (connected to bombings and arson attacks by Klaus Baader and Ulrike Meinhof, the Red Army Faction founders) in the mid 1970s. The Green/Alternative Movement in West Berlin offered these disenfranchised militant or radical intellectual new (legitimate) form of political expression. In its formative stages, the party was simply called *Alternative—Ballot 3: For Democracy and Environmental Protection*. The less radical (more mainstream) supporters of this newly constituted party (like Petra Kelly and Otto Schilly), however, left West Berlin in 1980 and created the party of the Greens in the Federal Republic, which was headquartered in Bonn.

12. Likewise, the Green/Alternative Party in Berlin received 7 percent of the popular vote in 1985, and 11 percent in 1989 during the Senate elections. These percentage points, which reflect popular support both at the federal and local levels, remained relatively stable. But after German unification in 1990, the political landscape experienced a shift toward the Right, and the Green Party struggled to retain its membership within the German Federal Parliament. The West German Greens subsequently formed various alliances with East German alternative groups (such as Bündnis 90)—a strategy apparent both at the federal and local levels. In Berlin, the Green/Alternatives lost their electoral Senate seats after reunification. And in 1993, party members agreed to merge the name and political agenda with former East German activists to create a common union coalition: Alliance 90/The Greens (*Bündnis 90/Die Grünen*).

13. See Chasseguet-Smirgel (1986: 123).

14. This ideological diversity was enhanced by pragmatic as well as local problems. West Berlin, at the time of my research, was a walled city. Political debates were focused on housing shortages, rent control, unemployment, the absence of daycare centers, and so on. In rural areas or urban settings elsewhere in Germany, the political process clearly embraced other issues. In Frankfurt, for instance, leftist activism mobilized support against a proposed airport expansion, because such a project was linked to attempts at radical deforestation.

15. See Feher and Heller (1984: 41), Markovits and Gorski (1993), and Korff (1991) for further discussion of the signification of "red" and "green" as colors of German political identity.

16. The importance of this color symbolism is suggested by the fact that "green" was prevalent as a symbol of political identity even when the party's name did not explicitly embrace it. In 1988, the West Berlin chapter of the

Green Party was simply called *Alternative—Ballot 3* (now renamed Green/Alternative); although absent in its name, green was used in public image making: the facade of the Berlin Party headquarters was painted green; the Party emblem, the hedgehog, was represented in green (sometimes red) on party stationary, envelopes, posters, and stickers; election campaign materials featured the color green very prominently; and graffiti by party supporters often contained green representations and signs. For an additional discussion of this symbolism, see Linke (1988).

17. See *Economist* (1984: 37).

18. This includes idiomatic phrases like *Die Fahrt ins Grüne* or *Das Haus im Grünen.*

19. See Chasseguet-Smirgel (1988: 153).

20. Ibid.

21. Ibid.

22. Die Grünen (1984b: 16–17). See Chasseguet-Smirgel (1988:153–54).

23. Die Grünen (1984a: 25). Also Chasseguet-Smirgel (1988: 154–55).

24. Lanzmann (1985: 75–77).

25. See Silbermann (1982); for a review of his study, see "Holocaust mindert nicht den Judenhaß," *Süddeutsche Zeitung* 15 (January 19, 1984), 44.

26. This appears to be a rather conservative estimate, which was computed by the Federal Bureau for Criminal Investigation (*Bundeskriminalamt*). Another public statistic was provided by the Federal Bureau for Constitutional Protection (*Bundesverfassungsschutz*), which cited 2,984 acts of violence against foreigners, a third of them arsons, for the same time period (see *Archiv für Sozialpolitik* 1993a: 31; 1993c: 32; 1993 [February] 14).

27. See Ebermann and Trampert (1991:10). These arson attacks were not exclusively directed against members of foreign populations, that is, non-Germans (i.e., immigrants, refugees, asylum-seekers): the term "foreigner" (*Ausländer*) itself became a classificatory term for salient Others, including German Jews, ethnic Turks, and blacks.

28. See Kinzer 1992 (*New York Times* [November 24]), p. 7; *Archiv für*

Sozialpolitik (1993a: 31, 1994 [March]: 33).

29. See Sauer (1955: 426), in Herzog (1991: 440, n. 107).

30. See *Archiv für Sozialpolitik* (1993 [February]: 14–5).

31. See *Archiv für Sozialpolitik* (1993 [March]: 15).

32. See *Archiv für Sozialpolitik* (1994 [May]: 38).

33. See *Archiv für Sozialpolitik* (1994 [July]: 30).

34. See Lidtke (1982: 190–1, 192). For an extensive discussion of the symbolic uses of "fire" and "flame" under the Nazis, see Mosse (1975: 8, 40–2, 51, 77, 83, 88, 92, 102, 105, 133, 171, 189, 202–7).

35. See Skierka (1988: 4).

36. See Dînhoff (1988: 30).

37. See Lorenzo (1988: 10).

38. See Holle (1988).

39. Ibid.

40. Thaler (1991: 14).

41. Pohrt (1991: 35).

42. See Müller (1985: 106).

43. I recorded these slogans and texts during different stages of fieldwork in Germany: 1988–89, 1994 (Berlin), 1995 (Coblenz). For similar versions recorded elsewhere, see *Der Spiegel* (1989: 26–50), and *Interim: Wöchentliches Berlin-Info* 59 (June 29, 1989): cover jacket.

44. See Pokorny (1959: 1103–5).

45. See Pokorny (1959: 945–6).

46. Ibid.

47. See, for instance, Peukert (1987), Haeberle (1989: 365–79), Plant (1986), Werner (1988), Burleigh and Wippermann (1991: 77–112, 136–97), Schilling (1983), and Heger (1980).

48. See, for instance, Theweleit (1987: 22), and Quinn (1994).

49. See *Archiv für Sozialpolitik* (1993c: 28).

50. Ibid.

51. See *New York Times* (1992: 12).

52. See *Archiv für Sozialpolitik* (1993c: 30).

53. See *Archiv für Sozialpolitik* (1993c: 32).

54. See *Archiv für Sozialpolitik* (1993a: 29). According to a police report issued several weeks later, the girl had presumably fabricated the attack and inflicted the injury herself (see *Archiv für Sozialpolitik* 1993b: 15–16). Given the frequent collusion of the German police with rightist militants (in the many cases of official acquiescence or actual complicity), I tend to question the accuracy of the report. If the attack indeed was a product of fantasy, it remains a valuable bit of information because in this instance, the reterritorialization of the body is imagined through the violent embodiment of the swastika.

55. See *Archiv für Sozialpolitik* (1993b: 15).

56. See Atkinson (1994a: 13). In this case, after being unable to apprehend the perpetrators, police investigators claimed that the girl, who is confined to a wheelchair, inflicted the injury herself and then fabricated the story about the attack (see Atkinson 1994b; *New York Times* 1994a/b; Tomforde 1994a/b). Given the details of the case, I consider this finding of the German prosecutors unlikely. But even as fantasy material, the incident follows the same cultural logic, as I have suggested in this passage.

57. See Gremliza (1991: 8).

58. Ibid.

59. See *Archiv für Sozialpolitik* (1993c: 32).

60. See *Archiv für Sozialpolitik* (1993c: 32).

61. The following examples of violent verbal protest were recorded in *Der Spiegel* (1989: 30); I encountered the second example during fieldwork in Berlin (1994). Shortly after hearing of this slogan from one of my informants, whose daughter had used it during a political rally, I saw it in written form. The slogan was scribbled across the pages of a visitor's book at the "Topography of Terror," a museum exhibit built on the grounds of the former Berlin gestapo headquarters.

62. See Reuss (1988: 16).

63. Such rallys were not unique. In West Berlin, a total of 7,000 such demonstrations had been registered between 1988 and 1989. For further discussion of the cultural history of German demonstrations and the political symbolism of protest, see Warneken (1986) and the edited collection by Warneken (1991), which contains a number of decisive essays; the contributions by Korff (17–36) and Balistier (257–81) are especially relevant for understanding the historiography of leftist opposition.

64. This tensive difference between the articulation of violent discourse at the local level and its complete absence at the national or regional level requires an expanded discussion, which I cannot offer here.

65. A key scenario, according to Ortner, consists of an analogic (metaphoric) narrative blueprint that encodes and prescribes certain culturally effective courses of action by suggesting dramatic, phased sequences of stylized behavior that are culturally valued: "it is played and replayed in the most diverse sorts of social contexts—because it suggests a clear-cut strategy for arriving at culturally defined success" (Ortner 1973: 1341–2).

66. According to Rîhrich (1977: 1108), the idiom is older than Nazism and Auschwitz, deriving originally from the language of chemists and physicists.

67. See Kapielski (1988: 9).

68. See Chasseguet-Smirgel (1988: 161), and Brainin and Kaminer (1982).

69. See Schrep (1983: 72–3), and Lange-Feldhahn et al. (1983: 207, 209) for further elaboration of the event.

70. See Elias (1939) and Weber (1947).

71. For instance, Durkheim (1933), Sorel (1941), Foucault (1979), Girard (1979), Freud (1961), and Canetti (1973).

72. See Fein (1979), and Melson (1992).

73. See Hilberg (1985), Lifton (1986), Friedlander (1988), and Bartov (1996).

74. See, for example, Herzfeld (1992).

75. See Heitmeyer (1992), Held et al. (1992), Hoffmeister and Sill (1993), Marx (1994), and Ostow (1995).

76. See Feldman (1991), Kuper (1981), Malkki (1995a), and Tilly (1970).

BIBLIOGRAPHY

•

Accati, Louisa. 1979. "Lo spirito della Fornicazione." *Quaderni Storici* 41: 650.

Ackerknecht, Ernst. 1971. "Primitive Autopsies and the History of Anatomy." In his *Medicine and Ethnology*. Vienna: Hans Huber.

Adelson, Leslie. 1993. Making Bodies, *Making History: Feminism and German Identity*. Lincoln: University of Nebraska Press.

Adorno, Theodor W. 1980. *Stichworte. Kritische Modelle 2*. Frankfurt: Suhrkamp Verlag.

Alba, Richard. 1990. *Ethnic Identity: The Transformation of White America*. New Haven: Yale University Press.

Albrecht, R. 1982. "Was ist der Unterschied zwischen Türken und Juden? Antitürkenwitze in der Bundesrepublik Deutschland." *Zeitschrift für Volkskunde* 78: 220–29.

Alfelder Zeitung. 1980a. "Kabinett stoppt Vorschlag zur Eindämmung der Asylbewerber." *Alfelder Zeitung*, Nos. 129/130 (June 12), p. 1.

Alfelder Zeitung. 1980b. "Asylverfahren wird beschleunigt." *Alfelder Zeitung*, No. 152 (July 3).

Allen, Ann Taylor. 1991. *Feminism and Motherhood in Germany 1800–1914*. New Brunswick: Rutgers University Press.

Allen, Theodore W. 1994. *The Invention of the White Race*. New York: Verso.

Aly, Goetz, Peter Chroust, and Christian Pross. 1994. *Cleansing the Fatherland: Nazi Medicine and Racial Hygiene* (Belinda Cooper, trans.). Baltimore: The Johns Hopkins University Press.

Anderson, Benedict. 1992 [1983]. *Imagined Communities: Reflections on the Origin and Spread of Nationalism*. Reprint. London: Verso.

Andrews, Edmund L. 1998. "Anatomy on Display." *New York Times* (January 7), pp. 1, 4.

Anthias, Floya, and Nira Yuval-Davis. 1994. "Women and the Nation-State." In *Nationalism* (John Hutchinson and Anthony D. Smith, eds.), pp. 312–16. Oxford: Oxford University Press.

Appadurai, Arjun (ed.). 1986. Introduction. In *The Social Life of Things*, pp. 3–63. New York: Cambridge University Press.

Archiv für Sozialpolitik. 1993a. "Jeder ist uns der Nächste. Zwölfter Teil einer unvollständigen Chronik der Gewalttaten gegen Ausländer im wiedervereinigten Deutschland." *Konkret* 1 (January 1): 28–31.

Archiv für Sozialpolitik. 1993b. "Jeder ist uns der Nächste: Dreizehnter Teil einer unvollständigen Chronik der Gewalttaten gegen Ausländer im wiedervereinigten Deutschland." *Konkret* 2 (February): 14–17.

Archiv für Sozialpolitik. 1993c. "Jeder ist uns der Nächste: Zwanzigster Teil einer unvollständigen Chronik der Gewalttaten gegen Ausländer im wiedervereinigten Deutschland". *Konkret* 10 (October): 28–32.

Archiv für Sozialpolitik. 1993d. "Jeder ist uns der Nächste: Einundzwanzigster Teil einer unvollständigen Chronik der Gewalttaten gegen Ausländer im wiedervereinigten Deutschland." *Konkret* 11 (November): 23–24.

Archiv für Sozialpolitik. 1994a. "Jeder ist uns der Nächste: Fünfundzwanzigster Teil einer unvollständigen Chronik der Gewalttaten gegen Ausländer im wiedervereinigten Deutschland." *Konkret* 3 (March): 32–6.

Archiv für Sozialpolitik. 1994b. "Jeder ist uns der Nächste: Siebenundzwanzigster Teil einer unvollständigen Chronik der Gewalttaten gegen Ausländer im wiedervereinigten Deutschland." *Konkret* 5 (May): 38–9.

Arendt, Hannah. 1964. *Eichmann in Jerusalem.* Munich: R. Pieper.

Arendt, Hannah. 1990. *On Violence.* Chicago: University of Chicago Press.

Atkinson, Rick. 1994a. "Neo-Nazis Cut Swastika Into Face of Disabled German Teenager." *Washington Post* (January 12), p. A13.

Atkinson, Rick. 1994b. "Swastika Incident Allegedly Fabricated." *Washington Post* (January 15), p. A16.

Bächtold-Stäubli, Hanns. 1917. *Deutscher Soldatenbrauch und Soldatenglaube.* Strasbourg: K. J. Trübner.

Baldwin, Peter (ed.). 1990. *Reworking the Past: Hitler, the Holocaust, and the Historians' Debate.* Boston.

Bartov, Omer. 1996. *Murder in Our Midst: The Holocaust, Industrial Killing, and Representation.* New York: Oxford University Press.

Bartov, Omer. 1998. "Defining Enemies, Making Victims: Germans, Jews, and the Holocaust." *The American Historical Review* 103 (3): 771–816.

Bauman, Zygmunt. 1989. *Modernity and the Holocaust.* Ithaca, NY: Cornell University Press.

Bauer, Yehuda. 1998. "The Past That Will Not Go Away." *In The Holocaust and History* (M. Berenbaum and A. J. Peck, eds.), pp. 12–22. Bloomington: Indiana University Press.

Benhabib, Seyla. 1992. "Models of Public Space: Hannah Arendt, the Liberal Tradition, and Jürgen Habermas." In her *Situating the Self,* pp. 89–120. New York: Routledge.

Benjamin, Jessica, and Anson Rabinbach. 1989. Foreword. In *Male Fantasies,* by Klaus Theweleit. Vol. 2, ix–xxv. Minneapolis: University of Minnesota Press.

Berenbaum, Michael, and Abraham J. Peck (eds.). 1998. *The Holocaust and History.* Bloomington: Indiana University Press.

Betances, Samuel. 1992. "Race and the Search for Identity." In *Race, Class, and Gender* (Margaret L. Andersen and Patricia Hill Collins, eds.), pp. 277–86. Belmont, CA: Wadsworth Publishing Company.

Bhabha, Homi K. 1984. "Of Mimicry and Men: The Ambivalence of Colonial Discourse." *October 28* (spring): 125–33.

Bhabha, Homi K. 1985. "Sly Civility." *October 34* (winter): 71–80.

Bhabha, Homi K. 1986. "Remembering Fanon." Foreword to Frantz Fanon, *Black Skins, White Masks* (Charles Lam Markmann, trans.). London: Pluto.

Bhabha, Homi K. (ed.). 1990. *Nation and Narration.* New York: Routledge.

Birkenmaier, Werner. 1980. "Das Asylrecht im Härtetest." *Deutsches Allgemeines Sonntagsblatt,* No. 7 (February 17): 3.

Bloch, Ernst. 1990. *The Heritage of Our Times.* Cambridge: MIT Press.

Bloom, Lisa. 1994. "Constructing Whiteness: Popular Science and National Geographic in the Age of Multiculturalism." *Configurations* 2 (1): 15–32.

Boddy, Janice. 1982. "Womb as Oasis: The Symbolic Context of Pharaonic Circumcision in Rural Northern Sudan." *American Ethnologist* 9 (4): 682–98.

Boehling, Rebecca. 1996. *A Question of Priorities: Democratic Reform and Economic Recovery in Postwar Germany.* Providence, RI: Berghahn Books.

Bolafi, Angelo. 1979. "Notes and Commentary: An Interview with Jürgen Habermas." *Telos* 39: 163–72.

Bookhagen, C., E. Hemmer, J. Raspe, E. Schulz, and M. Stergar. 1969. *Versuch der Revolutionierung des bürgerlichen Individuums.* Berlin.

Borneman, John. 1986. "Emigres as Bullets: Immigration as Penetration." *Journal of Popular Culture* 20 (3): 73–92.

Borneman, John. 1992a. *Belonging in the Two Berlins: Kin, State, Nation.* Cambridge: Cambridge University Press.

Borneman, John. 1992b. "State, Territory, and Identity Formation in the Postwar Berlins, 1945–1989." *Cultural Anthropology* 7 (1): 45–62.

Bouquet, Mary. 1996. "Family Trees and Their Affinities: The Visual Imperative of the Genealogical Diagram." *Journal of the Royal Anthropological Institute* (n.s.) 2: 43–66.

Bourdieu, Pierre. 1984. *Distinction: A Social Critique of the Judgement of Taste.* Cambridge: Harvard University Press.

Bourdieu, Pierre. 1991. *Language and Symbolic Power.* Cambridge: Polity Press.

Brainin, Elisabeth, and Jsodor Kaminer. 1982. "Psychoanalyse und Nationalsozialismus." *Psyche* (November).

Brubaker, Roger. 1992. *Citizenship and Nationhood in France and Germany.* Cambridge: Harvard University Press.

Brügge, Peter. 1981. "'Nächstes Jahr nackert in d'Oper': über den Münchner Streit zwischen Katholiken und den Nackten." *Der Spiegel* 34 (August 17): 150–51.

Brügge, Peter. 1985. "'Braun wennst bist, hast überall Kredit.' über die Münchner Kulturrevolution der Nacktbader." *Der Spiegel* (August 5): 148–49.

Bude, Heinz. 1995. *Das Altern einer Generation: Die Jahrgänge 1938 bis 1948.* Frankfurt.

Burke, Kenneth. 1989. *On Symbols and Society.* Chicago: University of Chicago Press.

Burleigh, Michael, and Wolfgang Wippermann. 1991. *The Racial State: Germany, 1933–1945.* Cambridge: Cambridge University Press.

Burns, Rob, and Wilfried van der Will. 1988. *Protest and Democracy in West Germany: Extra-Parliamentary Opposition and the Democratic Agenda.* New York.

Bynum, Caroline Walker. 1987. *Holy Feast and Holy Fast.* Berkeley: University of California Press.

Camporesi, Piero. 1984. *Il sugo della vita: Simbolismo e magia del sangue.* Milan: Edizioni di Comunita.

Canetti, Elias. 1973. *Crowds and Power* (Carol Stewart, trans.). New York: Contiuum.

Carter, Erica. 1997. *How German Is She? Postwar West German*

Reconstruction and the Consuming Woman. Ann Arbor: University of Michigan Press.

Chasseguet-Smirgel, Janine. 1986. *Sexuality and Mind: The Role of the Mother and the Father in the Psyche.* New York: New York University Press.

Chasseguet-Smirgel, Janine. 1988. "Das Grüne Theater." In her *Zwei Bäume im Garten* (Eva Moldenhauer, trans.), pp. 135–61. Munich: Verlag Internationale Psychoanalyse.

Christenfeld, Timothy. 1996. "Wretched Refuse is just the Start: Alien Expressions." *New York Times* (March 10), sect. 4, p. 4.

Claussen, Detlev. 1986. "In the House of the Hangman." In *Germans and Jews since the Holocaust* (Anson Rabinbach and Jack Zipes, eds.). New York.

Connell, R. W. 1990. "The State, Gender, and Sexual Politics." *Theory and Society* 19 (5): 507–44.

Connerton, Paul. 1989. *How Societies Remember.* Cambridge: Cambridge University Press.

Corbey, Raymond. 1988. "Alterity: The Colonial Nude." *Critique of Anthropology* 8(3): 75–92.

Cornel, Hajo (ed.). 1985. *Zum Thema Kultur.* Berlin: Alternative Liste, Kulturbereich.

Cuddihy, John Murray. 1987. *The Ordeal of Civility: Freud, Marx, Lévi Strauss, and the Jewish Struggle with Modernity.* Boston: Beacon Press.

Dalton, Russel J. 1988. *Citizen Politics.* Chatham, NJ: Chatham House.

Davin, Anna. 1978. "Imperialism and Motherhood." *History Workshop* 5: 9–65.

Delumeau, Jean. 1978. *La peur en Occident, XVIe-XVIIIe siecles.* Paris: Fayard.

de Lauretis, Teresa. 1988. "Sexual Indifference." *Theater Journal* 40 (2): 151–77.

de Lauretis, Teresa. 1989. "The Violence of Rhetoric: Considerations on Representation and Gender." In *The Violence of Representation* (N. Armstrong and L. Tennenhouse, eds.), pp. 239–58. London: Routledge.

De Soto, Hermine, and Konstanze Plett. 1995. "Citizenship and Minorities in the Process of Nation Rebuilding in Germany." *Polar* 18 (1): 106–121.

di Leonardo, Micaela. 1994. "White Ethnicities, Identity Politics, and Baby Bear's Chair." *Social Text* 41 (winter): 165–91.

Dirke, Sabine von. 1997. *"All Power to the Imagination!": The West German*

Counterculture from the Student Movement to the Greens. Lincoln: University of Nebraska Press.

Dominguez, Virginia R. 1986. *White by Definition: Social Classification in Creole Louisiana.* New Brunswick: Rutgers University Press.

Dönhoff, Marion Gräfin. 1988. "Station auf dem Weg zur Hölle: Ein Nachwort zum 9. November." *Die Zeit* (December 30) 1: 60.

Douglas, Mary. 1980. *Purity and Danger: An Analysis of the Concepts of Pollution and Taboo.* London: Routledge.

Drosdowski, Günther (ed.). 1972. *Duden: Das große Würterbuch der deutschen Sprache.* Vol. 3. Mannheim: Bibliographisches Institut/Dudenverlag.

Droste, Wiglaf. 1988. "Tazionalsozialismus. Die Fortsetzung des Holocaust mit liberal-humanistischen Mitteln." *die tageszeitung* (November 14): 9.

Duden, Barbara. 1991. *The Woman Beneath the Skin* (T. Dunlap, trans.). Cambridge: Harvard University Press.

Dundes, Alan. 1984. *Life is Like a Chicken Coop Ladder: A Portrait of German Culture Through Folklore.* New York: Columbia University Press.

Dundes, Alan (ed.). 1991. *The Blood Libel Legend: A Casebook of Anti-Semitic Folklore.* Madison: The University of Wisconsin Press.

Dundes, Alan, and Thomas Hauschild. 1983. "Auschwitz Jokes." *Western Folklore* 43: 249–60.

Dundes, Alan and Thomas Hauschild. 1987. "Kennt der Witz kein Taboo? Zynische Erzählformen als Versuch der Bewältigung nationalsozialistis cher Verbrechen." *Zeitschrift für Volkskunde* 83 (1): 21–31.

Durkheim, Emile. 1933. *The Division of Labor in Society* (George Simpson, trans.). Glencoe, IL: The Free Press.

Dürr, Hans Peter. 1994. *Nacktheit und Scham: Der Mythos vom Zivilisationsprozeß.* Frankfurt/Main: Suhrkamp Verlag.

Dwinger, Edwin Erich. 1935. *Die letzten Reiter.* Jena: Eugen Diederichs Verlag.

Dwinger, Edwin Erich. 1939. *Auf halbem Wege.* Jena: Eugen Diederichs Verlag.

Dyer, Richard. 1988. "White." *Screen* 29(4): 44–65.

Ebermann, Thomas and R. Trampert. 1991. "Zum Städele hinaus . . ." *Konkret* 11: 10–14.

Eder, Klaus. 1993. *The New Politics of Class: Social Movements and Cultural Dynamics in Advanced Societies.* New York: Sage.

Edinger, Lewis J. 1986. *West German Politics.* New York: Columbia University Press.

Edwards, Elizabeth (ed.). 1992. *Anthropology and Photography 1860–1920.* New Haven: Yale University Press.

Eggebrecht, Harald. 1998. "Mehr als nur Haut und Knochen." Süddeutsche Zeitung (January 17): 1.

Eglau, Hans Otto. 1972. "Beate Uhse: Die Liebesdienerin der Nation." In his *Die Kasse mußstimmen*, pp. 215–30. Düsseldorf: Econ Verlag.

Ehrenreich, Barbara. 1987. Foreword. In *Male Fantasies*, by Klaus Theweleit. Vol. 1, pp. ix–xvii. Minneapolis: University of Minnesota Press.

Eley, Geoff. 1992. "Nations, Publics, and Political Cultures: Placing Habermas in the Nineteenth Century." In *Habermas and the Public Sphere* (Craig Calhoun, ed.). Cambridge: MIT Press.

Elias, Norbert. 1939. *Über den Prozess der Zivilisation.* 2 vols. Basel: Haus zum Falken.

Enloe, Cynthia. 1993. *The Morning After: Sexual Politics at the End of the Cold War.* Berkeley: University of California Press.

Enloe, Cynthia. 1995. "Have the Bosnian Rapes Opened a New Era of Feminist Consciousness?" In *Mass Rapes* (Alexandra Stiglmayer, ed.), pp. 219–30. Lincoln: University of Nebraska Press.

Enzensberger, Hans Magnus. 1976. "Von der Unaufhaltsamkeit des Kleinbürgertums." *Kursbuch* 45: 1–8.

Fallada, Hans. 1933. *Little Man, What Now?* New York: Simon and Schuster.

Fallada, Hans. 1955. *Damals bei uns Daheim.* Reinbeck: Rowohlt.

Fanon, Frantz. 1967. *Black Skin, White Masks* (trans. by Charles Lam Markmann). New York: Grove Press.

Favazza, Armando R., and Barbara Favazza. 1987. *Bodies Under Siege: Self Mutilation in Culture and Psychiatry.* Baltimore: Johns Hopkins University Press.

Feher, Ference, and Agnes Heller. 1984. "From Red to Green." *Telos* 59: 35–44.

Fehrenbach, Heide. 1994. *German Body Politics.* Post-doctoral fellow's project, Rutgers Center for Historical Analysis. Rutgers University.

Fehrenbach, Heide. 1995. "Die Sünderin or Who Killed the German Man?" In her *Cinema in Democratizing Germany*, pp. 92–117. Chapel Hill: University of North Carolina Press.

Fehrenbach, Heide. 1996. "Mixed-Blood: Discourses of Race, Sex, and German Democratization." Paper presented at the *Tenth Berkshire Conference on the History of Women*, University of North Carolina at Chapel Hill. June 7–9, 1996.

Fein, Helen. 1979. *Accounting for Genocide.* New York: Free Press.

Feldman, Allen. 1991. *Formations of Violence: The Narration of the Body and Political Terror in Northern Ireland.* Chicago: University of Chicago Press.

Feldman, Allen. 1994. "On Cultural Anaesthesia: From Desert Storm to Rodney King." *American Ethnologist* 21(2): 404–18.

Feldman, Allen. 1996. Personal Communication (June 16).

Feldman, Allen. 1997. "Violence and Vision: The Prosthetics and Aesthetics of Terror." *Public Culture* 10(1): 24–60.

Fischer, Joshka. 1984. *Von grüner Kraft und Herrlichkeit.* Hamburg: Rowohlt.

Fiske, John. 1994. "Whiteness." In his *Media Matters: Everyday Culture and Political Change*, pp. 41–53. Minneapolis: University of Minnesota Press.

Forsythe, Diana. 1989. "German Identity and the Problem of History." *ASA Monograph* 27, pp. 137–56. Washington, D.C.: American Anthropological Association.

Foucault, Michel. 1973. *The Order of Things* (A. M. S. Smith, trans.). New York: Random House.

Foucault, Michel. 1975. *The Birth of the Clinic.* New York: Vintage Books.

Foucault, Michel. 1978a. "The Eye of Power." *Semiotext* 3(2):6–9.

Foucault, Michel. 1978b. *History of Sexuality* (R. Hurley, trans.). New York: Random House.

Foucault, Michel. 1979. *Discipline and Punish: The Birth of the Prison.* New York: Vintage Books.

Frankenberg, Ruth. 1993. *White Women, Race Matters: The Social Construction of Whiteness.* Minneapolis: University of Minnesota Press.

Frankfurter Allgemeine Zeitung. 1980a. "Länder bei der Lösung des Asylproblems im Stich gelassen." *Frankfurter Allgemeine Zeitung*, No. 40 (February 16), p. 4.

Frankfurter Allgemeine Zeitung. 1980b. "Bonn sorgt sich über die steigende Zahl von Asylbewerbern." *Frankfurter Allgemeine Zeitung* (March 1).

Frankfurter Allgemeine Zeitung. 1980c. "Der Bundesrat will allem zustimmen 'was ein Stück weiter führt'." *Frankfurter Allgemeine Zeitung* (May 29).

Frankfurter Allgemeine Zeitung. 1980d. "Änderung des Asylrechts gefordert." *Frankfurter Allgemeine Zeitung*, No. 126 (June 2), pp. 1–2, 4.

Frankfurter Allgemeine Zeitung. 1980e. "Baum will mit einem Sofortprogramm die Flut der Asyl-Bewerber eindämmen." *Frankfurter Allgemeine Zeitung*, No. 128 (June 4), pp. 1–2.

Frankfurter Allgemeine Zeitung. 1980f. "Anarchisches Asylrecht." *Frankfurter Allgemeine Zeitung*, No. 130 (June 7).

Frankfurter Allgemeine Zeitung. 1980g. "Wo sich die Koalition mit der Opposition in der Asylanten-Frage einigen könnte." *Frankfurter Allgemeine Zeitung*, No. 134/D23 (June 12), p. 1.

Frankfurter Allgemeine Zeitung. 1980h. "Wehner sieht Einigkeit im Kabinett zum Asylrecht." *Frankfurter Allgemeine Zeitung*, No. 135/23D (June 13), p. 1.

Frankfurter Allgemeine Zeitung. 1980i. "Soviel Asylbewerber wie Dorfbewohner." *Frankfurter Allgemeine Zeitung*, No. 146 (June 27), p. 1.

Frankfurter Allgemeine Zeitung. 1980j. "Visum-Pflicht für Türken tritt im Oktober in Kraft." *Frankfurter Allgemeine Zeitung,* No. 146 (June 27), p. 2.

Frankfurter Allgemeine Zeitung. 1980k. "Frankfurt will kein Lager für Asylbewerber." *Frankfurter Allgemeine Zeitung,* No. 152 (July 4).

Fraser, Nancy. 1993. "Rethinking the Public Sphere: A Contribution to the Critique of Actually Existing Democracy." In *The Phantom Public Sphere* (Bruce Robbins, ed.), pp. 1–32. Minneapolis: University of Minnesota Press.

Freud, Sigmund. 1972. *The Interpretation of Dreams* (James Strachey, trans. and ed.). New York: Avon Books.

Freud, Sigmund. 1961 [1930]. *Civilization and Its Discontents* (James Strachey, trans.). New York: W. W. Norton.

Freud, Sigmund. 1976 [1900]. *The Interpretation of Dreams.* Harmondsworth: Penguin Books.

Freudenreich, Johann. 1989. "Verfahren wegen Volksverhetzung. Judenvernichtung als Computerspiel." *Süddeutsche Zeitung* 34 (February 10): 13.

Friedlander, Henry. 1995. *The Origins of Nazi Genocide: From Euthanasia to the Final Solution.* Chapel Hill: University of North Carolina Press.

Friedländer, Saul (ed.). 1992. *Probing the Limits of Representation: Nazism and the "Final Solution."* Cambridge: Harvard University Press.

Friedman, Jonathan. 1991. "Consuming Desires: Stategies of Selfhood and Appropriation." *Cultural Anthropology* 6(2): 154–63.

Friedman, Jonathan. 1994. "The Political Economy of Elegance: An African Cult of Beauty." In his *Consumption and Identity* (ed.), pp. 167–87. Harwood Academic Publishers.

Friedrich, Dorothea. 1986. "Not der Augen. Die Nacktheit oder der nackte Körper nackt." *Frankfurter Allgemeine Zeitung* 211 (September 9), Beilage—Frankfurter Magazin, Heft 341, pp. 46–50.

Fromme, Friedrich Karl. 1980a. "Suchen sie Schutz oder Wohlstand?" *Frankfurter Allgemeine Zeitung,* No. 144/25D (June 25), p. 1.

Fromme, Friedrich Karl. 1980b. "Dämme gegen Asylanten-Springflut." *Frankfurter Allgemeine Zeitung,* No. 122 (May 28), p. 10.

Fuss, Diana. 1989. *Essentially Speaking: Feminism, Nature, and Difference.* New York: Routledge.

Fuss, Diana 1994. "Interior Colonies: Frantz Fanon and the Politics of Identification." *Diacritics* 24(2/3):20–42.

Gallagher, Charles A. 1995. "White Reconstruction in the University." *Socialist Review* 24 (1/2): 166–87.

Gallagher, C., and T. Laqueur (eds.). 1987. *The Making of the Modern Body: Sexuality and Society in the Nineteenth Century.* Berkeley: University of California Press.

Ganser, Armin. 1977. "Nackt unter Palmen—ohne Entblößungspflicht." *Frankfurter Allgemeine Zeitung* 46 (February 24), Reiseblatt, p. 10.

Ganser, Armin. 1979a. "Europas Strände öffnen sich den Nackten." *Frankfurter Allgemeine Zeitung* 153 (July 5), Reiseblatt, p. 3.

Ganser, Armin. 1979b. "Immer mehr Strände für die nackten Deutschen." *Die Welt* 126 (June 1): Reise, p. v.

Ganser, Armin. 1979c. "Versteckspiel mit neuen Nacktbadeständen." *Süddeutsche Zeitung* 90 (April 19), Reise, p. 2.

Ganser, Armin. 1980. "Wenn auch die letzten Hüllen fallen." *Frankfurter Rundschau* 92 (April 19): 71.

Ganser, Armin. 1984. "Nacktbaden ist nichts Besonderes mehr." *Süddeutsche Zeitung* 112 (May 15): 42.

Geyer, Michael. 1996. "The Politics of Memory in Contemporary Germany." In *Radical Evil* (Joan Copjec, ed.), pp. 169–200. London.

Geller, Jay. 1992. "(G)nos(e)ology: The Cultural Construction of the Other." In *People of the Body* (Howard Eilberg-Schwartz, ed.), pp. 243–82. Albany: State University of New York Press.

Gerhard, Ute, and Jürgen Link. 1991. "Kleines Glossar neorassistischer Feindbild-Begriffe." In *Buntesdeutschland* (Heiner Boehncke and Harald Wittich, eds.), pp. 138–48. Reinbek: Rowohlt.

Gilman, Sander L. 1982. *On Blackness Without Blacks: Essays on the Image of the Black in Germany.* Boston: G. K. Hall.

Gilman, Sander L. 1986a. "Black Bodies, White Bodies: Toward an Iconography of Female Sexuality in late Nineteenth-Century Art, Medicine, and Literature." In *Race, Writing, and Difference* (H. L. Gates, Jr., ed.), pp. 223–61. Chicago: University of Chicago Press.

Gilman, Sander L. 1986b. *Difference and Pathology: Stereotypes of Sexuality, Race, and Madness.* Ithaca, N.Y.: Cornell University Press.

Gilman, Sander L. 1987. "The Struggle of Psychiatry with Psychoanalysis." *Critical Inquiry* 13: 293–313.

Gilman, Sander L. 1992. "Plague in Germany, 1939/1989: Cultural Images of Race, Space, and Disease." In *Nationalisms and Sexualities* (Andrew Parker, M. Russo, D. Sommer, and P. Yaeger, eds.), pp. 175–200. New York: Routledge.

Girard, René. 1979. *Violence and the Sacred* (Patrick Gregory, trans.). Baltimore: Johns Hopkins University Press.

Glücksmann, Andre. 1984. *La force du vertige.* Paris: Fayard.

Godelier, Maurice. 1990. *The Making of Great Men.* Oxford: Cambridge University Press.

Goldberg, David Theo. 1993. *Racist Culture: Philosophy and the Politics of Meaning.* Cambridge, Mass.: Blackwell.

Goody, Jack R. 1983. *The Development of the Family and Marriage in Europe.* Cambridge: Cambridge University Press.

Gordon, Linda. 1996. "How Mexicans became Black; Orphans, Motherhood and the Construction of Race; An Arizona Story." Paper presented at the *Center for the Critical Analysis of Contemporary Culture* (CCACC), April 9, 1996. Rutgers University: New Brunswick, New Jersey.

Graf, William David. 1976. *The German Left since 1945: Socialism and Social Democracy in the German Federal Republic.* Cambridge: Cambridge University Press.

Greenhouse, Stephen. 1994a. "As Tide of Haitian Refugees Rises . . ." *New York Times* (June 30), p. A3.

Greenhouse, Stephen. 1994b. "Haitians taking to the Sea in Droves." *New York Times* (June 28), pp. A1, A6.

Gremliza, Hermann L. 1991. "Pogrom in Zivil." *Konkret* 11 (November): 8.

Griesbeck, Michael. 1997. "Asyl für politisch Verfolgte und die Eindämmung von Asylrechtsmißbrauch". *Aus Politik und Zeitgeschichte* (Beilage, Das Parlament) B46/97 (November 7): 3–10.

Grill, Bartholomaeus. 1989. "So normal, so stinknormal." *Die Zeit* 8 (February 17): 15.

Grill, Bartholomaeus, Michael Haller, Kuno Kruse, Hinrich Luehrssen, and Reinhard Merkel. 1989. "Alte Parolen, neue Parteien. Gegen Asylbewerber, Gastarbeiter und Aussiedler: Heil ohne Hitler?" *Die Zeit* 8 (February 17): 13–17.

Grimm, Jacob, and Wilhem Grimm. 1897. *Deutsches Wörterbuch.* Vol. 4. Leipzig: Verlag von S. Hirzel.

Grossmann, Atina. 1995. "Unfortunate Germans: Victims, Victors, and Survivors at War's End, Germany 1945–1950." Working Paper: Center for German and European Studies, University of California, Berkeley.

Grosz, Elizabeth. 1994. *Volatile Bodies: Toward a Corporeal Feminism.* Bloomington: Indiana University Press.

Gruhl, Herbert. 1990. "Die Grünen habe ihre Chance verpaßt!" *Die Grünen: 10 Bewegte Jahre* (Michael Schoeren, ed.), p. 148. Vienna: Carl Ueberreuter.

Grundgesetz und Landesverfassung. 1971. *Grundgesetz für die Bundesrepublik Deutschland und Verfassung für Rheinland-Pfalz.* Mainz: Hase & Köhler Verlag.

Grünen, Die. 1984a. *Das Bundesprogramm.* Bonn: Die Bundespartei der Grünen.

Grünen, Die. 1984b. *GAL: Programm für Hamburg.* Hamburg: Grün–Alternative Liste.

Guggenberger, Bernd. 1985. "Die nackte Wahrheit ist nicht immer das Wahre. Über die Grenzen zwischen Intimität und Öffentlichkeit." *Frankfurter Allgemeine Zeitung* 177 (August 3), Beilage: Bild und Zeit, pp. 1–2.

Habermas, Jürgen. 1981. "New Social Movements." *Telos* 49: 33–37.

Habermas, Jürgen. 1985. *Die neue Unübersichtlichkeit.* Frankfurt/Main: Suhrkamp Verlag.

Haeberle, Erwin J. 1989. "Swastika, Pink Triangle, and Yellow Star: The Destruction of Sexology and the Persecution of Homosexuals in Nazi Germany." In *Hidden from History* (Martin B. Duberman, Martha Vicinus, and George Chauncey, eds.), pp. 365–79. New York: Monthly Review Press.

Haeser, Heinrich. 1971. *Lehrbuch der Geschichte der Medizin und der epidemischen Krankheiten.* 3 vols. Reprint. Hildesheim: G. Olms.

Hall, Stuart. 1981. "Notes on Deconstructing the Popular." In *People's History and Socialist Theory* (R. Samuel, ed.), pp. 227–339. London: Routledge and Kegan Paul.

Hall, Stuart. 1985. "Signification, Representation, Ideology: Althusser and the Post–Structuralist Debates." *Critical Studies in Mass Communication* 2 (2): 91–114.

Hall, Stuart. 1986. "Gramsci's Relevance for the Study of Race and Ethnicity." *Journal of Communication Inquiry* 10 (2): 5–27.

Hall, Stuart. 1992. "Race, Culture, and Communications: Looking Backward and Forward at Cultural Studies." *Rethinking Marxism* 5, 1 (spring): 10–18.

Hall, Stuart. 1995. "The Whites of Their Eyes: Racist Ideologies and the Media." In *Gender, Race and Class in the Media* (Gail Dines and Jean M. Humez, eds.), pp. 18–22. London: Sage Publications.

Handler, Richard. 1988. *Nationalism and the Politics of Culture in Quebec.* Madison: University of Wisconsin Press.

Hannaford, Ivan. 1996. *Race: The History of the Idea in the West.* Baltimore: Johns Hopkins University Press.

Haraway, Donna. 1991. "Race." In her *Primate Visions: Gender, Race, and Nature in the World of Modern Science*, pp. 152–56. New York: Routledge.

Harrowitz, Nancy A., and Barbara Hyams (eds.). 1995. *Jews and Gender*. Philadelphia: Temple University Press.

Hartman, Geoffrey (ed.). 1994. *Holocaust Remembrance: The Shapes of Memory*. Oxford: Oxford University Press.

Harvey, David. 1990. *The Condition of Postmodernity: An Enquiry into the Origins of Cultural Change*. Cambridge, Mass.: Blackwell.

Haug, Fritz Wolfgang. 1965. "Vorbemerkung." *Das Argument* 32: 30–31.

Heider, Ulrike. 1986. "Freie Liebe und Liebesreligion: Zum Sexualitätsbegriff der 60er und 80er Jahre." In *Sadomasochisten, Keusche, und Romantiker: Vom Mythos neuer Sinnlichkeit* (U. Heider, ed.), pp. 92–109. Reinbek: Rowohlt.

Heitmeyer, Wilhelm. 1992. *Die Bielefelder Rechtsextremismusstudie*. 2d ed. Weinheim: Juventa.

Held, Josef and H. W. Horn. 1992. *Du musst so handeln, daß Du Gewinn machst . . .* Text No. 18. Duisburg: Duisburger Institut für Sprach–und Sozialforschung.

Herold, Thea. 1993. "Die nackte Republik." *Die Zeit* 42 (October 15): 71.

Herzfeld, Michael. 1987. *Anthropology through the Looking Glass*. New York: Cambridge University Press.

Herzfeld, Michael. 1992. *The Social Production of Indifference*. New York: Berg.

Herzog, Dagmar. 1998. "Pleasure, Sex, and Politics Belong Together: Post–Holocaust Memory and the Sexual Revolution in West Germany." *Critical Inquiry* 24 (winter): 393–444.

Heutgen, Alfons. 1980. "Eine Schutzstätte wird geplündert." *Deutsches Allgemeines Sonntagsblatt*, No. 7 (June 22).

Hilberg, Raul. 1985. *The Destruction of the European Jews*. 3d rev. ed. New York: Holmes and Meier.

Hobsbawm, Eric, and Terence Ranger (eds.). 1983. *The Invention of Tradition*. New York: Cambridge University Press.

Hoffmeister, D., and O. Sill. 1993. *Zwischen Aufstieg und Ausstieg: Autoritäre Einstellungsmuster bei Jugendlichen und jungen Erwachsenen*. Opladen: Leske und Budrich.

Holle, Peter. 1988. "Aktionen gegen Parolen. Vierseitige Flugschrift erzürnt viele Langener." *Frankfurter Rundschau* (December 17): 14.

hooks, bell. 1992. "Representations of Whiteness in the Black Imagination."

In her *Black Looks: Race and Representation*, pp. 165–78. Boston: South End Press.

Horn, Rebecca. 1997. "Annäherungen an das Denkmal für die ermordeten Juden Europas." *Erläuterungs bericht.* Engeres Auswahlvertfahren zum DenKmal für die ermordeten Juden Europas. Berlin.

Horsman, Reginald. 1981. *Race and Manifest Destiny: The Origins of American Racial Anglo–Saxonism.* Cambridge: Harvard University Press.

Hsia, R. Po–Chia. 1988. *The Myth of Ritual Murder: Jews and Magic in Reformation Germany.* New Haven: Yale University Press.

Interim. 1989. "Müll raus, Menschen rein." *Interim: Wöchentliches Berlin-Info.*, Nr. 59 (June 29): cover page.

Jäger, Margret. 1993. "Sprache der Angst." *die tageszeitung* (March 24).

Jeggle, Utz. 1997. "Phasen der Erinnerungsarbeit." In *Erinnern gegenden Schlu·strich: Zum Umgang mit dem Nationalsozialismus* (K. Scöînberger and M. Ulmer, eds.), 70–82. Freiburg: Joachim Haug Verlag.

Jeske, Jürgen J., Eckhard Neumann, and Wolfgang Sprang (eds.). 1987a. "Körperpflege und Pharmazie." *Jahrbuch der Werbung in Deutschland, Österreich und der Schweiz* 24: 418–23.

Jeske, Jürgen J., Eckhard Neumann, and Wolfgang Sprang (eds.). 1987b. "Diskussion: Das Nackte in der Werbung." *Jahrbuch der Werbung in Deutschland, Österreich und der Schweiz* 24: 39–55.

Jhering, Barbara von. 1988. "Sprachkünstler auf hohem Seil. Stoiber, Kohl und die taz: Sprachliche Entgleisungen oder neuer Antisemitismus?" *Die Zeit* 49 (December 2): 79.

Joffe, Josef. 1996. "Goldhagen in Deutschland." *New York Review of Books* (November 28): 18–21.

Jolly, Margaret. 1993. "Colonizing Women." *Feminism and the Politics of Difference* (S. Gunew and A. Yeatman, eds.), pp. 103–27. Boulder: Westview Press.

Jones, Ernest. 1951. *On the Nightmare.* New edition. New York: Liveright Publishing Corporation.

Kandiyoti, Denize. 1994. "Identity and Its Discontents: Women and the Nation." In *Colonial and Post–Colonial Theory* (Patrick Williams and Laura Chrisman, eds.), pp. 376–91. New York: Columbia University Press.

Kapielski, Thomas. 1988. "Klassenloser Luxus. Auch der Dschungel ist schon zehn Jahre alt." *Die Tageszeitung* (October 17): Berlin–Kulturseite (reprinted: November 14, p. 9).

Kaplan, Cora. 1992. "'White skin': Ethnology, Nationalism, and Feminism

in the 1840s." Faculty Fellow's project, *Center for the Critical Analysis of Contemporary Culture*. New Brunswick: Rutgers University.

Kelly, Joanna. 1995. "Representations of the Cultural Other Within Print Media Images." Unpublished manuscript, Rutgers University. 10 pages.

Kimpel, Harald, and Johanna Werckmeister. 1995. *Die Strandburg: Ein versandetes Freizeitvergnügen*. Marburg: Jonas Verlag.

Kinzer, Stephen. 1993. "Did a Town in Germany Pay a Firebug for Attack?" *New York Times* (August 25): pp. A1, A6.

Kinzer, Stephen. 1996. "A Curator Who doesn't Blush." *New York Times* (January 30): p. 4.

Kirshenblatt–Gimblett, Barbara. 1998. *Destination Culture: Tourism, Museums, and Heritage*. Berkeley: University of California Press.

Klappenbach, Ruth, and Wolfgang Steinitz (eds.). 1967. *Wörterbuch der deutschen Gegenwartssprache*. Berlin: Akademie Verlag.

Klee, Ernst (ed.). 1975. *Gastarbeiter: Analysen und Berichte*. 3d ed. Frankfurt/Main: Suhrkamp Verlag.

Klein, Heinz Günter. 1980. "Asyl–Sorgen." *Rhein–Zeitung* (June 25).

Klemperer, Victor. 1987 [1946]. *Lingua Tertii Imperii. Notizbuch eines Philologen*. 4th ed. Berlin.

Köhler, Michael. 1985a. "Jeder sein Michelangelo oder: Der Körper als Kunstwerk." In *Das Aktfoto* (M. Köhler and G. Barche, eds.), pp. 282–88. Munich: Verlag C. J. Bucher.

Köhler, Michael. 1985b. "Stimmen zu Nacktheit und Sex in der Werbung. Eine Dokumentation." In *Das Aktfoto* (M. Köhler and G. Barche, eds.), pp. 274–81. Munich: Verlag C. J. Bucher.

Konkret. 1994. "Zusammentfassung der Diskussion von der Arbeitsgrauppe Gedenkstätte der Initiative 9. November 1938." *Konkret* 1: 42.

Koonz, Claudia. 1987. *Mothers in the Fatherland*. New York: St. Martin's Press.

Korff, Gottfried. 1991. "Symbolgeschichte als Sozialgeschichte? Zehn vorläufige Notizen zu den Bild– und Zeichensystemen sozialer Bewegungen in Deutschland." In *Massenmedium Straße* (B. J. Warneken, ed.), pp. 17–36. Frankfurt/Main: Campus Verlag.

Korff, Gottfried. 1997. "Olfaktische Symbole: Riecht der Osten anders?" Paper presented at the Institutskolloquium, Ludwig–Uhland–Institut, University of Tübingen. Tübingen (Germany), October 23, 1997.

Körperwelten. 1997. *Körperwelten: Einblicke in den menschlichen Körper* (Landesmuseum für Technik und Arbeit in Mannheim and Institut für Plastination, eds.). Heidelberg: Institut für Plastination.

Köster, Barbara. 1987. "Rüsselsheim Juli 1985." In *Wir haben sie so geliebt, die Revolution* (Daniel Cohn–Bendit, ed.), p. 244. Frankfurt.

Kreft, Ursula. 1991. "Alles mit Mass und mit Ziel." *Konkret* 11 (November): 28–29.

Kreyssig, Gert. 1978. "Immer mehr ziehen sich aus, um sich auszuziehen. Hüllenlos in Jugoslawien." *Stuttgarter Zeitung* 170 (July 27): 23.

Kuntz–Brunner, Ruth. 1990. "Sexualpolitik: DDR." *Frankfurter Rundschau* 28 (July 13): 5.

Kuper, Leo. 1981. *Genocide.* New Haven: Yale University Press.

Kurthen, Hermann, Werner Bergmann, and Rainer Erb (eds.). 1997. *Antisemitism and Xenophobia in Germany after Unification.* New York.

Lacoue–Labarthe, Philippe, and Jean–Luc Nancy. 1989. "The Unconscious is Destructured like an Affect." *Stanford Literature Review* 6 (fall): 191–209.

Landes, Joan. 1988. *Women and the Public Sphere in the Age of the French Revolution.* Ithaca: Cornell University Press.

Lange–Feldhahn, Klaus, Claudia Duppel, Axel Pfaff, and Ingrid Reick. 1983. "11. 11. 1981 — Ausbruch (?) aus dem Irrenhaus." In *Friedensbewegung: Persönliches und Politisches* (K. Horn and E. Senghaas–Knobloch, eds.), pp. 202–17. Frankfurt/Main: Fischer Verlag.

Lanzmann, Claude. 1985. *Shoah: An Oral History of the Holocaust; The Complete Text of the Film.* New York.

Laponce, J. A. 1981. *Left and Right: The Topography of Political Perceptions.* Toronto: University of Toronto Press.

Lavie, Smadar. 1990. *The Poetics of Military Occupation: Mzeina Allegories of Bedouin Identity Under Israeli and Egyptian Rule.* Berkeley: University of California Press.

Lears, T. J. Jackson. 1983. "From Salvation to Self–Realization: Advertising and the Therapeutic Roots of the Consumer Culture, 1880–1930." In *The Culture of Consumption* (R. Wightman Fox and T. J. J. Lears, eds.), pp. 1–38. New York: Pantheon Books.

Ledbetter, James. 1995. "The Unbearable Whiteness of Publishing." *Village Voice* XL, 30 (July): 25–28.

Levine, Lawrence W. 1977. *Black Culture and Black Consciousness: Afro–American Folk Thought from Slavery to Freedom.* New York: Oxford University Press.

Lewis, Wyndham. 1929. *Paleface: The Philosophy of the Melting Pot.* London: Chatto and Windus.

Lidtke, Vernon. 1982. "Songs and Nazis." In *Essays on Culture and Society*

in Modern Germany (D. King et al., eds.), pp. 167–200. College Station, TX: A & M University Press.

Lifton, Robert Jay. 1986. *Nazi Doctos: Medical Killing and the Psychology of Genocide.* New York: Basic Books.

Linebaugh, Peter. 1975. "The Tyburn Riots against the Surgeons." In *Albion's Fatal Tree* (D. Hay, eds.), pp. 65–111. New York: Pantheon Books.

Link, Jürgen. 1983. "Asylanten, ein Killwort." Auszüge einer Bochumer Vorlesung vom 15. Dezember 1982. *kultuRRevolution* 2 (February): 36–38.

Linke, Uli. 1982. "Caste and Class in Germany: A Study of the Power Politics of Labor Migration from 1955–1980." *The Kroeber Anthropological Society Papers* 61/62: 78–87.

Linke, Uli. 1988. "The Language of Resistance: Political Rhetoric and Symbols of Popular Protest in Germany." *City and Society* 2 (2): 127–33.

Linke, Uli. 1990. "Folklore, Anthropology, and the Government of Social Life." *Comparative Studies in Society and History* 34 (4): 605–46.

Linke, Uli. 1992. "Manhood, Femaleness, and Power: A Cultural Analysis of Prehistoric Images of Reproduction." *Comparative Studies in Society and History* 34 (4): 579–620.

Linke, Uli. 1994. "The New Politics of Nature: Fears of Contamination and Race in Postcold War Germany." Paper presented at the 18th annual conference of the *German Studies Association.* Dallas, Texas, September 29–October 2, 1994

Linke, Uli. 1995. "Murderous Fantasies: Violence, Memory, and Selfhood in Germany." *New German Critique* 64 (winter): 37–59.

Linke, Uli. 1996. "The Politics of Memory and Denial: Holocaust Language and Street Violence in Germany." In *Receptions of Violence: Iconoclastic After–Texts, After–Images and the Post–Ethnographic Site* (Allen Feldman, ed.). Chicago: University of Chicago Press.

Linke, Uli. 1997. "Colonizing the National Imaginary: Folklore, Anthropology, and the Making of the Modern State." In *Cultures of Scholarship* (Sally Humphreys, ed.), pp. 97–138. Ann Arbor: Michigan University Press.

Linke, Uli. 1999. *Blood and Nation: The European Aesthetics of Race.* Philadelphia: University of Pennsylvania Press.

Linke, Uli, and Dundes, Alan. 1988. "More on Auschwitz Jokes." *Folklore* 99 (i): 3–10.

Lipsitz, George. 1993. "The Possessive Investment in Whiteness: Racialized

Social Democracy in America." Unpublished manuscript. Paper presented at the annual meeting of the *American Studies Association*, Boston, November 1993.

Lipstadt, Deborah. 1993. *Denying the Holocaust: The Growing Assault on Truth and Memory*. New York.

Lopez, Ian F. Haney. 1996. *White by Law: The Legal Construction of Race*. New York: New York University Press.

Lorenzo, Giovanni di. 1988. "Vor 50 Jahren in Bayrisch Gmain. Der angekündigte Tod der Witwe Klara Dapper: eine alte Frau nahm sich aus Angst das Leben — ein Kurort wurde 'Judenfrei'". *Süddeutsche Zeitung* 253 (November 2): 10–11.

Lowie, Robert H. 1945. *The German People*. New York: Farrar.

Lutz, Catherine A. 1988. *Unnatural Emotions*. Chicago: University of Chicago Press.

Lutz, Catherine A., and Jane L. Collins. 1993a. "The Color of Sex: Postwar Photographic Histories of Race and Gender." In their *Reading the National Geographic*, pp. 155–58. Chicago: University of Chicago Press.

Lutz, Catherine A., and Jane L. Collins. 1993b. *Reading the National Geographic*. Chicago: University of Chicago Press.

Maier, Charles S. 1989. *The Unmasterable Past: History, Holocaust, and German National Identity*. Cambridge: Harvard University Press.

Malik, Kenan. 1996. *The Meaning of Race: Race, History, and Culture in Western Society*. New York: New York University Press.

Malkki, Liisa H. 1995a. *Purity and Exile*. Chicago: University of Chicago Press.

Malkki, Liisa H. 1995b. "Refugees and Exile: From 'Refugee Studies' to the National Order of Things." *Annual Review of Anthropology* 24: 495–523.

Malkki, Liisa H. 1996. "National Geographic." In *Becoming National* (Geoff Eley and Ronald Grigor Suny, eds.), pp. 434–53. New York: Oxford University Press.

Mann, Gunter. 1984. "Exekution und Experiment: Medizinische Versuche bei der Hinrichtung des Schinderhannes." *Lebendiges Rheinland–Pfalz* 21 (2): 11–16.

Markovits, Andrei S., and Philip S. Gorski. 1993. *The German Left: Red, Green, and Beyond*. Cambridge: Cambridge University Press.

Markovits, Andrei S. and Simon Reich. 1997. *The German Predicament: Memory and Power in the New Europe*. Ithaca, NY: Cornell University Press.

Martin, Emily. 1987. *The Woman in the Body*. Boston: Beacon Press.

Martin, Emily. 1990. "The Ideology of Reproduction." In *Uncertain Terms* (Faye Ginsburg and Anna Lowenhaupt Tsing, eds.), pp. 300–14. Boston: Beacon Press.

Martinez–Alier, Verena. 1974. *Marriage, Class, and Colour in Nineteenth Century Cuba*. London: Cambridge University Press.

Marx, Rita. 1994. "Zum Verlieren der Emphatie mit dem Opfer in der Gegenübertragung." Paper presented at the International Colloquium: *Gewalt: Nationalismus, Rassismus, Ausländerfeindlichkeit*. Februrary 10–13, 1994, Berlin.

Mattson, Michelle. 1995. "Refugees in Germany: Invasion or Invention?" *New German Critique* 64 (Winter): 61–85.

Mayer, Elkebarbara, Martina Schmolt, and Harald Wolf (eds.). 1988. *Zehn Jahre Alternative Liste*. Bremen: Steintor.

McCormick, Richard W. 1991. *Politics of the Self: Feminism and the Postmodern in West German Literature and Film*. Princeton: Princeton University Press.

McDowell, Deborah E. 1995. "Postmortems: Facing the Black Male Corpse." Keynote Address, at the Graduate Student Conference *Negotiating Identities in the Americas: Race/Gender/Nation*, sponsored by the Institute for Research on Women, April 1, 1995. New Brunswick: Rutgers University.

Melson, Robert. 1992. *Revolution and Genocide*. Chicago: University of Chicago Press.

Meyers, Jochen. 1984. "Nacktheit ist nichts Besonderes mehr an südlichen Stränden." *Süddeutsche Zeitung* 187 (August 14): 42.

Minkenberg, Michael. 1994. "Alte Politik, neue Politik, anti–Politik: Wohin treibt das Parteien System?" Paper presented on the DAAD–panel at the annual meeting of the German Studies Association, Dallas, Texas, September 29 – October 2, 1994.

Minkenberg, Michael. n.d. *What's Left?: The Left and Nationalism in Post–Socialist Europe*. Ithaca, NY: Cornell University Press.

Moeller, Robert G. 1996a. *Protecting Motherhood*. Berkeley: University of California Press.

Moeller, Robert G. 1996b. "War Stories: The Search for a Usable Past in the Federal Republic of Germany." *American Historical Review* 101 (October): 1008–48.

Moeller, Robert G. (ed.) 1997. *West Germany under Construction: Politics, Society, and Culture in the Adenauer Era*. Ann Arbor: University of Michigan Press.

Mommsen, Hans. 1991. *From Weimar to Auschwitz.* Princeton: Princeton University Press.

Moore, Henrietta. 1988. "Women and the State." In her *Feminism and Anthropology*, pp. 128–85. Minneapolis: University of Minnesota Press.

Moore, Henrietta (ed.). 1990. *Space, Text and Gender.* Cambridge: Cambridge University Press.

Morley, David, and Kevin Robins. 1996. "No Place like Heimat: Images of Home(land) in European Culture." In *Becoming National* (Geoff Eley and Ronald G. Suny, eds.), pp. 456–78. New York: Oxford University Press.

Morrison, Toni. 1993. *Playing in the Dark: Whiteness and the Literary Imagination.* New York: Vintage.

Mosbach, Doris. 1991. "Vom Ab–Geschmack der grossen weiten Welt: Exoten im Dienste der Werbung." In *Menschen Fresser, Neger Küsse: Das Bild vom Fremden im deutschen Alltag* (Marie Lorbeer and Beate Wild, eds.), pp. 118–23. Berlin: Elefanten Press.

Mosler, Peter. 1977. *Was wir wollten, was wir wurden: Studentenrevolte— zehn Jahre danach.* Reinbeck.

Mosse, George L. 1975. *The Nationalization of the Masses.* New York: Howard Fertig.

Mosse, George L. 1985. *Nationalism and Sexuality: Middle–Class Morality and Sexual Norms in Modern Europe.* Madison: University of Wisconsin Press.

Mosse, George L. 1993. *Confronting the Nation.* Hanover: Brandeis University Press.

Muchembled, Robert. 1983. "Le corps, la culture populaire et la culture des elites en France." In *Leib und Leben in der Geschichte der Neuzeit* (A. E. Imhoff, ed.). Berliner historische Studien, vol. 9. Berlin: Dunker and Humblot.

Muchembled, Robert. 1985. *Popular and Elite Culture in France, 1400–1750.* (L. Cochrane, trans.). Baton Rouge: Louisiana State University Press.

Müller, Siegfried (ed.). 1985. *Graffiti: Tätowierte Wände.* Bielefeld.

Müller–Hill, Benno. 1988. *Murderous Science* (George R. Fraser, trans.). Oxford: Oxford University Press.

Münch, Ursula. 1992. *Asylpolitik in der Bundesrepublik Deutschland.* Opladen: Leske and Budrich.

Naumann, Klaus. 1996. "Die Mutter, das Pferd und die Juden: Flucht und Vertreibung als Themen deutscher Erinnerungspolitik." *Mittelweg 36*, 4 (Aug.–Sept.): 70–83.

Nazzari, Muriel. 1996. "The Waxing and Waning of Matrilineality in Sao Paulo, Brazil: Historical Variations in an Ambilineal System, 1500–1900." In *Gender, Kinship, Power* (Mary Jo Maynes et al., eds.), pp. 305–18. New York: Routledge.

Nederveen Pieterse, Jan. 1992. *White on Black: Images of Africa and Blacks in Western Popular Culture.* New Haven: Yale University Press.

Neuffer, Elizabeth. 1994. "Berlin Sheds its Reserve in Springtime." *The Boston Globe* (May 16), foreign journal, p. 2.

New York Times. 1991. "Video Game Uncovered in Europe Uses Nazi Death Camps as Theme." *New York Times* (May 1): p. 10A.

New York Times. 1992. "Swastikas Drawn on Death Camp Memorial." *New York Times* (October 25): p. 12L.

New York Times. 1994a. "3 Skinheads Cut a Swastika on a Disabled German Girl." *New York Times* (January 12): p. A9.

New York Times. 1994b. "German Attack Called Unlikely." *New York Times* (January 15): A9.

Nierenberg, Jesse. 1984. "Ich möchte das Geschwür loswerden. Türkenhass in Witzen in der Bundesrepublik Deutschland." *Fabula* 25: 229–40.

Nordstrom, Carolyn. 1991. "Women and War: Observations from the Field." *Minerva* 9 (1): 1–15.

Nordstrom, Carolyn. 1996. "Rape: Politics and Theory in War and Peace with Stribethrough." *Australian Feminist Studies* 11 (23): 147–62.

Offe, Claus. 1987. "Modernity and Modernization as Normative Political Principles." *Praxis International* 7(1): 2–17.

Olujic, Maria. 1995. "Representation of Experience and Survival of Genocidal Rape in Croatia and Bosnia." Paper presented at the International Conference on *(En)Gendering Violence*, Zagreb, Coatia. October 27–28, 1996.

Omi, Michael, and Howard Winant. 1994. *Racial Formations in the United States: From the 1960s to the 1980s.* 2d. ed. New York: Routledge.

O'Neill, Mary R. 1984. "Sacerdote ovvero Strione: Ecclesiastical and Superstitious Remedies in Sixteenth-Century Italy." In *Understanding Popular Culture: Europe from the Middle Ages to the Nineteenth Century* (Steven L. Kaplan, ed.), pp. 53–83. New York: Mouton.

Ortner, Sherry. 1973. "On Key Symbols." *American Anthropologist* 75 (5): 1338–46.

Otto, Karl A. 1988. "Wenn über die Einreise der deutsche Stammbaum entscheidet: 'Deutschtümmelei' oder 'Verfassungsauftrag'? Anmerkungen zur Problematik der Aussiedler–Politik." *Frankfurter Rundschau* (16 December), no. 293, pp. 14–15.

Pai, Claudia. 1985. "Sex Shops. Als Novität ein Gummi–Mann." *Die Zeit* 12 (March 13): 40.

Parker, Andrew, Mary Russo, Doris Sommer, and Patricia Yaeger. 1992.

"Introduction." In their *Nationalisms and Sexualities* (ed.), pp. 1–18. New York: Routledge.

Peck, Jeffrey M. 1996. "Rac(e)ing the Nation: Is There a German 'Home'?" In *Becoming National* (Geoff Eley and Ronald G. Suny, eds.), pp. 481–92. New York: Oxford University Press.

Peukert, Detlev J. K. 1987. *Inside Nazi Germany: Conformity, Opposition, and Racism in Everyday Life* (Richard Deveson, trans.). New Haven: Yale University Press.

Philipp, Wolfgang. 1980. "Asylmißbrauch—ein Problem der Wirtschaft?" *Frankfurter Allgemeine Zeitung* (April 1).

Piwitt, Hermann Peter. 1978. "Niemand mußhungern: Das Gerede von der 'Überbevölkerung' ist ein verbrecherischer Mythos. Zwei Amerikaner haben ihn zerstört." *Konkret* 8 (August): 39.

Plant, Richard. 1986. *The Pink Triangle: The Nazi War against Homosexuals*. New York: H. Holt.

Pohrt, Wolfgang. 1991. "Stop den Mob." *Konkret* (May) 5: 34–35.

Pokorny, Julius. 1959. *Indogermanisches Etymologisches Wörterbuch*. 2 vols. Bern: Francke Verlag.

Poovey, Mary. 1988. *Uneven Developments*. Chicago: University of Chicago Press.

Preuss–Lausitz, Ulf. 1989. "Vom gepanzerten zum sinnstiftenden Körper." In *Kriegskinder, Konsumkinder, Krisenkinder: Zur Sozialisationsgeschichte seit dem zweiten Weltkrieg* (U. Preuss–Lausitz et al., eds.) Weinheim.

Proctor, Robert. 1988. *Racial Hygiene: Medicine under the Nazis*. Cambridge: Harvard University Press

Quinn, Malcolm. 1994. *The Swastika: Constructing the Symbol*. London: Routledge.

Rabinbach, Anson, and Jessica Benjamin. 1989. Foreword. In *Male Fantasies*, by Klaus Theweleit. Vol. 2, ix–xxv. Minneapolis: University of Minnesota Press.

Reimer, Wulf. 1998. "Nächtliche Wallfahrt zu den Toten." *Süddeutsche Zeitung* (March 2): 1, 2.

Reiche, Reimut. 1988. "Sexuelle Revolution—Erinnerung an einen Mythos." In *Die Früchte der Revolution: Über die Veränderung der politischen Kultur durch die Studentenbewegung*. Berlin.

Reuss, Eberhard. 1988. "Prozess gegen junge Rechtsradikale: 'So richtig Lust hatte keiner'. Warum schlugen sie Asylbewerber krankenhausreif?" *Die Zeit* 49 (December 2): 16.

Rhein–Zeitung. 1980a. "Aufstieg zum Asyl–Land Nummer Eins." *Rhein–Zeitung* (February 1).

Rhein–Zeitung. 1980b. "Die Flut der Ausländer überfordert viele Städte." *Rhein–Zeitung* (April 2).

Rhein–Zeitung. 1980c. "Union fordert Änderungen im Asylrechts–Entwurf." *Rhein Zeitung* (June 25).

Ridgeway, James. 1990. *Blood in the Face: The Ku Klux Klan, Aryan Nations, Nazi Skinheads, and the Rise of a New White Culture.* New York: Thunder's Mouth Press.

Riedle, Gabriele. 1988. "Richtigstellung. Zur Beschäftigung mit der Geschichte." *die Tageszeitung* (November 14): 8.

Robbins, Bruce (ed.). 1993. *The Phantom Public Sphere.* Minneapolis: University of Minnesota Press.

Roediger, David R. 1991. *The Wages of Whiteness: Race and the Making of the American Working Class.* New York: Verso.

Röhrich, Lutz. 1977. *Lexikon der sprichwörtlichen Redensarten.* Freiburg: Herder.

Roll, Evelyn. 1996. "Goldhagens Diskussionsreise: Der schwierige Streit um die Deutschen und den Holocaust; Eine These und drei gebrochene Tabus." *Süddeutsche Zeitung* (September 9).

Rommel, Manfred. 1989. "An Weltoffenheit gewinnen: auf dem Weg zu einer multi–kulturellen Gesellschaft." *Die Zeit* 8 (February 17), p. 4.

Roth, Jürgen. 1998. "Body Counts." *Konkret* 4 (April): 50–52.

Roth, Martin. 1989. "Xenophobie und Rassismus in Museen und Austellungen." *Zeitschrift für Volkskunde* 85 (1): 48–66.

Rothman, David J., Steven Marcus, and Stephanie A. Kiceluk (eds.). 1995. Introduction. In their *Medicine and Western Civilization* (ed.). New Brunswick: Rutgers University Press.

Sacks, Karen Brodkin. 1994. "How did Jews become White Folks?" In *Race* (Steven Gregory and Roger Sanjek, eds.), pp. 78–102. New Brunswick: Rutgers University Press.

Said, Edward. 1978. *Orientalism.* New York: Random House.

Salomon, Ernst von. 1930. *Die Geächteten.* Berlin: Rowohlt.

Sauer, Hermann. 1955. "Zwischen Gewissen und Dämon: Der 20. Juligestern und heute." *Junge Kirche* (1955): 426.

Saxton, Alexander. 1990. *The Rise and Fall of the White Republic. Class Politics and Mass Culture in Nineteenth–Century America.* London: Verso.

Schaefer, Eva. 1996. "Commentary" on "Feminist Theories of Postmodernism in the Study of Social Change," at the *Tenth Berkshire Conference on the History of Women: Complicating Categories–Women, Gender, and Difference.* University of North Carolina at Chapel Hill, June 7–9, 1996.

Schalk, Willie, and Helmut Thoma (eds.). 1993a. *Jahrbuch der Werbung in Deutschland, Österreich und der Schweiz.* Vol. 30. Düsseldorf: ECON Verlag.

Schalk, Willie, and Helmut Thoma (eds.). 1993b. "Untitled." *Jahrbuch der Werbung* 30: 256, 287.

Schauer, Rainer. 1982. "FKK: Meist fallen die Hüllen unerlaubt." *Die Zeit* 21 (May 21): 57.

Schein, Louisa. 1994. "The Consumption of Color and the Politics of White Skin in Post–Mao China." *Social Text* 41: 141–64.

Schilling, Heinz–Dieter (ed.). *Schwule und Faschismus.* Berlin: Elefanten Press.

Schirner, Michael. 1987. "Hatten Sie schon mal den Weltgeist als Kunden?: Das Nackte in der Werbung." *Jahrbuch der Werbung in Deutschland, Österreich und der Schweiz* 24 (J. J. Jeske, E. Neumann, and W. Sprang, eds.), pp. 39–41. Düsseldorf: ECON Verlag.

Schmalz, Peter. 1987. "Wenn beim Fallen der Hüllen die Philosophie abgelegt wird." *Welt* 184 (August 11): 3.

Schrep, Bruno. 1983. "Totschlagen, alles totschlagen." *Der Spiegel* 37 (33): 72–73.

Schütt, Peter. 1981. *Der Mohr hat seine Schuldigkeit getan.* Dortmund: Weltkreis Verlag.

Schwerdtfeger, Günther. 1980. *Welche rechtlichen Vorkehrungen empfehlen sich, um die Rechtstellung von Ausländern in der Bundesrepublik angemessen zu gestalten?* Munich: C. H. Becksche Verlagsbuchhandlung.

Sedgwick, Eve Kosofsky. 1992. "Nationalisms and Sexualities in the Age of Wilde." In *Nationalisms and Sexualities* (A. Parker et al., eds.), pp. 235–45. New York: Routledge.

Senders, Stefan. 1996. "Laws of Belonging: Legal Dimensions of National Inclusion in Germany." *New German Critique* 67 (winter): 147–76.

Sennett, Richard. 1994. *Flesh and Stone: The Body and the City in Western Civilization.* New York: W. W. Norton.

Seremetakis, C. Nadia. 1996. "In Search of the Barbarians: Borders in Pain." *American Anthropologist* 98 (3): 489–511.

Severin, Klaus. 1997. "Illegale Einreise und internationale Schleuserkriminalität: Hintergründe, Beispiele und Maßnahmen." *Aus Politik und Zeitgeschichte* (Beilage, Das Parlament) B 46/97 (November 7): 11–19.

Siegler, Bernd. 1989. "Schweigemarsch gegen Ausländerhass." *Berliner Tageszeitung* (January 16): 5.

Siegler, Bernd, and D. Ennsle. 1989. "Ausländerfeindlichkeit in der Bischofsstadt." *Berliner Tageszeitung* (February 18): 5.

Siepmann, Eckhard et al. (eds.). 1984. *CheSchaShit: Die Sechziger Jahre zwischen Cocktail und Molotov.* Berlin.

Silbermann, Alphons. 1982. *Sind wir Antisemitisten?* Cologne.

Silverman, Kaja. 1989. "White Skin, Brown Masks: The Double Mimesis, or With Lawrence in Arabia." *differences* 1(3): 3–54.

Skierka, Volker. 1988. "Vor 50 Jahren im schleswig–holsteinischen Friedrichstadt. Ein Hort der Toleranz versank in die Barbarei: wie in der Nacht des 10. November den Juden im Ort die Existenz zerstört wurde." *Süddeutsche Zeitung* 255 (November 4): 14.

Smith, Carol. 1995. "Race–Class–Gender Ideology in Guatemala: Modern and Anti–Modern Forms. *Comparative Studies in Society and History* 37 (4): 723–49.

Soeffner, Hans–Georg. 1992. "Stil und Stilisierung: Punk oder die über höhung des Alltags." In his *Die Ordnung der Rituale*, pp. 76–101. Frankfurt/Main: Suhrkamp Verlag.

Soltau, Heide. 1987. "Erotische Irritationen und heimliche Spiele mit der Lust: Das Nackte in der Werbung." *Jahrbuch der Werbung in Deutschland, Österreich und der Schweiz* 24: 42–50.

Sorel, Georges. 1941. *Reflections on Violence* (T. E. Hulme, trans.). New York: P. Smith.

Spiegel, Der. 1979. "Beate–Uhse–Sexhandel. Stramme Pflicht." *Der Spiegel* 23 (June 4): 207–10.

Spiegel, Der. 1980a. "Deutschland: Da sammelt sich ein ungeheurer Sprengstoff." *Der Spiegel* 23 (June 2): 17–1: 8.

Spiegel, Der. 1980b. "Finished, aus, you go, hau ab. Ausländerwelle." *Der Spiegel* 25 (June 16): 32–35.

Spiegel, Der. 1982a. "Sex–Tourismus: Kenia." *Der Spiegel* 46 (November 1): 191–96.

Spiegel, Der. 1982b. "Italien: Antikes Ideal. Nackte Busen verstoßen in Italien immer noch gegen die öffentliche Moral." *Der Spiegel* 35 (August 30): 133, 135.

Spiegel, Der. 1983. "Grüne: heckern und kleckern." *Der Spiegel* 35 (August 29): 59–61.

Spiegel, Der. 1984. "Schleswig–Holstein: Früh bis Spät." *Der Spiegel* 3: 52, 65.

Spiegel, Der. 1984b. "Griechenland: Hohes Niveau." *Der Spiegel* 40 (October 1): 172–75.

Spiegel, Der. 1985. "Froh jubelt ihr beim kleinsten Lichtstrahl. Touristen an südlichen Stränden." *Der Spiegel* 32 (August 5): 142–51.

Spiegel, Der. 1988. "Hochschulen. Bis aufs Hemd." *Der Spiegel* 52: 62–63.

Spiegel, Der. 1989. "Die neuen Deutschen. Einwanderungsland Bundesrepublik, I: Fremdenfurcht verändert die politische Landschaft." *Der Spiegel* 43 (7): 26–50.

Spiegel, Der. 1990a. "Ham'Se was mit Strapsen: Westdeutsche Porno- und Sexhändler wollen DDR erobern." *Der Spiegel* 16 (April 16): 47–56.

Spiegel, Der. 1990b. "Striptease im Parlament: Nach der Mauer fallen in der DDR nun auch die sozialistischen Sexualtabus." *Der Spiegel* 17 (April 23): 262–65.

Spivak, Gayatri Chakravorty. 1985. "The Rani of Simur." In *Europe and its Others* (Frances Barker et al., eds.), pp. 128–51. Colchester: University of Essex.

Steiger, Ricabeth, and Martin Taureg. 1985. "Körperphantasien auf Reisen. Anmerkungen zum ethnographischen Akt." In *Das Aktfoto* (M. Köhler and G. Barche, eds.), pp. 116–36. Munich: Verlag C. J. Bucher.

Stewart, Susan. 1993. *On Longing.* Durham, NC: Duke University Press.

Stiglmayer, Alexandra. 1994. *Mass Rape.* Lincoln: Nebraska University Press.

Strack, Hermann L. 1909. *The Jew and Human Sacrifice [Human Blood and Jewish Ritual].* New York: The Bloch Publishing Co.

Strobl, Ingrid. 1993. *Das Feld des Vergessens: Jüdischer Widerstand and deutsche "Vergangenheitsbewältigung."* Berlin: Edition ID Archiv.

Sutton, Constance R. (ed.). 1995. *Feminism, Nationalism, and Militarism.* Washington, D.C.: Association for Feminist Anthropology/American Anthropological Association.

die tageszeitung [taz]. 1989. "Volks–frei–tag vor der Wahl." *die tageszeitung* (January 27), pp. 15–16.

Tanaka, Stephan. 1995. *Japan's Orient.* Berkeley: University of California Press.

Taussig, Michael. 1992. *Mimesis and Alterity: A Particular History of the Senses.* New York: Routledge.

Temkin, Owsei. 1977. "The Scientific Approach to Disease." In his *The Double Face of Janus and Other Essays in the History of Medicine.* Baltimore: Johns Hopkins University Press.

Thaler, Frank. 1991. "Germany's Right–Wing Revival: Bashers." *The New Republic* (December 9): 14–16.

Theweleit, Klaus. 1987. *Male Fantasies. Vol. 1, Women, Floods, Bodies, History.* Minneapolis: University of Minnesota Press.

Theweleit, Klaus. 1989. *Male Fantasies. Vol. 2, Male Bodies: Psychoanalyzing the White Terror.* Minneapolis: University of Minnesota Press.

Thornton, Robert Jay. 1988. "Time, Context, and the Interpretation of Violence." Unpublished manuscript.

Thornton, Robert Jay. 1990a. "The Peculiar Temporality of Violence." Rutgers Center for Historical Analysis. Unpublished manuscript.

Thornton, Robert Jay. 1990b. "The Shooting at Uitenhage, South Africa, 1985: The Context and Interpretation of Violence." *American Ethnologist* 17 (2): 217–36.

Tilly, Charles. 1970. "The Changing Place of Collective Violence." In *Essays in Theory and History* (Melvin Richter, ed.). Cambridge: Harvard University Press.

Time. 1981. "Sex Sale Appeal." *Time* 117, 15 (April 13): 82.

Todorov, Tzvetan. 1990. "Measuring Evil." *The New Republic* (March 19): 30–33.

Toepfer, Karl. 1997. *Empire of Ecstasy: Nudity and Movement in German Body Culture, 1910–1935.* Berkeley: University of California Press.

Tolmein, Oliver. 1992. "Mehr als nur Symbolik. Anmerkungen zur neuen Erklärung der 'Revolutionären Zellen'." *Konkret* (March 3): 37.

Tomforde, Anna. 1994a. "Wheelchair Girl Disfigured." *Guardian* (January 12)," p. I, 9:3.

Tomforde, Anna. 1994b. "Swastika girl not to be charged." *Guardian* (January 19),: p. I, 9:1.

Torgovnick, Marianna. 1990. "Entering Freud's Study." In her *Gone Primitive*, pp. 194–209. Chicago: University of Chicago Press.

Turner, Brian S. 1984. *The Body and Society.* Oxford: Basil Blackwell.

Uhse, Beate. 1989. *Mit Lust und Liebe: Mein Leben.* Frankfurt: Ullstein.

Ullrich, Volker. 1996. "Daniel J. Goldhagen in Deutschland: Die Buchtournee wurde zum Triumphzug." *Die Zeit* 38 (September 13).

Vidal–Naquet, Pierre. 1992. *Assassins of Memory: Essays on the Denial of the Holocaust* (Jeffrey Mehlman, trans.). New York.

Volland, Ernst. 1987. *Gefühl und Schärfe.* Bremen: Rixdorfer Verlagsanstalt.

Wade, Peter. 1993. *Blackness and Race Mixture: The Dynamics of Racial Identity in Colombia.* Baltimore: Johns Hopkins University Press.

Wahlprogramm. 1989. *Wahlprogramm der Alternativen Liste.* Berlin: Alternative Liste.

Walsh, Mary Williams. 1995. "Skin–Deep Problem Divides Germany." *Los Angeles Times* (September 28), pp. E 1, 10.

Walser, M. 1961. "Schwarzer Schwan." In *Gesammelte Werke* (1982). Frankfurt am Main: Suhrkamp Verlag.

Ware, Vron. 1992. *Beyond the Pale: White Women, Racism and History.* London: Verso.

Ware, Vron. 1996. "Seeing Through Skin." Paper Presented to *The Humanities Gender Group*, Rutgers University, New Brunswick, NJ,; March 18, 1996.

Warneken, Bernd Jürgen. 1986. *Als die Deutschen demonstrieren lernten.* Tübingen: Ludwig–Uhland–Institut für empirische Kulturwissenschaft.

Warneken, Bernd Jürgen (ed.). 1991. *Massenmedium Straße: Zur Kulturgeschichte der Demonstration.* Frankfurt/Main: Campus Verlag.

Wassermann, Rudolf. 1992. "Plädoyer für eine neue Asyl-und Ausländerpolitik." In *Aus Politik und Zeitgeschichte, Beilage zur Wochenzeitung Das Parlament,* 9 (February 21): 13–20.

Weber, Max. 1947. *The Theory of Social and Economic Organization* (A. M. Henderson and T. Parson, trans.). New York: Oxford University Press.

Werner, Josef. 1988. *Hakenkreuz und Judenstern: das Schicksal der Karlsruher Juden im Dritten Reich.* Karlsruhe: Badenia.

West, Cornel. 1993. "The New Cultural Politics of Difference." In *The Cultural Studies Reader* (Simon During, ed.), pp. 203–17. New York: Routledge.

Whalley, Angelina. 1997. "Der menschliche Körper—Anatomie und Funktion." In *Körperwelten* (Landesmuseum für Technik und Arbeit in Mannheim and Institut für Plastination, eds.), pp. 249–94. Heidelberg: Institut für Plastination.

Whitney, Craig, R. 1993. "Germans Begin to Recognize Danger in Neo–Nazi Upsurge." *New York Times* (October 21): pp. A1, A6.

Wieseltier, Leon. 1994. "After Memory." In *The New Republic Reader* (D. Wickenden, ed.), pp. 169–83. New York: Basic Books.

Wildenthal, Laura. 1994a. "Citizenship in the German Empire: The View from the Colonies, 1905–1914." Paper presented at the *International Conference of Europeanists*, Chicago, April 1, 1994.

Wildenthal, Laura. 1994b. *Colonizers and Citizens: Bourgeois Women and the Woman Question in the German Colonial Movement, 1886–1914.* Ph.D. Dissertation, Department of History, University of Michigan, Ann Arbor.

Will, Wilfried van der. 1990. "The Body and the Body Politic as Symptom and Metaphor in the Transition of German Culture to National Socialism." In *The Nazification of Art* (B. Taylor and W. van der Will, eds.), pp. 14–52. New York: The Winchester Press.

Williams, Brackette F. 1995. "Classification Systems Revisited." In

Naturalizing Power (S. Yanagisako and C. Delaney, eds.), pp. 201–36. New York: Routledge.

Williams, Raymond. 1973. "Base and Superstructure in Marxist Cultural Theory." *New Left Review* 82 (November/December): 37–56.

Wolfe, Patrick. 1991. "On Being Woken Up: The Dreamtime in Anthropology and in Australian Settler Culture." *Comparative Studies in Society and History* 33: 197–224.

Yanagisako, Sylvia, and Carol Delaney. 1995. "Naturalizing Power." In their *Naturalizing Power* (ed.), pp. 1–22. New York: Routledge.

Yuval–Davis, Nira, and Floya Anthias. 1989. *Women-Nation-State*. New York: St. Martin's Press.

Zinovieff, Sofka. 1991. "Hunters and the Hunted: Kamaki and the Ambiguities of Sexual Predation in a Greek Town." In *Contested Identities: Gender and Kinship in Modern Greece* (Peter Loizos and Evthymios Papataxiarchis, eds.), pp. 203–20. Princeton: Princeton University Press.

INDEX

•